Table of Contents

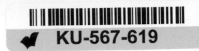

Table of Contents

Table of Contents

Foreword

A Sculpture Reader was first conceived as an anthology celebrating the 25th anniversary of *Sculpture* magazine, a monthly journal published by the International Sculpture Center. We quickly realized, though, that these articles could provide more than a simple commemoration of the magazine itself. While countless books and monographs are published every year on contemporary art and artists, no one volume has focused on our specialty—contemporary sculpture, in all its wide-ranging possibilities. Gathered together in book format, the articles first published in *Sculpture* offer a valuable overview of three-dimensional art since 1980. *A Sculpture Reader*, together with other ISC Press books, is designed as a reference handbook and entry point into the field of contemporary sculpture.

The articles collected here focus on individual artists, not themes or movements—although larger, collective interests do emerge from the particulars. Rather than giving a comprehensive, retrospective look at the art of our time, they offer a progressive viewpoint, spreading out in a series of snapshots that capture various aspects of sculpture as it has developed over the past quarter century. Most of the articles, whether they were published in the magazine as reviews or features, are based on a significant exhibition in the career of the artist. As such, each article gives a concrete look at what a particular artist was showing at that time, in the context of his or her work as a whole, as of the date given at the head of each article.

The artists covered in this volume range from very well known to less known to emerging, from the United States, Germany, France, Italy, England, Japan, Korea, India, Belgium, Sweden, Spain, Holland, South Africa, and Venezuela. The articles are a cross-section of the most accomplished and interesting sculpture of our time, but we make no claim to include every recognized or acclaimed artist in this first volume. Some of the best and best known artists, such as Richard Serra, Maya Lin, Mario Merz, David Nash, James Turrell, and Tony Cragg, appear instead in *Conversations on Sculpture*, a collection of over 40 interviews published by ISC Press in 2007. *Conversations on Sculpture* also includes emerging artists and others whose accomplishments deserve more recognition, from across the U.S. and Europe, as well as from China, Argentina, Cuba, and elsewhere in the increasingly globalized art world.

Although the work covered in *A Sculpture Reader* dates from about 1980 to 2006, the first article in the collection, Barry Schwabsky's discussion of Michelangelo Pistoletto, was actually published in *Sculpture* in 1992. Though a number of valuable articles were published in the magazine's first decade, 1982–91, most of the artists covered then appeared in later articles, and we decided to include the more recent discussions. A happy accident of our decision to start with 1992 and with Pistoletto is that, as Schwabsky makes clear, this artist associated with Arte Povera was very concerned in the late 1960s and throughout subsequent decades with reinventing sculpture, with starting over. After the important movements of the '60s—Minimalism, Post-Minimalism, and conceptualism in particular—there arose what has been called "Post-movement" art, a sense (particularly pronounced in sculpture)

that each artist reinvents art rather than building on the accomplishments of the previous generation or even those within a contemporary group or movement.

Over and over in this volume, we encounter artists who are concerned with defining or creating sculpture as a medium all over again. While some art writers and critics deplore this open, "everything goes" character, which they see as diluting the integrity of the sculptural object, we see cross-currents and affinities surfacing in the most unexpected and exciting ways. Our synchronous, rather than retrospective, approach in *A Sculpture Reader* emphasizes the flow of this constant reinvention of sculpture. We hope that readers of this anthology—whether students, teachers, practicing artists, critics, or art lovers—will trace their own connections among the myriad streams of contemporary art presented here and begin the next reinventions of sculpture.

Special thanks are due to Michael Klein, former Executive Director of the International Sculpture Center, for the original concept of *A Sculpture Reader* and the ISC Press and to Johannah Hutchison, current Executive Director—this book would not have been possible without their support. We also thank the writers for their contributions to *Sculpture* and their permission to reprint these articles, as well as the artists and their galleries and photographers for the images that they have made available. This publication was made possible in part by generous support from the National Endowment for the Arts, the Kanter Family Foundation, and Toby Devan Lewis. We also thank Virginia Nostrand Lee and Laura Dillon (former editorial assistants for *Sculpture*), the former editors of *Sculpture* (Suzanne Ramljak, Penelope Walker Kiser, and Rolly Strauss), as well as the current and former staff members of the International Sculpture Center and the readers and supporters who have kept *Sculpture* going for more than 25 years.

—**Glenn Harper & Twylene Moyer**

Introduction by Karen Wilkin

For an astonishingly long period in the West—from dynastic Egypt until about 1930—sculpture was synonymous with statue. For thousands of years, sculptures were monoliths, more often than not made in the image of human beings, carved or modeled and cast in a precious, enduring material such as stone or bronze. Traditional sculptures were frequently conceived for architectural settings, but even when they gained their independence, they remained aloof from ordinary experience, isolated on pedestals. Even with the advent of Modernism, in the mid-19th century, sculptors remained essentially faithful to the idea of sculpture as statue—or more accurately, as precious, permanent monolith—and continued to depend, as they seemingly always had, on our ingrained awareness of our own bodies and our sense of our capacity for movement to animate dense, solid forms.

The first truly radical changes in the conception of what a sculpture could be didn't occur until early in the 20th century, when adventurous international artists began to probe the implications of Cubism, expanding collages into three-dimensional constructions. At first, they employed such un-sculptural, often ephemeral media as paper, sheet metal, and wire or experimented with new-minted curiosities such as celluloid. Then, in the late 1920s, Pablo Picasso and his compatriot Julio González, began to put materials and methods appropriated from industry—techniques that González used in the automobile factory where he earned his living—into the service of art. These non-traditional means permitted— even encouraged—new kinds of open structures, assembled from thin linear and planar elements. The structures, instead of being, as sculptures had been for centuries, carved or modeled opaque solids that displaced space, were now loose-limbed, visually transparent constructions that embraced a chunk of air.

It's perhaps significant that this de-materialization of the monolith began in the uneasy decades following World War I, when long-established social certainties crumbled. The advent of open construction in non-art materials corresponded, roughly, with the gradual erosion of the lexicon of high-minded allusions—literary, religious, and social—once shared by the audience for public sculpture. In the wake of the subsequent upheavals of the last troubled century and in our disquieting present, this once common set of references has increasingly been replaced by private mythology, self-reference, and the language of mass culture, with accompanying changes in both imagery and form. Whatever larger parallels we choose to draw, it's plain that as new conditions elicited new aesthetic needs and solutions, and provided new material possibilities (though some notably inventive Modernists continued to find fruitful territory in carving or modeling), the heady combination of a new structural language and new physical means proved liberating and inspiring for many artists, well into the 20th century. By the 1950s, sculptors were routinely experimenting not only with scrap metal, structural beams, and industrial joining techniques—which already risked developing their own clichés—but also with plastic, glass, fiberglass, and a whole range of other surprising materials whose adoption, like Picasso and González's adoption of welded metal, was not only a response to unprecedented formal desiderata and emotional imperatives, but was also a signal of freedom from time-worn assumptions, a declaration of modernity itself.

The effects of this declaration resonate in the practice of virtually all serious sculptors working today. From the 1960s on, sculptors have questioned even the most entrenched assumptions about what sculpture could be. Marcel Duchamp's readymades—the notorious urinal, the bottle rack, the bicycle wheel, and the snow shovel—had long since changed ideas about what could be considered sculpture and why, but even those who subscribed to non-Duchampian definitions of what might be thought of as art proposed dramatic alterations to once-sacrosanct truths. The pedestal disappeared. Sculptures began to inhabit our own space, declaring their difference from other things in the real world by refusing to resemble anything pre-existing. Explicit and even oblique reference to figuration, even uprightness itself, along with its accumulated associations of verticality and confrontation with the human body, came to seem expendable. For some purists, sculptures became geometric paradigms. With the advent of what I suppose must be called Postmodernism—or more, accurately, for those who embraced Duchamp's ideas about the superiority of the verbal over what he called "aesthetic delectation"—such once-taken-for-granted conditions as coherence, objecthood, and material integrity appeared unessential. Why should a sculpture have to be hard? Or singular? Or tangible in any way? Or even visible? Artists have announced the idea of sculpture as performance, as the relic of an action, as process, as threat, as accumulation, as (perhaps unvisited) place, as light, as idea, employing materials that the most radical of their ancestors would have been startled by, including the latest mechanical and digital technology. And, the trajectory of art's evolution being what it is, qualities once deemed hopelessly retardataire, even reactionary, are now seen to be worth exploring once again. Figuration, mass, and even traditional methods have been given new life—and often sharply altered meanings—by present-day practitioners. In recent decades, the effects of the rapidity of modern travel, the international metastasis of pop culture, and the staggering impact of the Internet have been added to this unstable set of possibilities, resulting in an exponential expansion of what might come under the rubric of "sculpture," so much so that the term can seem a baggy monster, a catchall for everything that cannot readily be termed "painting."

To compound the difficulty, today's remarkably diverse, hard-to-categorize sculpture—indeed, today's art of all kinds—can no longer be viewed as a local, regional, or even national phenomenon. Instead, it is the province of a community of globally dispersed, often geographically mobile artists, all of whom are surprisingly aware of what is going on elsewhere, and whose work is often less obviously informed by the places of their origin or residence than by an international lingua franca. The collection of essays that follows, while by no means a complete overview, attempts to come to terms with this phenomenon by documenting the work of a broad sampling of this unclassifiable, wide-ranging group of artists, since 1980. Some of the sculptors scrutinized are from the U.S. and some from elsewhere; some are young and some seasoned. Their approaches and their material palettes, even their fundamental conceptions, are markedly dissimilar. The essays, written by an equally diverse group of critics, encompass everything from discussions of specific bodies of work or particular exhibitions, to analyses of entire careers. Cumulatively, they provide a comprehensive, revealing guide to the multivalent character of sculpture in recent

decades. The territory mapped by the essays is so wildly varied that it can seem bewildering, but slowly, it becomes clear that what unites artists and writers alike, however casually, is their shared belief in the expressive power of the notably disparate objects, conditions, or interventions under review—objects, conditions, or interventions that, since they are all clearly "not painting," we may choose to refer to as "sculpture." In other words, the collection makes plain that while sculpture may have altered almost beyond recognition over the past century, it has not lost its power to compel and move us. Things were undoubtedly a lot simpler when all one had to contend with were statues, but they were also undoubtedly a lot less interesting. **KW**

New York, December 2005

Michelangelo Pistoletto

by Barry Schwabsky
1992

The key image for the interpretation of the work of Michelangelo Pistoletto has always been the mirror. At this stage in his career, however, we should be able to see that, for the artist, the mirror has served more as a means than an end. As in Cocteau's *Orphée*, where mirrors are the means of passage from the realm of the living to that of the dead, the mirror has been less a window for Pistoletto than a door, and it has been the means of passage between, among other things, the world of painting and that of sculpture. We rarely remember that Pistoletto began as a painter, influenced above all, as he himself has said, by the works of Francis Bacon—though his first important commentator, Luigi Carluccio, cited Dubuffet as a source as well—and that his first use of the mirror was not as part of a work of art but as a tool in the process of art-making. Like any traditional painter, he used a mirror in order to take himself as the subject of his work—in order, that is, to make self-portraits.

So Pistoletto began his career as a painter; and, as a painter, his subject was psychological. "The first reflective painting I made was one that was painted black, on which I'd laid half an inch of varnish. I realized that on this very shiny black surface I could depict my face by using the reflection in the painting itself. From then on I stopped looking in a mirror, because I could see myself directly in the painting and reproduce myself there."[1] It was not long, however, before Pistoletto began using actual metal mirrors to paint on—something Brunelleschi is said to have done in the 15th century—and then, giving up altogether the subjectivity implicit in the act of painting, began transferring photographic images to his mirrors. These mirror pictures produce a peculiar effect, one that has not been much remarked in the criticism but which has a certain bearing on the question of these works' relation to sculpture on the one hand and painting on the other. A conventional topos in the *paragone* of the two mediums has been the fact that sculpture enables its viewer to move about the figure and see it from all sides, whereas painting can only depict a figure from a single viewpoint—we only see one side of it. To circumvent this limitation, painters would depict mirrors in order to provide a second view of the figure. Of course in Pistoletto's mirrors, we see the depicted figures from only one side, just as in painting; but when we see ourselves in the mirror, we appear to be on the other side of the represented figures, and we see ourselves moving around them as we move before the mirror. In the resultant mingling of the real world and the fictive one, we are given an image of ourselves as engaged in a specifically sculptural mode of perception, though through pictorial means. The mirror is the threshold, here, between mutable and frozen realities, that is, between life and art, reality and fiction. In terms of Pistoletto's development (but in striking contrast to any conventional iconology of the mirror, which is always taken to suggest narcissism and self-regard), it is the means of passage between the psychological and the social. We can also cite the interpretation of an art historical precedent of which Pistoletto was probably unaware: "An actual framed XVIIth-century Dutch or German mirror is in the Museum of Fine Arts in Boston. At the bottom of the mirror, there is a painted *Vanitas*

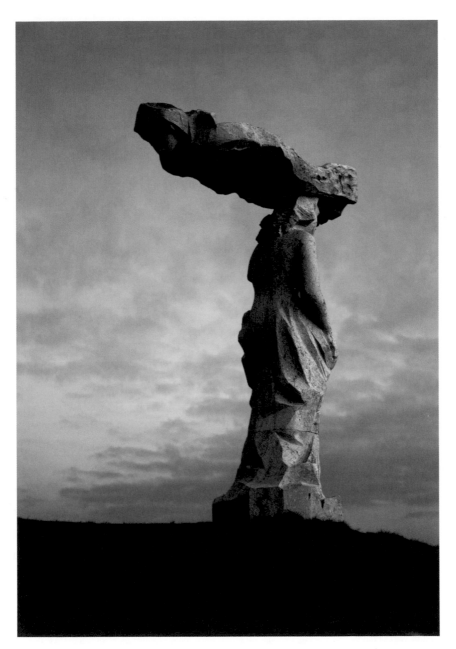

Dietrofront, 1981.
Cast marble.

still-life—a composition with books and a skull, symbols of transience. Anyone looking into the mirror could see his own reflection, accompanied, as it were, by the symbols of Vanitas. But his own reflection was itself fleeting and disappeared when he moved out of range of the mirror. In which case what remained then, paradoxically enough, is the Vanitas painted on the glass, as if to show that the symbols of the ephemeral are lasting, while reality is transitory and devoid of any imperishable existence."[2]

The next major additions to Pistoletto's repertoire, the *oggetti in meno*, the "minus objects" of 1965–66, are more difficult to interpret, in many ways, than the mirrors. It is possible to see them as simply taking up the thematic of the Duchampian readymade (and, more particularly, the assisted readymade). They are "minus objects" in the sense of everyday things that have been subtracted from everyday reality, promoted to the special status of art objects. But I suspect this would be a simplification. Pistoletto has never seemed very interested in or impressed by the power of art as an institution: his interests are far more theatrical than didactic. He would rather animate a situation than illustrate or demonstrate a thesis. Although his works as a group can be considered to constitute a set of "logical operations on a set of cultural terms," as academically respectable postmodern work in an Anglo-American cultural setting is supposed to, this may be precisely in order to be as "eclectic" as possible, that is, in order to define as many distinct positions to dramatically enact as possible.[3] And although these works clearly take Pistoletto farther into the sculptural mode than the mirrors did, it should be remembered that he would later emphasize that "I used the term 'object' and not 'sculpture' for them. It would be wrong to think of them as sculptures, because for me they are paintings."[4]

If they are "paintings," they are metaphysical ones in the tradition of de Chirico, creating fields of empty, abstracted space around themselves like the abandoned piazzas of *Ariadne* (1913) or *The Enigma of a Day* (1914). Of course, Pistoletto exaggerates to make a point by referring to painting in this context; it might have been less potentially misleading to speak of "pictures" (picture is to painting as object is to sculpture). As Germano Celant writes of the artist's procedure with the minus objects, "He insists on removing the figures from his imaginary world, or cutting them away from himself as they pass through."[5] In doing so he makes room for the viewer, whose path or gaze is not directed by any of the rhetoric of sculpture but must wander without fixed bearings through this alien terrain of the ordinary, of what Pistoletto correctly refers to as "objects."

Up until now, in speaking of Pistoletto's art in the early and mid-1960s, I have been considering work that precedes the appellation "Arte Povera," which has become attached to it. When Celant published the 1967 manifesto that gave currency to the term, an adaptation of Jerzy Grotowsky's call for a "poor theater," it was illustrated with a number of works whose appearance and titles were equally mute and "formal," among them Giovanni Anselmo's *Struttura*, Alighiero Boetti's *Oggetto*, Emilio Prini's *Perimetro*—and Pistoletto's *Oggetti in Meno*.[6] These are not really

the kind of works that would be primarily associated with the term "Arte Povera," nor are they the sort of works that these artists would primarily be concerned with over the next few years. Celant's article calling for an art "committed to contingency, to events, to the non-historical, to the present…, to an anthropological viewpoint, to the 'real' man (Marx), and to the hope (in fact now the certainty) of being able to shake entirely free of every visual discourse that presents itself as univocal and consistent," like any really powerful example of the genre of the manifesto, was more about what the work of these artists implied than what it was, more about the kind of work they were moving *toward* than what they had actually done.

In the case of Pistoletto, the work that perhaps best exemplifies his relation to Arte Povera is his familiar *Venus of the Rags* (1967). The work consists of a plaster reproduction of a classical figure, nude but holding her shed garment in her left hand, turned away from the viewer with a face hidden in a pile of real and very colorful rags. For an illustration of the kind of dichotomies on which Celant's text depends, one could hardly do better. The hard, frozen, and idealized statue of Venus, a reproduction pretending to the aura of art and historicity on the one hand; the soft, formless, and quotidian pile of rags, indistinguishable yet marked by difference and individualized by use on the other—the real stuff of history-in-the-present. This is what Marco Meneguzzo has called "the opposition between a world of representation and the universe of existence—which constituted the basic aporia upon which this generation of young artists had grown up."[7] We cannot dismiss the associations with the Marxist category of the *lumpenproletariat,* literally the "rag proletariat," what we now call the "underclass," but even closer to the surface is the opposition here between an ideal of femininity as the cause and object of desire and the realities of sweatshop labor behind the production of the rags and household labor involving their use. But beware: although a reading of Celant might lead us to assume that this opposition is being deployed by Pistoletto for polemical ends, nothing in the work itself allows us to go so far. We can only say that the artist is incorporating both of these supposedly incompatible realities in his work without pretending to synthesize them, that his decidedly impure and contingent art still intends to incorporate everything that had already been claimed by idealism and tradition, by aesthetics and historicism. We should also note that Pistoletto lays claim to the realm of sculpture by invoking the conventional form of statuary such as supposedly had been revoked by Modernism on the same grounds that painting had relinquished the form of the picture.[8]

So Pistoletto, both precursor and protagonist of Arte Povera, shows his deep ambivalence toward its very notion precisely in formulating its emblematic work. Augusta Monferini has also remarked that "after having been the soul, even in fact the strategist of Arte Povera, Pistoletto was the only one among the artists in the group not to remain imprisoned in a determinate poetics; 'director' of Arte Povera, he was within it even as he nonetheless remained outside it."[9] In fact one might say that at this point his work split off into two distinct directions, each of them tending to elude some aspects of the Povera rubric even while confirming others. On the one hand, there was his plunge

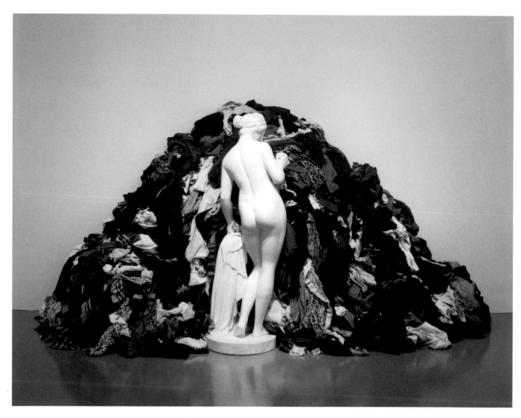

Venus of the Rags, 1967.
Plaster and fabric, 180 x 200 x 120 cm.

into the realm of happenings, "actions," and theater, taking up and intensifying the promiscuous mixing of realities implied by the mirrors—what Celant called "a focalization of gestures that add nothing to our refinements of perception, that don't contrapose themselves as art to life, that don't lead to the fracture and creation of two different planes of the ego and the world, and that live instead as self-sufficient social gestures, or as formative, compositive, and anti-systematic librations, intent upon the identification of the world and the human individual."[10] This occupied Pistoletto from 1967 through 1970 and again from 1976 to 1981. On the other hand, his work of the 1970s also showed a tendency toward a new and more analytical use of the mirror. In these works, the mirror is no longer the support for a photographic image but instead a self-sufficient object that can be either split or fragmented or else combined with others into three-dimensional structures. To quote a phrase Pistoletto gave as a title to several works around 1975–76, as well as to his 1988 retrospective in New York at P.S.1, this was the period of *The Division and Multiplication of the Mirror*. This work, as Monferini says, "energetically re-affirms the plastic and structural vocation of Pistoletto's art as a spatially 'organizational' element in dialectical confrontation with the

'shapeless' disintegration or dissemination of his own Arte Povera."[11] In these works, Pistoletto reaches toward a new sculptural exuberance in his use of mirrors, insofar as for the first time he uses them as an almost neutral material to be "carved" or employed as material for construction. Here, the reflective capacity of the mirror seems directed primarily toward itself. Pistoletto has said that he intended "to tell the story of a true god resuming His place…In this story, the god, by dividing Himself, creates not one but two sons, as two parts of the same mirror, each with the same ability to mirror."[12] The mirror has withdrawn from the life it was originally supposed to reflect, becoming a self-engendered profusion of views of itself even as it also takes its place in the world as a freestanding object or, if still attached to the wall, as a spatially avid object, spreading itself across an expanse of some 15 feet, as in *Drawing of the Mirror* (1979), or imposing itself through the use of heavy antique frames, as in *The Shape of the Mirror* (1975–78).

Although he has taken part in numerous retrospective projects and has continued his work with image-bearing mirrors and various kinds of object-oriented work, since the early 1980s Pistoletto has been primarily involved with a most untraditional approach to the question of sculpture in its traditional sense. In many ways this portion of Pistoletto's career still remains to be digested by an art world fixated on his work of the 1960s. "We know very well what sculpture is," as Rosalind Krauss provocatively asserted, after two decades in which, "sculpture" having become a term that could be applied to almost anything, we had begun to think that we could never know just what sculpture is.[13] For Pistoletto, at least, Krauss's statement was undeniable. He knew what sculpture was—essentially, statuary in the old-fashioned sense, the vertical figure, the monument—because he had already used it, appropriated it, in the *Venus of the Rags*. By 1981, however, he was ready to *make* sculpture, rather than just use it. A first step toward understanding Pistoletto's sculpture in the 1980s may depend on our ability to see its continuities with the first two decades of his work, even though a more profound understanding of it could well turn out to confirm the deep differences that in fact seem to be the most striking on first view. (Contrast is also a continuity.)

What the first view is likely to give us is a sense of heaviness, obscurity, obtuseness. The sculptures are often of very large dimensions, and yet they seem somehow fragmentary, incomplete. Although some are carved in marble, they are more often made of materials that are soft, like canvas, or both soft and "nasty," like Styrofoam. Mostly it is hard to tell just what they're made of, and in fact the artist insists on referring to their constituents as "anonymous materials." The forms are either more or less geometrical, though never hard edged and always clearly showing the signs of hand as opposed to machine work, or else more or less representational of the human figure; but the emphasis would be on the "more or less" rather than on the geometrical or the representational. I'd take a cue from the materials and likewise call them "anonymous forms."

These are objects that swallow space: "Idiotic thicknesses of a crushed and dribbled art, as arduous as childbirth."[14] Sculptures that, beginning from zero, need to feed voraciously on as much of their environment as possible. Now we

can begin to see the connections, for instance, to Pistoletto's first mirrors. Those, the end of painting for him, avidly sucked in all of the life and movement and imagery surrounding them, but always in order to send it back, in order to almost disappear. These works, the beginnings of sculpture, are to the mirrors as black holes are to stars: they retain what they take in, hoard it, fatten on it. They are also the inversion of the creation myth surrounding the "divided and multiplied" mirrors of the 1970s: "The spirit of ancient art went out towards the moon, and now the spirit of my sculpture is returning from the moon. It's a change of direction. Thus the sacrality of the past takes its form again in my sculpture as an inverse projection…There exists a soul common to the giant sculptures of Easter Island, to medieval wood carvings, and to Michelangelo's marbles, and this is what I want to rediscover in sculpture today. This term 'sculpture' is now concentrated on the question soul or non-soul, plenitude or void, god or non-god. Against monotheism I counterpose a center in every fragment, I occupy the spatial and environmental void of the art of the 1960s with the consistency of a full form."[15]

Against the myth he had propounded earlier of a god creating a world out of itself to populate with fragments of itself, the new myth is of a creation through anonymous fragments cohering into a renewed body, a new monumentality. And more than any contemporary artist I can think of, Pistoletto has actually succeeded in creating something like a monument. I am referring to his *Dietrofronte* (*Aboutface*, 1981–84), which stands in Florence near the Porta Romana. Its placement is significant, because this monument does not mark a central point but a liminal one, a threshold. You pass it (usually while riding in an automobile) before entering one of the gates to the old city. It marks the point where the periphery meets the center, and, as the name implies, it looks both ways. Consisting of two "anonymous" figures, one horizontally perched on the head of the other, it assumes both verticality and horizontality, both stasis and flight. It takes its place in the city of Michelangelo with complete humility and unquestionable dignity.

With the failure of Auguste Rodin's monumental projects, Rosalind Krauss has claimed that "one crosses the threshold of the logic of the monument, entering the space of what could be called its negative condition—a kind of statelessness, or homelessness, an absolute loss of place. Which is to say one enters Modernism."[16] If that is so, then I would go on to say that with *Dietrofronte* we have crossed a new threshold, the negation of the negation—not "back" into pre-Modernism, as if that were possible, but into something different which it would be unfortunate to call Postmodernism. The art of the 1960s and 1970s—what Krauss would call Postmodernism—tended to "reflect" life by negating or at least blurring the distinctions between art and life, multiplying the positions an object could take in the conceptual logic in which terms like "art" and "life" participate. In a work such as *Dietrofronte*, we can see a new monumentality taking shape, in which life can rediscover itself precisely through its difference from a sculpture that holds itself apart, that effaces its ability to show the social body its own image in order to allow society to find that image in each of its members. And in fact the best commentary that I can think of for

this work would not be in the words of a critic or aesthetician but in the words of a social philosopher, Albrecht Wellmer: "What shows itself in the work of art can only be recognized as something showing itself on the basis of a familiarity with it which did not before have the character of perceptual evidence. It is as if a mirror had the capacity to show the "true" face of human beings: we should only be able to know that it was their *true* face on the basis of a familiarity with them which only assumed the form of an unveiled sensual presence when the image of them appeared in the mirror. We can only recognize the 'essence' which appears in the apparition if we already *know* it as something which does not appear."[17] Pistoletto's sculpture "shows" the social precisely through this refusal to make it "appear." **BS**

Notes

[1] Michelangelo Pistoletto, quoted by Augusta Monferini, "Percorso di Pistoletto," in *Michelangelo Pistoletto*, eds. Augusta Monferini and Anna Imponente, (Milan: Electa, 1990), p. 11 (my translation).

[2] Jan Bialostocki, "Man and Mirror in Painting: Reality and Transience," in *The Message of Images: Studies in the History of Art* (Vienna: IRSA, 1988), p. 107.

[3] See Rosalind E. Krauss, "Sculpture in the Expanded Field," in *The Originality of the Avant-Garde and Other Modernist Myths* (Cambridge, MA: MIT Press, 1985), p. 288.

[4] Pistoletto, quoted by Germano Celant, "Reflections of Lava," in Pistoletto: *Division and Multiplication of the Mirror*, eds. Germano Celant and Alanna Heiss, (New York: Institute for Contemporary Art, 1988), p. 24.

[5] Celant, op. cit., p. 24.

[6] Germano Celant, "Arte Povera: Appunti per una guerriglia," *Flash Art* (November–December 1967); reprinted in *Flash Art XXI Years: Two Decades of History* (Milan: Giancarlo Politi, 1989: 3); tr. Henry Martin, pp. 189–91.

[7] Marco Meneguzzo, "Towards Arte Povera, 1963–1969: The History between Poetic and Strategy," tr. Howard Rodger MacLean, in *Verso L'Arte Povera: Momenti e aspetti degli anni sessanta in Italia* (Milan: Electa, 1989), p. 12.

[8] The picture-form would be re-evoked in the same year as Pistoletto's *Venus of the Rags* (1967) by another artist associated with Arte Povera, Giulio Paolini, with his *Giovane che Guarda Lorenzo Lotto*. In the early 1970s, Paolini would also begin using fragments of classical statuary, as would Jannis Kounellis later in the decade. Page 21 of the *Verso L'Arte Povera* catalogue reproduces some frames of a 1968 film by Luca Patella, showing the Roman artist Pino Pascali up to his neck in a lake or river and kissing the mouth of a likewise submerged classical Venus.

[9] Monferini, op. cit., p. 14 (my translation). Meneguzzo in *Verso L'Arte Povera*, p. 20, agrees that "Pistoletto…who enjoyed success before the others did…acted as a catalyst, at least in those first years of the maturing of ideas and the 'coagulation' of a group."

[10] Celant, "Arte Povera," op. cit., p. 190.

[11] Monferini, op. cit., pp. 14–16 (my translation).

[12] Pistoletto, quoted by Celant, "Reflections of Lava," op. cit., p. 27.

[13] Krauss, op. cit., p. 279.

[14] Michelangelo Pistoletto, "Hard Poetry" (1985), in *Pistoletto: Division and Multiplication of the Mirror*, op. cit.

[15] Pistoletto, quoted by Monferini, op. cit., p. 16.

[16] Krauss, op. cit., p. 280.

[17] Albrecht Wellmer, *The Persistence of Modernity: Essays on Aesthetics, Ethics, and Postmodernism*, tr. David Midgley, (Cambridge, MA: MIT Press, 1991), p. 25.

Giuseppe Penone

by Michael Brenson
1992

Giuseppe Penone was born on a farm in the village of Garessio in northwestern Italy, not far from the sea. He was raised in a peasant culture with an animistic feeling for nature that he contrasts with the exploit-and-conquer approach to nature in southern and central Italy, which was shaped by Greece and Rome. After attending art school in Turin and watching in disbelief as students "who did not live in England made sculpture like Henry Moore," he returned to his culture "of the village, of the mountain, a culture that was very old," with "its love for the tree" and for the "magic of the stone."[1] It was there that he found his artistic identity.

However, by the time Penone began investigating his childhood culture's belief in the indivisibility of human beings and nature, he was also a child of 1968. "There was a rejection of the whole culture," he recalls of that momentous year. "Society was trying to build a new order." He did not want to make sculpture that was "about art history." His project, and, he believes, the project of his generation, was "to look at reality." So he was returning to an old culture with a mission to help build a new world. He was going back to basics, determined to fill in the "gap between man and nature," with a highly analytical, self-conscious mind that questioned everything—including "man" and "nature."[2]

Penone's sculptural blend of radical ambition and ancient reverence has the potential to change the way everything is seen. His objects, drawings, and writings are gentle in their tone and texture, yet startling in their insights. (Who else would even suggest that the act of looking, in which the eye moves up and down and around an object, is a plant-like action?) His works can seem slow yet sudden, naked yet private, epic yet unrhetorical. Penone blurs distinctions between hard and soft ("even stone is fluid," he has written, even a "mountain crumbles and becomes sand"), interior and exterior, eye and body, beginnings and ends.[3] His work argues that nature offers a conceptual ground for the challenge to traditional hierarchies and categories that is characteristic of much influential post-1968 art.

Whether this argument is accepted or not, Penone offers an abundance of discovery and delight. In his work something right under our feet or just out of the reach of our hands or eyes is always being exposed. In his tree sculptures, the embryonic sapling we could not have suspected inside a wooden beam stands before us naked. The recognition that years of footsteps wearing down the stone steps of an abandoned 18th-century mill in Yorkshire have the same polishing effect as does a stream on a pebble—in other words, that the actions of water and the actions of feet can be analogous—makes the images of these commonplace steps seem like a revelation.

Pelle di foglie and *Respirare l'ombra*, 1999.
Bronze, metal cages, and laurel leaves, view of installation at the Centre Pompidou, Paris.

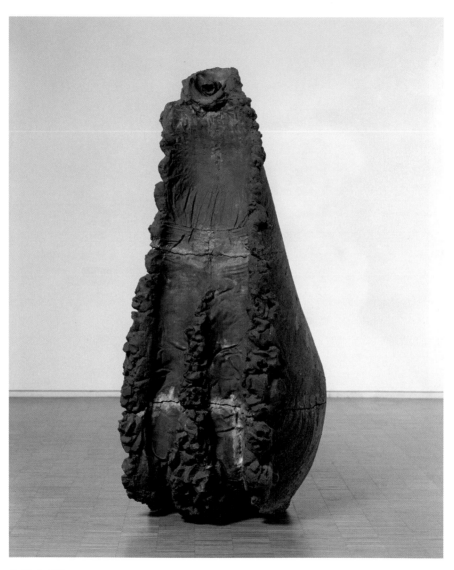

Soffio 6, 1978.
Terra cotta, 158 x 75 x 79 cm.

In Penone's down-to-earth world, the marvelous is always immanent. His sculptures, which he has described as natural readymades, are not representations of what was seen or known, as paintings might be, but revelations of what has been there all along. "It is always an image that exists before," he says of his work. "It becomes an image that was not seen."

His "Mind Landscapes" are large drawings made by applying charcoal to a plaster cast of a child's brain, putting Scotch tape over the charcoal, then using a photographic process to enlarge the image on the tape onto large strips of plastic. The drawings are like x-rays of what we cannot see inside our skulls. These x-rays of the brain look as if they could also be x-rays of a tree, or a block of marble, or the earth.

Penone has also made drawings more than 30 feet long based on the skin of the eyelid. He put gel on his eyelid, put Scotch tape on the gel, then made something like a biologist's slide by putting the tape between two strips of glass. Then he projected the slide onto sheets of paper from about 20 feet away and slowly drew in the image. The skin of the eyelid, as veiny as a brain, unfolds across the wall like a curtain, or a shroud, or a vast panorama of virgin land.

Penone's sculpture is a sustained attack on distance. Nothing in it is captured or sealed off or framed. Everything in it that is old and familiar seems youthful and new. Sometimes Penone shows parts of the body so magnified that it is as if we were seeing them from the thickness of a fingernail away. He also creates numerous images of embeddedness: his hand, cast in iron, gripping the bones of a tree; his body leaning face forward into wet clay; potatoes given the shape of his head growing in the earth. For Penone, the human is embedded in nature and nature is embedded in the human. "Man is nature," Penone says—and he wants the fluid interrelationship between them to be experienced from within.

Like many inhabitants of animistic cultures, Penone venerates trees. He has identified the tree with sculpture in its solidarity, fluidity, and verticality, and in its ability to carry within it the memory of its gestures and growth. Its shape, branches, and bark suggest to him snakes, roads, and rivers. In *I Have Been A Tree in the Hand* (1984–91), the shape of the cut sapling, with an iron cast of Penone's hand gripping its trunk as if to staunch bleeding, resembles veins and arteries of the human circulatory system. Trees, like human beings, are upright systems with skins through which air and water flow.

Penone is best known for sculptures in which he chisels away the annual rings of an industrial wooden beam and arrives at the pristine embryonic sapling fossilized at its core. He has installed these sculpture-trees alone and in groups. He has laid them flat, like stone figures on tomb sculptures, or stood them straight, allowing them to soar like a cathedral vault. The embryonic tree may be cut free and liberated from the concentric rings around it or half-

embedded in them. Somewhere in all of these works, the full thickness of the original beam is present and the number of rings in the mature tree is visible.

These sculptures are hard to forget. They were created very slowly, inch by inch, day by day, yet their impact is instantaneous. When the sapling is seen encased in its growth rings, the beam and mature tree seem like a womb and tomb. By showing the embryonic tree amid its rings, growth and time appear to have been uncovered and exposed. The entire life of the tree, from childhood to old age, seems present all at once.

Penone is six feet tall with black hair and a farmer's solidity. He has the attentiveness and articulateness of someone for whom the pleasure of existing and the pleasure of defining are inseparable. His manner is so unpretentious and unflappable that it is hard to imagine him defensive or insistent. He has a way of moving that seems neither fast nor slow, neither tentative nor hurried. He radiates restless certainty, restrained energy, and self-effacing pride.

Since 1978 he has made his enormous drawings in a large (about 120 feet long and 40 feet wide) wood-beamed, light-filled loft-studio on the fifth floor of a former 19th-century hospital in the heart of Turin. He lives with his wife, Dina, their daughter, Caterina, and their son, Ruggero, on the hill of a former vineyard in the village of San Raffaele, about 15 miles east of Turin. Their spare, spacious house, with its thick walls and marble floors and windowsills, was a ruin when they bought it; it is not yet entirely restored. Nearby is a former two-car garage that is now the studio in which Penone and his assistant, Sergio Galli, chisel beams.

On his 25 acres of land, Penone has marked his presence in telling but almost imperceptible ways, including planting a bronze branch into one young tree and one of his iron hands into another; he is considering clearing a tree-shaped path. He has a dog, around a dozen cats that run wild, and a handful of chickens, which he was eventually obliged to seal in a coop near his plentiful garden because a previous dog enjoyed making the chickens into a meal.

Penone's sensitivity to the life of the land is astonishing. Walking up a dirt path he saw the tiny legs of a fly sticking out of a hole in the ground. With his thumb and index finger he grabbed the legs and pulled the fly up to his face, examined it for a few seconds, then deposited it safely back into its hole.

Although Penone feels a deep sympathy with the Renaissance artists Alberti and Leonardo, who he believes "began to study nature as it is," he is aware that his view of nature is very different from the one identified with Italian art, in which the focus, Penone says, "is on man."

His view is also radically different from the most influential approaches to nature in American art. Penone does not create immense landscapes in which human beings cannot make a difference: on the contrary, he shows how the imprint of fingers on bark can affect the growth of a tree. His sculptures are not attempts to compete with nature, or to become nature, or to use nature as a source of artistic power, all of which assume a hierarchy, as well as the gap between human beings and nature that he is trying to fill.

But his sculpture *does* have an epic dimension, and it does grow out of his experience of nature. It depends on his ability to communicate an experience of the fluidity and interconnectedness of everything that lives. He finds something of human beings in potatoes, trees, and water, and something of water, trees, and potatoes in human beings. He believes that trees gesture when they compete with other trees to get enough light and struggle for equilibrium—like a "tight-rope walker with his outstretched arms"—when a bronze branch tips their weight to one side.[4] His work suggests how much effect a mere fingernail can have when it digs into plaster or earth. Penone moves between the very small and the very large, and he is constantly stretching and collapsing time.

Penone has made a number of large magical works inspired by the tiny fingernail. The one from 1989 measures 12.5 by 6 feet. It consists of a shallow mound of laurel leaves partly covered by curved, fingernail-shaped glass. Like a fingernail, glass is translucent and sharp, and, Penone says, it transmits vibrations. Leaves are soft and organic, like flesh. Like a fingernail, a leaf grows and then falls off or is shed; both are part of a cycle of growth and death. Like a nail on a finger, the heavy glass seems entombed amid the leaves, but the leaves also seem like its womb. This fingernail not only looks gigantic, but it also feels gigantic because of the scale of the questions it asks. In Penone's work even the relationship between finger and nail can be an event.

Although Penone has essential similarities with the Arte Povera artists who put Italy back on the art map in the 1970s—including his feeling for process and humble materials and his wish to make art that will not be considered in terms of form—his differences from them are important. Penone is a generation younger than Mario Merz and Jannis Kounellis. He sees their sculpture as an extension of painting. "When you think of painting, you have a frame, or support, where you can put things," he says. "With Merz, an igloo is a container for form. It is always like a canvas. Like a spiral, or table, you can put things in it." Penone likens painting to the concept of the bourgeois living room. He feels little connection to it.

He feels closer to artists like Richard Long and Ulrich Rückriem, and also Giovanni Anselmo, who, like him, was affiliated with Arte Povera. Anselmo "looked at the reality of things," Penone says. "If it is about stone, it is about the reality of the stone, about the weight of the stone, not the image or form of the stone."

The rejection of painting is fundamental to Penone's way of seeing. It can be felt in the transience and openness of his work (for example, the glass covers only some of the laurel leaves, the others could blow away). It can also be felt in his resistance to a single style. "In our market system of art, and with collectors," he says, "they want to have the same product, so they can recognize the artist. That is not possible for me. It is so crazy to work with just one combination and be identified with one form. It is better to be identified with a way of thinking. It is better for me to have several forms to reflect this thinking and not the same form in which you can put all this thinking."

Penone's thought is guided by nature and by a consciousness of its precariousness. Since art is a human activity and human beings are nature, art too, for Penone, is nature. He believes that in nature life is geared toward survival. One of his aims in exposing the links between human beings and nature is to help ensure the survival of the species. "If one destroys nature," he says, "one destroys an equilibrium and one destroys the possibility for man to survive."

The moral, aesthetic, and spiritual dimensions of Penone's work go together. Its aesthetic power depends on the revelation of the world in and around us. This revelation is also a recognition of meaning and spirit. And of a soul that is ever present, but as Penone says of the concept of a tree, "can never be fixed or known."

The political dimension of Penone's work also reflects a consciousness of nature formed by his childhood culture and by 1968. Penone believes that any genuine questioning of reality, any convincing attempt to see the world without preconceptions, with entirely fresh eyes, will have some radical effect. "To make a research on reality" is "something religion never likes," Penone says, "and which the structure of society does not accept easily, because that puts in question the problem of power, the problem of political organization, the problem of the concept of reality in general."

If you are touched by Penone's work, you will feel that the world is there to be discovered anew every day. You will feel the similarities and differences between all living things. You will wonder about the legitimacy of any new art that assumes a clear-cut division between human beings and nature. You may not agree with Penone that it is "stupid to say that man is more important than grass or a stone," but you will see the potential of sculpture that finds in grass or stone a grand purpose and scale. **MB**

Notes

1 Unless otherwise noted, all quotations are from interviews with the artist conducted partly in English, partly in French (with which he is more comfortable), May 1991.

2 Giuseppe Penone, *The Eroded Steps* (Aegis Publishing and Henry Moore Sculpture Trust, 1989), p. 21.

3 *Giuseppe Penone*, catalogue for an exhibition in Bristol and Halifax, U.K., 1989, p. 17. This is probably the best source for Penone's many statements about his work.

4 Ibid., p. 45.

Rebecca Horn

by Ann Wilson Lloyd
1993

While Rebecca Horn is best known in the U.S. for her clattering, splattering automata, in Europe, where her films are sometimes shown on television, she has a larger audience with a broader knowledge of her works. In 1992 Horn became the first female recipient of the Kaiserring, a prestigious German art prize. In 1988 she received the grand prize for her installation *The Hydra Forest/Performing: Oscar Wilde*, at the Carnegie International. Her status as "a Modernist who has seriously engaged her mentors" and the symbolic role of her works as "the bride-machines who, rather than denying the Duchampian bachelors, have come back to overwhelm them," are thoroughly established.[1] More cunning and precise than Kafka's axe, Horn's work conspires to mesmerize, whip, caress, and electrify the frozen seas within us. Her feathered machines, steel-rod pendulums, tapping hammers and awls, paint-splattering contrivances, fire-spitting copper snakes, dripping tubes, suspended typewriters, beds, and baby grand pianos perform eternal mating dances aimed at the erogenous zone called the mind.

Horn's work touches on but moves beyond feminist reaction or revenge, and it moves beyond the body as memento mori or site of gender politics. The artist takes biology as model, not as destiny, by synergizing a honed vocabulary of basic elements. Like nature, Horn's work has a limitless, organically evolving form. It both mimics and replicates natural systems: it is at once afferent and efferent, capable of both embracing the universe and creating one of its own.

Horn's spiraling opus bores into the complexities at the core of human-animal behavior, whether acculturated, instinctual, or combined. Her layered references to birds and snakes, sensuous entrapment, entrancement, and climactic relief aim directly at our reptilian brain stems and evolutionary memory. Her synesthetic methods are metaphors for a neurological system with its synapses in continuous cycles of fire-and-reload, its brain waves resonating through the senses, the intellect, and various levels of consciousness.

The Solomon R. Guggenheim Museum in New York—with its organic gyre and visually connected galleries—is an appropriate setting for Horn's 1993 retrospective. Her site-responsive installation makes the neurological metaphor more explicit. Lead tubing links galleries and works by appearing to penetrate the museum's spiral ramp. Lead pipes also played a dominant (and also subtly interconnecting) role in her installation (1992) at Documenta IX in Kassel, Germany. Installed in a top-floor classroom of a former schoolhouse, the pipes originated in the inkwells of old-fashioned school desks that Horn had mounted upside down in rows on the ceiling. The pipes then snaked (invoking heavy lead pencil marks) through the room's frosted windows, down the outside of the building and into the courtyard below. There they terminated behind an installation of Franz West's carpet-covered Freudian couches. These couches provided row seating for an outdoor cinema screen, with evening film offerings including

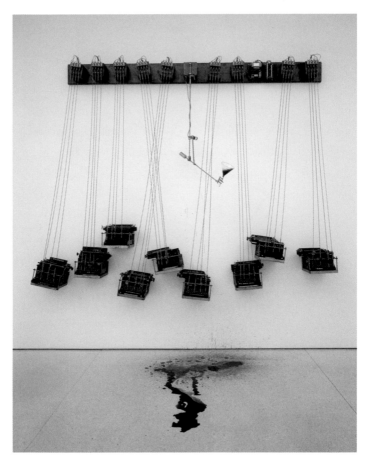

Blue Monday Strip, 1993.
Typewriters, metal, and motors, approximately 488 x 348 cm.

Buster's Bedroom, Horn's recent feature-length film. Meanwhile, back inside the schoolroom, ink dripped from the pipes and splashed into glass beakers on the floor, while tiny metal arrows drilled rhythmically against the window glass. This interior/exterior scenario provoked inner- and outer-world associations ranging from memories and longing to wittiness and art world collaborations.

Horn's large installations are sometimes enigmatic but usually unforgettable. While audiences may not always connect with her subtle literary allusions (Dante, Wilde, Proust, Kafka, and Beckett) or her alchemical notations, they will respond to sensations of lush materials and startling methods. Her oft-noted references to medieval alchemy—the piles of pigment, glass beakers of mercury, coal or sulfur, pools of liquid, and flashing electrical fires—are presented as a potent Minimalist statement, stripped down to the essentials for a desensitized, literal-minded 20th-century audience. The exquisite timing, grace, and suspense of her mechanized works are choreographed with a nervous,

Paradiso, 1993.
Plexiglas, pumping system, lightning machines, fox machines, water, and ink, dimensions variable.

animalistic movement that is authentic enough to reach the most primitive of reflexes. The audience is often drawn slyly within the "danger zones" of these performances. In *High Moon* (1991), two rifles cast around and aim fleetingly at the viewer before facing off and blasting blood-red liquid at each other.

With an exquisite sense of life's absurdities and dualities, Horn probes the back side of every polarity: compel/repel, pleasure/pain, body/mind, chicken/egg. Two of her site-responsive installations tread that no-man's-land. *The Counter-Moving Concert* (1987), for Skulptur Projekte Münster, was set inside a previously walled-off medieval city keep that had been used as an 18th-century prison and more recently as a torture chamber by the Gestapo. Horn kept her intervention to a minimum in this already loaded locale, installing a few red candles, small tapping hammers, collapsing wings, and a glass funnel overhead that dropped water at an excruciatingly slow rate.[2] *Missing Full Moon* (1989), a site piece at Bath, U.K., also reactivated a formerly boarded-up space—the Cross Bath, an 18th-century enclosed mineral pool dating to Roman times. Horn pumped the pool's sulfuric blue water through copper piping submerged just below the water's surface. Just above the surface, an interconnecting ganglia of glass beakers bubbled and spurted.

Horn's recurring themes (allusion, alchemy, the paradox of attraction) and what she calls her vocabulary of "signs and secret language" pervade her projects.³ Even a simple childhood tale contains prescient elements of these symbols and obsessions. Born during World War II, Horn was brought up in the country by a governess and relatives until age eight, when her parents insisted she be sent to boarding school. She recalls: "I made a strange deal with my mother. In the village we always played around undressing ourselves—at this age you begin to be interested in sex and so you have these games you play—and I said I would love to have a blanket made of butterfly wings that caresses my whole body. My mother said, OK, you go to boarding school and we'll make one for you... Anyway, my mother gave me a big package and put me into the car with her chauffeur, and I was taken to the boarding school. It was an idiotic big castle in a park. The chauffeur dropped me off, and there I was sitting with my package and my suitcase. I saw all these crying children arriving and I thought how strange this place is. Right there I decided that I would stay for only one day and then go back home. At some point I opened my package. In it was just an ordinary blanket with printed butterflies on it. I was so furious I took the blanket and climbed up on the high wall surrounding the park where they couldn't find me, and I sat there all night crying, waiting till the chauffeur came back so I could throw the blanket at my mother and go home. But no one came back for a year."⁴

Her most pivotal life experience occurred when she was a young adult attending art school. She suffered a two-year bout with tuberculosis, precipitated by working with polyester resins, and was confined for six months to a public sanatorium. It was "terrible, frightening and strange," she recalls. Isolated and reduced to working in bed, she started making soft-material sculpture—body-related pieces she built for friends, or occasionally, for total strangers. These strangers were people, she says, that "I had seen somewhere and something about them fascinated me…that was the origin of my performance pieces."⁵

This brush with mortality and the works for friends led to a series of sadistic-looking body-oriented works such as *Arm Extensions* (1968), *Cornucopia, Séance for Two Breasts* (1970), and her first powered mechanical work, *Overflowing Blood Machine* (1970), all of which were based on personal experience with physical frailty and body-consciousness. A later series of headgear adorned with things like feathers and pencils shifted the site of her physical concerns. She wore these in performances such as the one in which she rhythmically brushed the pencil mask back and forth, streaking the wall with an image "which corresponds to the rhythm of my movements."⁶

Early issues continued to be integrated in her work: nubile sensuality, confinement, body-consciousness, a collector's fascination with exotic specimens (human and animal), and ultimately, the goal of magical, apocalyptic transcendence. In *Unicorn*, a 1970 performance piece, Horn convinced a young woman, a perfect stranger chosen solely for her perfect posture and the fluid way she walked, to wear a white unicorn horn and harness in a semi-nude performance. Horn not only built the personalized apparatus, but through the course of the project, developed a rapport

with this fairly conventional person, introducing her to Horn's own unconventional ways of thinking. The "dramatic tensions inherent in the relationship were built into the climax of the performance," when the woman, dressed only in the unicorn headpiece, "took a trance-like journey" through a Hamburg park.[7]

Horn's work is often linked to that of Joseph Beuys, who was teaching at Düsseldorf while she studied at Hamburg. Horn, as a first-generation, postwar German artist who came of age during the cult era of Beuysian influence, was undoubtedly influenced. But while she initially worked in tandem with Beuys's mythologies of physicality, suffering, and redemption, it was perhaps his prototypical performance and conceptual hybrids that provided the larger model. Horn sharpened those hybrids, however, with her appreciation for Duchamp, "whose light touch and subversive irony were only partially understood by Beuys."[8] She herself claims Duchamp's own sources, the pre-Dadaists and their tableaux of inner-world absurdity and fantasy, as more important to her, and Raymond Roussel as a special interest.[9] Indeed, Roussel's 1911 performance *Impressions d'Afrique* was redolent of contemporary Horn. His *Earthworm Zither Player* consisted of a vitrine in which a live earthworm "played" an instrument by secreting drops of mercury-like "sweat," which slowly slid down the strings and produced sound.[10]

Distinct from all predecessors is Horn's high degree of trenchant, formal elegance, an impact perhaps of Minimalism with its lessons of self-contained, succinct statement. *Paradise Window* (1975) is a beautiful life-sized column of shiny black curling feathers. In performance it opens slowly and sensuously to reveal a naked woman standing inside. As an empty kinetic piece or a static sculpture, it is equally effective—a dark and mysterious phallic object. Other performance-sculptures, such as *The Chinese Fiancée* (1976), have this same delicate, erotic, almost sinister way of expanding, entrapping, and filling space, both physically and metaphorically. They connote intense yearning—for another locus, the perfect specimen or lover, or one of Horn's mentor-legends from the past.

Berlin Exercises–Dreaming Underwater (1974–75) is a filmed documentation of several performances done in a Berlin studio when Horn was away from her (at that time) adopted base of New York. One segment, "Two Hands Scratching Their Respective Wall," seems an attempt to summon the muses to this unfamiliar, empty space as the artist slowly, eerily scrapes along either wall with rod-like finger extensions. In a really brutal segment Horn chops methodically away at her long red hair. As it gets shorter and shorter, the pointed shears jab closer and closer to her eyes. When at last she stops, her hair looks awful, and she appears close to tears.

The loose plot in Horn's first narrative film, the Surrealist *Der Eintänzer (The Solitary Dancer, or The Gigolo,* 1978) is again inspired by her absence from New York. The action all takes place inside the narrator's (Horn's) head as she conjures up an assemblage of imaginary people who come and go in her sublet New York studio. This film marks the beginning of a character ensemble that shows up in various incarnations in successive films and begins to be alluded

to in gallery installations. There is a ballet mistress, an odd set of female twins, and a dancing blind man. Fantasy machines, like "Mechanical Tango" (a dancing table) and "Feathered Prison Fan" (which, as it envelops a young dancer, is reminiscent of Horn's childhood dream of a butterfly blanket), also make their debut. These strange bionics often seem to have more personality than the variously desensitized flesh-and-blood characters they encounter. Horn's symbolic cast of relics—feathers, eggs, field glasses, sharp-pointed objects, pianos, metronomes, and butterflies—also play important roles.

In *Buster's Bedroom*, Horn's homage to Buster Keaton, she wove these components into her most sophisticated film to date. Set in a sanatorium for harmlessly deranged silent film stars—supposedly the sanatorium that Keaton himself was confined to for alcoholism—the twisting plot continues Horn's running theme of induced torpor building toward ecstatic release and her fascination with the chemistry of attraction. There is the ageless diva who keeps butterflies in a refrigerated stupor, believing them to be the souls of her lost lovers; a phony doctor (played by Donald Sutherland) who charms poisonous snakes in his basement herpetorium; and Diana Daniels (Geraldine Chaplin), who, as the doctor's pretend patient and frustrated lover, has confined herself to a wheelchair (with a convenient mechanical whiskey-serving arm) for 14 years. An ingénue and an assortment of loonies round out the cast.

Horn's film narratives are non-linear, dream-like, and visually vivid; there is a crucial balance of wit, suspense, elegance, and lush sensuousness. Like dreams, they only flirt with logic, keeping the audience in that netherland where neurological intake must be processed simultaneously by intellect and senses. With all of Horn's work, we take an uncharted journey into our own physiological and intellectual mysteries. Like body and brain, journey and mission merge: both are charged by "life energy...constant curiosity...[that] tremendous longing to discover limitless, timeless moments."[11] **AWL**

Notes

1 Bruce W. Fergson, an independent curator who has worked with Rebecca Horn, in conversation with the author
 at the Institute of Contemporary Art, Boston, Massachusetts, December 7, 1992.

2 Horn, in conversation with Demosthenes Davvetas, "Rebecca Horn," *Galeries Magazine* (June/July, 1991): 97.

3 Horn quoted in Robert Enright, "Fierce Vulnerabilities: Rebecca Horn in Conversation with Robert Enright,"
 Border Crossings (Fall 1991), pp. 15–16.

4 Ibid., p. 18.

5 Rebecca Horn, artist statement for the exhibition "Diving through *Buster's Bedroom*," exhibition catalogue,
 (Los Angeles: Museum of Contemporary Art, Fabbri Editori, 1990), p. 43.

6 Mina Roustayi, "Getting Under the Skin," *Arts* (May 1989): 61.

7 Horn, op. cit., p. 38.

8 Jill Lloyd, "Disrupting Consumerist Culture, German Sculpture since Beuys," *Art International* (Spring 1989).

9 Enright, op. cit., p. 22.

10 Roselee Goldburg, *Performance Art From Futurism to the Present* (New York: Abrams, Inc., 1988), p. 77.

11 Davvetas, op. cit., p. 97.

Bruce Nauman

by Ann Wilson Lloyd
1994

Bruce Nauman is the artist we hate to love. His traveling retrospective of over 65 works can be a harrowing experience. With seemingly little effort, he pushes our buttons and provokes complicitous responses. Repeatedly we are baited with multi-media displays, beckoning enclosures, bright lights and colors, then rewarded with hectoring videos, claustrophobic spaces, disembodied heads, and mutant animals.

The exhibition's eerie, dissonant sounds alone serve as a kind of primal warning, particularly as they echoed through the maze of stone rooms in Madrid's Reina Sofia museum, the cavernous 17th-century former hospital building where the show premiered in 1993. While a former hospital is an apt site for Nauman, his art needs little in the way of site. Especially with his mature works—increasingly theatrical multi-media installations that blend *commedia dell'arte* with the sensory onslaught of Antonin Artaud's Theater of Cruelty and the intellectual onslaught of Ionesco's and Beckett's Theater of the Absurd—viewers supply their own responsive contexts.

These more recent works seem almost medieval in spirit, incorporating conflicted personas of alchemist and jester, Dr. Frankenstein and Cotton Mather.[1] Yet in the end, Nauman steadfastly refuses to cast himself in any specific role. Unlike today's more sententious political artists, Nauman remains a sly devil's advocate, provoking real passions and then withdrawing from the argument.

The video piece *Violent Incident* (1986), for instance, seems to have anticipated the current debate about the causal effects of violence in popular media. Twelve monitors arranged in a bank play concurrent but unsequenced sketches in which male and female actors begin by treating each other politely, then segue to cruel jokes, such as jerking chairs out from under each other. The violence escalates, but because of the continuously switching roles, gender politics remains ambiguous. *Violent Incident*, like other Nauman video pieces (*Clown Torture* [1987], *Shit in Your Hat—Head on a Chair* [1990], and *Anthro/Socio* [1991]), gives a perverse twist to Artaud's theory of invoking audience catharsis through dramatic hostility. Viewers feel their adrenaline rising, but are ultimately left in a complex space where the argument is no longer clear cut nor merely intellectual.

The exhibition catalogue acknowledges Nauman's debt to the German philosopher Ludwig Wittgenstein.[2] It was Wittgenstein's acceptance of the validity of failed arguments as well as proven ones that evidently ushered Nauman into a conceptual space beyond polemics—a crucial development in the burgeoning free-for-all of the mid-1960s art world. Nauman's further consideration of artists such as Man Ray, Picasso, Jasper Johns, and Willem de Kooning resulted in a determination to explore the full diversity of art, to focus on ideas rather than

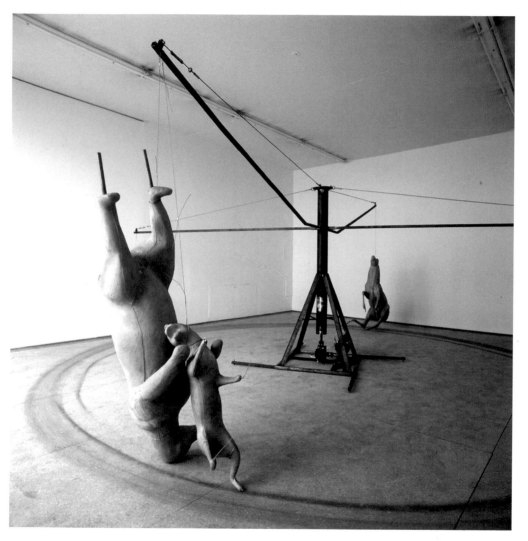

Carousel, 1988.
Steel and cast aluminum, 84 x 216.75 in.

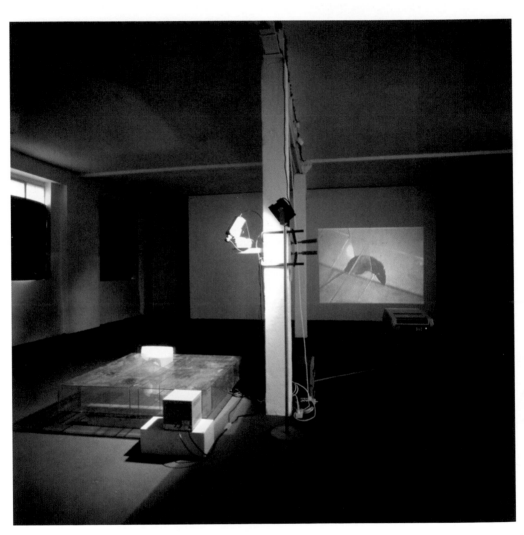

Learned Helplessness in Rats (Rock and Roll Drummer), 1988.
Plexiglas maze, video camera, scanner and mount, switcher, 2 videotape players, color video monitors, black and white
video monitor, video projector, 2 video tapes (color, sound), dimensions variable, maze: 22 x 126 x 130 in.

a signature style or formal concerns, and to underwrite his acknowledged Dadaist inclinations with an innate investigative motivation.[3]

One Wittgenstein proposition in particular—"A point in space is a place for an argument"—seems to distill the Nauman ethos.[4] Through his refusal to embrace any single style, Nauman staked out a territory of contention, and the retrospective reveals his continuing preoccupation with tension—actual, metaphorical, and conceptual—and his strategies for invoking it. Interestingly, these strategies often involve the act of casting, in both its sculptural and theatrical definitions. The exhibition itself could even be called a cast or husk, a funhouse parody, an obverse, inverse, or "yes, but" response to artistic, political, and social concerns. Nauman increasingly aims for a metaphorical reflection of aspects of late-20th-century culture and politics—a conceptual imprint that can be expansive, reactionary, and/or subversive, but always wrought with contradictory gut reactions.

The exhibition's chronological structure at the Reina Sofia placed Nauman's initially self-conscious body works into a context with his more recent socially conscious ones. The viewer slowly gains an awareness of his or her own indefinite position within the larger, even more arbitrary and unstable body politic. A vocabulary emerges as Nauman revisits certain tactics: traditional sculptural castings; doses of innocence injected via children's games, clowns, and puppets; popular technologies like video, neon, and hologram; and a formal, Minimalist presence undermined by heavy symbolism, sloppiness, or vulgarity. For all of Nauman's shifting methods and protean results, the retrospective reveals him repeatedly holding the mirror up to himself.

Nauman dismissed his initial attraction to painting as a solution too limited and too suspiciously "lush" (though he remains attracted to color, particularly garish neon tones).[5] This decision freed him to explore the then-fringes of art-making, film and self-conscious performance, along with more traditional methods of sculpture, and it revealed early traces of his contrary nature. His first literal castings—droopy, rough, elongated organic forms of fiberglass and rubber—seem to pit process against Minimalism's hermetic, hard-edged perfection. These early works, made on the West Coast shortly after graduate school at the University of California, were subsequently recognized as part of an "anti-form" Zeitgeist then hovering over both coasts and Europe. It was not so much a movement as a simultaneous natural reaction to Minimalism and highly formal abstraction on the part of younger artists, among them Louise Bourgeois, Eva Hesse, Robert Morris, and Joseph Beuys.[6] Nauman more directly parodied Minimalism (and edged into the spatial void) with his wry, elaborately titled *Shelf Sinking into the Wall with Copper-Painted Plaster Casts of the Spaces Underneath* (1966), *Platform Made Up of the Space between Two Rectilinear Boxes on the Floor* (1966), and *A Cast of the Space Under My Chair* (1966–68). These works were visual and conceptual discussions (arguments) about points in space, interiors versus exteriors, mirror images, shells or castings, and the tension between the reality of an object and the space around it.

Nauman personalized such concerns with his next works, self-conscious parodies of body, self, and art history: the castings *Henry Moore Bound to Fail* (1967) and *From Hand to Mouth* (1967), as well as a series of essentially one-liner color photographs with punning titles such as *Self-Portrait as a Fountain* (1966–67), *Waxing Hot* (1966–67), and *Feet of Clay* (1966–67). In the throes of self-doubt brought on by his studio isolation following graduate school, Nauman made hay out of existential angst with works like *Collection of Various Flexible Materials Separated by Layers of Grease with Holes the Size of My Waist and Wrists* (1966), a strop of scruffy materials à la Hesse, Beuys, and Morris, and *Neon Templates of the Left Half of My Body Taken at Ten-Inch Intervals* (1966), an eerie, green, glowing apparatus-like sculpture that combines Minimalism and technology with a gothic sense of body consciousness. With his ironic and iconic spiraling neon piece *The True Artist Helps the World by Revealing Mystic Truths (Window or Wall Sign)* (1967), which was inspired by a beer sign left in his storefront studio, Nauman seemed to seal his own fate. Doomed by his own definition, henceforth he had to crawl repeatedly back inside the conceptual labyrinth and find yet another way to rob us of our illusions.

Nauman's late 1960s performance pieces, 25 films and videotapes in which he documented his ordinary, compulsive actions such as pacing, bouncing balls, and playing the violin, continued to reflect and record his agony in the studio, his desperate argument with himself over how to go about the business of being an artist. Drawing on Man Ray, Samuel Beckett, Alain Robbe-Grillet, Merce Cunningham, John Cage, Karlheinz Stockhausen, not to forget Fluxus and Warhol, these works are among Nauman's most self-absorbed and tedious, notable for their elaborate effort to make visual art out of avant-garde music and theater, as in *Violin Turned D E A D* (1969) and *Six Sound Problems for Konrad Fischer* (1968).[7] The last piece combines audiotape, tape recorders, and furniture in a Cage-ian arbitrariness crossed with a Beckett bleakness. A few works from this period do captivate—for one, the wired-for-sound cubicle titled *Get out of My Mind, Get out of this Room* (1968), where viewers gullibly step inside an empty room and are then stung with the title's intensely whispered exhortations.

Nauman's performance pieces led to his first corridor installations, in which he permanently removed himself as performer and made viewers both research subjects and audience. *Corridor Installation (Nicholas Wilder Gallery Installation)* (1970), with its disorienting video surveillance system (the camera and monitor are in separate passageways), presages present times, when virtually all public activity is subject to technological scrutiny. *Yellow Room (Triangular)* (1973) is a sharp-cornered triangular environment lit by nauseous yellow light that makes one feel like a rat in a shrinking cage. It is also a walk-in version of the era's still prevalent Minimalist sculpture and hard-edged geometric painting.

Nauman's self-consciousness resurfaced in the mid-1970s, following the widespread exposure (and widely mixed critical response) from his first major museum show, a 1972 retrospective that traveled from the Los Angeles County

Museum of Art to the Whitney Museum of American Art. The sepulchral *Audio-Video Underground Chamber* (1972–74) and the obscure *Consummate Mask of Rock* (1975) seem, in retrospect, obvious efforts to regain cover. The former is a creepy cement vault, actually buried underground in the Reina Sofia courtyard, next to a Calder mobile. The vault was rigged with a video camera that showed a dimly flickering image of its vacant interior, which was relayed onto a monitor upstairs in the museum next to a small window overlooking the courtyard. Viewers could simultaneously experience both the interior and exterior of the buried chamber.

Consummate Mask of Rock consists of a room-sized installation with rectangular limestone chunks strewn about and, on the wall, a tortured, rambling litany based on the children's jingle "The House that Jack Built." Nauman's version, however, ends rather melodramatically with "PEOPLE DIE OF EXPOSURE."

Nauman seemed to want to stay underground with his subsequent tunnel pieces. *Untitled (Model for Trench, Shaft and Tunnel)* (1978) and *Model for Tunnel Made up of Leftover Parts of Other Projects* (1979–80) are both formal quotations of his early cast latex strips and, through the conceit of calling these room-sized works merely models, conceptual exercises in casting an awesome image in the mind's eye. In the context of increasing media attention and public fears about global nuclear proliferation, these structures take on an ominous symbolism: underground nuclear testing, radioactive waste dumps, and survival shelters. And yet *Untitled (Model for Trench, Shaft and Tunnel)* also recalls the sleek, triangular intersection of Brancusi's *Torso of a Young Man*.

Nauman became more overtly political and symbolic with the hanging chair and I-beam piece *South American Triangle* (1981), inspired by his readings of Latin American political strife and torture.[8] The piece itself is fairly neutral, the only disconcerting element an upside-down chair strung up in the triangle's center. Chairs are another recurring image in Nauman's work, standing in for the actual body, à la Jasper Johns. *Musical Chairs: Studio Version* (1983) is a related piece, a hanging assemblage of a polished aluminum circle, a triangle of wooden beams, and three variously positioned chairs. The piece has some of the brio of early Mark di Suvero.

These formalist, somewhat remote hanging sculptures could be abstractions of the ideas presented in Nauman's next spate of multi-media pieces—more neons, the clown video installations, and the first of his tortured, mutant animal works—all of them late examples of the Nauman showmanship that most of us know and dread. *Carousel* (1988), a motorized merry-go-round that drags four grotesque animals around by their necks, echoes the scale, cable suspension, and circular format of the earlier chair and geometric pieces, but here Nauman makes explicit a sense of cruelty and despair only hinted as in *South America Triangle*. These animal forms continue Nauman's engagement with castings, in this case prefabricated taxidermist forms that are used to support animal hides.

Carousel also revels in the perverse treatment of childhood themes. Unfortunately Nauman's wicked circus-beast trick, *Model for Animal Pyramid II* (1989), is represented here only by a photomontage. The riotous *Clown Torture* (1987) is present, though, in all its cringing glory. This riveting video installation shows a clown sitting on a toilet, smiling sheepishly, rolling and unrolling toilet paper, turning the pages of a magazine, trying desperately to perform. Meanwhile other clowns on monitors scoot backwards across the floor, screaming "No-o-o-o-o, No-o-o-o-o, No-o-o-o-o," in convincing displays of terror. The grim *Ten Heads Circle/Up and Down* (1990) features pairs of human heads cast in candy-colored wax strung from wires like a mobile for a forensic laboratory.

Nauman's flashing neon signs—*Raw War* (1970), *Run from Fear, Fun from Rear* (1972), *Violins, Violence, Silence* (1981–82)—have a similar baiting, irreverent, embarrassing, contentious effect. Colorful and attractive, their buzz is reminiscent of backyard bug-zappers. Are they one-liners or linguistic Minimalism? One could argue that the shifting letters turn abstract language into concrete sculpture and concrete meanings into abstract paradox, a concise synergy of Dada, Pop, and Conceptualism in which philosophical issues are reduced to anagrams, pop slogans, and vulgarities. *One Hundred Live and Die* (1984), a billboard-sized permutation of "live and die" with 50 other words ("suck and die," "suck and live," "piss and die," "piss and live"), ironically merges a bumper-sticker mentality with the flashiness and formal vanity of early '80s Neo-Geo painting. Actually this is existential linguistic Minimalism, a cynical sound bite of modern life that seems even truer now than when it was made. Nauman's neons never stray far from their linguistic roots. *Hanged Man*, one of the three works constituting *Chambres d'Amis (Krefeld Piece)* (1985), combines gallows humor with the children's word-and-picture game by invoking Beckett's *Waiting for Godot*. Executed (literally) in colorful, jerky neon, *Hanged Man* makes a cartoon of sex and death within an intrinsically commercial medium.

Nauman's ongoing emphasis on research is most evident in *Learned Helplessness In Rats (Rock and Roll Drummer)* (1988), another multi-media installation. Consisting of a vacant Plexiglas maze with a camera and spotlights directed on it, a large video wall projection showing a close-up of a rat darting through an identical maze, and an audio-video projection of a rock drummer pounding away, the work repels/compels viewers with a combination of deafening, arrhythmic noise and the nervousness of the projected rat. We search the plastic maze, vainly seeking the actual rat. But then it dawns: we are the rat.

It has been said that the combination of Dada and genius is rare. Though some of Nauman's more powerful recent pieces are not included (the exhibition stops at 1990), the show confirms his genius and place in the tradition of Dada-inspired art. It also provides a reference point for understanding the current apathetic, abject, narcissistic art making by many of today's younger artists. They may not realize how much groundwork Nauman actually laid out for them—nor how he deftly sublimates and centrally casts us in the role of hapless Everyman. **AWL**

Notes

1 Others have also discerned Nauman's puritanical streak: "Nauman has been for a quarter century now the puritan conscience of the American avant-garde." See Adam Gopnick, "Bits and Pieces," *The New Yorker* (May 14, 1990).

2 Neal Benezra, "Surveying Nauman," in *Bruce Nauman* (Minneapolis: Walker Art Center, 1994), p. 21.

3 Ibid., p. 15.

4 Ludwig Wittgenstein, *Tractatus Logico-Philosophicus*, proposition number 2.0131. Originally published 1922.

5 Nauman, quoted in Benezra, op. cit., p. 17.

6 Lucy Lippard, *Eva Hesse* (New York: Da Capo Press, 1992), pp. 83–84. This observation is made in an account of the group show "Eccentric Abstraction," Nauman's first New York exposure, at Fischbach Gallery in 1966, curated by Lippard and also including Eva Hesse, Frank Lincoln Viner, Louise Bourgeois, Alice Adams, Don Potts, Gary Kuehn, and Keith Sonnier.

7 Benezra, op. cit., p. 26.

8 Ibid., p. 37.

Stephan Balkenhol

by Stephanie Jacoby
1996

In February 1992, the young German artist Stephan Balkenhol installed an eight-foot-tall standing male figure on a buoy in the Thames River in London for the exhibition "Doubletake: Collective Memory and Current Art," organized by the Hayward Gallery. The wooden statue caused much confusion among passersby, many of whom called the police and several of whom attempted to come to its rescue. One man even jeopardized his life by jumping into the ice-cold river and had to be saved himself.

Over the last decade, Balkenhol has established himself as one of Europe's most unorthodox sculptors by rejuvenating the tradition of siting figurative statuary in civic spaces. He has had major shows throughout Europe, where he is represented in several museums. The first North American exhibition of Balkenhol's work, "Stephan Balkenhol: Sculptures and Drawings," is a 12-year survey organized by Neal Benezra, chief curator of the Smithsonian's Hirshhorn Museum and Sculpture Garden in Washington, DC. Thirty sculptures—freestanding male and female figures, busts, reliefs, and ensembles of animals and humans—in addition to a recent series of 16 large-scale drawings are included.

During the late 1970s and early 1980s, Balkenhol studied at the Hochschule für Bildende Künste in Hamburg, a school highly respected for its Minimalist and conceptualist bent. As a student and later a studio assistant of the Minimalist sculptor Ulrich Rückriem, Balkenhol soon realized that the figurative tradition in sculpture had been interrupted in the 1960s. Startled by Minimalist dogma condemning figuration and eager to forge a direction for himself, Balkenhol scrutinized the history of art—from Egyptian and Archaic Greek sculpture to 20th-century Expressionism—in an effort to "reinvent the figure."

Balkenhol pursues tradition and innovation at the same time. He carves figures by hand and without assistance, adding color to highlight hair and facial features and to define clothes or fur, leaving the bare, light-toned wood to render skin. Unlike the highly finished figurative bronze and stone sculptures of the classical tradition, honoring heroic, political, and military achievement, Balkenhol's figures are utterly commonplace and have an unfinished quality that emphasizes their materiality. The artist's use of scale (his figures are either larger or smaller than life) and his reintroduction of the base, which sculptors of abstract art had largely abandoned since the 1960s, establish subtle yet distinct boundaries between sculpture and viewer. Balkenhol explains: "I always wanted to keep the sculptures as open as possible…I wanted an expression from which one can imagine all other states of mind, a point of departure from which everything is possible." Through generalized carving devoid of individualized characteristics, his sculpture provocatively occupies a space between art and life.

Man With Black Pants, 1987.
Painted and carved beech wood, 229.5 x 92 x 88.2 cm.

Three Hybrids, 1995.
Synthetic polymer on wood, each approximately 121.3 x 50.2 x 34.3 cm.

Although he works in a medium often associated with the Expressionist tradition, Balkenhol sets his mute likenesses apart from carved and painted wood sculpture by early 20th-century German Expressionists and from the related work of his contemporary, Georg Baselitz. Instead, he continues the Minimalist tradition of his teacher, Rückriem, in his insistence on material, plastic form, and serial repetition, as evident in *Three Figures* (1985) and *Relief Heads 1–6* (1988). Each of these works appears to consist of disconnected elements joined only by their rigorous formal structure. In the late 1980s Balkenhol's sculpture, his relief heads in particular, had been compared to Jeff Wall's early photo series of young workers and to portraits by the German photographer Thomas Ruff, who depicts young, middle-class men and women with expressionless faces, linked by their overall structure and commonality.

Whereas in the 1980s Balkenhol fashioned primarily psychologically disengaged figures and animals, in 1990 he began to investigate narrative and its ensuing concerns and to arrange sculptures in groups. Among the most notable of these works are an installation of three figures in the garden of the Städtische Galerie, Frankfurt

(1991–94) and a flock of 57 penguins on individual pedestals, a particularly popular piece in the collection of the Museum für Moderne Kunst in Frankfurt. Balkenhol has also set out to carve small male figures interacting with docile undomesticated animals. He has further explored narrative content by carving and siting a black male and white female figure on the roof of the Museum Africa for the first Johannesburg Biennale and by creating personifications of a devil and an angel, which were included in the 1995 Carnegie International in Pittsburgh. **SJ**

Annette Messager

by Judith Page
1997

Annette Messager describes her installation *Dépendence/Indépendence* as a "rain of objects." A more appropriate description for the hundreds of separate elements hung from the ceiling of Gagosian's downtown gallery is a deluge of objects. Photographs, stuffed letters, organic forms and body parts, numbered placards, taxidermied animals, plastic bags of fabric and yarn scraps, and strands of knit gloves are suspended and enmeshed in dark tangles of yarn and net. The effect is overpowering and claustrophobic. The viewer could be exploring an ancient cavern (or a grandparent's attic) or be engulfed in a dense marketplace crammed with shoppers and merchandise. The brilliance of Messager's installation lies in the breadth of its metaphorical possibilities—Canal Street to Mammoth Cave to Miss Havisham's dining room.

The arrangement of the elements within the installation initially appears random, even chaotic, but after careful investigation a pattern—of sorts—emerges. Related objects are massed in specific sections of the gallery, and sample objects from one section are inserted into other sections. For example, a large group of photographs of grimacing and distorted faces is massed in the left rear corner; similar photographs appear sparsely in other locations in the installation. Other massings include the strung-together words, one letter on top of the other, in the right rear corner; taxidermied animals in the center; and bags of scraps, glove loops, and lines in the gallery front, tapering off to a few strands of yarn. The overall configuration is heart-like, which says a great deal about Messager's intentions as she literally and metaphorically pours her heart out to her audience.

The French words that Messager carefully spells in chintz fabric also allude to the heart—specifically, affairs of the heart. *Colére* (anger), *jalousie* (jealousy), *mensonge* (lie), and *promesse* (promise) are included in the emotional torrent of words referencing expectations and disappointments in love (and in life). Slightly sleazy and sentimental in their flowery encasements, the words have a raw power and, in conjunction with ghoulish stuffed stocking heads, shredded fabric debris, and taxidermied cats and rabbits, they seem ominous. All is not bleak, however. Near the center of the room, a taxidermied fox is shrouded by a white net. In the midst of the gloomy atmosphere, the delicate construction radiates like a beacon of hope. Even the heavy mass of stuffed limbs dangling overhead seems powerless to crush the fragile structure below. The fox peers out of the net as if in wonder of its past and present circumstances, of a live animal becoming a stuffed trophy, then becoming part of *Dépendence/Indépendence*. Messager, without being didactic, subtly re-affirms life through the power of regeneration.

One of the most notable aspects of *Dépendence/Indépendence* is the viewer's participation in the installation. Messager designed the structure so that the elements do not touch until they are activated by someone walking

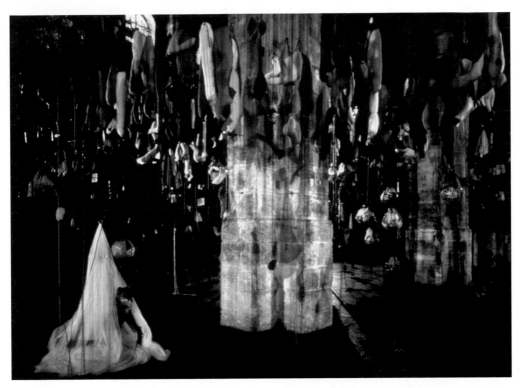

Dépendence/Indépendence, 1995/1996.
Cloth, taxidermic animals, thread, and rope, 6 x 30 x 30 meters.

through the piece. Even one person sets up enough movement between the delicate strands of yarn and the net structures to cause a slight breeze, a waving tentacle, an entwining vine. Initially the movement is alarming, then the impression fades. The fibers do not harm, they caress, and that is Messager's gift to her viewer—a physical connection between artist and audience that nourishes the spirit. **JP**

Jesús Soto

by Ricardo Pau-Llosa
1997

The recent Jesús Soto retrospective at the Galerie Nationale du Jeu de Paume in Paris should initiate a reconsideration of kinetic art's emotional and existential range. Soto is one of the most original, profound, and enduring of the kineticists. By the time of the Venezuelan artist's arrival in Paris in 1950, the dynamics of space and form had migrated inexorably and permanently from the domain of aesthetic and scientific theory into everyday life. Motion had become the symbol-resistant Zeitgeist in ways that no stream-trailing Futurist locomotive could embody or outrace.

Soto brought an existential dimension to the kineticism that developed from the moving art of Duchamp, Vasarely, and Calder. Soto's work infuses public and corporate spaces, which might otherwise be thought of as empty, with visual energies that conjure the flash dance of the sub-atomic. Nonetheless, there is a reflection on human presence in Soto's art that is absent from the work of some other early Op and kinetic artists. Jean Tinguely, for example, takes us no further than a parody of spiritless industrialization and vulgar consumerism. In Soto's work, movement is always linked to presence, in most instances to the body itself. Rows of metal arcs dangling before a lined surface coalesce their actual, almost aquatic movements with the optical kinesis generated by the observer's motion in relation to the work. When shifts in point of view create optical illusions in Soto's works, these illusions are a natural effect of the pursuit of a higher goal. This primary goal consists of forging an ambiguous sense of aesthetic space. On the one hand, there is the space defined "within" the work; on the other, the space defined by the viewer's position vis-á-vis the work. Soto's appropriation of this second manifestation of aesthetic space predates, by at least a decade, the Conceptualist view of the gallery and museum context as an inextricable element of the act of apprehending works of art.

Though revered in Europe and Latin America and widely respected in Asia, Soto does not have the fame in the United States that he deserves. This despite two major American retrospectives, one at the Solomon R. Guggenheim Museum in New York (1974) and the other at the Center for the Fine Arts in Miami (1985). This lamentable imbalance is due in part to the provincialism of an American art world still dominated by Manhattan, as well as to unfortunate timing. The first wave of kineticism (Yaaciv Agam and Pol Bury, as well as Tinguely and Soto) emerged in Europe precisely at the time that the U.S. was touting its first home-grown movement in the arts—Abstract Expressionism.

Soto's relative obscurity in the U.S. may also be due to his personality. He is soft-spoken and erudite, and his aplomb is altered only by the impassioned articulation of ideas. When I asked Soto to comment on the general ahistoricism of so many trendy experimentations, he remarked, "One can invent something truly strange and new—as Dada did,

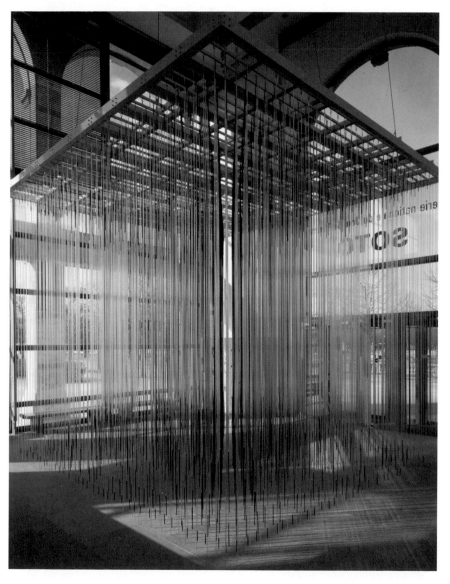

Cube Pénétrable, 1996.
Mixed media, 450 x 500 x 400 cm.

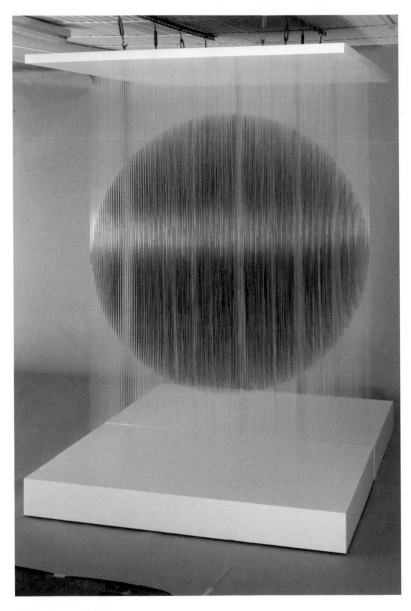

Sphère Concorde, 1996.
Mixed media, 257 x 184 x 184 cm.

for example—only if one is fully aware of iconoclasm." Soto always started from the premise that, for an experiment to be a true work of art, it must somehow transmit a sense of the history it is rebelling against.

The culmination of Soto's myriad "investigations" (a word he uses frequently) is no doubt his "Pénétrables" series (1967–97), plastic or metal cords hanging from grids which the spectator must transverse. Soto also has realized many non-traversable works in which metal rods painted in different colors evoke the illusion of a hovering volume, usually a cube or a sphere. These "virtual" works trigger shimmering optical effects as the spectator approaches them. The first Soto "Pénétrable" to also project a virtual volume is the one greeting viewers at the Jeu de Paume exhibition.

The desire to reach out to the average person has been a constant in Modernism, and kineticism—especially Soto's brand of it—with its desire to fuse sculpture and architecture is hardly the exception. For Soto, the artist contributes to society by being the individual who has the talent and ability to "see our everyday lives in terms of space-time, and see new ways in which the world surrounds us and in which we belong to that world. After all, each of us is simply a variation in space-time."

Reminiscing about the '60s in Paris, Soto remembers the distance he liked to keep from Cuban novelist and musicologist Alejo Carpentier who, along with the Argentinean Jorge Luis Borges, launched "magical realist" literature. Carpentier had lived in Venezuela during the previous decade, and Soto disagreed with his idea that the universal lay in the local and regional. He recalls Carpentier's remarks when he entered a Soto exhibition at the Denise René Gallery. Seeing the kinetic works and the open layout of the exhibition, Carpentier exclaimed, "This is Guyana," Soto's home province of vast plains and dramatic *tepuys* (huge, plateau-like rock formations of a stark verticality that dot Venezuela's Gran Sabana.)

That Soto's spaces are rooted in his native environment of eastern Venezuela, and more broadly in a New World sense of vastness, is not a new idea, but it's one Soto has trouble embracing. He does recognize that abstraction is far from an exclusively European reality. "Arabic civilization was closer than European civilization to the truth in conceiving of space as immeasurable. Geometry was a trap, one I had to use, to make these concepts legible to the Western public." While Soto has done much to transcend the lingering power of perspective in art, he reveres the Renaissance masters. He says, "Perspective, which for centuries was unquestioned in Europe, is only one way of interpreting the third dimension. An Indian of the Orinoco, who constructs circular houses and conceives of the universe in such terms, doesn't understand perspective. In a Western context, the intersection of the infinitely small and the infinitely large is a difficult concept to live with. We can understand it theoretically or scientifically, but we resist its effect on our everyday lives. Westerners define themselves as observers of the world, so, as an artist, I have to come up with ways of making that observer feel and experience the infinite spaces of which we are all made."

It is precisely in the orchestration of those experiences that participants find themselves feeling, and not just thinking, things that they didn't plan. Crossing a "Pénétrable" produces a simple yet jolting experience. Spectators must not only redefine their relationship to the space that immediately envelops them, they must also reconfigure their sense of the horizontal trajectories through this space. They stand, and are thereby implicated in the prototypes of the infinite that surround them and brush their faces and bodies. They find themselves as existential centers in a microcosm where no center is possible, and they feel their subjectivity at once exalted and dissolved. The fundamental attributes of their physical beings and their visual universe—distance, form, color, solidity, emptiness—have never presented themselves in clearer terms. There is a luminous loneliness in that.

Emerging from a "Pénétrable," the spectator's view of Soto's other sculptures is profoundly altered. The spectator can now make sense of the cool experimentations with repetitions of dots done during the '50s, and, from the same period, of Soto's haunting use of pieces of worn wood. Soto would paint his signature planes of black and white lines on their smooth portions and place bent wires in front of them. It was always about a dialogue with the sensuous, overwhelming chaos of the immediate and the physical and not about withdrawing from it into some Pythagorean refrigerator of mathematical concepts. And the spectator can make more sense of the marvelous "Escrituras" ("Writings") of the '60s and '70s. Curved into unpredictable shapes, metal rods dangle in front of lined surfaces exalting the fundamental ambiguity of language—its semantic redolence and physical immediacy, and its capacity for infinite recombination. The journey into the "Pénétrable" has closed the circle. Life now enters the vibrant, no less sensuous, construct of the mind, and an interface occurs, a silent mirroring. A new kind of identity attempts to be born.

"No artist today," says Soto, "can ignore space-time. We must find artists, even among those who continue to work within two-dimensional formats, who provoke a new sentiment: that in art there are no longer observers but participants. The artist does not have the final word." **RP**

Martin Puryear

by Matthew Kangas
1997

Martin Puryear's four recent sculptures can each be traced to forms dating back at least a decade. These forms—the bird or decoy shape, the irregular upright head, the punctured sphere—all have precedents in earlier work and consistently reappear in the artist's studio work and public commissions.

At Donald Young Gallery, in his first Seattle solo exhibition since his 1981 West Coast debut at the defunct alternative space And/Or, Puryear did more than confirm the promise of his first Seattle installation, *Where the Heart is (Sleeping Mews)*. He brought back to Seattle the fruits of his labors in the intervening years. At the same time, he attended the dedication of his newest public work, *Everything that Rises* (1996), on the University of Washington campus.

The four new works were untitled. A tall bird-like sculpture of pine, cypress, ash, and rope is a see-through version of *Untitled* (1988) made of ponderosa pine. The base of the new work is made of a lattice of pine. This finds a predecessor in *Untitled* (1989) shown that year at the São Paulo Biennale where Puryear won the grand prize. With a conical base like a badminton shuttlecock, *Untitled* (1989) reinforced the artist's interest in dismantling our expectations of sculptural mass and volume. The new "cousin" of these two works differs in that a rope is suspended from its "beak."

An untitled pine and basswood piece also takes a decoy shape, but with a laminated pine base or "body" and a basswood "neck" extending in two connected curves above. With a full sphere halfway up and a truncated sphere for its "head," this work is like a giant tinker-toy construction, appearing as though it could be easily dismantled at any moment.

Never a joiner or a group-goer, all the same, Puryear is no longer the maverick he claimed to be in a 1987 *New York Times Magazine* article. Now, he is revered because he towed his own path, the path to the enigmatic, ambiguous, large-scale handmade object. Even when working in metal, as in the giant new doughnut-shape made of tarred wire mesh and punctured with four holes, Puryear brings something different to his chosen materials. The pillow-like base of black metal mesh satirizes the notion of a support or pedestal for sculpture.

A five-foot-high curved, brushed copper-sheeting piece hints that Puryear's next direction may be yet more craft-like: a preoccupation with surface. Glimmering and glinting, the copper is seamless and continuous, like mottled skin with its share of birthmarks. Until now, Puryear has stressed a weird amalgam of anonymous execution and eccentric shape.

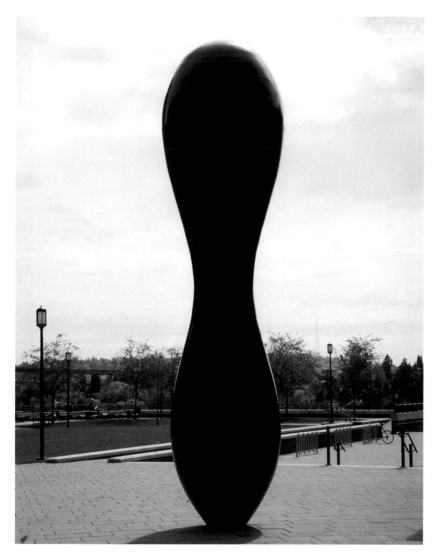

Everything That Rises, 1996.
Bronze, 23 ft. high.

Untitled, 1997.
Copper, 65 x 54.5 x 48.5 in.

The forms are mute, yet never modular. But with the activated copper surface, the mark of the maker is evident as never before. Puryear is drawing in copper, reminding us of its soft qualities, however erect and determined its final shape may be.

Puryear's sculptures are not just silent shapes: they affirm humanity's encounter with materials and the very origins of art in the handmade. In the process, he may yet again astonish us and jump-start American sculpture. He's already rescued it once. **MK**

Jorge Pardo

by Michelle Grabner
1997

Jorge Pardo is one of the most influential taste-makers of the late '90s. He has all the cachet of Rem Koolhaas, the Gap, or Arne Jacobsen. Moving through exhibition spaces like an interior designer on Prozac, Pardo negotiates pretentious style with pedestrian needs. He tows a short line between apathy and passion, dragging behind him issues of craft, function, and aesthetics in an effort to define and undermine the social, economic, and psychological manifestations of late 20th-century taste.

According to Paul Reilly: "The eccentricities of the intellectual in one generation have a way of becoming the accepted standard for the discriminating in the next."[1] By grafting the traditional forms of architecture, furniture design, and graphic design to sculpture and installation, Pardo establishes a new attitude toward taste and style—an attitude that presumes formal values not social status. As Yilmaz Dziewior states in a recent review of Pardo's work, "Pardo is not attempting to give new weight to craft or industrial design, as, for example, John Ruskin and William Morris were. Rather, his subtle play with both genres is an intelligent crossover of design and free, unapplied art; it posits a model for seeing things differently."[2]

This year Pardo will complete three important museum projects in the United States alone. His elaborate project at the Museum of Contemporary Art in Chicago involved weekly installations in the project space and the site-specific dry-docking of an altered 29-by-9-foot sailboat in the MCA's atrium. In collaboration with Tobias Rehberger, Pardo participated in the Guggenheim Museum SoHo's "Rooms with a View: Environments for Video." In conjunction with the Museum of Contemporary Art in Los Angeles, he is working on a long-awaited 3,800-square-foot residence that will serve as his living space and as the site for selected works of art from MOCA's permanent collection.

With its nose pointed at Lake Michigan—less than two city blocks away—Pardo's Santa Cruz 27 racing craft at the MCA is a proud testament to two revolutionary designers: West Coast boat builder Bill Lee and early 20th-century Modernist architect Rudolph Schindler. Purging the vessel's shell of its superfluous amenities—leaving only the mast and deck railing—Pardo's brawny, albeit sleek, fiberglass form gleams with a pure white finish. The effect is that of an enormous plaster cast dotted with subtle rigging. Below deck, Pardo constructs a clean minimal interior inspired by the 1922 house that Schindler built as his California residence.

In an interview discussing the redesign of the boat with MCA curator Amada Cruz, Pardo said, "The inspiration of Schindler is not a one-to-one relationship. I like the economy and invention of the Schindler House. I want to invoke Schindler through the changes that I make to the boat. I am interested in how streamlined one can be when

Local Adhesives, 1997.
Mixed media, installation view.

referring to a house or an architect or a historical situation. It's not going to be a Schindler house inside the boat. It's more like an attitude toward the economy of the materials and spatial relationships."[3]

Pardo's boat is a hybrid product that weaves together the mass-produced hull of the Santa Cruz 27 with a customized architectural design. He confuses the lesser value of mass taste with the distinctive value of unique taste, the consumer with the patron, the client with the window shopper. "Pardo's basic assumption seems to be that art-goers are also shoppers," states Suvan Geer.[4] And conversely, that shoppers are also art-goers who are equally capable of appreciating materials and spatial relationships.

Pardo's appropriation of design runs parallel with Andrea Zittel's appropriation of style/lifestyle. Her living units are efficient stylizations of High Modern interiors. However, Zittel's intentions are utopic and holistic. She attempts to heal the mind, body, and soul of the viewer-inhabitant. Her prototypes of mobile, simplistic domestic spaces "liberate the user from an overwhelming barrage of decisions and responsibilities by consolidating all living needs into a small, organized living unit."[5] Pardo, on the other hand, has no such visionary intent. Like the best designers, he plays first to the eye and then to the mind, leaving social welfare at the steps of the Los Angeles Municipal Building.

Vince Robbins, 1997.
Bent plywood, latex paint, Velcro, plastic, steel, light bulb, electrical wire, dimensions variable.

In his series of week-long installations in the MCA's project space, Pardo further complicates taste's currency in the material world. Using permanent collection pieces, children's drawings, didactic wall information, and commercial adhesives, he insouciantly screws with the little taste value the art museum has reserved in its coffers. One display featured the juxtaposition of a Martin Puryear sculpture with a Frank Gehry corrugated cardboard dining set. Propped on brightly colored platforms designed by Pardo, the two objects stimulated a dialogue between meaning and function, design and sculpture, furniture and form. Here again, Pardo equates one-of-a-kind sculpture with mass-producible design. Where Puryear employs natural wood, Gehry uses an inexpensive wood by-product. Yet by mounting both works on attention-grabbing risers, Pardo offers them both as fine art on pedestals in an art museum and as manufactured products found in a high-end specialty store.

During another week, Pardo took the liberty of installing a series of drawings made by his two young nephews. Their clumsy lines of marker and color pencil scribe out favorite cartoon figures in a spatially naive style: the same

style so many modern artists have attempted to imitate (one drawing in particular had the possibility of being a portrait homage to Uncle Jorge or perhaps it was just a loose interpretation of Fred Flintstone). Minimally installed throughout the space, these drawings shared the walls with a monumental text introducing the names and birth dates of the young artists. Pardo's appropriation of standardized museum didactics graphically competed in scale and style with the genuine renderings of the children. This use of institutionalized rhetoric casts ironic suspicion on museum practice and its pretentious role as cultural arbiter. By installing elementary school drawings on the museum walls, Pardo treats the authority of the art institution with the same casual attitude as a parent (or uncle) treats a refrigerator whose surface is cluttered with kid's art and ghastly magnets.

Weeks four and seven ushered in displays of adhesives from a local Chicago company. This time Pardo transformed the MCA's project space into a highly aestheticized trade show, again relying on the same institutional authority that he critiques to heighten the formal qualities of this taken-for-granted medium. "The relationship that the things have [is] pretty tenuous…What does it take for a relationship to be worth something in a work of art? It's a question that runs through my work. What's the minimum expectation in a juxtaposition between one thing and another?"[6]

Every fine craftsperson has a deep appreciation for adhesives. Both professional and hobbyist know the search for the right glue can be an arduous one—like a painter finding the ideal brush or a chef finding the perfect knife. Also, for an adhesive to be successful it must be invisible on the finished project. In this display, Pardo gives the adhesive its long-overdue applause, reminding viewer and artisan alike that adhesives are not only essential to craft but beautiful in their own right.

A synthesis of Jeff Koons and Fred Wilson, Pardo regularly crosses the borders that once protected art from the banalities of the everyday.[7] However, unlike Koons and Wilson, Pardo does it absentmindedly. There is no room for the heralding of kitsch or the politics of racial equity in his search for slick, obtainable taste. His philosophies toward materials, invention, and critique are also indebted to Richard Artschwager and his prolific use of Formica. And like Artschwager, Pardo is an artist who has a command of design and industrial materials rather than a designer seeking alternative marketing strategies. By eroding the distinction between the practices, Pardo opens up the neglected territories of practical high art and design for mere stylistic innovation.

Invited by the Guggenheim Museum SoHo and Deutsche Telekom Galleries to participate in "Rooms with a View: Environments for Video," Pardo, along with Tobias Rehberger, Dan Graham, Angela Bulloch, and Vito Acconci, created a site receptive for viewing artists' videos. Installing a labyrinth of interlocking plywood dividing screens, Pardo's gallery married '70s retro-hip with modern architecture and contemporary loft-living practicality. Hinged firmly together with Velcro, the delicately bent, sunflower-yellow panels clustered in the space potentially ready for

domestic arrangements. Yet under the glow of a single hanging lamp—spilling out arcs of yellow light—the room was gloriously hypnotic in abstract terms alone. Repetition, saturated color, confusion, and order so strongly permeated the atmosphere that viewing the videos from Rehberger's two futurist orbs—also suspended in the space—became a challenge. Installed next to Acconci's video monitor jungle gym, Pardo and Rehberger's environment beckoned viewers with civility: eliciting memories of mom's Lemon Pledge kitchen and a junior high rec-room, complete with glowing lava lamps and shag carpet.

While Pardo regularly mines the museum, he also mines the home. His four-year project, "a sculpture that is also a house," started out in 1994 as an edition of 10 books or sculptures (Pardo makes reference to them as catalogues) with foldouts and pop-up schematic drawings. The nearly completed residence in Los Angeles' Mount Washington area is designed to be a domestic extension of MOCA. When asked about the relationship between the sailboat and the house, Pardo responded, "It relates just in terms of my interest in doing something that's in the world. The kind of object that the boat is, is very similar to the kind of object the house is. One of the ways they relate is they are both objects that mediate information. I use the house and the boat like a camera; I run subjects through them. I am interested in the scale of exhibitions, and when I say 'scale' I mean the scale of the scope of an exhibition."[8]

Inspired by architects Ray and Charles Eames, Richard Neutra, Craig Ellwood, and John Lautner, Pardo's single-story structure recounts the conventional postwar designs of the 1950s and '60s. Even though Pardo is required to follow Los Angeles building codes and ordinances, he does have the autonomy to select work from MOCA's permanent collection and create a decor in his new home that will best feature those borrowed treasures. Opening up his house to museum-goers for the duration of the exhibition and living in a museum display is not necessarily a ground-breaking concept. Chris Burden, Vito Acconci, and Dan Graham are only a few of many artists who engage architecture as a vehicle to heighten issues of public versus private space. What is exciting about Pardo's house is that he continues to jump over the political ramifications of his projects in favor of "good" design, solid craft, and hip, retro style.

In the past, taste values filtered their way down the social and economic ladder. This linear progression of style and fashion has changed with the development of mass production and mass consumption, thus leaving the capitalists in charge of taste. Pardo has taken on the role of taste-maker, not to ordain himself with aristocratic privilege, but to open up design possibilities to the unquestioning consumer. Pardo is also doing more for the sculptural language by side-stepping sculpture and object-making altogether. Working from the outside (in the arena of potential mass design) he passionately preaches the word of material, form, spatial relations, and craft to the entire consuming populace—not just to a small group of art collectors. **MG**

Notes

[1] Paul Reilly, "Taste at the Turning Point," *Idea: International Design Annual* (1953): 12.

[2] Yilmaz Dziewior, review of Jorge Pardo, *Artforum* (November 1995): 100.

[3] Pardo, quoted in *Jorge Pardo*, exhibition catalogue, Museum of Contemporary Art, Chicago, and Museum of Contemporary Art, Los Angeles, 1997.

[4] Suvan Geer, "Jorge Pardo Gets Honest About Hype," *LA Times* (August 2, 1991).

[5] Andrea Zittel in a letter to Linda Weintraub, 1994.

[6] Pardo, quoted in *Jorge Pardo*, op. cit.

[7] See Linda Weintraub, "Art on the Edge and Over," *Art Insights* (1996): 203.

[8] Pardo quoted in *Jorge Pardo*, op. cit.

Matthew McCaslin

by Michael Klein

1998

Underneath the Brooklyn side of the Brooklyn Bridge and across the street from where Walt Whitman wrote for the *Brooklyn Eagle* before the Civil War sits a small loft building where sculptor Matthew McCaslin has worked and made his home for the past nine years. McCaslin is a family man, married, with a son. His sculptures too have a domestic quality. *48 Hours in a Day* (1991), McCaslin's signature piece, is an elegant, three-dimensional collage that sweeps across the wall, made up of an assortment of lengthy wires, light fixtures, clocks, receptacles, and switches—something like Matisse meets The Home Depot. The viewer reads the wires as drawn lines, the lights as color, and, with the other elements, the piece reads as a three-dimensional rebus.

Since his early shows, beginning in the late '80s at Daniel Newburg Gallery in the United States and continuing with more recent European venues such as Rolf Ricke in Germany, Massimo Minini in Italy, and Erika + Otto Friedrich in Switzerland, McCaslin has built a loyal following of collectors, curators, and critics. And yet, in spite of all this activity, he is still somewhat unknown. Only in the last two years has he begun to exhibit regularly in museums on this side of the Atlantic, with shows at the St. Louis Art Museum, the Dallas Museum of Art, and the Whitney Museum of American Art at Philip Morris. His works are also in the collections of the Walker Art Center and the Museum of Contemporary Art in Los Angeles.

McCaslin's second-floor walk-up studio, next door to his home, is a simple showroom and storage space housing his materials: lighting and plumbing fixtures, coaxial cable, electric fans, light switches, VCRs, and video monitors. He is quite matter-of-fact about his use of construction materials: "I find low technology's simplicity beautiful," he explained to an interviewer in 1996. When I asked him to explain further, he added, "After high school I built houses for a living in San Francisco. I had gone out west in search of the perfect wave—I needed a job, I had a truck, and I met a construction crew in need of transportation. We renovated Victorian homes. Through on-the-job training, I became a carpenter/electrician/plumber." McCaslin recalls that "it was the perfect second job for an artist, especially when I came back to New York to go to art school. And look, I still have all my fingers."

McCaslin turns the American minimal-industrial aesthetic on its head. He is less interested in the mystique and the strict principles of Minimalism than in the aesthetic of the materials themselves, especially with respect to two specific issues: How can these materials be employed in sculpture, and what do the materials themselves suggest to the viewer? Many of McCaslin's works contain ordinary mechanical devices like radios, clocks, and fans. But, as in René Magritte's paintings, the clearly recognizable objects function in unexpected ways. McCaslin's clocks only measure time when the sculpture is installed—they don't measure real time, just expended time, working or spent time.

Alaska, 1995.
Television sets, clocks, VCR, electrical hardware, and rolling cart, 48 x 120 x 36 in.

In a similar way, electric fans, a kinesthetic feature in some of McCaslin's sculptures, evoke Alexander Calder's "pure play of movement," as Jean-Paul Sartre described it, rather than representing or functioning as fans. McCaslin seeks to transform building materials into lines, shapes, and circuits of sculptural significance.

An untitled piece completed for "Departure Lounge," an innovative show at P.S.1's The Clocktower (1997), featured an immense cluster of McCaslin's usual goods, suspended from the ceiling and dramatically cascading to the lounge below. The installation was an extreme alternative to the often visually numbing public art found in today's corporate and airport lobbies.

McCaslin has recently expanded his repertoire of materials to include video. This video, either stock or new footage, has become a substantial component in the visual network of, for example, *Bloomer* (1995) and *Harnessing Nature* (1996), both room-sized installations. In the earlier work's video element, flowers bloom in time-lapse sequences, and in the later piece, waves crash on the shore. In either "situation," a word McCaslin frequently uses, nature is present, but only by means of technological transmission.

48 Hours in a Day, 1991.
BX light fixtures, receptacles, switches, extension cords, and clocks, 80 x 100 x 12 in.

McCaslin also employs recorded sound. For example, *Breakdown Celebration* (1995), a floor sculpture consisting of some 40 fluorescent tubes, uses the eerie voice of HAL, the computer in Stanley Kubrick's 1968 visionary film *2001: A Space Odyssey*. In the film, HAL is in conflict with a member of the crew, who finally disconnects the computer. As the machine loses power, HAL's voice fades into a series of almost incomprehensible mutterings.

For McCaslin, there are ultimately no winners or losers in the human relationship with technology. He feels that, like anything manmade, technology is subject to complex patterns of use and function, innovation and obsolescence. Technology's failures are akin to humanity's and vice versa. McCaslin's use of an industrial iconography also has a pragmatic side—he conceives of his works as objects that can be modified to fit a variety of environments, practically any home or office or gallery.

For a commission in a German bank's headquarters in Nuremberg, TV monitors and miles of wire stand in sharp contrast to the otherwise efficient, modern, polished lobby. "The bank and their clients love it," McCaslin reports.

His other projects include a recent installation at Baumgartner Gallery in Washington, DC, an installation at Feigen Gallery in New York with light as its theme, and an elaborate presentation scheduled for a museum in St. Gallen, Switzerland, which will then tour Europe. "Can you work with so many deadlines?" I inquired. McCaslin replied, "That's how houses get built. Now it's my work. I like it this way." **MK**

Robert Irwin

by Carolee Thea
1998

Robert Irwin's *Prologue: X 18³* is the first of a two-part installation on the third floor of the Dia Center for the Arts in New York City. The entire space is divided into 18 chambers by fine white mesh scrim, a material that Irwin first discovered being used as a window covering in Amsterdam in 1970. At Dia, the scrims are stapled to their supports like stretched canvases and soar to the ceiling to define the open, cubed areas. As in most works of this kind, the forms are determined by the artist, but it is the viewer who activates the paths.

Irwin's precision, attention to minute detail, and passionate concern for the consistency of the whole are evidenced in this work. The measure of the empty spaces between chambers suggests the thickness of a wall or a body, or the light emanating through the north-south windows, orienting the viewer. Near the center, the natural light dims, while shadows flatten to allow something else to emerge. Here, vertical fluorescent lights affixed to the ceiling emit an eerie artificiality, while the meditative nature of the repetitions combines with a sense of inside-outside play to help viewers create their own contemplative space.

When Kasimir Malevich did a white-on-white painting and was accused of nihilism, he looked his public in the eye and said, "Ah, but we have a world of pure feeling." One viewer told me she thought that Irwin's installation was like a device for sensory deprivation. Her reaction typifies the entertainment orientation of today's glutted global art culture. Irwin's work usually has a kind of "unthingness," presenting an uncanny reflexiveness to the viewer rather than visual objects. Irwin says, "The real beauty of philosophy is the examination of your own moment, your own being in circum-stance. When people walk into a gallery where I've installed some of the things I've been doing recently, a lot of them say, 'Oh, it's an empty room.' The question then, of course, is empty of what?" The point of Irwin's work is to draw peo-ple into a place once considered too incidental to have meaning. For an artist to make the viewer a critical player by inscribing his or her specific experience into the work is a humanistic goal. Irwin defines a phenomenological or mys-tical path that may allow him and the viewer to escape from Modernism or the dictates of a critical guru.

Irwin was first an illustrator and then an abstract painter who became disaffected with the gestural element of abstraction, which, for him, denied the viewer a direct perspective experience. Rooted in the phenomenology of Maurice Merleau-Ponty, Irwin's belief is consonant with the effort to understand the way people think and to rede-fine their relations with themselves and the world—to stand back, suspend judgment, and grasp things and ideas.

The history of modern art can be read as a progressive reduction of imagery and of gesture. Malevich wrote in 1915, "Over the past millennia, the artist has striven to approach the depiction of an object as closely as possible, to transmit

Part I: Prologue: X 18³, 1998.
Mixed media, installation view.

Untitled, 1968–69.
Acrylic lacquer on formed acrylic plastic, 54 in.diameter.

meaning, essence, and purpose. Now objects have vanished like smoke, for the sake of a new culture of art, a new art with metaphysical implication." From 1920 to 1923, Malevich's colleague, El Lissitzky, installed his works, called *Prouns*, in Berlin. They were considered interchange stations between painting and architecture. Such Suprematist ideas, among the antecedents to Irwin's work, were derailed by the political situation. The De Stijl artists (Piet Mondrian and Theo van Doesburg) also attempted to make an integrative art. *Salon De Madame B à Dresden*, an environment created by Mondrian in 1925–26 was not exhibited until 1970 at the Pace Gallery in New York City.

In the early '60s, the breaking down of rigid artistic classifications began again in the New York studios of Robert Rauschenberg and Jasper Johns. Irwin and a group of California artists also aimed to remove the boundaries between painting, sculpture, and architecture, but they made use of new materials like plastics, light, space, and color to do it.

Irwin shared ideas with some Minimalists, although the California artists were not, strictly speaking, part of that movement, because of their use of dissolving and seductive materials and surfaces. For Irwin and James Turrell, these materials were necessary components in dealing with light and space, even when the ultimate goal was to seek the elimination of the object. At first, light, dark, sun, and shadow; time and space; sound and silence; and fire, smoke, scrim, and string were the materials. Over the years, becoming more complex in methods and media, they began to use dielectricoated glass, luminescent and phosphorescent agents, Plexiglas, polyester, resin, cast acrylic, fiberglass, neon, fluorescent lights, and high-intensity and xenon projectors.

Philosophical questions of the nature of one's being in the world merged with light phenomena for these artists through their study of both Oriental mysticism and aerospace scientists' explorations in brain probes and sensory deprivation. The aerospace industry had attempted to specify and to quantify mystical phenomena, enabling the experience of subtle introspective states during which one's perceptual system could become more acute.

In 1971, the Experiments in Art and Technology Project (E.A.T.) matched artists with scientists, mathematicians, technicians, and engineers from major corporations and industries. One project, led by Jane Livingston, an associate curator at the Los Angeles County Museum of Art, teamed Irwin, Turrell, and Edward Wortz, an experimental psychologist from Garrett Aerospace. For several months the three pursued whatever interested them: they sat in anechoic chambers; they played with light; they discussed ideas. Neither the art hardware nor the fascination with the spectacle of the E.A.T. projects coincided with the true focus of Irwin's interest, however. He took a more physiological approach in which perception precedes conception. He was interested in dissolving the object in the subject.

Born in 1928 in Long Beach, California, Irwin studied art at the Otis Institute in California. He became a hot-rod enthusiast, ballroom dancer, handicapper at the track, and Abstract Expressionist. His paintings, influenced by Philip Guston, Willem de Kooning, Clyfford Still, and Ad Reinhardt, were exhibited at the L.A. Ferus Gallery when Irving Blum became the director. At Ferus, he hung out with artists who dabbled in Zen and Oriental philosophies, like Alan Lynch and Craig Kauffman. Other Ferus friends were Ed Kienholz, Billy Al Bengston, and Ed Moses. Irwin's interest in abstraction waned, and he followed a reductive path influenced by the work of Giorgio Morandi. He began to explore human perception.

His first breakthrough was with a group of handheld paintings (1959–60). Reduced in scale, they were meant to be experienced privately, breaking down the barrier between the artist's gesture and his audience. Four of these were exhibited at the 1997 Pace Wildenstein mini-retrospective. The paintings of the next period, "Pier Series" (1959) and *Crazy Otto* (1962), had the muted background colors of Morandi but with a few thin fluorescent-like lines painted as if light were streaking the surface. In *Untitled* (1966), he suspended an 82-by-82-inch canvas six inches from the wall. This work was filled with a gnomic rendering of pink and green dots, more intense in the center and disintegrating nine inches before the edge, making the boundary seem to dematerialize. It cast a shadow that activated the surrounding space.

By using round or oval shapes, Irwin then sought to eliminate the dilemma of the edge. Two of his disk paintings, originally exhibited at the São Paulo Biennial in 1965, were also shown at Pace Gallery. One, made of spun aluminum, is projected 18 inches from the wall. In order to diffuse the light within the surface, Irwin sprayed 50 to 100 transparent, thin, grainy, matte-finished layers of automotive paint onto the work. Illuminated from four different sources above and below the disk, the form loses its identity in a tight, luminous quatrefoil. The halation, merged with the environment, creates a kind of virtual objecthood. The second disk, made of formed acrylic plastic, juts from the wall by means of a 24-inch clear Plexiglas cylinder. The acrylic surface material followed the aluminum in a natural progression toward the dematerialized object. These works were exhibited in a small show at the Pasadena Art Museum in 1968.

For Irwin, these works posed further questions rather than answers. From 1969 to '70, he made the last of his portable objects: a number of clearly visible, prism-like cast acrylic columns. In 1970, Jenny Licht, a curator at the Museum of Modern Art in New York, invited Irwin to create an installation. Using the entire project space, Irwin suspended a white scrim 10 feet from the ground and attached shimmering stainless steel wires to the wall. Painted white only at the wall connections, the wires appeared to float while they and the scrim divided the room. The environment was lit with alternating warm and cool lights. This work was followed by others using scrims. In *Prologue: X 18³*, the work at the Dia Foundation, Irwin heightens and refines the viewer's apprehension of a situation, through

his understanding of the specifics of the site, its context, its space, and its formal qualities. The second part of the Dia installation, *Excursus: Homage to the Square³* (after Joseph Albers), is scheduled to open in the fall of 1998. Irwin will introduce colored gels into the existing cubes, which will bleed one color into the other, modifying the fluorescent light.

Though many of Irwin's projects have been realized, many exist only in drawings and plans. Many of his site works use landscape design as a form of sculpture and as a container for viewer and architecture (such as the *Central Garden*), extending his interest in perception into a larger arena. **CT**

Teresita Fernández

by Anne Barclay Morgan
1999

Since her return from a residency in Japan, Miami-based Teresita Fernández has relocated to New York to focus on her installation works. Subtle in their comprehension of and response to space, her installations are separate, well-defined, and carefully constructed structures or even entire rooms. With sources as diverse as modern architecture, Minimalism, and 17th-century garden design, her aesthetic is controlled and subdued. Fernández describes her work as very somber, evoking silence or quiet. As she points out, her installations are neither illustrative nor narrative, but rather "about the tone of the space." She aims to put viewers into a familiar yet unfamiliar environment in order to make them aware of the "hum" of the space. By making a more undefined space, the experience itself becomes the work. The viewer must, according to the artist, "want to slow down to that pace" in order to fully appreciate her work.

While her installations are reductive or minimal in aesthetic and reflect an exactness and precision in execution, Fernández always starts with a specific image for the structure of the space—such as a swimming pool, a landscape, or a dressing room. For the opening of the new museum building of MoCA (Museum of Contemporary Art of North Miami) in 1995, Fernández built a swimming pool in the museum's separate project space. Walking up a flight of stairs, the viewer entered the shallow end of a pool interior. The floor then sloped down to the deep end. Lined with portholes, the pool allowed different angles of perception and a mingling of interior and exterior that conveyed both a sense of the pool as a structure and the sensation of submersion for those inside the pool and those outside peering in. Fernández built a similar pool into the rectangular gallery space of Deitch Projects in SoHo in 1996. Surrounded by a narrow ledge that allowed viewers to walk above the empty and inaccessible pool interior, this structure evoked a sensation of danger.

One of her recent installations, *Landscape Projected*, was conceived for the group show "X-Site," curated by Lisa Corrin at The Contemporary in Baltimore. To give viewers "the feeling of walking into a very expansive landscape," Fernández built a 20-by-30-foot room with a drop ceiling in which she placed a 21-inch circular oculus. On the floor, she placed a very long set of pipes, covered with a sheer stocking-like fabric pulled so tautly that it resembled frost. These were arranged in a pattern reminiscent of a formal boxwood hedge, and like a hedge they formed a spatial barrier; viewers had to walk over the pipes in order to fully experience the installation. The floors, pipes, and walls were painted a very yellow shade of green, which then faded atmospherically into white toward the ceiling.

With her restrained aesthetic, Fernández achieved the sensation of being in a closed space that opened up into a landscape, though an obviously fake, contrived one. Her idea for the installation stemmed from extensive research into 17th-century pleasure gardens such as Versailles and Vaux le Vicomte, where designers manipulated panoramic

Landscape Projected, 1997.
Oculus light, pipes, fabric, sound component, and paint, 96 x 240 x 360 in.
View of installation at UC Berkeley Art Museum, Berkeley, California.

views with the viewer's changing position in mind. Specific vistas were intended to be perceived at prescribed vantage points, sometimes in the interest of optical illusion. These principles coincide with concepts Fernández has always been interested in—the body moving through space and the creation of meaning through the viewer's position and perception.

For the first time, Fernández also incorporated sound in *Landscape Projected*, that of a lawn sprinkler going around in circles. She wanted to create "a correlation between the sound and what you see, although one is not illustrating the other." The light from the oculus and the sound were both projected in a circular pattern in the room. Thus the sound, which resembled that of a film projector, underlined that the whole room had become a three-dimensional projection. Fernández argues that although the space is physical, it is also a projection of both light and sound: "You are projecting yourself into something that is beyond the physicality of the room."

As *Landscape Projected* demonstrates, Fernández uses formal qualities to focus on specific concepts. In that sense, her work is primarily conceptual. Although her sculptural objects and installations exhibit an exactness of execution

Untitled, 1996.
Wood, paint, and pencil, 240 x 480 x 252 in.

reminiscent of Sol LeWitt, their ambiguity keeps them from being easy to read. By making viewers aware of placement and the power invoked by a specific position, she subtly lures them to ask questions and make the connection between power and physicality. She aims to provide the viewer with a direct experience of perception or power based on position because, in her words, "in order to form an opinion or a question for yourself, you have to first experience it."

While there is a simplicity in the overall appearance of her work, the layers of perception and therefore of meaning are complex. Her installations inevitably elicit a thoughtful silence on the part of the viewer and an opening of perceptual faculties. Fernández continues to explore notions of perception and power with the added use of sound and the collusion of the senses. **ABM**

Heide Fasnacht

by Kathleen Whitney
1999

During the past 20 years, the notion of "imagination" has been given short shrift. With very few exceptions, a fast scan through the art magazines of the past two decades leaves the impression of rigid categories of work produced by legions of practitioners any one of whom could be substituted for the other without a marked change in outcome. Risk-taking and imagination are bound within learned patterns and conventions; these characteristics of the creative process have been increasingly repressed by the art world's proprieties and rules of presentation. Artists have come to be viewed as agents without true instrumentality, vehicles through which the culture practices its logic and performs its prohibitions.

Heide Fasnacht has never subscribed to this kind of passivity. She belongs instead to the rather small ranks of artists whose work represents a triumph of individual imagination over the repressions of style and fashion. Fasnacht's work is an amalgam of intelligence, humor, and craft, representing nothing less than a grand attempt to give poetic form to knowledge. Her work is always handsome, elegant even, yet it seems remote from its own appearance. This is work more engaged with itself than with the viewer; its appearance seems more a side effect of its subject matter than a strategic attempt to attract.

Fasnacht's interest in a range of phenomena has led her to read widely from an eclectic mix of interrelated scientific literature. Rorschach testing, R.L. Solso's cognitive research on rapid eye movement, and astronomer Sir William Herschel's incorrect 19th-century charts of the Milky Way—these sources provide a foundation for Fasnacht's interest in creating metaphorical guides to the familiar and arcane territories of the universe and human psychology. Her work is neither duplication nor critique of impersonal scientific technique but a quirky, humorous attempt to make allegory from information. Like Jorge Luis Borges's obsessed mapmaker, Fasnacht carves out patterns of order from phenomena too large and complex to understand on any level other than the metaphorical.

While black and white photographs and maps of stars, eye-scans, and continents provide a visual format for much of Fasnacht's imagery, her aesthetic is derived from the art of the '70s. Artists of this period engaged in a phenomenological examination of experience and of the notion of objectivity. The act of perception itself was emphasized and distinguished from the subject of observation. Focus was centered on the process of observation rather than the observed thing. Similarly, Fasnacht attempts detachment from the "idea" of sculpture while at the same time trying to be receptive to the phenomena that have attracted her.

These interests and approaches represent a highly conflicted relationship with abstraction. Fasnacht's work appears "realistic" in that its imagery is drawn from "factual," "scientific" sources such as maps and photographs, all supposed

Oculama, 1989.
Wood, masonite, and paint, 24 x 24 x 12 in.

Pearl Harbor, 1998.
Polymer clay and metal, 8.5 x 12 x 10.75 in.

representations of reality. This use of ready-made images is a major change within a body of work that was overtly abstract in the past. Yet for all its roots in fact, her imagery has more of a cartoony than a realistic flavor—a form that invites fantasy and the slippage of meanings. While the work is formally true to its roots in observed phenomena, it performs a clever reversal in the way it reveals and emphasizes the abstraction concealed in a realistic image. Her art achieves its effect by calling attention to the split experience fundamental to modern life—the separation between the retinal and the conceptual, the immediately perceived and the slowly understood, the instinctual and the learned. The viewer experiences her work as a contradiction because of the tension between the coolly distanced, analytical sources of the images and their dense, expressionistic appearance. Each object is layered with intersecting stories and allusions that seem to create systems of order while at the same time undermining any notion of fixed relationships.

Fasnacht chooses materials and processes of fabrication for their particular visual qualities. The way they are combined results in an idiosyncratic object with a highly specific visual texture that bears a rich mixture of memory, association, and emotional charge. Although much of what she does is based on an analysis of systems, the work flouts the notion of systems, the idea of fixity and rules, suggesting the inadequacy of ideas of coherence. It introduces an alternative to the known order of things, and is also a criticism of that order.

Over the course of a 20-year career, Fasnacht's material choices have been integral to her melding of structure and meaning. As her interests in particular phenomena became more theoretical in nature, the physiognomy of her work followed suit: metaphor gradually replaced physicality. For the past three years, Fasnacht has been producing a body of work that is her most dematerialized to date. This current work borrows its form from stop-action photography of natural phenomena involving explosive forces. She finds these images in textbooks from the '40s and '50s, black and white illustrations saturated with the aura of faith, hope, and excitement that permeated the sciences at that time. Though the phenomena that attract her are basically unrelated, all involve wind, air, and movement through space. The work's composition is drawn from the physics of explosion, a ready-made form that allows expression of Fasnacht's deeply psychological narrative. Controlled disorder, anxiety, and the goofy insecurity of objects have always been the subtext of Fasnacht's work. In the "explosion" series, cataclysmic movements of air and particulate matter are transformed as Fasnacht relates them to the natural functions and experiences of the body.

The objects begin as large, intricately detailed black and white drawings. A drawing such as *Bomb* (1997), based on a number of photographs of similar events, is a kind of compendium of related occurrences rather than a rendering of any one particular moment in time. The drawing functions as the maquette for the sculpture, in a way that allows Fasnacht to analyze and refine aspects of the phenomena that most interest her. The black and white of the drawings and their original sources dictate the color choice for the sculpture.

Sneezes, volcanic eruptions, geysers, and bomb blasts are either miniaturized or enlarged from the drawings. *Little Sneeze* (1997) is one of the first of this series. It is mounted on the wall in such a way that the sneeze appears as if it were erupting from a giant mouth hidden just inside the sheet rock. This sneeze is composed of minute balls of black or white polymer clay strung patiently on steel wires radiating vortex-like from a centralized core. Like Fasnacht's other objects, it is based on a stop-action photograph of a sneeze-in-progress, complete with delicate spray of spit. The image is humorous and also beautiful; there is a hysterical tension between the scale of this object and the viewer's experience of it.

A more recent work, *Eruption* (1998), miniaturizes a volcanic eruption, presenting it as a tabletop souvenir of a catastrophe. Also composed from balls of black and white polymer clay adhered to steel wires, this piece is Fasnacht's most figurative, with an exaggerated Betty Boop-like cloud form standing with hip cocked atop a cone-like platform. The figurative association makes it appear miniaturized. In the sense that the piece is considerably smaller than human-scale, Fasnacht uses the idea of the miniature to create a scale of fantasy. At small scale, all immensities are controllable, comprehensible—an entire industry catering to children is based on this simple fact. Fasnacht's baby volcanic eruption is a distant relative of the little accessories sold to model train owners so that they can re-create a realistic landscape for their trains to pass through. *Eruption* combines Disney's "gee-whiz ain't nature

grand" sentimentality with Fasnacht's subversive humor. The jokiness of the piece is emphasized by the contrast between the big, white, breasty, top-heavy cloud of smoke and the slightly smaller, black cone of a base. The point of the joke is delicately sandwiched between these two weights: the thin, tenuous, waist-like plume emerging from the "crater."

If the miniature can be seen as a metaphor for interiority and the gigantic as an exaggeration of the exterior, Fasnacht's recent work falls somewhere in between. Its intimate scale and detailed surface invite fantasy; at the same time, the sense that the image was enlarged from a photograph makes it apparent that the object is not realistic—that it is, instead, something else, something imaginary, invented, thoroughly unreal. This dissonance between what the viewer believes is reality and what is presented in its place, invites a more ironic and humorous reading.

This sense of linkage between the intimate and the grotesque has long been present in Fasnacht's work. Her earliest exhibited work was made from laminated wood, its surfaces worked in various ways so that the physical transformation of the material was emphasized by the surface treatments. This group of objects included smoothly sanded combinations of cones and ovals placed at tilted axes and raw, distressed cocoons of wood. *Oculama* (1989) is typical of this body of work. These fantastical, large structures suggest the relationships of atoms and certain aspects of new theories in particle physics such as quarks. Typically, each object demonstrates its generating conception as well as the physical labor required to produce it.

Layering, laminating, sewing together: additive processes have always been integral to Fasnacht's work. The way in which the material is worked is an aspect of the nature of that material, and her process is always in balanced dialogue with material. Fasnacht has used laminated rubber to create big, floppy forms that emphasize a relationship with the human body. These wall-hung and freestanding pieces are made from layered, glued, and riveted sheets of conveyor belt rubber. In *Terra Lingua*, Fasnacht emphasized the skin-like nature of the material, which underlined the relationship of her forms to those of the body. In subsequent works such as *Pony Tail Girls*, Fasnacht laminated layers of colored rags together to create bilaterally symmetrical forms that duplicate the ink blot patterns of the Rorschach test.

In many ways, Fasnacht is a traditional object-maker: her work occupies space with all the formal considerations of sculpture's presence. At the same time, she approaches sculpture as an arena for the exploration of ideas, an open system that's perpetually expanding. In this way, she is able to provoke questions about meaning and content: her work not only provides an experience of art, it also questions the nature of that experience. Marcel Duchamp's secretive search for the meaning of art culminated in the notion of the aesthetic as an illuminating erotic gas. He saw the

interaction between viewer and object as a performance of mutual attraction, sexual in nature—a ménage à trois in which the absent artist seduces the viewer via the agency of a third party, the art object. The object exudes some kind of pheromone or attractant—a love gas of sorts.

Fasnacht's work subscribes to this Duchampian notion. It is oddly sexy, obliquely invoking the felt presence and experience of the body without ever showing one. The concreteness of her imagery is a prop, a pretext for dreaming and free-association. Her work perceives the mechanics of nature as analogous to sensations experienced by the body: the eruption of a volcano is associated with the force of orgasm, the propulsive force of a sneeze is akin to the centrifugal force exhibited by a tornado. The nature of her seduction is indirect, achieved through storytelling, invocation, and transference. Fasnacht's work responds to the viewer, giving up information and memory impressions. More than mere arousal occurs. Interaction with Fasnacht's work dramatizes the interrelationships in the world at large between signifier and signified, code and content, as well as between artist and viewer. **KW**

Atelier van Lieshout

by Rebecca Dimling Cochran
1999

Traditionally, an "atelier" was an artist's workshop, where apprentices carefully crafted works by hand under the tutelage of a master. Atelier van Lieshout is, in fact, an apt moniker for the studio that the Dutch artist Joep van Lieshout established in 1995. Filled with a variety of artisans working on several different projects, the Rotterdam space is not merely a house of production. It is a place where the unique vision of a talented group of people comes to life.

Atelier van Lieshout's oeuvre is difficult to classify. Sculpture, industrial design, and architecture all seem to play an important role in the conception and construction of their work. Although the Atelier exhibits in museums and galleries throughout Europe and the United States, more than 50 percent of their production consists of functional pieces designed for residential and commercial spaces. Thus they blur the distinction between "fine" and "commercial" art and defy most forms of labeling.

A graduate of the Academy of Modern Art in Rotterdam, Joep van Lieshout grounds his work in the classical tenants of sculpture: composition and proportion. His early constructions coupled found objects such as bright red plastic beer crates and rough concrete paving stones. By balancing the components' visual weight in symmetrical, geometric arrangements, Lieshout achieved a rhythmic harmony that seemed to marry the disparate materials.

Lieshout adopted similar principles in his creation of more functional artworks. In "Collection 1989," the standardized measurements of pre-cut lumber functioned as the basic proportional element for a series of utilitarian tables and shelving units. Each piece was coated with a brightly colored polyester resin, which has become the signature of Atelier van Lieshout. This incredibly lightweight material leaves a hardened shell that is both durable and waterproof. Even without internal supports, the malleable component can be molded into freestanding elements such as the sinks, hand basins, baths, and kitchen units in Lieshout's "Collection 1990."

In a direct challenge to the value assigned to unique works within the traditional fine art market, Lieshout produced these "Collections" in unlimited multiples. Beyond the pieces created for exhibition, others were made and delivered to order. Numerous site-specific commissions soon became a natural extension of this program. In 1990, he built a bar for serving drinks within the Museum Boijmans van Beuningen in Rotterdam. This led to bars and restroom facilities for Rem Koolhaas's Grand Palais Convention Center in Lille (1994), busing stations for the cafeteria

The Good, The Bad, and the Ugly, 1998.
Mixed media, work installed at the Walker Art Center, Minneapolis, Minnesota.

in the Museum of Modern Art in New York (1995), and a renovation for the Alliance Française in Rotterdam (1995–96), among others.

Each of the discrete objects placed within these interiors consists of either a hollow shell of molded polyester or simple coatings over a basic interior frame. To accommodate his desire to create self-contained works, Lieshout developed a new compound, which combines interior and exterior layers of strong, glass-fiber-reinforced polyester with light, brittle polyurethane foam. This "polyurethane sandwich construction" allows the creation of walls in which the polyfoam acts as an insulator and the hard shell is durable and watertight.

Atelier van Lieshout uses this sandwich technique to make self-sufficient, portable housing units. Some, like the *Modular House Mobile* (1995–96), come replete with cab and engine. (In 1996, the unit was actually driven

Mobile Home for the Kröller Müller, 1995 (exterior).
Mixed media, 300 x 800 x 700 cm. Work installed at the Kröller Müller Museum, Otterlo, the Netherlands.

to exhibitions in New York, Chicago, Winnipeg, and Los Angeles.) A truly functional unit with a toilet and shower at the rear, it is not without its creature comforts: the seats and dash are covered with woolly fur, and the floor is lined in cowhide. The contrast in both color and texture between the hard, utilitarian shell and the plush, warm furnishings infuses the work with an element of decadence. This is similarly true in Lieshout's *Bais-ô-Drôme* (1995), a traveling party on wheels. Hitched up to a vehicle, it becomes a utopian retreat with all the necessities: a large bed, an integrated sound system, and liquor dispensers mounted on the wall. A commission for the Walker Art Center, *The Good, the Bad, and the Ugly* (1998), has a different twist. A permanent full-scale wood cabin, designed after traditional pioneer shelters, connects to a 50-foot moveable trailer. This detachable "room" also functions as a "Mobile Art Lab," which the museum plans to take into the community for hands-on activities, performances, lectures, and community gatherings.

Made-to-order variations of these portable housing units can be constructed from Atelier van Lieshout's *Master and Slave Units* (1994–95). The stretched skin wall panels of the "master unit" are screwed to floor and roof and can be dismantled to attach various "slave units." Depending on the function of the building, each owner can select from a sleep unit, a lounge unit, a bureau unit, a utility unit, a dinette unit, a sit-pit unit, or a staircase unit. For example, *Mobile Home for the Kröller Mueller* (1995), which is parked in the museum's sculpture garden, has a sleep unit, a utility unit, and a sanitary unit attached to the "master" frame.

While self-reliance and self-provision are integral components of these units, each caters to a particular taste or lifestyle. Atelier van Lieshout's newer work takes a broader perspective. Based on what they consider to be the practical necessities of contemporary society—shelter, protection, reproduction, and a few extracurricular pleasantries—they have designed units with specialized functions that, when placed together, can create a self-sufficient community. *Autocrat* (1997) is a spartan survival unit fitted with a device for catching rainwater, slaughtering animals, and salting and preserving meat. (It should be noted that the Atelier has, in fact, slaughtered and preserved a pig, documentation of which was shown at the Galerie Roger Paihaus in Paris in 1997.) In 1998, they premiered their *Workshop for Alcohol and Medicine* and a *Workshop for Making Bombs* in Toulouse, France.

Recent works that further illustrate the Atelier's vision of a self-reliant utopian world began a U.S. tour in January 1999. Their *Saw Mill/Tree Cutting Unit* (1998), *Chemistry Lab* (1998), *Kitchen and Dining Container* (1998), and *Modular Multi-Person Bed* (1998) are among the various objects, models, drawings, and watercolors exhibited. **RDC**

Bernar Venet

by Carter Ratcliff
1999

Almost 30 feet high and painted bright red, Bernar Venet's *Acute Angle of 19.5°* (1986) stands in sharp contrast to the predictably right-angled façade of a nearby office building in Austin, Texas. At La Défense, in Paris, another drama of contrast opposes the inevitable rectangularity of the surrounding architecture and the grandly irregular shapes of *Two Indeterminate Lines* (1988). Several years ago, a flock of Venet's *Indeterminate Lines* settled in the heart of Paris, on le Champ-de-Mars. Improvised on the factory floor, these large forms are, in their way, as spontaneous as line scribbled on a sheet of paper or forms the sculptor might have produced by twisting bits of wire. Thus the unpredictable curves of Venet's sculpture offered a counter-proposal to the Eiffel Tower, the arrangement of smooth, carefully engineered curves that marks one end of le Champ-de-Mars.

This is how Venet's works make themselves known to us—by contrast with their settings, and he has orchestrated these confrontations on five continents. In 1998 a group of his sculptures was seen in Seoul, Korea. Two years earlier, another group went on view in Shanghai and Hong Kong. He is represented in collections in Tokyo and Bogotá, in Caracas, São Paulo, and Agadir, Morocco. Needless to say, he has exhibited widely in Europe, from Poland to Spain, and in North America, from Quebec to California. Internationally visible, Venet's sculpture has engaged an extraordinary variety of sites, always by construing the monumental as one side of a dichotomy that in its starkest form, comes down to this: there, in buildings and streets and traffic is the world; here, embodied in beams of steel, is art.

This principle of opposition—sculpture against world, art against non-art—is so reliable that it is easy to overlook the oppositions within Venet's oeuvre. These are important, for they generate his forms. Venet advances by going to extremes, one after the next, systematically. Many who know him now as a fabricator of large works in metal have forgotten or never knew that he made his mark during 1967–71 as a conceptualist—an artist whose works were in effect intangible. And not everyone remembers that the monumental improvisations of the *Indeterminate Lines* offer a precise contrast to the carefully measured arcs and angles of the sculptures he made toward the end of the 1970s.

Venet's newest works are wall pieces torch-cut from slabs of steel. Called *Indeterminate Areas*, these sculptures find their clearest contrast in the unambiguously determinate areas of the canvases the artist painted—or built—after his conceptualist period. Shaped by such geometric devices as arcs and chords, these works have crisp, regular edges and impeccably smooth surfaces. Though tangible, they seem a bit ethereal—as if Venet had not quite persuaded them to leave the realm of thought and enter the world of physical objects. By contrast, the jaggedly irregular outlines and rough surfaces of the *Indeterminate Areas* defy us to formulate any coherent thoughts about them.

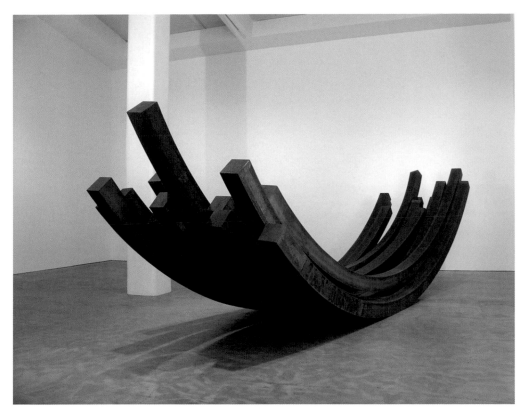

94.5° Arc x 13, 2004.
Rolled steel, 76.5 x 65 x 259 in.

A metal-cutting torch is not a precision instrument, and in the violence of the artist's method one senses both hazard and haphazardness. Much of the detail, the texture, of these sculptures is random.

Confronting us with the fact of sheer matter, the *Indeterminate Areas* are not formless, exactly, yet their shapes elude description. Moreover, their eccentricities of outline do not inspire metaphorical readings. These forms are in no way organic or crystalline or geographical. Referring to nothing outside themselves, not even to the architectural forms that contain them, the *Indeterminate Areas* don't seem especially self-referential either. At most, they refer to the idea of area simply by embodying it. Yet their sheer mass attenuates to nearly nothing even that elementary concept.

When Venet first installed the *Indeterminate Areas*, he mounted them close to the wall. Now he has distanced them from their backdrops. Hovering before us, they are "more sculptural," as the artist says.[1] Or one could say that,

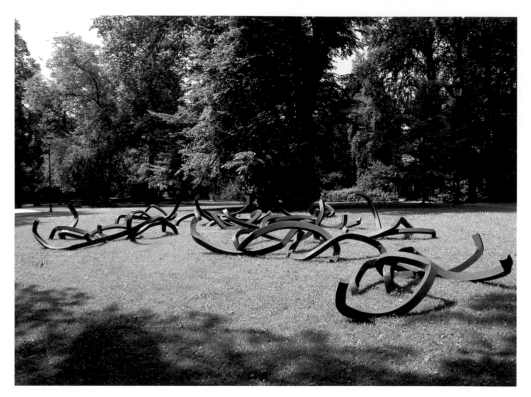

Random Combination of Indeterminate Lines, 1990.
Rolled steel, dimensions variable.

in recent installations, the *Indeterminate Lines* have become less graphic and therefore have moved farther from their origins. For these massive steel objects originate in the artist's marking-pen scribbles on smallish pieces of paper. Moving the pen back and forth at high speed, he extended and compressed his *Indeterminate Line* until line became area and the image of a new kind of sculpture appeared. And that is all that appeared. It's important to stress, once more, that Venet's forms are not allusive. They are not hieroglyphs to be deciphered or traces of some otherwise invisible mystery. More to the art historical point, Venet's quickly scribbled line has only the most tangential resemblance to lines produced by the Surrealist method of automatic drawing.

According to André Breton, Surrealism's leader and chief strategist, automatism would turn the artist's hand into a seismograph hypersensitive to repressed energies. Eluding the usual considerations of taste and common sense, the pencil would inscribe an image of the unconscious on paper. Presenting themselves as revolutionaries who had extracted and combined all that was valuable in Marxism and Freudianism, the Surrealists promised a utopia of lib-

erated thought and feeling. But after the World War II, promises of that sort seemed, at best, empty. By the early 1960s, when Venet launched his career, Surrealism was not merely old-fashioned but discredited. Like many Europeans of his generation, he cultivates no utopian yearnings. He is dubious of all ideologies, whether prophetic or backward-looking.

"No theory can stand for very long," Venet has said. It is either trampled in the rush of new theories, or it survives by "turning in on itself." Fortified by the reiteration of its own assumptions, theory "begins to show a doctrinal, dogmatic character."[2] Nonetheless, one might suppose that during his conceptual period, Venet was, if not devoted to theory, at least somewhat charmed by it. After all, in those years he exhibited blow-ups of algebraic equations, exercises in set theory, and charts of data gathered in physicists' laboratories.

Recycling the analytical methods—and the literary tone—of linguistic philosophy, certain of Venet's conceptualist colleagues displayed a formalist bent. And there were other variants, other emphases. Sociologically tinged conceptualism had the flavor of Expressionism in an academic mode. Venet turned to hard science and advanced mathematics. Isn't it possible that he wanted to employ these disciplines as the basis for a new aesthetic? In fact, he paid little or no attention to the particulars of his graphs and charts, which he chose on the recommendations of experts in the pertinent fields.[3] These images interested him chiefly because they were such clear instances of "monosemy"—the quality of conveying a single, unambiguous meaning.[4]

It would be difficult to prove that any image, utterance, or gesture is absolutely unambiguous. The Romantics believed in the inexhaustibility of symbol, and their belief was sustained by many artists of the avant-garde. Though we may not have kept this article of aesthetic faith intact, we do tend to feel that interpretation is never done—that there is always more to say about a work of art. Venet resists this feeling. Suspicious of theory's narrowness, he is equally skeptical of the expectation that the meanings of art will flow for as long as we continue to seek them. The "monosemy" of his conceptual works brought that flow to a halt, or at least slowed it. And it brought into sharp focus the impatience with ambiguity that had animated Venet from the outset.

With his earliest works—the tar paintings of 1961—he dispensed with color and texture. Oil paint is expressive almost by default. His layers of tar defeated expressiveness, reducing signs of the hand to evidence that flat, rectangular surfaces had been covered with an ordinary material. On Romanticism's Gothic margins, black acquires a heavy burden of symbolic meaning. In Venet's tar paintings, black is simply black. And when he introduced color, he kept it under strict control: on a gridded surface, he would paint each rectangular compartment in a single hue according to a predetermined pattern and schedule. Next came cardboard reliefs, then tubular sculptures cut from plastic piping ordered from industrial suppliers.

At each step, Venet presented as clearly as possible a familiar quality or process: flatness, layering, compartmentalization, color, roundness. He could not, of course, control the responses of viewers, who were free to elaborate the clarities of his art into whatever manifold meanings they liked. Yet the clarities were insistent, uncompromising, and invited a direct, unfanciful reading. One was encouraged to note color, forms, and textures precisely as they were. Nothing else was relevant, except a sense that one's experience was unusually plain and direct. And, of course, it was even plainer and more direct—more efficiently contained within the bounds of "monosemy"—in his works of conceptual art.

When his conceptualist interlude ended in 1971, Venet wrote commentaries on his own work, taught at the Sorbonne, and lectured throughout Europe. In 1976, he returned to object-making. Though his conceptual pieces were objects—large sheets of paper bearing graphs and other notations—their physical presence was incidental. And his canvases of 1976 had the look of illustrations enlarged from the pages of a geometry text. Undeniably palpable, they nonetheless owed much of their impact to the sheer perspicuity of their defining arcs, angles, and chords. By 1978, precise black lines inscribed on canvas had become equally precise forms built of wood and mounted on the wall. Darkened with graphite, they led directly to the earliest of his steel sculptures—forerunners of the vast objects that Venet has installed in public sites throughout the world.

When he made the transition from wood to steel, a new element entered his repertory: the indeterminate line, which he defines as a linear form that departs from regularity according to no particular plan.[5] An enlargement of a particular scribble, each indeterminate line has its own character. Each is, so to speak, an individual. Yet this individuality is not offered as interesting in itself. Venet does not encourage us to see his *Indeterminate Lines* as expressive. He wants us to focus on indeterminacy in general, in contrast to the determinacy—the regularity—of his arcs and straight lines.

Likewise, Venet wants us to see his tar paintings in contrast to his chromatic paintings. In opposition to the random shape of his *Heap of Coal* (1963), he offers the precisely delimited shape of a *Black Collage* (1963), for example, or a canvas of the late 1970s. Patterns of this sort are the work not only of artists but also of art historians, who suggest that we see the predominantly linear paintings of the Florentine Renaissance in contrast to the coloristic paintings of Venice. Critics count on us to see painting in contrast to sculpture, and it may well be that we understand the verbal in some deep, ungraspable contrast to the visual. Contrast is so fundamental to meaning that we usually take it for granted. It remains implicit. Venet has made it explicit—a subject of his art.

In 1997, at the Musée de Grenoble, he presented an installation of straight metal beams. Suspended from the ceiling on wires—some from their centers, others from one end—these beams restated with monumental concision

two elemental motifs: the horizontal and the diagonal. The vertical is the initial theme of Venet's recent *Accident Pieces*, which begin as neat arrays of beams propped against a gallery wall. Then, with a well-directed shove, the beams fall into an unpremeditated heap and the reassurances of Euclidean order vanish. The beams are still straight, yet there is no clarity in their relations. Determinate pattern has descended into randomness.

Though precise, the oppositions that shape Venet's oeuvre have a certain versatility. Every contrast is also an affinity, and if we were to trace them all we would find that the artist's paintings, sculptures, drawings, and works of conceptual art are bound together in a complex but always perspicuous unity. Thus the *Accident Pieces* share the clarity of determinate lines with canvases and sculptures from the late 1970s and near-chaos with the *Random Combinations of Indeterminate Lines*, which first appeared in 1991. Faced by a painting with a crisp outline, an *Indeterminate Area* opposes its clarity while mirroring its flatness. To follow a bit further the interweaving of contrast and affinity in Venet's oeuvre—any of his paintings, however precisely delineated its shape, shares two-dimensionality with the *Indeterminate Areas*, which present this quality in contrast to the three-dimensionality of a work like *Heap of Coal*. Yet *Heap of Coal*, in its own way, marks an indeterminate area.

Though linkages through likeness are strong at every point in Venet's development, contrasts generate his formal repertory and thus seem more salient. His reliance on polar oppositions sometimes gives him the air of an extremist. Still, there is nothing fanatical about his leaps from one pole to the other, no sense that he is driven to his options. At most one could say that he has conducted his analyses of form in such a severe idiom that the contrast between art and the world is never in doubt. Nor is it absolute.

In the fullness of its interconnections, Venet's oeuvre offers an analogue to the plenitude of ordinary reality. And in a recent proposal for a project at the scale of the globe—a work of art that would embrace the world—he merges the aesthetic with ordinary reality. *The Grand Diagonal* would consist of two identical parts, one in Paris, the other in Hong Kong. In each city, a pole 300 feet long and 20 feet in diameter would jut from the earth at a sharp angle. Precisely aligned, these shapes would imply a direct connection between two sides of the globe, and in the vicinity of each pole would be television monitors that showed in real time the activity at the other site.

As the formal or, perhaps, the conceptual link between Paris and Hong Kong is amplified in an exchange of images, one city sees at least a bit of what the other is doing. Integrating Venet's characteristic geometry with representations of daily life, *The Grand Diagonal* suggests that from the beginning his purpose has been to offer for aesthetic contemplation not only the elements of the real but also their interconnectedness. From the fragments isolated in his quest for "monosemy," Venet has generated a vision of the fullness of being. **CR**

Notes

1 Unless otherwise noted, all remarks by the artist are from a conversation with the author, September 11, 1998.

2 Bernar Venet, unpublished notes, September 1991, p. 1.

3 Thierry Kuntzel, "Bernar Venet: Logic of the Neutral," in *Bernar Venet*, exhibition catalogue, (La Jolla, California: La Jolla Museum of Contemporary Art, 1976), p. 12.

4 In 1973 Venet contrasted the monosemic image with the polysemic, which is subject to several interpretations as indicated by its context, and the pansemic, which is "non-figurative" and thus "open to all interpretations." Because it "offers but one semantic level," a monosemic image allows the artist "to leave the field of the expressive image and to investigate that of the rational image." These notes, which credit Jacques Bertin with identifying and labeling the three varieties of image, were first published in 1973, by the Gallery Foksal, Warsaw. See *Bernar Venet*, exhibition catalogue, (New York: Castelli Uptown, 1986), p. 8.

5 Bernar Venet, conversation with Catherine Millet, *Bernar Venet: Sculptures*, exhibition catalogue, Berlin, 1987 (Paris: Ministère des Affaires étrangères, 1987), pp. 36–37.

James Carl

by John K. Grande
1999

The expository tires piled on top of each other in James Carl's recent show at Galerie Clark look natural, but they are not. Each has been handcrafted out of coroplast, a synthetic material, and the seemingly accidental nature of their presentation is actually pre-arranged. Carl's attitude to the role of the artist in the creative process recalls Walter de Maria's Meaningless Work manifesto from 1960, wherein he wrote: "Meaningless work is potentially the most…important art-action experience one can undertake today."[1]

For some time now, Carl has based his career on making disposable mass-produced items. In a previous show at Galerie Clark in 1993, he presented a myriad of consumer appliances—"disposable art"—that called into question art's position in the chain of production/consumption. Meticulously pieced together from cardboard in real-life scale, these constructions were indeed "life-like" reproductions of functional consumer objects. Refrigerators, stoves, radios, record players, toasters, a television, and a washer and dryer littered the gallery space. The process they engendered, the craft of construction and contemplation they entailed, presented a mask of consumerism—the "art-like" design of the assembly line. The care and time taken to make these pieces from the discarded containers of exactly the products they represented—in fact, a kind of creative employment without consumer value—commented on the value placed on dehumanized work in an age of mass production. As such, this 1993 installation became a place where Henry Ford met Gautama Buddha somewhere between the assembly line and the recycling depot. Two philosophical points of view also intersected: that of the East—religiously astute and in a state of being consumed—and that of the West—spiritually vacuous and overloaded with the products of an ephemera-culture of materialism. E.F. Schumacher in *Small is Beautiful* comments on the Buddhist view of work, now being challenged throughout Asia by an emergent consumerism and loss of permanence: "The Buddhist point of view takes the function of work to be at least threefold: to give a man a chance to utilize and develop his faculties; to enable him to overcome his ego-centeredness by joining with other people in a common task; and to bring forth the goods and services needed…the consequences that flow from this view are endless. To organize work in such a manner that it becomes meaningless, boring, stultifying, or nerve-wracking for the worker would be nothing short of criminal; it would indicate a greater concern with goods than with people…Equally, to strive for leisure as an alternative to work would be considered a complete misunderstanding of one of the truths of human existence, namely that work and leisure are complementary parts of the same living process and cannot be separated without destroying the joy of work and the bliss of leisure."[2]

Carl inserts this concept into the context of art-making and takes it one step further. Each week, during the Galerie Clark installation, he placed several "appliances" out in the street as garbage. Often, they would disappear, having been picked up by passersby. Alternatively, the discards were taken to a garbage dump, thus bringing the process

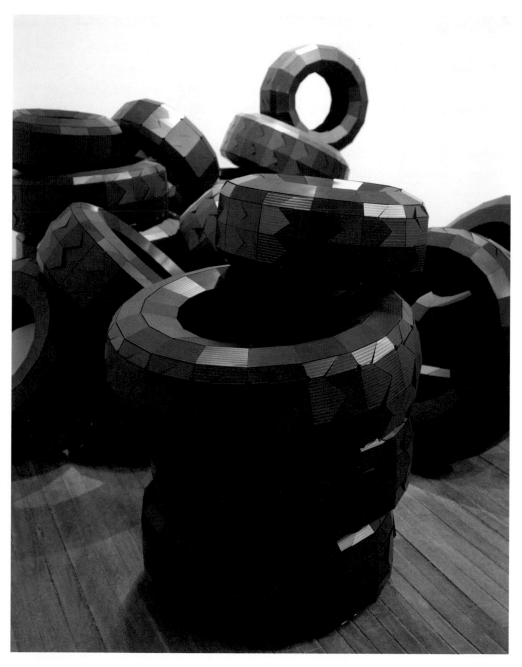

White Walls, 1998–ongoing.
Corrugated plastic, each unit approximately 10 x 23 in. diameter.

of production full circle. By not using actual appliances and by incorporating the element of work into the equation, Carl broached questions no longer standard to current artistic practice. His crafted objects are made to appear like consumer items, but they are every bit as ephemeral, changing, and short-lived as elements in nature and in the art world. The "2% Show," held at P.S.122 in New York's East Village in 1997, took the same approach. A pile of cardboard replicas and containers was installed inside the gallery, while outside about 50 plastic milk cartons were left for gallery visitors and pedestrians to collect and take home. While the cartons looked the same whether made of synthetic plastic or more natural cardboard, they became a façade, a mask of the product metaphors they represented. The whole question of appearance or beauty in art became a side issue. Carl mimics the production process if only to suggest a more timely and coherent sense of self and community, one that is ultimately humorous and poetic.

Carl took irony a step further with his "Public Works" show held at the Grunt Gallery in Vancouver in April 1993, which explored the artist's intimidation by the "disintegrated sense of community that characterizes our urban environment, and the alienated sense of art and the artist within that non-community." Carl attempted to "focus on issues and materials that form a sort of common currency within these fractured, polycentric social environments. Searching for the wider disunity that we have come to accept as (post)modern life."[3] In *Public Works: Cardboard Only*, he reconstructed a full-scale garbage dumpster. Detailed down to the nuts and bolts and made out of cardboard, the work was placed in an alleyway beside a "real" dumpster after the show. Carl's "maquette" of the real thing challenged the waste disposal function of the original container by building the same purpose into a material that itself is judged as mere waste. The work was then taken away by a real garbage truck. *Redemption* (1993), another work in the show, consisted of a crucifix made of returnable beer cans, a symbol that Carl towed around Vancouver while collecting more "found" beer cans. Carl commented: "If there is no salvation in emptying the bottle, at least there's redemption for the empty bottle."[4] An attempt to re-establish a meaningful dialogue between artist and public outside the usual context for art, *Redemption* was a performance piece that, like the replicated dumpster, became a tongue-in-cheek caricature of the sacred or mystical side of the ecological movement.

In a solo show held at the Central Academy of Fine Art in Beijing, China, in 1995, after studying with stone carver Sui Jin Guo, Carl exhibited a body of work that played on and with notions of the ephemeral and throw-away in modern consumer society. Included were a microphone made of jade and *Empty Orchestra* (1995), a disc-man made of black jade complete with a light jade laser disc, whose empty center resembled an ancient Chinese coin. A sense of humor and an understanding of Chinese attitudes about art merge in the "products" Carl made, not with throw-away but with permanent materials associated with ancient Chinese carving.

In a show at Scotiabank Plaza in Toronto in 1996, Carl displayed a cardboard replica of a Chevy Caprice detailed right down to the tires. The car was prominently displayed on a platform usually assigned to BMWs or Jaguars, set amid

all the postmodern affluence of the plaza. The piece was only partially three-dimensional: the car's façade was propped up by a structure like those used to support promotional display presentations in banks, business conventions, and movie theaters. To bring the message home, Carl placed various replicas of disposable consumer objects, again assembled out of found cardboard, in a pile of cardboard garbage beside *Caprice* (1996) and in the showroom window for passersby to see.

Carl addressed not only the disposable object per se with his Scotiabank Plaza installation, but also the nature of symbolic and structural design in built environments. The marble, steel, and tile used in contemporary architectural practice disguise rather than embody the underlying structure of the building. Applied over the interior pillars, walls, ceilings, and floor of the Scotiabank Plaza, a skin-deep veneer of opulent materials creates a delusion of surface sensation. *Empirical* (1996) expressed these contradictions in the simplest of ways. The three cardboard replicas of banking machines that Carl built in one-to-one scale and displayed behind a glass wall on the Plaza mezzanine were as abstract and unreal as the experience of withdrawing money from the real ones. The tabula rasa look of Carl's "dummy" machines evoked the same feeling of disconnectedness that one experiences when watching TV, staring at a computer screen, or reading a newspaper. Piles of blank newspapers placed in stands in the public space of the building commented further on media overload.

For an installation titled *Fountain* (1997), held at the Toronto Sculpture Garden, Carl assembled nine soft-drink dispensers in a curve on the grounds of the sculpture garden; their fronts were emblazoned with a stock panoramic image of Niagara Falls that extended across all nine dispensers. The curve mirrored the curve of the falls themselves. Long a subject for artists, Niagara Falls, called the "Well of the World" in the colonial era and once a sublime example of nature's majesty and grandeur for artists such as Albert Bierstadt, became a comment on water itself. A resource once thought of as infinite, the water in this photo is presented as a purist image, perhaps even more idealized than 19th-century images of Niagara Falls in its Modernist, ad-like presentation. The sense that image culture rebuilds the real world, altering our perception and understanding of real physical environments, was furthered by the bottles dispensed from the machines at a price of one dollar. Six brands emerged at random, including Perrier, Valvert, Montclair, and Carl's own brand. The gesture created an ironic comment on the artist's relation to production systems in mass consumer society. *Fountain*, like *The Spring Collection* (1991), a performance/event that included a five-by-eleven-foot igloo assembled out of discarded anti-freeze containers left lying on the streets of Montreal, encouraged public interaction with the art. *The Spring Collection* had Carl serving blue-tinted drinking water that looked more like Prestone windshield wiper fluid than "naturally pure" drinking water.

While Marcel Duchamp's signed readymades sought to broaden our definition of what art could be, they were also a dispassionate endorsement of the manufactured product as art. The syntax of production in the form of actual

Fountain, 1997.
Nine vending machines, bottled water, and backlit photo-mural.
View of installation at the Toronto Sculpture Garden, Toronto.

manufactured products had unambiguously entered the arena of material expression. Symbols of art's deferral to the forces of production, Duchamp's readymades abandoned the creative element of discovery that comes from working and transforming materials to incorporate what had not until then been art—the manufactured product—into art. Carl uses the language of the mass-produced consumer object and re-creates it not to extend the language of mass production into the realm of art, but instead to draw parallels between artistic production and mass production. The supports, the objects, the blackboard, the canopy wall icon on the Buren-like painted wall section, and the gallery space are presented as part of an ongoing and continuous simulacrum. Everything is equalized: the art, the environment, the people in it. The meaning of material is expressed at its most essential—as matter and energy. The switch in Carl's recent show at Galerie Clark was from objects and events (the ephemeral flotsam and jetsam of today's society) to information, imagery, and communication.

The codes and signifiers of our postmodern paradigm are so pervasive that they create a web in which the real and the artificial meanings of art and life become intertwined and confused. Carl included a series of children's blackboards, each with a brightly colored, hybridized logo adhered to it (distant echoes of General Idea's logos and crests). Hand-drawn on a computer by Carl and then produced by a commercial sign-maker, they blend craft and technology,

alluding as an aside to Joseph Beuys's blackboard drawings. The didactic, universal blackboard found in every class-room now becomes an aphorism for the way technology has affected the very process of learning. Carl's symbols—the option key logo from computer keyboards, the top of a dish detergent bottle, a generic flag and flag pole, a scroll symbol, a laurel leaf—are all found-object symbols. As symbols of the hybridization of meaning, of the storage and transmission of knowledge whereby ideas, words, and images have become digitized, losing some of their meaning in the process, Carl's logos capture the ambiguity of the image/object as metaphor for production most succinctly. As he comments: "In this show I have adopted the tools of the contemporary sign-maker—corrugated plastic, adhesive vinyl, Exacto knife, and computer—in the fabrication of a more or less hypothetical collection of compound, cross-bred signs. While embracing the absurd and the self-contradictory, the intent is yet distinct from the tiny Surrealist "mysteries" in that I'm fundamentally concerned with the possible."[5]

Surrealism claimed to draw from a vast array of visual metaphors and object-oriented representations culled from the unconscious. Salvador Dali's paranormal paintings of the Arcadian landscape of the supposedly unconscious mind were ultimately as conscious and premeditated as art can be: his melting clocks, crutches, and ants used the conventional metaphors of Freudian psychology and religion for their effect. With all the material manifestations of the unconscious that now permeate our physical reality, one wonders if humanity has abandoned functional reality in favor of an image-based reality. For all its weaknesses, functional reality still allows the individual to make his or her own associations within a neutral backdrop of relatedness. Meaning is thus simplified, evolved within an inner space of reflection. Carl states: "Over the last year, my work has shifted from an engagement with the street-side trash of consumer culture to the cerebral compost of…'popular intelligence.' I've begun to excavate the vast heaps of collectively stored mental images and visual ideas, from the remnant icons of atrophied belief systems (national identity) to the regurgitated, in-bred imagery of promotional strategies. I'm fascinated by our ability to process, inter-nalize, and endure the constant traffic of this information."[6]

The series of 24 images of *Rasta Fries* (1998), each a variation on the one next to it in the four Rasta colors, is re-fabricated and self-construed symbolism. Graphic, commercial, even corporate, they are brought into a world where countless images and forms present themselves daily—each of them potentially symbolic yet reduced in impact or meaning by their very volume. Carl's creations make an equally important point about the role played by art-making in society, for these symbols have no other function than as art. At the center of *The Original Six* (1998), a collection of oversized, three-foot-high disposable Bic lighters placed on circular and square presentational plat-forms and handcrafted from the same materials as their originals, stands a gray and black trophy (a re-creation of the Stanley Cup). The colors of the original six National Hockey League teams appear on the lighters. Carl comments: "It occurred to me that the forced union of disposable fire source and ice hockey insignia suggested by these found Bic lighters was at least as perplexing, not to say surreal, as a fur-lined tea cup."[7]

While the Surrealists created images that suggested the human unconscious, we now live in a world that is truly surreal and physically incongruous, an environment where images and objects are spatially and materially dislocated. *The Original Six* explores this notion by using the disposable icon of a Bic lighter as its central subject. Scale is subverted by pure design, and the forms could as readily be taken from a CAD-designed building as a Bic lighter. Indeed, the oversized logo of a canopy awning placed on an adjacent light blue wall further blurred the boundaries between Carl's art and its surrounding environment. (Stylistically Carl's logos are reminiscent of Patrick Caufield's Pop paintings, but Carl's creations are computer crafted and machine printed.)

Carl's work, in all its labor-intensive permutations, continues to demonstrate what the performance artist Allan Kaprow, in his essay "The Real Experiment," has called "life-like" art, which remains connected to everything else, as opposed to "art-like" art, which remains separate from life and everything else.[8] Just as the latter performs a function in relation to mainstream Western traditions because galleries, museums, and professionals need artists whose art is "art-like," so "life-like" art is said to remain outside these traditions, performing a more generic social and ethnological function. The question now becomes: Is Carl ultimately re-fabricating the meaning of avant-gardism itself? If so, how long before his post-Pop hybrid of '60s Conceptualism is itself incorporated into mainstream institutions? The answer can be found in the lobby of the Art Gallery of Ontario, where *Empirical*, the bank machines Carl originally set up in the non-space of Scotiabank Plaza can now be seen. The answer to the ultimate meaning of artistic production, however, will never be found there, for like Carl's art it is never stated; instead, it is ironic, and often palpable, ever so slightly cheeky. **JKG**

Notes

[1] Walter de Maria, quoted in Suzi Gablik, *The Reenchantment of Art* (New York: Thames and Hudson, 1992), pp. 135–136.

[2] E.F. Schumacher, *Small is Beautiful: A Study of Economics as if People Mattered* (London: Abacus, 1977), p. 45.

[3] James Carl, *Meditations at the Foot of the Great Wall*, exhibition catalogue, (Hong Kong: Ming Pao Yue Kan, May 1991).

[4] Carl, cited in *Public Works*, exhibition catalogue, (Vancouver, Canada: Grunt Gallery, 1993), n.p.

[5] Carl, artist's statement, Galerie Clark, Montreal, 1998.

[6] Ibid.

[7] Ibid.

[8] Allan Kaprow, "The Real Experiment," in *Essays on the Blurring of Art and Life* (Berkeley: University of California Press, 1996), pp. 201–218.

Miguel Berrocal

by Robert C. Morgan
1999

There is a phrase from the Russian-born writer Vladimir Nabokov, author of *Lolita*, that I cannot help but remember in relation to the work of the esteemed Spanish sculptor Miguel Berrocal.[1] When asked about his writing method, Nabokov asserted that he always proceeded with "the precision of an artist and the intuition of a scientist." When the interviewer suggested that the author had mistakenly reversed the terms, Nabokov insisted that he had not. He meant it exactly as stated. Art was about precision; science was finally a matter of intuition.

For anyone who knows the work of Berrocal and the method that he has pursued over the past 40 years, Nabokov's statement makes perfect sense. There is an undeniable precision in Berrocal's sculpture, a precision that is the very essence of his work. Like a surgeon or a mathematician, Berrocal analyzes the exact proportions and measurements of the formal idea that he is projecting into some new manifestation. Detail by detail, Berrocal sets forth the task of pulling apart and putting together the various components that will eventually become the expressive result of his efforts.

Whether the sculpture is a monumental work, such as his large-scale projects in Madrid, *Manolona* (1992), or Seville, *Doña Elvira* (1990), or one of his numerous multiple editions, such as *Micro Maria* (1969–73), Berrocal never relinquishes the fact that every detail of the work counts. Every aspect of the form is important—the choice of the material, the look of the surface, the way the sculpture is assembled. Whether large or small, the assembly of each sculpture is the result of producing individual units or elements, which are cast individually as interlocking parts. These elements are precisely designed by the artist before they are given three-dimensional life. For Berrocal, the technical aspects of the sculpture are directed toward a sensory meaning that becomes a metaphor of existence in time and space. In fact, one could say that his sculptures are about the puzzle of existence, and it is within this context—the context of the assembling—that Berrocal discovers these realities over and over again. In this sense, the precision of Berrocal's art is like a journey through some unknown metaphysical reality where the substance of life is explored and investigated, pulled apart and reconstituted. It is a purposeful equivocation poised between the physical and the metaphysical that endures in the sculpture of Berrocal.

Although Berrocal has enjoyed a reputation as a major sculptor for more than four decades in Europe, his work is perhaps less understood in the United States. Berrocal's art is born from a specific cultural understanding of classical form, a formal reality by which he is able to achieve a certain ironic distance in his work. Despite arguments that art possesses its own universality, one cannot easily avoid the cultural basis from which art comes into being. Art may have autonomy, but it cannot exist outside of certain cultural parameters. There are forms that carry

Richelieu Big, 1973.
Wood, 170 x 152 x 123 cm.

significance in one geographical location that may fail to communicate in other places, but this is more the result of an information bias than a qualitative standard related to a real cultural understanding.

Born near Malaga in 1933, Miguel Ortiz Berrocal was formally educated in mathematics, chemistry, and the exact sciences. Later he studied architecture. His early education became an important foundation in the evolution of his career as an artist. His work began to receive acclaim when, at age 21, he exhibited several paintings in the Spanish pavilion of the 27th Venice Biennale. Shortly after this occasion, Berrocal committed himself to making sculpture. Since then, he has had major exhibitions throughout the world, including a traveling retrospective, originating at the Palacio de Velázquez in Madrid (1984–85), for which a monograph was produced. In 1998, a retrospective of more than 60 works was mounted at the Olympic Museum in Lausanne, Switzerland. He has been the recipient of several important commissions in Madrid, Seville, Bordeaux, Malaga, and Verona and has received numerous awards and citations, including the prestigious Chevalier de l'Ordre des Arts et des Lettres. In Malaga, a museum devoted to the work of Berrocal was founded a few years ago, and in February 1999, an exhibition of his work opened at the Conde Duque in Madrid.

Pepita, 1996.
Kevlar and carbon fiber, 3 meters.

Berrocal's method is different from that of much recent Modernist sculpture in which the orientation is directed toward an external view of the sculptural object. Whereas other sculptors in the modern figurative tradition tend to emphasize the abstraction of form on the exterior surface, Berrocal is interested in the sculpture that exists within the sculpture. As early as 1958–59, he became involved with the design and production of the interlocking shapes that form the interior structure of his work. *Large Torso* (1959), for example, consists of seven bronze elements. Each element is a sculptural form unto itself and also a clearly distinguishable sculptural component in relation to the whole. One can view these elements within the external sculpture as having an independence of their own. The elements in themselves have a sculptural presence, a lexicon that is the raison d'être of the form seen from the outside; thus, both the interior and the exterior are important to the holistic reading of the work.

The precision in Berrocal's work comes from his extraordinary, albeit uncanny, ability to design and forge elements that maintain a perfect fit in terms of the ultimate form. His process of thinking—resulting in a parallel physical manifestation of the interior with the exterior—began in 1955–57 while he was working on an early commission of balustrades for the city of Carrara, Italy. As Berrocal's design for the sculpture evolved, he discovered that there were eight distinct aluminum elements used in the construction of the entire assembly. From this point on, he began

to think in terms of elements in which various permutations could be derived, initially in non-objective constructions, such as *Le Bijou* (1960), and eventually in his better-known figurative works—the reclining nudes, the standing women, and the upright torsos. The last theme eventually led to his largest torso to date, a magnificent, large-scale kinetic work, *Citius Altius Fortius* (1991–92), made of six discretely moving elements, that currently stands in front of the Olympic Museum in Lausanne.

For Berrocal, making sculpture—whether in bronze, marble, wood, or more recently in Kevlar—is not only a matter of craft and design, but also a matter of finding a physical and symbolic language to deal with these technical and formal processes. The language of form requires both precision and extreme formal acuity, verging on scientific know-how and the ability to articulate traditional plastic ideas through sensory inventiveness, abstract thinking, and mathematical prowess. Berrocal's language as an artist is founded on a thorough formal understanding of space and a clear technical knowledge of materials. Yet there is also a deeper conceptual language, a language that transcends the delimitations of the visible. From within the visible, Berrocal brings us to another level of cognition, a sensory cognition, a memory of form in relation to history. For within the visible lives the invisible, and the invisible itself becomes the opening to another series of abstract elements, engaging not only to the eye, but to the mind as well.

For this reason, it is possible to speak of Berrocal's achievement as a sculptor in conceptual terms. By dealing with parts (elements) in relation to the whole (form), the conceptual aspect of the work becomes an undeniable aspect of what we are seeing. The visible interlocking parts become hidden within the visible whole. We know of their exis- tence only by deconstructing them, by pulling the form apart according to a specific method. It would be like writing Oriental calligraphy. You cannot begin anywhere at random and correctly write the ideogram. There is a system that one needs to learn, a system based on knowing the correct place where one begins to build the marks in a system- atic order and thereby to construct (or deconstruct) the form.

From a phenomenological or even a gestalt approach, one might talk about sculpture in general as something that is never fully seen at any given moment. This raises the question as to the definition of sculpture. We can assume that a form exists in three-dimensional space, yet there is also a temporal process involved in the way the form is seen. Whether the scale of the work is large or small is a relative matter. Berrocal deals with all sizes, all scales, all proportions. His forms contain various permutations that are determined according to his intention. Whether they be a multiple edition or a monument, Berrocal adjusts the scale to the space—the space of the city plaza or the space of the hand that intimately disassembles the bronze form.

As one moves around the enormous biomorphic shapes and bulging tentacles that form the luminous white *Doña Elvira* (1990), located in the center of Seville, or the series of 10 *Almogávar* torsos (1981–83), each based on the

shape of an ancient anvil, one could argue that these sculptures are never seen in their totality at any given moment. This occurs because each sculpture requires time and movement (of one's body) in order for the work to be seen. Sculpture is not an instantaneous titillation like the discovery of an image on the Internet. Sculpture requires patience. The eye guides the body, and the body becomes the eye that circumambulates around the form. By conceptually assembling the various angles of vision through one's own physical experience, the cognitive dimension of Berrocal's work begins to coincide with the form's sensory appeal.

The work of Berrocal, as so accurately shown in the *Almogávares*, is a construction of parts in relation to the whole. This is fundamentally a gestalt concept. Each torso is constructed of elements that can be deconstructed. It is possible to de-mystify the classical appearance of the exterior and to see it in an "overall" context as a series of discrete units. *Almogávar V—Roger de Lauria*, named after a medieval warrior, might be seen in a way not dissimilar to the appearance of a disemboweled Corvette engine spread over a suburban lawn in Los Angeles. To reconstruct the sculpture, one would have to perform the task systematically like the strokes of the calligraphic brush, to put it in order, then to view the whole once again.

Another example of this gestalt phenomenon is a large sculpture in wood called *Richelieu Big* (1973). Berrocal constructed this impressive work, named for the infamous French cardinal, as part of a series begun in the '60s that focused on the theme of the classical male torso. Each torso is a dismountable sculpture, originally cast in several units, representing historical or mythical personalities, such as Adamo Secundus, David, Goliath, Samson, and Alexander the Great. *Richelieu Big* is unique in that it was constructed from 61 elements of laminated and precision-cut wood. The complexity of thought and the mathematical ingenuity that went into the final result are staggering. Again, it is a matter of embedding the conceptual form within the visible exterior and thus demystifying the aura of classical sculpture.

Berrocal is ultimately interested in democratizing art without sacrificing the emotional elegance and sophistication of thought that allow the mind to reflect on the nature of reality and thus to soar beyond the mundane trivia of our so-called information age. His emphasis on multiple editions, beginning with *Maria de la O* (1962–63), has been the cause of considerable misunderstanding over the years. While the multiple was initially intended as a means to reduce the price of art and thereby to make it accessible for those who would not be able to afford a unique work, Berrocal was often accused of "turning commercial" or even of trying to subvert the art market. On more than one occasion, the artist was approached by important international galleries who wanted to represent him on the condition that he stop producing the multiples and make only unique sculpture, but he refused.

Back in the '70s, there was much talk in New York about how to expand the dissemination of art beyond the current marketing structure, but when given the opportunity few artists were willing to refuse offers that would require them

to produce objects according to the standards of the market. It became apparent that aesthetics could not be fully divorced from the realities of the market—a conundrum that even William Morris confronted in his work with the Arts and Crafts guilds in England over a century ago. While this aspect of Berrocal's work is often ignored, it is a topic of considerable importance.

In the meantime, Berrocal is involved with many large-scale projects, public commissions, exhibitions, set designs, and recently with an educational project in Spain in which he created a multiple, *Retrato de Adriano* (1997–98), to be used specifically for students in developing their cognitive skills. As with his public art, the multiples are also in a sense public, but on a smaller scale. They are public to the extent that the same sculpture is disseminated to 200 people or, in some cases, 10,000 people. This, of course, delights Berrocal as he continues to provoke the existing market and, in doing so, makes a significant contribution to our transglobal culture by evoking the fundamental questions, the questions that make us reflect on the puzzle of existence.

Yet within this publicity, there is also an intimacy—a conjugation of the democratization of art as idea and art as a tactile, visual, physical, even metaphysical reality. In this sense, Berrocal's attitude toward sculpture is completely convincing. His aesthetic approach emanates from the age-old position of classicism, but within that vocabulary he is striving to de-mystify the pretensions that have accumulated within Western culture for so many centuries. He is a responsible artist who is not out to destroy a tradition, but who wants to have fun with it, while teaching us something in the process. **RCM**

Notes

[1] I am uncertain about the exact source of the phrase; I read it some 30 years ago. I believe it was in the context of an interview published in an early number of *Evergreen Review.*

Ken Unsworth

by Ken Scarlett

1999

One could compare the mature work of the Australian artist Ken Unsworth with that of Louise Bourgeois since they both rely on personal obsessions and a range of potent, recurring symbols: with Bourgeois, her childhood and sexual references; with Unsworth, his wife and her performance as a pianist, in addition to death, destruction, and the possibility of a "Stairway to Paradise." Just as Bourgeois has used some symbols repeatedly, such as multiple breasts, cells, and rooms, Unsworth has used the grand piano, skulls, ladders, and stairs again and again in a variety of installations. Both artists have a highly developed sense of the theatrical, deliberately and skillfully establishing an atmosphere that envelops the spectator.

It is always much easier to discuss a lifetime's work when an artist develops and progresses in a simple linear manner, so that one can follow the changes from A to B to C. With Unsworth, the progression is not so clear-cut. Over the course of his career, A, B, and C often occur simultaneously or reappear years later. The extremely comprehensive retrospective exhibition at the Art Gallery of New South Wales, which filled several large galleries on two floors, was not organized in any chronological fashion; instead, it was arranged around areas of the artist's work—maquettes, sites, stones, body as object, reliefs, installations, and drawings.

One of the earliest maquettes, *Rose Shed* (1971), which combines mild steel wire, bandages, and thorns, has a Surrealist quality and an inherent viciousness. During the same year, Unsworth produced *Cantilever 11*, which can be linked with Minimalist sculpture, then fashionable in Australia. In their sheer diversity the maquettes show a restless, ever-inquiring mind: sheets of slate suspended, bundles of sticks tied together, stones suspended, with innumerable variations on each idea.

Suspended Stone Circle (1974–78), originally only 28 by 38 by 25.5 centimeters, grew to 1,100 centimeters in diameter, becoming *Suspended Stone Circle 11* (1984), in which over 100 large river stones were suspended from slender wires in a huge circle of breathtaking simplicity. Held up from three points on the ceiling, the rocks appeared to defy gravity, levitating about 45 centimeters above the floor. The delicate pattern of the innumerable fine black wires and the subtle shadows of the rocks belied the immense weight of the stones—and the five days of arduous work to install the piece. Once assembled, the simple logic of the construction was immediately clear, yet what a leap of imagination it must have taken to envision the possibility. And the public loved this construction, which was acquired for the Art Gallery of New South Wales in 1988; in 1998, the Sydney *Morning Herald* voted it Sydney's most popular artwork.

I'll Build a Stairway to Paradise, 1985–98.
Painted timber, light, and sound, dimensions variable.

Rapture, 1994.
Piano, straw, burnt sheet music, and plastic mice, 310 x 149 x 310 cm.

Unsworth's maquettes for steel structures explore unlikely relationships, an interest that removes them from the restrictions of Minimalist sculpture. The basic forms of cube, cylinder, sphere, annulus, and rectangular prism resemble the Minimalist vocabulary, but Unsworth's sculptures balance precariously, defy gravity, combine mass with slender line, or sprout vicious spikes like medieval instruments of torture.

The works in the "Sites" section, which were represented by photographs, drawings, and maquettes, mark a significant move out of the studio in the early '70s and into the environment. These works often came close to Minimalist sculpture, yet, again, the basic geometric forms were given a further meaning, sometimes mysterious or symbolic, other times delightfully amusing. *Razor Back* (1975) and *Stick Mound* (1977), for instance, were both simple geometric forms, built by driving sticks into the ground. The process of their construction introduced a sense of mystery into the simplicity, transforming these works into objects seemingly left over from some unknown ritual. *Shark* (1978) consisted of ridges of earth, precisely forming a huge spiral in the landscape. Within the spiral was a series of triangular projections, looking remarkably like the dorsal fin of a shark, a fearful sign known to all Australian swimmers, yet made ridiculous because the fish appeared to swim in the dry soil of the landscape.

Another facet of Unsworth's art is his unique ability to explore a wide range of human states, from humor to pathos, from terror to laughter, from sublime thoughts to physical pain. His first series of performances, *Five Secular Settings for Sculpture as Ritual and Burial Piece*, which occurred at the Institute of Contemporary Art in Sydney in 1975, certainly involved the artist in a high degree of risk and physical pain. He hung from his neck between two massive beams of wood; he was tied hands and feet and suspended from a diagonal pole; with hands and feet secured in a rack, he hung down toward the floor, and—most dramatic of all—he was entombed in a glass case, which was slowly filled with sand. Even the video, which shows the slow shoveling of sand into the vertical glass case, the gradual disappearance of his body, then the complete covering of his head, is agonizing to watch. As the seconds, then the minutes tick by, one wonders how long he can hold his breath or if will he indeed escape. Then an attendant smashes the glass and sand pours out, revealing the artist still standing, still alive. Unsworth has said that by practicing meditation and controlling his breathing he was able to hold his breath for up to 3.5 minutes. For the audience, the suspense must have been frightening. One could make comparisons with two other Australian performance artists, Stelarc and Mike Parr, who also took themselves (and their audiences) to the extremes of physical endurance.

Fear, particularly fear of death, recurs as a theme in a number of Unsworth's works, such as the large relief *Dreams of Panic* (1991). Death is depicted as a centrally placed figure with an outstretched skeletal hand, holding a cane that projects from the wall. In the manner of a blind person, the cane repeatedly, constantly taps the floor. Death is a blind visitor tapping his way through the dark. Another relief, *Elegy* (1994), enshrines an upright piano on a stage, between black curtains. Everything is burnt, destroyed. The performer has departed.

The relief *In The Air* (1992) also contravenes accepted sculptural practice: five old brass gramophone horns project strongly from the otherwise flat surface, and a lump of plaster with a china figure sits separately in front. The lack of compositional control is forgiven as one absorbs the subtle and delightful essence of the work. The china figure is a kitsch ornament, the sort of cheap prize given away at a fun fair. The young girl, in a long flowing evening dress, restrains a dog, which leaps forward with great energy. A modern version of Diana and the hounds? Trite it may be, but the figure, full of joyous energy, is an immediately recognizable symbol of youthful love of life. And if one listens intently, one picks up the sounds emanating from the speakers, which are plugged into the surface of the relief, suggesting the earth's surface. It is the gentle sound of crickets chirping. What is *In The Air*? Spring? The possibility of falling in love? In a fascinating way, the kitsch figure gives the artist a direct point of communication with a wide audience.

In a similar manner, Unsworth used a popular song of the '30s, "I'll Build a Staircase to Paradise," endlessly repeating in the extremely simple, but magically evocative installation *I'll Build a Stairway to Paradise* (first version 1985, re-erected 1987, and modified for the 1998 exhibition). In a small darkened room, a staircase rose steeply and disappeared through the ceiling. Bathed in a soft pink light, the staircase hovered above the ground in a mystical manner without any visible means of support. Unsworth's ability to reach his audience was demonstrated to me when I overheard a conversation between a father and his very young son. "What's up there?" asked the boy. "Whatever you want son," replied the father. This perfect answer left the boy to discover his own understanding of the work, just as the artist would wish.

Fly By Night (1984), which appealed to a somewhat more sophisticated audience, subtly debunked opera and made sly fun of religion. Five winged rocks hovered high in the space, gently moving their wings, like adolescent angels still learning to fly. A tape endlessly played a ponderous rendition of "Softly Awakes My Heart," from the opera *Samson and Delilah*. On the floor, a motorized toy dog grew excited, more and more agitated, and then barked hysterically at the apparitions in the sky. As with so many of Unsworth's installations, the work opened up a wide range of personal interpretations and ambiguous meanings.

The range of his production does not indicate that Unsworth has moved with the current fashion. Rather he has an ability to extend, alter, even ridicule contemporary modes of expression. He frequently brings together visual and aural components into unexpected juxtapositions, forcing the spectator to rethink and reassess. The artist says, "I like the idea of awakening a response—sadness, nostalgia, disconcertedness, a pang of fear maybe. The sense of something being just out of reach." He keeps his audience on the alert for the unpredictable.

Unsworth is also prepared to make demands on the spectator, as with *Good Thoughts* (1995–98), which required time and contemplation from the audience. In the center of a small room, a glass cube, filled with water, stood

on top of a pedestal. Submerged in the water, a plaster head lay in a position of serene repose. An endless stream of bubbles rose from the ear to the surface, like "good thoughts" made visible. Wires from the glass tank were strung across the space to connect with seven old-fashioned speakers high in the ceiling, which made the good thoughts audible in the faint sounds of a Korean Buddhist chant.

In total contrast to these joyous, humorous, or contemplative installations, *Temperature* (1984, 1987, 1998) was diabolically unnerving. A brick wall had been built from floor to ceiling, with only a small hole knocked through the bricks at floor level. Most people squatted down, peered in, and left; few had the courage to crawl into the room on hands and knees. Those who did venture into the darkened room were silenced, or talked in whispers. In the middle of this stark and intimidating space was a very solidly built wooden bench with a gas cylinder set in one end and a large cast iron vat set in the other. The vat was full of murky water, from which protruded a very large industrial thermometer. It appeared that one had accidentally stumbled across a mysterious, but life-threatening experiment.

There were certainly black moments in the exhibition. In fact, the color black occurred again and again—black pianos, black crows, black curtains—and the catalogue had the artist's name in gloss black on a matte black cover. Undoubtedly the most persistent and distinctive image in the Unsworth survey was the black grand piano, which was used most effectively in the two major works that viewers encountered when they entered the exhibition spaces. *Rapture* (1994) is an extraordinary grand piano with seven keyboards rising one above the other, like a grand staircase taking one to a higher level. In place of the maker's name, Unsworth substituted his wife's name, Elisabeth Volodarsky, in gold Gothic lettering. Is he suggesting that his wife, as a concert pianist, is capable of transporting her listeners to a higher plane and inducing a sense of "rapture?" If so, the rewards are brief and transitory. On top of the piano was a mass of straw, and if one looked closely one noted that mice were eating the straw and that the musical score was burnt and almost destroyed. The viewer of this most evocative work was taken through a range of emotional reactions, from surprise to amusement, from introspection to melancholy. Typically, Unsworth leaves the interpretation to each spectator, allowing for multiple explanations.

Going down the escalator to the other section of the exhibition, one was immediately confronted by no less than three grand pianos, facetiously titled *Piano Trio (Teaching Three Pianos to Sing in Unison)* (1998), all up-ended with keyboards on the floor and strings displayed vertically. Three metronomes ticked loudly and constantly. On each piano, bolted to the frames at different positions, was a mechanical device with long sticks attached. At the press of a button the sticks were activated, and they proceeded to whack the strings of the pianos with vigor and a certain viciousness. A number of broken strings indicated the force of the attack. Spectators jumped back in alarm, then burst out laughing, though one lady said loudly: "It's no way to treat a piano!" Not quite John Cage's "prepared piano," yet both sound and silence were part of the work. Most of Unsworth's installations include sound, and some

of his drawings (*Sound Composition 1* [c.1978], for example) actually look like experimental musical scores and conceivably could be played. *Slapstick* (1983–98) consisted of nine motorized sticks, which came to life in an entirely irregular manner, rose up, whacked the wooden floor with a hard, sharp sound that could be heard throughout the gallery, then subsided into unexpected silence. Just as the people in the vicinity lapsed back into normal gallery viewing, the sticks repeated their brief but disruptive performance.

The noise emanating from some of the installations had spectators, particularly children, running from gallery to gallery to check on the source of the activity. *Litost* (1984–98) attracted a lot of attention in this way, as a seemingly possessed wooden chair periodically shook and jumped violently, producing a nerve-racking, harsh sound. On a circular screen at the end of the darkened room, a projected image of a similar wooden chair appeared to burn endlessly—one thought of the traditional vision of Hell as an endless inferno of flames.

Heaven and hell, rapture, humor, melancholia—Unsworth has a wonderful ability to cover an extremely wide range of concepts—concepts that are sometimes subtle or esoteric and other times deliberately popular or kitsch. He is able to make his ideas visible and accessible not only to the art cognoscenti, but also to the general public, a unique skill when contemporary art is often unintelligible to large sections of the community. **KS**

Nils-Udo

by John K. Grande
1999

Active in the field of environmental art since the 1960s, Nils-Udo creates significant structures that play with land-scape scale, planting or assembling materials that link a specific site, horticulture, and art. Seen in Japan, North America, India, and Europe, his work has developed an expressive language with its own unique syntax. By high-lighting nature's presence, Nils-Udo's landscape montages make us all the more aware of our place in relation to nature. His approach is tactile and extemporaneous, playing visually with the various organic and inorganic ele-ments available in a given site. Works such as *Hungerwiese, Birkenpflanzung* (*Birch tree planting*, 1975) and *Fichtenpflanzung* (*Spruce tree planting*, 1976) in the Chiemgau region of Germany, and more recent works like *The Blue Flower: Landscape for Heinrich von Ofterdingen* (1993–96), make use of constructions as well as birch and spruce tree plantings. The plantings from nature represent what they are—trees and plants. Nature becomes a plat-form on which the artist layers a discourse of human intervention in relation to the landscape and the life it contains. A sense of the transitoriness of life is inscribed onto the landscape in these ever-changing works. We see Nils-Udo's work in documents, photos, and catalogues more often than we see it in reality—ephemerality is an omnipresent theme, with nature playing the central role and the artist acting as an interpreter.

Some of his works use an assemblage of natural found elements and others are created through plantings alone, as in *Hungerwiese, Birkenpflanzung*, which consists of trees planted in a circle, or *Für Gustav Mahler, Pappelpflanzung* (*Poplar planting*, 1976), an ascending V-shaped planting on a hill in Chiemgau. Nature continues to create these artworks after they are put in place, confronting the notion of art as a highly specialized endeavor opposed to nature.

Artists have long been inspired by the natural world, yet for the past two centuries nature has become increasingly a "subject" to be appropriated or contained in a work of art. Art is considered distinct from nature, even if nature is the raw material or source for its expressions. This separation goes to the heart of our civilization's dilemma over identification with nature. Nature is not just a concept or a generality, it is a constant presence whether as climate, vegetation, topography, or specific life forms. The evidence of our relation to nature is everywhere, not just in "the way things are assembled" but in the things themselves—be they manmade or natural. Fax machines, concrete, automobiles, steel, and glass all derive from nature, yet we barely recognize nature as a presence in contemporary life. Our modern-day vision is a techtopic one. We codify and process our responses to images, yet deny the pres-ence of the real world around us. Nils-Udo's works are, in his own words, a "documentation of a dying world expe-rience. To bear witness, at the last possible moment, to a now seemingly anachronistic perception of life, an atti-tude that can barely be understood, even by those willing to do so."[1]

The Frog, 1994.
Raft, water lenses, dead leaves, and fern leaves,
view of site-specific work in the forest of Marchiennes, France.

Nils-Udo's work, unlike that of the Minimalist-inspired Land artists Michael Heizer and Robert Smithson, retains a sensitivity to site, to the permacultural matrix of living elements. It more closely parallels the work of Andy Goldsworthy, David Nash, or Bob Verschueren. Nils-Udo's nature constructions, plantings, and arrangements of found elements evidence a need to seize the tactile environmental reality and to build a language out of it—but nature remains an equal player.

Nils-Udo seeks to establish connections between living, natural environments and his presence therein, something that is "minus minus good" (to borrow a phrase from George Orwell) in the high-tech world of contemporary art, where virtual reality and cyberspace are equated with the real thing. There are patterns and structures in Nils-Udo's works that flow over into and incorporate the natural environment, yet references to human intervention are there too. The borders between nature and human culture are hazy. As Nils-Udo states: "Turning nature into art? Where is the critical dividing line between nature and art? This does not interest me. What counts for me is that my actions, Utopia-like, fuse life and art into each other. Art does not interest me. My life interests me. My reaction to events that shape my existence."[2]

Red Rock Nest, 1998.
Bamboo, earth, oranges, limes, and lemons, view of site-specific
work at Red Rock Canyon, California.

We do not call a beaver's hut art or architecture, yet the logs are tooth-carved and the hut is a built construction. The divide between humanity and nature has become so clearly delineated a conception that nature has become a foil used to describe artificiality. The billboard or screen image of a leaf or a caterpillar, for instance, is now used to sell product. Product and production imagery (itself a product) reduce and channel our conception of nature's domain, just as a J.M.W. Turner or John Constable painting, perhaps unintentionally, emphasizes humanity's dominion over nature, condensing the sublime into a tableau. We bestow our consciousness, our ability to recognize the links between things, environments, and experiences to the micro-screen. Sensory experience, however, is pre-conscious as much as conscious. Marshall McLuhan described civilization as Euclidian and centralized. He contrasted this with the oral and acoustic character of primordial cultures. The latter, he believed, responded to the simultaneous, the holistic, and the harmonious.[3] Within an otherwise chaotic universe of energy patterns and riotous growth and energy, Nils-Udo introduces "civility," in the form of structures, designs, and plantings, and the dialogue within his works is an interplay between this civility and the holistic realm invoked by McLuhan. The connections to nature are sometimes screened or rendered into a language of material, other times re-ordered into a comprehensible interpretation of acoustic, tactile, and visual environments.

Object-based art, even installation art, is largely propagated for the museum or gallery venue. As a result, it exists to justify the space. We are provided with a brief snapshot of an artist's vision expressed in a phenomenological way, but the contexts in which the creative act takes place are artificial, distanced from (if ultimately layered on) the permaculture of the earth. The artificiality of creation is emphasized rather than the age-old links between cultural activity and nature. In Nils-Udo's work, on the other hand, subtle curtains of marigolds hang from an ancient arch in *New Delhi, India* (1994) or bedeck cacti in *3 Kakteen* (1994), reminding us of the fragile balance between human activity and nature.

The structure in an early Nils-Udo work such as *Hommage à Gustav Mahler* (1973) is literal in its use of natural materials to build a syntax or "language" of expression, playing with symmetry, undulations, and variations, effectively drawing lines in space with tree branches. The heterogeneity of his expressive language, indeed the complexity of the structures and forms he builds, evokes an architectonic dialogue on culture and nature. In *Der fliegende Wald*, *Fichtenpflanzung* (1984), a 10-meter-high micro-landscape set on a raised platform of tree logs in Lyons, Nils-Udo built a structure out of nature only to set nature atop it. Nature supports nature. His various structures reference our culture's capacity to build meaning into what is essentially a self-generating continuum of life. Elements of a site— colors, shapes, weight, luminescence, and durability of nature's diverse elements, even the broader geological strata or lay of the land—are integrated into Nils-Udo's morphologies of human presence in nature. *Erlenpflanzung auf Grassoden-Schiff/Sitz aus Rundholz, Sallenelles* (France, 1990) encourages a reflection on the history of the land and the way humanity has altered and shaped it. Atop an ogival-shaped mound cut away by Nils-Udo, stand planted trees and a chair—the presence of civilization in the ever-changing matrix of natural history is evoked. The structure and language of living elements, our relation to unrecorded history, agriculture, the wilderness, and the culture of nature all intertwine in this work. Here, parallels can be drawn with Alan Sonfist's *Circles of Time* (1986–89), created in Florence, a work that references the geological, vegetal, and human history of Tuscany.

The structure of language is the ultimate preserve of a culture's mindset. Working with a natural system complete in and of itself, Nils-Udo applies a language of experience through material assemblage in novel ways to describe rather than define. As he says, "Even when I work alongside nature, preparing my intrusions as gently as possible, they always remain a basic contradiction within themselves. My whole work rests on this contradiction. It does not escape the inherent destiny of our existence. It injures what it touches: nature's virginity."[4]

This interchange with temporal experience is atypical for our era. A gap separates the "I-ness" of formal expression, the tautologies of avant-gardism, and the real world. Nils-Udo seeks to offer a mutualist vision wherein nature as environment is an omnipresent backdrop. In revealing the diversity in a specific environment, he establishes links between human and natural history, between nature and humanity that are always there, yet seldom recognized.

With a profound sensitivity, Nils-Udo's work expresses the limitations of the art object and recognizes the role that permaculture plays in planetary survival. As contemporary art plows into the future, a sense that art need not reference objective reality at all has been projected through the virtual metastasis of the screen. Nils-Udo's work moves in the other direction, evidencing nature's constant place in our lives, even as natural resources are increasingly limited, delineated, and quantified. The dialogue with time and place that is an eternal backdrop to Nils-Udo's art is as much a comment on our civilization's history of exploiting nature as it is a reflection of the ephemeral nature of life itself.

Nature's processes of endless reproduction and re-creation are largely unrecognized by most of us as we go about our daily lives. Nils-Udo breaks through this dream state of contemporary post-industrial culture to make explicit the manifold ways we perceive, define, and reflect on reality. He provides us with a key to understanding the primordial roots of the human condition and reminds us that habitat, food, and material resources are constants for any culture, whatever the state of technology. In 1994, at the Château de Laàs in the Pyrenees, Nils-Udo created a living spiral from various corn species to celebrate the 500th anniversary of the grain's introduction from the Americas. At the center of the spiral was an octagonal tower with original non-hybrid species of Mayan corn growing on top. Sheaves of corn trailed down the sides to the ground. While the wooden tower recalled earlier structures such as *Der Turm* (1982), a composite stone, pillar-like tower created for the Bentheimer Sandstein Symposium, the links between agriculture and aesthetic vision were emphatically underlined by the spiral walkway and corn plantings that surrounded the central votive structure. Atmosphere, climate, and living forms are linked in a global sense, but the changes and transformations are gradual and geospecific, and Nils-Udo sustains this sense of the continuity and specificity of nature within his aesthetic. The microcosm begets the global vision. He calls the details of nature "potential Utopias," to be found under every stone, on every leaf, and behind every tree, in the clouds and in the wind. The dialogue is ultimately with the illusion of time, with immeasurable presence.

The Modernists severed links between nature and art to secularize art, and the Postmodernists eulogized the object/product and fell into a miasma of product metaphors. Nils-Udo seeks to unify culture with nature. He builds frameworks within a work, documenting the drama of nature's eternal gaze and his interventions therein as with a camera. These have included the elegiac, illusionistic tilted platform *Heidekrautpflanzung in Rautenform in Alter Eiche* (1986) created in Strasbourg, *Root Sculpture, Mexico City* (1995), and *Herbstbild, Oberbayern* (1997). The camera frame is referenced from within the work. The framing device challenges our notion of context—environmental within the work and imagistic when seen in a photo. The arrangement of elements re-creates a notion of civility, a memory of culture, evoking the sense that art, at its most essential, is economy, part of the culture of nature. The materials and environments that Nils-Udo works in and with merge notions of ecology and economy. Indeed, both words derive from *oikos*, an ancient Greek word that means household or home.[5]

For *Landscape with Waterfall* (1992), Nils-Udo worked nature into a human setting. First, he built an iron platform/balcony onto a building in Brussels, then he covered it with schist from the Ardennes, a tulip tree, a cornel tree, and ivy—a veritable transplanted ecosystem. A pump generated a waterfall that cascaded out onto the street. Here, art working with nature became an urban, as much as a rural issue. Echoes of this project can be found in a work conceived for a rest stop on the A29 Autoroute in the Paris-Le Havre region, later adapted for Expo 2000 in Hannover, and in other projects enacted in abandoned industrial parks and city sites, built to be maintained in perpetuity. *The Blue Flower: Landscape for Heinrich von Ofterdingen* (1993–96), a crater-like earth mound near Munich whose closed gate contains a newly generated ecosystem, and *Landscape with Lake* (1994–96) in Cottbus/Pritzen, Germany, built in collaboration with factory workers in the spirit of Joseph Beuys, are two other examples. An ecosystem with aquatic plants and fish has been integrated into the lake that forms the pivotal focus point in *Landscape with Lake*. To encourage the protection of endangered flora and fauna and to protest the clear-cutting of old-growth forest in British Columbia, Nils-Udo worked with Peter Gabriel near Tofino on the west coast of Vancouver Island in 1996, assembling floating installations that were set ablaze in a symbolic rebirth ritual.

Working with the environment as an interactive component of an artist's production implies an acceptance of our place in the cycle of nature. Nils-Udo's interactions are a *Gesamtkunstwerk*, an ethnology of the soul. His eclectic style carries with it a narrative of human history, for the language of his art is instinctual, building its nest in experience and circumventing the conventions of reproduction, containment, and mimesis. His work challenges these conventions, if only to make us realize that nature is ultimately neither a conception nor a representation, but quite simply the art of which we are a part. **JKG**

Notes

1 Nils-Udo, cited in *Art & Design Profile*, Special Issue "Art and the Natural Environment," (1994): 59.

2 Ibid.

3 Marshall McLuhan and Bruce R. Powers, *The Global Village: Transformation in World Life and Media in the 21st Century* (Oxford: Oxford University Press, 1992), p. 136.

4 Nils-Udo, op. cit., p. 59.

5 Ecology (*logos* meaning study) is the study of the home, and economics (*nomics* meaning management) is home management, while nature derives from *nasci*, meaning to be born.

Walter Zimmerman

by Sherry Chayat
1999

Walter Zimmerman's work is bursting with paradoxes. Like that of "Mary, Mary, quite contrary," his garden grows in monstrous ways. He often incorporates blown glass into his constructions, but there's nothing refined or decorative about these forms; instead, he pushes the glass to and beyond its limits, forcing the surfaces of his large, organ-like pods to crack and bubble. He uses found objects, but treats each bit of detritus with as much care and precision as a diamond setter. Wires and electronic components, light bulbs and hoses suggest function and communication, yet nothing works: attachments are blocked or severed, the current has imploded. In short, these sculptures are charged with metaphor. The impact is one of vulnerability, yearning, obsession, and terror.

Much taken with his exhibition at the Everson Museum of Art in the fall of 1997, I arranged to meet Zimmerman at his recent New York City show, which included works from 1994 to the present. Some of the pieces jutted out from the wall; others were anchored to the floor. Still others were freestanding étagères and carts that looked as though they had come directly from hideous medical experiments in some dingy basement storage room.

"When I moved into working with glass, I had every intent of doing what everyone else does," Zimmerman told me. "I had a very formative class at New York Experimental Glass Workshop with Jane Bruce in which she said, 'Take the piece you like best and cut it in half.' It was a direct challenge to the idea of the precious object. What happened was I began seeing very personal themes start to emerge. I realized that the very thing I want distance from I must have in there, or the work has no weight, no defining past. The work articulates my own life."

At the age of 10, Zimmerman was placed in an orphanage, along with his three younger brothers. Later on, they lived with their father and stepmother in various towns in western Pennsylvania. Art classes in the many schools he migrated through and the discovery of Pittsburgh's Carnegie Museum were his lifeline. He enlisted in the Air Force in 1964, and spent his free time drawing in the base library. While Zimmerman was still in the service, his drawings were shown in a bank in Harrisburg, Pennsylvania. After a tour of duty in Iceland, he embarked on an acting career (during which he also created props and sets) that took him to Rhode Island, New York City, and New Jersey. In 1990, he went to see the Heller Gallery's "Glass America" exhibition, and all the divergent rivulets suddenly coalesced. He began studying at New York Experimental Glass Workshop and then entered the glass program at Rochester Institute of Technology, where he earned his MFA in 1994. The following year he won residencies at Hallwalls in Buffalo, New York, and the Creative Glass Center of America in Millville, New Jersey.

Succor, 1994.
Glass and mixed media, 62 x 48 x 60 in.

What carries Zimmerman's work far beyond the merely personal is its metaphysical depth and intellectual rigor—and a daring approach to glassblowing, an approach that no doubt reflects his evident ability to dance along life's precipices. He starts a piece in the usual way, adding layers of glass to the bubble at the end of the blowpipe. "The beginning process is very demanding," he says. "I handle the glass like a precious baby. Then the abuse happens. After the last bit of hot glass is blown, I take it and roll it through a bed of refuse—residue from the sawing, grinding, and polishing process. I dump the hot glass repeatedly in a bucket of water, which creates tiny cracks on the outside. Then I heat it up again, so it fuses a little and bubbles form on the surface. As it becomes more grizzled and the sheen is removed, whatever is puffing its way through appears. It's a hair-raising process, because of temperature variations at different points on any one piece. But if it breaks, I'll often just glue it back together. My work is not about perfection."

Urban Unit #3, 1999.
Glass and mixed media, 19 x 11 x 18 in.

In an interview for the catalogue that accompanied his show at the Everson, he told curator Thomas Piché, Jr.: "I see this parallel between the life of the glass and the life of the person. What happens when misfortunes happen? What happens to people who are the wrong color, the wrong shape, the wrong sexuality, the wrong size, the wrong economic level? What happens when all of these things impinge on this gathering of glass?"

In 1994, Zimmerman's experimentation led him to a breakthrough piece, *When In Use*. Suspended inside a metal box with a wire screen door are two blistered, blackened, red glass lungs from which tubes and pipes extend. They appear to be connected to two radiator hoses fastened unhelpfully to the wall: there is no breath possible here. Stains the color of vomit coat the interior of the box; on one of its outer edges is a red switch with the words "To Use." Engaged by the strangely beautiful yet chilling visual aspects of this sculpture, one begins to ponder the many connotations of use: what is useful or not, how to use what we've got, feeling useless, being used, misused, and abused, getting used to it all.

Another piece from the same period, *Succor*, is both monster and victim, its endlessly replicating pods extending from metal coils attached to a rectangular, encrusted metal shape that turns out to be an old radiator cover. It slouches toward us from its corner, where it hangs from the walls on three lengths of pipe. Back and front are fashioned alike, an obsessive-compulsive touch that implicates the room as much as it does the viewer. One pod, sheathed in plastic to keep its broken parts from exploding, adds a further note of anxiety. "I feel more intimate with things that are damaged," Zimmerman says. "A piece is often sparked by a found object, or an unexpected incident. Fortunately, as it begins to evolve, the more trivial concerns get burned away. I strive to be obedient to the needs of the work. It's an indirect process, but when I can pull it off, it resonates on a metaphorical level. I read a lot of fairytales and myths. Like insects and seed pods, the work feeds that subverbal level."

RSVD/4U (1995) is a disheveled wheeled étagère of taped and bound pipes with shelves of industrial-grade plastic. On four of them, glass pods lie in varying stages of decomposition, hooked up to inert hoses and tubes and a lightless metal lamp. A clutch of computer cables hangs mutely from one junction. The top shelf is empty—like a hospital bed vacated in the night and now, as the title suggests, "reserved for you." Knowing a little of Zimmerman's life, we can understand the pods as symbolic of the four brothers on their orphanage cots, with the empty one reserved for their sister, who remained with their mother. But this knowledge is unnecessary. There is no escaping the deep sadness condensed in this piece.

Zimmerman created two versions of *Wait* in 1997 for a group show in Rochester, which had gravity as its theme: "I found some fittings that were not meant to go together, but that fit each other, and I mounted them on the wall and let my unconscious mind work, and what happened was a pun: the words 'weight'—something suspended in space—and 'wait,' the suspense of waiting in time. It reminded me of the orphanage, where we were both guarded and worthless, and that continual sense of not knowing, of anticipation, of fear." *Version I* curves out from the wall, a translucent amber rectangle (a shellac-stained car mat) that seems to secrete slow drips of some bodily fluid, beneath a section of black exhaust hose. In *Version II*, a wire mesh cage encloses three arcing hoses on the wall; a large funnel catches their slow leakage. "When working in three dimensions, I want to conjure up the fourth—time," Zimmerman wrote in the catalogue that accompanied his exhibition at Urban Glass. "These works, undeniably present, like the fetish in the dark museum corridor, maintain a visceral connection with somewhere else…another time or place—preferably a future already worn, pillaged, and exhausted." Commenting on their ruined corporeality, he wrote that the sculptures mirror his own "flawed physicality. Screened in, bound to the wall or inescapably entwined with others like it, the glass speaks for me, expressing shame at my helplessness and mortality, and my powerlessness to do a single thing about it."

Berth, Version II (1997) was inspired by finds in a salvage store. "I realized I'd paid money for broken parts of old barbecue grills," he told me. "But I found the shapes so malevolent, so emotionally evocative." An encrusted grill, par-

tially revealed through an open-zippered covering, harbors glass tubes in rubber holders and is fastened to the wall; extending from it are wires that lead to an electric dial and a rubber spout. Hanging down from long cables, as if attempting to feed from that barren contraption, are five blown-glass pods that have been tightly encased in plastic. One of them has an open zipper that echoes that of the grill above: hunger met by hunger, the gaping maw, the torn breast. "I wanted the effect of a direct import from some meat-packing plant in Kentucky. I sewed garments for the glass from plastic bags I got from a T-shirt printing operation, and used a heat gun on them so they'd shrink down like a kind of skin."

Dependency Issue, done the following year, is a tall, narrow, sinister wall piece with a black rubber backing fastened by utilitarian grommets. Jutting out at the top on a perpendicular angle are a short length of pipe, a computer chip, and a rectangle of glass with a suspended chain. Beneath, hanging against the black ground like a body in an S&M dungeon, is a blood-red glass form encased in a tight, zippered garment. The torso ends in a red tube that's cut abruptly, like a severed phallus. The biological references continue in globs of yellow secretions at the ends of tubes leading into a rubber funnel. As if to caution us to keep away, twin sections of screening curve over the forms. As disturbing and unsettling as this sculpture is conceptually, it is also visually enticing: the viewer is simultaneously lured and repelled.

The most recent work in the New York City exhibition was *Urban Unit Number 3 (Red)*, finished in March of 1999. Two glass pods with bulbous ends attached to lengths of rubber tubing look as though they've been tossed carelessly into an old wire mesh basket suspended from lengths of plumbing pipes on wheels. The basket is too small; the pods, which have the look of harvested organs, are dangerously close to tumbling out. Adding to the claustrophobia is a lower shelf crowded with six specimen jars, each with 12 little bottles filled with substances suggesting various fluids; these and the pods in the basket above are numbered and lettered, the marks of some long-ago categorization or function. Tubes connect the two sections of the cart, and a pipe that projects over the top ends in a red bulb, as though about to squirt blood. "When I was in graduate school, the biological experiments being done—cloning, organ transplants, in vitro fertilization—had a science fiction quality," Zimmerman said. "Now they've become so routine that my work verges on journalism."

Although he doesn't always incorporate glass into his assemblages, he is drawn to it "for its implied spiritual qualities of innocence and fragility, for its actual strength, toughness, and adaptability—and because, having had the pleasure of creating something from the molten medium, I am then left with the question of what that something is now to do. I choose found objects for their character and traces of purpose, and precisely because they have been discarded, lost, or forgotten. Intuitively, I begin to make connections between the 'precious' glass and the 'valueless' detritus, operating in some ways like a speculative archaeologist piecing together a long-dead, technologically

remote past, and in some ways like a desperate survivor whose life might depend on this hastily constructed, awkward, and unlovely contraption."

These choices and connections are unflinchingly grounded in direct experience. Then, through an alchemical process that reflects both a penetrating inner journey and an exuberant love of mythology, drama, and visual effect, Zimmerman provides us with a body of work that illuminates our common struggle and invites us to examine fully the metaphors of our own interwoven lives. **SC**

Karin Sander

by Gregory Volk
1999

An elderly, gray-haired man wearing a blue suit stands with one foot ahead of the other: you feel age pressing on his body but also note his calm resolve. A child with a slightly concerned expression, nervous shoulders, and turned-in feet seems at once brave and scared; a young woman in bright, circa-1970s clothing, including a colorful hat with flaps over her ears, is an insouciant representative of youth culture on the loose. Everything is in miniature—a scale of 1:10—and everyone stands atop white pedestals. The reduced scale invites close attention to bodily details and what they express psychologically, or what you think they might express, and you find yourself enormously alert to the nuances of each individual: to how feet and hands are positioned, to a slope of the shoulders, to what a particular way of gazing might signify. You see the Turkish artist Ayşe Erkmen staring straight out with a calm gaze; Gudrun Inboden from the Staatsgalerie in Stuttgart, neck to ankles in a red cape and with a look of serene confidence; a self-conscious policeman in his uniform; and Karin Sander herself—the German artist who has come up with this startling new series of figurative sculptures that challenges just about every convention associated with the genre.

The twist here is that these figures were not made by hand at all and reveal nothing of Sander's own interpretations or subjectivity. Instead, they are made by an advanced technological process of three-dimensional photographic body-scanning in the one machine in Germany that does this sort of thing (usually for the fashion industry), leading to a computerized, layer-by-layer construction (fused deposition modeling, to be precise) in ABS plastic, a commercial acrylic, and finally to an application of precise, airbrushed color by a technician.

Sander has so far invited some 25 people to be scanned, including art world colleagues, but also friends, associates, and, in a couple of instances, virtual strangers. The results are intensely—also eerily—human, right down to the nuances of expressions, creases in clothes, postures, eye color, and hairdos. It is like looking not at miniature sculptures but at miniaturized people. All the big and tiny details of the body are there, but then so too are pronounced high-tech traces, like a slight blurring of the features, arising from the way that photographic images are sent through the computer and then brought back to the acrylic, and the ridges of the uniform, circular layers that form the figures. While Sander has completely dispensed with traditional notions of craft or personal touch with tools and materials, her figures remain enormously sculptural and visually engaging—not via hands-on effort in the studio, but through a seamless integration of photography, computer technology, mechanical production, and industrial collaboration.

Mixing an ultra-verisimilitude with references to toys and dolls, copies and clones, these figures are hybrid in the extreme, and as much as they suggest next-generation computer-based simulacra, they also recall the 19th-century

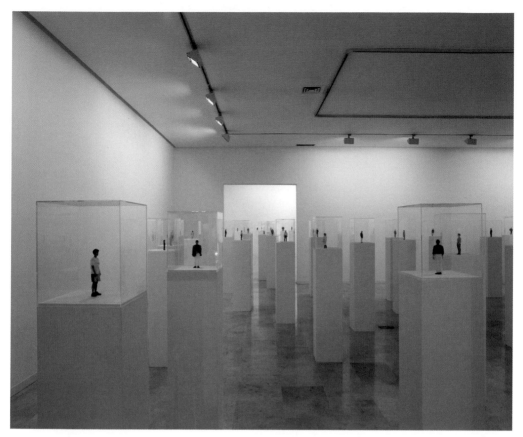

obsession with automata and other mechanical reproductions of the human. Throw in sci-fi scenarios like *The Incredible Shrinking Man*; certain alarming dreams when one is very, very small; horror flick terrors when a person, soul and all, is turned into an inanimate statuette; commemorative statues honoring some famous person; and natural history museum dioramas—and you get an idea of just some of the associations that these figures evoke.

Interestingly, Sander reaches this associative expansiveness not by intensifying her own interpretive powers, but by vaulting over the long-standing role of the artist as an interpreter or arbiter of the figure. In the process, she opens up some significant new territory for figurative sculpture, which has been enjoying a resurgence for the past several years. Unlike the wooden statues of Stephan Balkenhol, which are carved in that position and no other; the manic, emotionally charged video projections of Tony Oursler, which are assembled and arranged; or Charles Ray's notorious life-sized nuclear family, which is intended to evoke a kind of mutant creepiness, Sander's figures are neutral

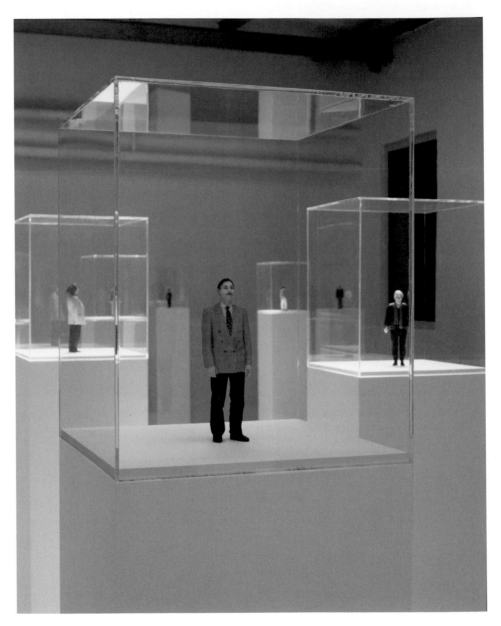

Dietmar Glatz 1:10, 1998.
3D bodyscan of living subject, rapid prototyping, FDM (fused deposition modeling),
ABS plastic, and airbrush.

and objective. They deal with objective visual information—exactly what the cameras recorded as the people stood in the scanning machine, and what the computerized process transcribed in acrylic. Also, they are not really portraits but self-portraits, for the people were free to choose their clothes, the posture they wanted to assume, what they wanted to physically communicate. But even though these are high-tech artifices, produced by a more or less automatic process, they engender a profoundly human response, precisely because they capture so much of the actual person.

Viewing them can be considerably disconcerting, for there is something disturbing and voyeuristic about scrutinizing these high-tech miniature copies of warm, breathing people. You almost feel as if you're breaking some taboo, looking a little too closely, intruding on another person's privacy—except for the fact that it's not a person at all but an acrylic statuette. It's not polite to stare, so the saying goes, but that's precisely what you do, with both wonder and consternation. This is a way of working with the figure that taps deeply into the slipperiness of "otherness," how one perceives others and is in turn perceived, how much one notices or doesn't notice. Through these images, you feel close to the people, but simultaneously remote, and you can't help but be aware of your own interior psychology: the alienation of incontrovertible distance from others, the vigor when that distance is breached through total engagement.

The whole series originated with a single work for the 1998 Kleinplastiktriennale in Stuttgart. Taking the term *Kleinplastik* (small sculpture) literally, Sander presented a small acrylic version of the exhibition's curator, Werner Meyer, with some humorously subversive results: instead of a curator presenting an artist, the artist presented the curator, and instead of a curator looming over the exhibition and its theme as some giant, custodial force, this suddenly small-scale curator took his place among all the other works. Of course, there was something absurd, ungainly, and, to borrow a term from Vladimir Nabokov, "topsy-turvical" about this work—but then Sander often allows for an element of the ridiculous to enter her otherwise rigorously conceived and executed projects.

For those familiar with Sander's work, this series of figures probably comes as a real surprise, chiefly because she has never been identified with the figure per se. There are, however, profound connections with her past work, for she has long been interested not in made or invented forms—for instance, autonomous art objects introduced into a space—but in taking and transforming things that already belong to the site in question, notably architectural structures like walls, wallpaper, windows, and floors, and in this case the curator of the exhibition himself. What results is an unusual principle of simultaneity, in which the space or situation as it normally is and as it has been reconfigured into art co-exist side by side in a delicate yet frictional balance.

A wall installation at the Basel Art Fair consisted of cut-out squares of the thin fabric already covering the walls, which were then fit into dozens of differently sized clip-on frames and displayed in a top-to-bottom salon style: not

paintings on the wall but the wall hung as paintings. When a work was sold, it was immediately removed to reveal the underlying excision that it covered, and in a hilarious take on the kind of buying and selling occurring everywhere else, prices were determined solely by size—bigger ones were more expensive, and smaller ones cheaper. It is tough to imagine a more bland and forgettable material than this wallpaper-like fabric that gives offices and exposition halls their generic, institutional look, but here it took on a new, thriving life as an emphasized and active force. Another time, Sander photographed every room in a university institute for telecommunications technology from a central perspective, turning these images into stacks of postcards, which were displayed as a grid on a front wall inside the building, like a photographic rendition of surveillance monitors: 216 shots of empty, interior spaces, each in its own small box on the wall. When entering, one saw a concentrated yet expansive rendition of the institute itself, but when the postcards were used (and they were free for the taking; editions of 5,000 were made for each room, which itself was pretty outlandish), the space was then distributed around the world through the postal routes—a dematerialized building in pieces, in motion, in full flight.

Perhaps the most acute example of the way that Sander uses minimal interventions to transform space is a series of wall-polishings, which have been accomplished at many different sites, including a work on the second floor of the Museum of Modern Art in New York. For these works, Sander sands and polishes rectangular forms directly into the surface of a wall. The forms refer to paintings on museum or gallery walls, but they are more like paintings in reverse: paintings that jettison pretty much all of what has traditionally constituted a painting, including canvas, brushstroke, and ultimately paint. What results are fantastically smooth fields with a mirror sheen that, depending on one's perspective, withdraw altogether into a near-invisibility or are startlingly reflective and shimmering. And rather than presenting self-contained visual events to the viewer, they are intensely active fields that directly respond to their environment with a kind of hyper-alertness: concentrating light on their surfaces, catching and displaying external space and events as fleeting imagery, serving as screens on which the site itself is both projected and distorted. It is interesting to note that Sander's figures are also "screens" on which the photographically captured surfaces of people are likewise projected. Immaterial in the extreme, and at times almost breathtakingly gorgeous, these wall-polishings quietly disrupt the surrounding architecture, dissolving it into ephemeral moments of flickering and reflection.

Constantly in Sander's work you find this drive toward the empirical facts of the situation: not a work on the wall, but a work that is the wall, however much transformed; not invented figures in a gallery or museum, but three-dimensional photographic renditions of actual people who might very well be there anyway. Not an egg-shaped sculpture, but a sculpture that is an egg, in an acclaimed work from 1994, which consists of nothing more than a raw, polished chicken egg set atop a pedestal. Sander used sandpaper to polish the egg by hand, turning its fragile surface into a shimmering, highly reflective field. Suddenly a normal egg becomes wildly sensual and luminous. It

seems, in fact, like a rare, exotic treasure: a 19th-century Fabergé egg, perhaps, or a bejeweled heirloom, even a devotional object with spiritual significance. It has an ethereal gorgeousness that seems frankly sublime, and it also resonates with suggestions of primal origins and primal femininity. At the same time, it is an over-the-top take on anti-monumental sculpture. While all sorts of "soft," temporary, or fragile materials have entered into sculpture during the past couple of decades, you just can't get more fragile than an egg.

Sander's work can be very austere and reductive, but there is also something refreshingly eccentric, and near-absurd, about how far she pushes her ideas. Consider a 1998 exhibition at the Stiftung für Konkrete Kunst in Reutlingen, Germany. A horizontal band of framed works on paper traveled along the walls through three huge exhibition halls on separate floors—770 works in total, which proliferated through the space and made a kind of path or route at eye level. At first glance they looked like a tremendous number of spare yet exquisite line drawings, but when you looked closer you discovered these weren't drawn marks at all but strands of human hair: one strand on each picture. Sander collected 10 strands of hair each from some 80 people, which were then pulled through dry glue and dropped, one by one, onto paper. The drawings consist of exactly how the hair landed. The physics of these mini-events, as well as the properties of the hair itself (whether it's curled, looped, winding, or straightened), and not any subjective decision by the artist, determined the composition.

As you followed these hair strands through the vast space, they formed an endlessly permutating pictorial alphabet—sometimes minimal and serene, for instance a more or less straight strand forming a wispy horizon line or angling upward to a gentle diagonal, but also tangled shapes that recalled juiced-up Abstract Expressionist gestures, and others in which the hair extended off the paper and over the edge to form extremely delicate mini-sculptures in space. Just about everything that could happen with a small line did, while the individuality of the hair, with its differences in thickness and tint, shape and length, wound up underscoring the individuality of the donors. A lot came together here: Minimalist-inflected austerities and a maximal, space-transforming presence; system and chance; serial repetition and unique, lyrical moments. Also, because the same person's hair was played out on a group of successive drawings, each group became a kind of self-portrait, one built from the tiniest of bodily details.

These "self-portraits" are just one example of the many times when people figure prominently in Sander's projects. For an artist who constantly seeks to rid her pared-down aesthetic of expressively human attributes, it is interesting to note just how often people, in some manner, are engaged, either as subjects or as viewers who are no longer mere observers but active participants. Emptying a gallery of anything recognizable as art, Sander once built a new floor rising six inches above the original one, which slightly yet decisively altered one's spatial orientation and turned the activity of visiting the gallery into a highly self-conscious but comical and invigorating experience. An Astroturf floor piece at the Museum of Modern Art, half inside the museum and half outside in the sculpture garden, doubled

as a place where people could lounge and relax, read and converse, and Sander's wall-polishings bring the viewer in as a muted reflection while they also constantly change according to the viewer's own movements. For an early work from 1990 in Lodz, Poland—which essentially heralded Sander's emergence as a major young artist—she repaired and restored two grimy passageways between buildings leading from the street to the courtyard and painted them a luminous white. Highlighting the everyday activity of pedestrians moving from here to there in a city, they suggested regeneration and renewal, and they also responded to the society-wide transition and hopefulness in Poland at the time, as it emerged from decades of communism.

Now people have directly entered Sander's work, and in a way that scrambles the borders between computer-based simulation and close-to-home human encounters. At Kunsthalle Göppingen, where Sander's figures were shown en masse for the first time, they were together in one part of a large exhibition hall, and they all faced the same direction, namely the entrance. When you walked in, expecting to see works on the wall or the floor, you were instead faced with a group of mini-figures eyeing you. At Künstlerwerkstatt–Lothringer Strasse in Munich, where they constituted a discrete installation in a four-person group show, they were also gathered together, but this time facing different directions; and at the more intimate Kunstverein Arnsberg, they were interspersed, seemingly randomly, through four rooms, to make a hilarious and hugely mediated version of an audience milling about, perhaps on opening night. You wander among them, and look at them separately: distinct individuals frozen into a particular posture, an instant of a life. Step back a little to look at them together and they are an absorbing mini-society filled with correspondences, differences, and personal idiosyncrasies. There is something richly humane about Sander's miniature renditions of human figures. This is a way of working with the figure that is at once challenging and magical, unnerving and chock-full of intricate life. **GV**

Alison Wilding

by Ian Tromp

2000

A graceful twist of holes punctures the surface of Alison Wilding's *Brain Drawing 8* (1996). A blurred gray-blue form hovers in the page's center, behind this curve of pinpricks. Indistinct both visually and cognitively, the form is marked not on the surface we see but on a second sheet of paper behind the first, which is made transparent by the application of silicone fluid. Alongside *Brain Drawing 7* (1996), in which a similar shape is enclosed by a penciled boundary with ear-like protuberances, we read the form as an x-ray view inside a human skull, a brain drawing.

The pattern of holes seems to drift across the form's ghostly edge, lacing into its darker body the white of the surrounding page. But, in a sense, to see the white of the under-page through the holes of the loop that borders but lies off the form is less compelling than the blackness visible through the body of the twist that covers it. Making visible the darkness beneath the surface, the holes act as the aperture of a pinhole camera or a camera obscura, drawing the unseen into sight. Besides bringing what lies beyond into vision, the pinholes work, too, to draw the viewer through the surface they break. These small piercings give the page an unusual mobility, creating a to-and-fro between the viewer, the punctured page, and the sheet beneath with its shadowy form.

Wilding frequently makes such perforations in her work—take, for instance, the sculptures *Bare* (1989–90), *Inside* (1987), and *Her Furnace* (1986–87). In each of these, the punctured surface similarly sets up a dynamic of disclosure and enclosure, acting as a screen that, while withholding physical access, imaginatively draws the viewer into the work's interior.

In an essay accompanying a group show in Oslo of works by British sculptors, Roderick Coyne said of *Fugue* (1992), which is punctured by many fine holes: "By looking through the aperture to the world inside, the observer necessarily loses bodily consciousness." He continued, "The uneasy sensation of becoming temporarily transmuted into an object, persuades the viewer to break contact with the wall of the sculpture in order to re-instate self-awareness."[1] Coyne takes the side of Thanatos and sees loss of awareness in the loss of bodily consciousness and, speaking in Freudian terms, death and oblivion. For Freud, though, Thanatos is countered and balanced by Eros. Likewise, the dynamic of revelation and concealment in Wilding's work, and the play of unsettlement and estrangement that runs through it, can as readily be seen as life-giving and erotic. Partial exposure leaves the viewer unsettled, wondering—something remains unseen. Hints are given that there is more, something other, beyond what is visible. Wilding repeatedly engages this play of the apparent, leaving things unsaid but silently cued. Forms emerge—as in *Brain Drawing 8*—from beneath an overlay; shapes are described by the folds and fall of cloth, as in *Into the Brass* (1987); something presses up through the flat surface of *Carpet 1* (1995), or seems eerily to be traveling under *Carpet 2* (1995–96).

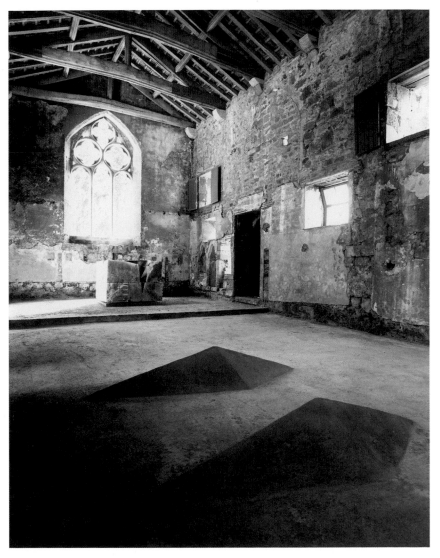

Désormais, 1998.
Two works: (foreground) *In Shadow*, 1998, rendered concrete, each object 38 x 255 x 86 cm.;
(background) *Harbour*, 1994–96, alabaster and cast silicone rubber, 130.5 x 152 x 158 cm.

In seeming contrast, *Echo* (1995) is obsessed by the visible—but its obsession also leads toward the unseen, as it becomes lost in its own myriad images. Developing a method initiated in *Assembly* (1991) and *Blue* (1993), *Echo* is made of interlocking strips of stainless steel; at its core, off-center, a ball of polished brass is enclosed. In a short text on the work's origin, Wilding spoke of its "concentrated stare, of brass at steel and steel at brass. It's an intense and obsessional stare and mirrors mine at it."[2]

The title touches off Ovid's telling of the myth of Echo and Narcissus, a myth fundamentally concerned with unattainable appearances.[3] The interlocked stories of Narcissus and Echo resound in *Echo*. Both of them die for love of Narcissus, "a beauty that broke hearts." Wilding's obsessional stare is that of Echo at Narcissus and that of Narcissus at his own reflected image; and the endless mirroring of the work, the plane of perpetual regression at its core—brass warmly mirroring steel, steel immaculately echoing brass—is Echo's dumbstruck repetition of whatever she hears.

Whereas *Blue* exists on an edge of transparency—fluctuating, fluttering, weightless, different surfaces one by one becoming invisible and then reappearing as the viewer moves around it—*Echo* is solid. But its weight is more that of its surroundings. Though it is a heavy and substantial object (almost a mile of steel strips weighing three-quarters of a ton), it too is weightless in its way and can seem to disappear in the shimmer of its planes.

The "bright trick of its surfaces" diffuses the work's edges, transforming it into an upright pool of reflections, simultaneously drawing in and rejecting the viewer.[4] *Echo's* construction of slotted strips of stainless steel can be described as a field of perforations, every single surface split, divided, cast back on another. But though the network of openings seems to allow passage into the body of the sculpture, its shimmering walls keep the viewer at a distance. Although vision is at the heart of the work, it is extremely difficult to see the brass ball at its center because, though it is open to contemplation, it is simultaneously closed; though it invites, it simultaneously rejects. It keeps its distance.

Part of an international exhibition, "artranspennine98," held at various venues—galleries, sculpture parks, parks, quarries, hotels, and libraries—across England's Pennine region, *Désormais* (1998) was installed in the 700-year-old Chapel of St. John the Evangelist at Skipton Castle. "Désormais" (meaning "henceforth") is the motto of the Clifford family, incumbents of the castle from 1310 until 1676; it is inscribed on the gatehouse through which visitors to the castle must pass on their entry into the grounds.

The installation consisted of two parts, *Harbour* (1994–96) and *In Shadow* (1998). *Harbour* is an approximate square worked from eight blocks of alabaster, one side split by a sharply inclined "V" that opens into the stones' hollowed-

out interior. This core is lined with black silicone rubber that surges over the rim and plunges into the sculpture's center. *In Shadow* consists of two lozenge-like, gently inclined pyramids, a figure that has recurred in several of Wilding's recent works. These forms were made from material identical to that of the floor itself, so that the shapes seemed to emerge from the floor, as if pressed up from beneath it.

Harbour was placed in the raised alcove where the altar once stood, in the path of light coming at different times of day from the window immediately behind it and from a high rose window at the chapel's western end. Beneath this window stands a medieval font, its hollowed-out stone form rhyming with *Harbour*. *Harbour*'s alabaster responded dramatically to the shifting light—morning sun through the large window behind setting off its almost fleshly tones, sunset through the rose window brushing a delicate amber across the stones. The black rubber held blues and greens caught through the windows from the world beyond the chapel.

In Shadow's placement meant that it very rarely received any direct light, and then only for a short time—and never a light intense or direct enough for the work itself to cast a shadow. Made of the same material as the floor, and usually in shadow, the work was often, again, at the edge of visibility. Just as *Blue* disappeared in its transparent planes, and *Echo* in the shimmer of its surfaces, so *In Shadow* seemed always just on the verge of disappearing into its surrounding gloom.

In a sense, the two parts of *Désormais* illustrate the polarities of Wilding's discourse of light and shadow, revelation and concealment. *Harbour*'s radiance is set against the emergent darkness of *In Shadow*; where the latter shades into the colors of the surrounding floor, the alabaster's extraordinary and shifting colors seem engineered to cast *Harbour* into view. And though there was a step up from the floor to the level of the altar so the two parts did not stand on the same ground, they were palpably linked.

In an early yet still remarkably apposite essay, Lynne Cooke discussed this last feature of Wilding's work in relation to the demise of the pedestal as a part of much modern sculpture. She spoke of Wilding's consequent strategy of introducing a perimeter for a sculpture, thereby "establish[ing] a precinct or enclave."[5] Some works feature actual precincts and are surrounded by visible fields or boundaries—the upright column of *Stain* (1991) is doubly secreted, by its expanse of dark woolen cloth and then again by its steel wall; *Stormy Weather (1987)* by its steel horizons.

But precincts in Wilding's sculpture are more commonly established by felt or implied boundaries or linkages, as in *Désormais*. Physically separate elements appear to be surrounded by a connecting or enclosing space. *Curvaturae* (1985) provides another example, in which a cope of leaded steel seems to extend outward to encircle the wooden form, though actually it stops well short of doing so.

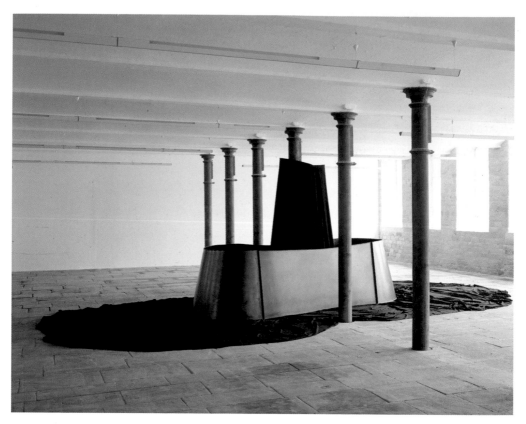

Stain, 1991.
Steel, rubber, and woolen cloth, 297 x 1,000 x 485 cm.

Cooke spoke of Wilding's "mode of thinking sensately," explaining that by this phrase she intended that the artist's thought is "fundamentally nondiscursive and unaccommodating to verbal analysis."[6] Though this sounds vague and even evasive, it reminds us that because so much of what we experience in relation to sculpture is embodied, known within the viewer's own frame, and responded to pre-verbally, it can be extremely difficult to write or speak about sculpture. Of course there is much to be said about sculptures as things-in-the-world, about their objecthood. But there is also a level of experience of sculpture which is less reasonable, less accommodating, more to do with our felt experience of our own bodies in relation to the body of the sculpture.[7]

It is Wilding's sensate thought—her ability to use sculpture as a way of thinking with and through the body—that is significant here, because it enables her to extend a work's boundaries and enliven the space between its apparently separate parts. In *Désormais*, it is what sets an uneasy edge in the air of the chapel—even though the atmosphere is restrained and still, there is yet an estrangement, a making-strange, between the installation's two elements.

Wilding so often links two or more objects that Cooke has called this "one of the basic phonemes of her private sculptural language" and describes how, "in her works one form supports another or shields it or rests within its compass or invades it or encroaches upon it."[8] Nearly 13 years later, in the essay accompanying the show of Wilding's work she curated in Canada, Renee Baert asked of the pear wood and lead wall sculpture, *Derange* (1997), "Does the larger element surrounding the smaller one protect or encroach, suffocate or embrace, share or territorialize? Is the lead intrusive or symbiotic, is it seeping to fit into the softer wood, or has the wood adhered to it, or have they grown together?"[9] Some of the power of Wilding's works lies precisely in the fact that these questions are so difficult to answer.

The combination of elements is seldom straightforward. Their linkage is often mysterious, suggesting the kinds of questions that Baert poses, dramatizing the space between them and opening up, in what seem at first to be works centered on form, questions of significance and suggestions of narrative. As Richard Deacon has said, "The ground shifts…and the formal has catapulted us into questions of meaning."[10]

This continues in Wilding's most recent studio work—as in *Carpet 2*, where something seems to be moving beneath the work's rubber surface, hinting at an unknown, or in *Disposition* (1999), where one senses an eerie presence beneath the mat. Upright filaments press through the surface, as if pushed up from beneath the earth—but on closer inspection, one notices that these twisting, hair-like strands are of the same surface as the rest of the mat, which makes them all the stranger. They are not a different substance, like hair growing from or through skin; they are more like a coating molded to skin and then removed so that the impress of the detail of each fine hair is retained in the surface—which is in fact precisely how the mat is made, molded from a plaster model and then cast in rubber, each strand reinforced by a wire support. The rubber feels like human skin to the touch, and the whole has a startling corporeality. One would not expect cast silicone rubber to be so skin-like, so fleshy—this essentially technological material is surprisingly organic in its appearance and form.

The cast concrete disk that completes the work is divided along a diameter a few degrees off the horizontal. Echoing Minimalist forms, the disk is pristinely geometrical against the unexpected corporeality of the mat. But something about its sectioning—the disposition of its angle, the implied momentum of its tipped mass—is strangely affecting. In his writings on photography, Roland Barthes refers to the punctum of an image—he defines this as "that accident which pricks me (but also bruises me, is poignant to me)."[11] It is a point of visual or affective focus, which particularly holds the viewer's attention, like the off-center diameter dividing the upright disk.

So each of the work's parts has a hold of its own, each separately draws the viewer's attention. But the two together evoke a curiously tensed theatricality. This stems simply from the conjunction of the mat and the disk, the juxtapo-

sition of geometric and organic form. There seems, too, to be a kind of dialogue or exchange between the two pieces: the reserved imminence of the concrete, so upright and still, meeting the contained movement of the rubber; a sense that the strands could grow and envelop the disk; that the disk could tip further and roll out of the work's precinct; that the disk could pitch and fall across the mat, crushing it.

These implied, inscribed narratives demonstrate again the enlivened space surrounding and connecting Wilding's sculptures. In the presence of *Disposition*, one is aware of possibility and unfoldment, an unknown as yet inarticulate but already suggested.

In *Désormais*, Wilding responded to a specific environment, making a site-specific work sensitive to its space, its lighting, and its materiality. These same concerns characterize her first large-scale public sculpture, *Ambit* (1996–99), located in the River Wear in Sunderland, North England. The work is made of 24 stainless steel cylinders connected by sprung joints and patterned on the outline of a ship. It floats in the river near the historic Wearmouth Bridge. Each cylinder is partly underwater and has powerful lights within the submerged section of its body, which by night create a bright nimbus in the surrounding waters.

The ship-like form shifts and alters with the tides and any other disturbance in the water, perpetually responding to its environment. Mostly the changes are subtle and slight enough to take a viewer by surprise, so that one suddenly notices that the outline has bowed out or narrowed, a side buckled or straightened. The stainless steel surfaces reflect sunlight and the sky, lights from the nearby bridge, and the walkway by the riverside. The color-neutrality of *Ambit* allows its silvered surfaces to take on the colors of the water, the sky, and the land. The water also changes color: on the night I arrived in Sunderland, the aura was brilliant blue-green and extended about four feet around *Ambit*; the following morning, the water was dark slate; by night, it was murky brown, the aura brightening it to dirty cream but extending no more than two feet. The water within the work moves more slowly than that around it, the linked cylinders forming a fluctuating enclave—an ambit—of stillness, in which every wave and movement in the water seems de-magnified, reduced—as if the work were a lens that made everything seem farther away so the water within the boundary reads as a microcosm of the river itself.

Movement and the sounds of water embed *Ambit* in time; its form locates it in history. Pann's Bank, where *Ambit* is sited, has been a home of industry in Sunderland since the 17th century. Most recently—from 1846 until 1966—the riverside area was used as a shipyard. The bay along the riverfront in which *Ambit* floats held Austin's Pontoon, an iron structure that was submerged and re-floated in order to lift ships out of the water for repair. *Ambit* responds not only to the shifting present, but also to the past.

In a sense there are two parts to the sculpture, whether these be counted as the work itself and the history of the site, or the sculpture and the river. What is clear is that the work again dramatizes its surroundings, enlivening the precinct of Pann's Bank, including the riverfront, the bridge, and the sweep of the river heading out to sea. In a review in *The Guardian*, Jonathan Jones remarked, "Reflecting Sunderland back on itself, it makes the city feel like a work of art."[12]

Late on an October evening, standing on the Wearmouth Bridge looking down on Austin's Pontoon, what captivates is, after all, not the work's movement but its stillness. Its shape shifts allow it to stand still in the river's currents, very gently bowing and buckling, elongating and compressing. Writing in a catalogue accompanying a show of Wilding's work from 1989 to 1996 in Calais, France, Penelope Curtis spoke of "a consistent overall direction...toward the light."[13] *Ambit* is an important step in this direction: its knowing accommodation and incorporation of the history of its site demonstrate her subtlety and care; its cut-back form and austere surfaces draw out the essential simplicity of her work; and its mute radiance distills and clarifies the mystery and drama of Wilding's oeuvre. **IT**

Notes

1 Roderick Coyne, quoted in Hilary Gresty, "Bare," in *Alison Wilding: Bare—Sculptures 1982–1993* (Penzance: Newlyn Art Gallery, 1993), p. 12.

2 Alison Wilding, "*Blue to Echo,*" in *Alison Wilding: Echo* (Nottingham: Angel Row Gallery, 1995).

3 See Ted Hughes, *Tales from Ovid* (New York: Farrar Straus & Giroux, 1997), pp. 69–78.

4 Wilding, op. cit.

5 Lynne Cooke, "Alison Wilding," in *Alison Wilding* (London: Serpentine Gallery, 1985), p. 9.

6 Ibid., p. 15.

7 F. David Martin's *Sculpture and Enlivened Space* (University Press of Kentucky, 1981) is a memorable articulation of our experience of sculpture in the body.

8 Cooke, op. cit., p. 11.

9 Renee Baert, "Speculative Topographies," in *Alison Wilding: Territories* (Edmonton: Edmonton Art Gallery, 1997), p. 14.

10 Deacon, quoted in Gregory Salzman, "Alison Wilding," in *Richard Deacon, Tom Dean, Remo Salvadori, Alison Wilding*, exhibition catalogue from the Art Gallery of Windsor, 1988, p. 63.

11 Roland Barthes (trans. R. Howard), *Camera Lucida* (London: Flamingo Books, 1984), pp. 26–27.

12 Jonathan Jones, "Ring of bright water," *The Guardian*, Saturday Review, (October 2, 1999): 4.

13 Penelope Curtis, "Full Fathom Five: The Sculpture of Alison Wilding," in *Alison Wilding: Sculptures 1989–1996* (Calais: Musée des Beaux-Arts et de la Dentelle de Calais, 1996), p. 8.

Richard Long

by Ian Tromp
2000

Rudi Fuchs treats *A Line Made by Walking* (1967) as Richard Long's prototypical work. He compares it to Malevich's *Black Square*, arguing that both of these works "canceled previous art in one grand abrupt statement of conviction."[1] But *A Line Made by Walking* articulated ideas and methods that had been initiated as early as 1964, when Long made a "drawing" in fallen snow on the Bristol Downs by rolling and steering a snowball.

This earlier work described four important themes, all of which have been developed and extended throughout Long's career: movement in space, marking the earth's surface, laying out paths across the ground, and his photograph of the "drawing" as documentation or text-making. *A Line Made by Walking* itself demonstrates these four themes: the act of walking the line for movement through space, the path walked, the mark on the surface of the earth, and the artist's photograph as a document of his actions and their outcome.

In fact, each of these themes could head a category within Long's oeuvre. Under "movement in space" would be the walks that are the foundation of his practice as an artist. "Marking the earth's surface" and "laying out paths across the ground" might be combined, as in *A Line Made by Walking*, or counted separately. They would contain, respectively, the "objects" that Long has made—the lines of stone, the circles of blackened wood, the splashes of mud and water—and the paths he has followed from maps, the tracks he has walked into dust and grass. "Text-making" takes place on at least three levels: first, there is the immediate fact of photographing many of the objects; at one remove, there are the texts with photographs, words, and maps; and there are the many books that Long has made over the years since 1970.

In what follows, I distinguish between walks, works, and texts. While the first of these categories is probably clear, the second two might require some explication. The distinction is derived from Roland Barthes's seminal essay, "From Work to Text." Barthes suggested that whereas a work is "a fragment of substance," a text is "a methodological field"; while "the work is held in the hand, the text is held in language."[2] In relation to Long's oeuvre: whereas the texts—with photographs, maps, and words—form a "field," a significant system capable of being decoded, of being "read," the works themselves—of stone, wood, and earth—are solid, weighty fragments of the real.

Long's walks emerged from the culture of dematerialization of art objects during the late 1960s.[3] For him, they expanded the range of possibility in art, removing it from the white cube of the gallery space and literally extending the boundaries of sculpture. He has summarized the development of his working methods as follows: "I progressed from using natural materials, from a snowball drawing in 1965, to a line made by walking across a field in 1967,

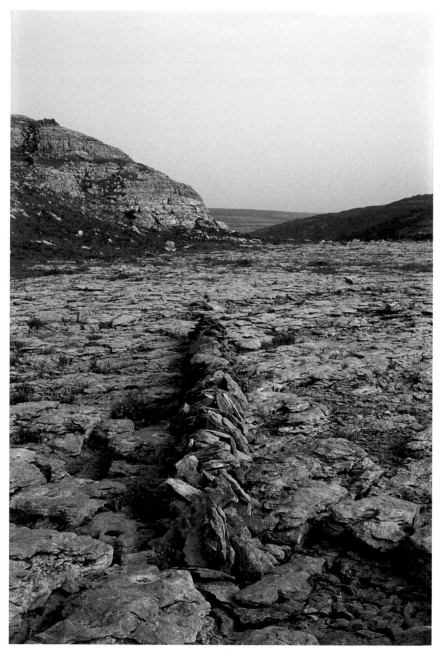

A Line in Ireland, 1974.
Photography and text.

to making just walking itself the medium of an artwork, by walking 10 straight miles across a moor in 1968 (*A Ten Mile Walk*). This enabled me to bring time and a great increase in scale and potential space into a work of art."

This genealogy does not indicate the prehistory of Long's methods, the temperamental and perhaps cultural determination of his walking. It does not tell us, importantly, that as a child he enjoyed walking and cycling holidays with his family. There is a certain mold of an English outdoorsman into which Long fits—of course, he is in many ways quite unlike this cultural type, but recognizing in him a characteristic set of attitudes to landscape and place can be helpful in understanding the motivation of his work.

In speaking of *A Ten Mile Walk*, he describes the "physical pleasure actually just doing the walk, spending a day walking across the moors following the compass point…which is a very enjoyable way to spend the day." But then he goes on to say, "It was also enjoyable because of the fact that I knew that I was making a very original, a unique and dynamic work of art which had a new scale to it, which was a sculpture which was invisible and in many other ways was interesting as art."[4] To every one of Long's walks there are at least these two aspects, the physical and the conceptual.

The walks bring together physical endurance and principles of order, action and idea. These two elements are well illustrated in the walks recorded in the text *Hours Miles* (1996). The idea for the walks is a simple inversion, a transposition of distance and duration, of time and space. Clearly, the physical commitment required to walk 82 miles in 24 hours is extraordinary. When we met in Bristol in 1997, Long spoke of this first of the two walks as "serious walking, with bloodied, blistered feet at the end."

Long walks in different ways, and different kinds of walk are often embedded within longer journeys. He has referred to "ritualized" walking, explaining that "when I use the word ritual…I mean that I am walking, but the purpose of the walk is not to make a journey."[5] In this practice of walking without destination, the walker's passage is marked by criteria other than arrival.

For example, *Alternatives and Equivalents* (1996), a four-day walk on Dartmoor, involved four different kinds of walking: "Slow walking / or meandering walking / or straight walking / or fast walking." *From Uncertainty to Certainty* (1998) is described as "a walk carrying a bag of pebbles with a word written on each." The random withdrawal of a pebble from the bag directs the walker's pace, direction, or manner: "Up down fast slow north south east west straight meandering." The movement from uncertainty to certainty is implicit in the diminishing range of possibilities as the number of pebbles in the bag is reduced—when Long withdraws the first pebble, 10 actions are possible, then he takes the second, leaving eight options, and so on, until the message of the 10th pebble is certain.

Walks may also be governed by ideas other than changing the actual way of walking. *Dartmoor Riverbed Stones* (1991), for instance, is a circular walk beginning and ending at the River Bovey in Dartmoor, England. A stone from each riverbed met is carried to the next river, so: "A stone from the river Bovey carried to the river Webburn / a stone from the river Webburn carried to the river Dart / a stone from the river Dart carried to Holy Brook." The walker moves stones from one location to another, articulating one of the fundamental tropes of Long's oeuvre, the transposition of place. This theme was played out elsewhere in *Mud Walk* (1987), "a 184-mile walk from the mouth of the river Avon / to a source of the river Mersey /casting a handful of river Avon tidal mud / into each of the rivers Thames Severn Trent and Mersey / along the way."

Mud Walk and *Dartmoor Riverbed Stones* allow an easy transition from passage to place, from consideration of Long's walks to speaking of his works. In an illuminating statement, *Five Six Pick Up Sticks, Seven Eight Lay Them Straight*, he wrote: "My outdoor sculptures are places. The material and the idea are of the place; sculpture and place are one and the same. The place is as far as the eye can see from the sculpture."[6]

The works made on walks are of "common materials, whatever is to hand, but especially stones."[7] By contrast, when Long makes works for exhibition or on commission, he usually uses quarried stone: "I go to the quarry and find the stones I like and order them, but without making the work, and then I have to make a guess. Those stones are delivered to the gallery and I make the work for the first time in the gallery."[8]

On walks or in galleries, Long's sculptures most commonly take the form of circles or lines, with occasional crosses, spirals, squares, and heaps. A sculpture's form is decided by its location. Long says: "I have the idea by just being in the place."[9] In the case of gallery works or commissions, the materials are sourced from other locations—so they are not of the place in the same way the stones are in a sculpture made on a walk. But the sculpture's form is still made in response to the environment, to the place of the gallery. One could say, paraphrasing Long, that while the material is not of the place, the idea is.[10]

The effects of these different ways of working with materials are quite marked. Because he works with "whatever is to hand" on his walks, the range of formal possibilities is proscribed. And yet, paradoxically, because he works with whatever he finds in a place, in a sense these works are open to great variation.

Though the material and formal premises of his sculptures are simple and limited, Long has in the course of his career produced remarkably varied work. Sometimes an outdoor sculpture will involve making something, sometimes it will require removal; sometimes a sculpture calls for moving stones or sticks from around the place into a pattern, sometimes it will mean Long walking back and forth in a straight line to flatten grass or smudge dust. Within the

range of circles and lines, it is possible to observe several distinctions: there are, first of all, those made by placing stones or sticks and those made by removing them; there are those in which stones are laid flat and those in which they stand upright; there are works in which the materials are tightly bunched together, overlap, or touch and others in which they are widely spaced; works in which the parts are aligned along an axis, works in which the eye follows swirls and patterns of stone, and others in which the placement of materials seems entirely haphazard. Each of these distinctions stands equally for works in stone and wood and earth.

Comparing a few circles clearly demonstrates the range of Long's approaches. In *Norfolk Flint Circle* (1990) and *Rome Circle* (1984), the stones are packed close together, forming an impenetrably dense visual field. By contrast, *Circle for Konrad* (1997) contains more space, its long slivers of stone disposed in graceful patterns, its edges defined and contained by stones placed side-on to the circle's perimeter. And then, finally, in *Circle of Memory Sticks* (1996), sticks of varying length are placed with staccato regularity to define an open, still space within the circle.

Long has sometimes disassembled outdoor sculptures—he might make a circle of stones, photograph it, and then take the circle apart. Other times he leaves sculptures behind when he continues walking. In the text *Dartmoor Time* (1995), he records "passing a pile of stones placed 16 years ago." It is in the nature of some of the works that they will quickly change or disappear. *Along a four day walk in Norway* (1973), for instance, is printed with a text reading: "The stones / sink slowly / with the melting snow / of summer." Likewise, the line walked into burnt heather in West East Line (1991) will lose its sharpness as the wind blows and eventually be obliterated by new growth.

Long has made several lines of poured water on earth and rocks and walls (*Shadows and Watermarks*, 1983), all of which very quickly evaporate and disappear. In galleries, he has often worked with mud on floors and walls. These works have ranged from lines walked in River Avon mud to handprints and thumbprints, enormous circles and arcs and long lines, as in *Muddy Water Line*, made for a 1996 exhibition at the Guggenheim Museum in New York. Again, within the mud works it is possible to distinguish quite different inflections: some have been made slowly, so that each handprint is visible (*White Mud Hand Circle*, 1996), others are made with fast, broad gestures, so that mud is splashed and sprayed widely, creating a nimbus around the form (*White Water Circle*, 1994). In floor works, the mud tends to be contained within the line or circle; on walls, it runs toward the ground. But look closely at one of the wall works and the carefully penciled perimeter becomes clear through the splash marks, revealing the contained energy of these works.

When a work is meant to last, as in gallery pieces and commissions, Long prepares a certificate giving instructions for its re-making should the work need to be dismantled. He says, "If the procedure says that this stone must be placed here and that stone there, or if it just says that stones can be chosen at random to make an equal density, then they should follow that. Each certificate is very precise for that particular work. If the procedure is followed cor-

rectly, each time every stone will be in a different place within the work, but nevertheless each time the work will look the same."[11] The certificates function as a kind of document: they describe and prescribe the manner of a sculpture's making so that it can be made again. They are texts existing alongside the work, both recording the form in its initial making and defining the sculpture.

The bulk of Long's texts have a memorializing function, recording the walks and outdoor works. In a 1982 statement, *Words After The Fact*, Long described his photographs as "facts which bring the appropriate accessibility to the spirit of…remote or otherwise unrecognizable works."[12] Of course, this leaves out photographs of works that are not remote but are inaccessible, either because they are privately owned or because they are records of sculptures that have disappeared.

It is useful to distinguish some of the ways in which Long uses photography. There are images that apparently simply record an action—as in the photograph by which *A Line Made by Walking* is known. Such images are obviously focused on a work. They record both work and place, "as far as the eye can see from the sculpture." Another example is the photograph of *Along a Four Day Walk in Norway* (1973). Photographs in this first mode I will refer to as recording images. Then there are images showing the landscape in which a walk is made. The photograph in *Throwing a Stone Around Macgillicuddy's Reeks* (1977) does not show the thrown stone or the path of the walk; rather, it records a view of the landscape in which the walk takes place. I will refer to photographs in this second mode as establishing images, following the cinematographic convention for a shot providing a key view of a landscape, person, or scene. Extending his use of establishing images, Long sometimes presents a series of photographs, often begun with a titled page, as in *Walking with the River's Roar*, a sequence in *Every Grain of Sand*, the book published in 1999 by Kunstverein Hannover, or—more comprehensively—in *Countless Stones* and *A Walk Across England*, both books recording single walks.

These two quite different modes of photography are combined in *Mirage*, a book published in 1998. A text titled *A Walk in a Green Forest*, described as "eight days walking in the Shirakami Mountains / Aomori Japan 1997," is printed on the left-hand page of a double spread. On the facing page is a photograph of a tent pitched within lush forest. The following three pages show photographs—in the first mode—of works made in the course of the walk (*Shirakami Line, Shirakami Circle, and Early Summer Circle*). The first image functions as an establishing image, recording a scene from the landscape in which Long walked. But then one notices in the center-background a circle too deliberate to be natural—Long has included in this second-mode photograph a view of *Early Summer Circle*.

This insetting of a recording image within an establishing image demonstrates something of the different expectations of each mode of photography. The recording images seem presented as transparent—we look through them

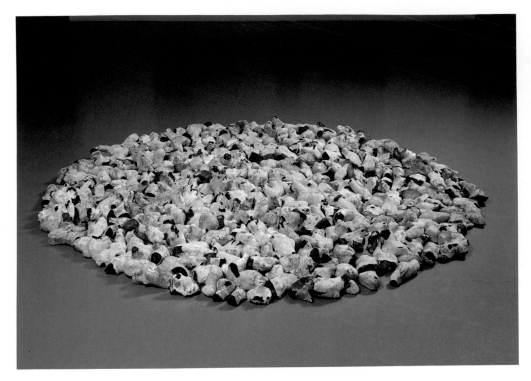

Norfolk Flint Circle, 1992.
Norfolk flint, 9 ft. in diameter as installed.

to see the sculptural works they represent. By contrast we look at the establishing images—from them we learn about the atmosphere and landscape of a place rather than the particularity of a work. In this instance, once one recognizes *Early Summer Circle*, a tension is set up in the image, and the eye shifts between these ways of looking.

In a conversation with Martina Giezen, Long says: "Taking a photograph does a certain type of job, records one moment, makes an image. And words do a different job. They can usually record the whole idea of a walk, maybe much better, more."[13] Whereas the photographs can represent just one image at a time from a walk, words are able to evoke many different aspects simultaneously.

One can, at least provisionally, transpose the terms from the above discussion to speaking of the texts with words, distinguishing between recording and establishing texts. The recording texts usually recount a walk or the idea for a walk—an example is *Mud Walk*, cited earlier, as is *Hours Miles*; another is *Granite Line* (1980), which reads: "Scattered along a straight 9 mile line / 223 stones placed on Dartmoor // England 1980." As in cinematography, establishing texts provide a more diffuse view, in which the observer is presented with a range of information rather than a specific focus, as in *On the Road* (1990) and *Rain Drumming on the Tent* (1997), which records, among other

information, "the wild flapping of the tent in the wind / a gurgling stream / abbey bells." While the recording texts are more closely tied to the idea of the walks, the establishing texts relate the experience thereof, restating the two fundamental aspects of any walk, the conceptual and the physical. The establishing texts are able, as Long says, to "record the whole idea of a walk, maybe much better."

At first glance, *Early Morning Senses Tropical Island Walk* (1989) is composed simply of five descending columns of words. The title, however, directs one to the key to reading the text: each column corresponds to one of the five basic senses. Thus the first column lists a number of sights: "bougainvillea," "white birds," "lilac flowers," "goats." The second catalogues objects touched and sensations felt: "damp dust," "mosquito bite," "Coco de Mer bowl." The third lists a number of sounds the walker hears: "cooing," "rustling," "bonjour." The fourth lists smells: "orange," "turtle droppings." And the final column is a list of tastes: "coco plum," "rainwater," "cinnamon bark." *Early Morning Senses Tropical Island Walk* forms a dense matrix of words, recording all aspects of the walker's physical, sensible experience of his walk.

Another good example is *A 118 Mile Walk under the Sky* (1980), which records climatic conditions and the appearance of the sky during the walk. It is printed to form a bank of words, 11 lines with seven phrases each. The words soon lose meaning as one reads, devolving to simple sounds and appearances. This effect is heightened by the lack of specificity in the walk's description and locale. As one reads, the words become confused; one's eyes get lost in their mass, scanning forward and slipping backward. The effect is similar to that of reading concrete poetry. One senses that the best response might be simply to take in the bank as such, without attempting to read each word, just as one looks up at the sky without discerning the margins of each cloud and yet sees everything. The words are abstract in that they give no indication of the walk, except its season and its length. One does not know if each of the 11 lines, and the seven descriptions of the sky given in each line, records a single day's observation of the sky, or if they just represent an appropriate way of organizing the information for display. (In his 1997 book, *Time After Time*, Long heightens the sense of this text's abstraction by printing it in Japanese—texts are sometimes translated for overseas exhibitions, but the decision to print this text in Japanese in a book otherwise in English, printed in Germany, demonstrates an intentional distancing.) As the title suggests, this is a walk "under the sky" rather than over the earth—and so the phrases describing the appearance of the sky operate as a kind of map of that perpetually changing locale.

Although many and diverse artists have made use of maps—from Vermeer to Cornell and Smithson—few have used them as literally as has Long. It is obvious that an artist who, in a career of more than 30 years duration, has worked primarily by walking across the earth, must have need of maps. He first began working with maps toward the end of the 1960s, in such works as *A Ten Mile Walk* (1968) and *Wiltshire* (1969). Like most of his map-texts, these early

texts employed maps produced by the Ordnance Survey. Since then, he has used many different methods to plot his journeys. Speaking very broadly, these various approaches to the map can be divided into two tendencies, which I will discuss as literal and as rhetorical usages.

The older, more literal map-texts have generally included actual fragments of maps used to plot a passage through the landscape. More recently, Long has removed the information on the maps to join words with certain aspects of the landscape, for instance, altitude, outline, or contour (*Wood to Stone*, 1991). I refer to this tendency to remove the actual, literal map from the completed text as rhetorical modes of mapping. Again, one might suggest that the older, more literal maps were made primarily in recording mode, whereas the rhetorical map-texts have more of an establishing function.

In 1990, Long combined a circle of words with an Ordnance Survey map to make *Sound Circle*. He penciled a circle onto a map of Dartmoor Forest, touching its northern extremity, and cut and pasted 120 words around the circle's perimeter. The words, stuck to the map's surface, each record a sound, be it natural ("wind," "pattering rain," "stream"), animal ("bleat," "hoof thump"), human ("not too bad a day"), or mechanical ("aeroplane"). Thus Long plots the aural experience of his walk on a more traditional representation of the countryside, transposing personal and impersonal indices of landscape. The circle becomes a secondary mapping, an account of the walker's experience meshed with the objective facts of altitude, distance, and place.

Long says, "Some walks are with maps and some without." Speaking to Richard Cork, he related that when he walked in the Hoggar Mountains in the Sahara, it was not possible to get good maps, which necessitated an entirely different approach to the walk. "The way I found my way in the Sahara was just by following the places where I could get water, without using a map."[14] Of course, the plan to walk from source to source of water is itself the basis of a kind of map. Similarly, in *Water Way Walk* (1989), Long used water sources to map a 152-mile southward walk in Wales and England. Long has also used his experience of wind as a means to record his passage. In *Wind Line Across England* (1986), he used the wind as a measure of distance traveled. If one reads from left to right across the line of arrows (and in so doing reads from west to east), the first arrow—pointing eastward—would represent the Irish Sea coast's onshore winds, which are soon met a little inland by an offshore breeze. Here, the landscape is mapped entirely abstractly, with no explicit reference to the landforms traverses by the walker.

Long's books have not yet received the attention they are due. Like the recording images and texts, they are usually seen as a transparent medium, a means of knowing his works and walks. On one level, this is what they are, but they are very deliberately constructed, and I believe they can be seen as an art form in their own right. Long suggests that they are a secondary form to the walks and the works, and by extension to the various kinds of text that

they anthologize: "I always say that my task as an artist is to put a stone on the ground, to walk a straight line across a mountainside, to put my hand on the wall with some mud. That really is the making of my art. Making a book is a completely different procedure. I don't deny that part of my work as an artist is making books, but it is very clear to me that there is a fantastic distinction between the art of walking across a mountain and the craft and aesthetics of making a book. And I only made the books because I walked across the mountainside."[15]

Different books are conceived with quite different intentions. I have already mentioned *Countless Stones* and *A Walk Across England,* two books recording single journeys. Long has also designed two major retrospective volumes, Fuchs's *Richard Long* (published for a show at the Guggenheim Museum in New York) and the book accompanying his 1991 Hayward Gallery retrospective, *Richard Long: Walking in Circles.* Both of these books give exhaustive overviews of his oeuvre. This is one obvious way in which Long uses the book as a form. But there is a wide range of other objectives and structuring principles among Long's published books and pamphlets.

Long begins planning his books by working with individual images, testing different combinations and conjunctions, and then making miniature mockups with quick drawings of each page. This allows him to have an overview of the entire book, thereby to establish and direct continuities of place and image, combine individual texts into sequences and passages, and to play with conventions of the book.

Falling roughly within the category of books produced to record single walks are pamphlets such as *From Around a Lake* (1973). This booklet has no words other than the title and the artist's name printed in black ink on the front cover and the colophon on the back outside cover. Within are 19 close-up photographs of leaves, presumably collected "from around a lake" in the course of a walk, printed in color (green) on pure white pages. The specific conjunction of facing pages seems to have been decided visually, since in most cases facing pages exhibit similarities of form; or perhaps the leaflet records a narrative continuity, for example, the leaves are presented in the order in which they were found. The spareness of the layout and the elegant vertical lines of the leaves harmonize to give the pamphlet a restrained beauty.

Different books can have quite distinct moods. For instance, *From Time To Time* (1997) seems more intimate than many of the other books and even feels slightly nostalgic. Several of the texts in it are concerned in some way with time and the passing of time. It begins with *Dartmoor Time*, a text to which I have already alluded, which evokes time in several different ways, from the precise record of "One and a half hours of early morning mist" to the geological time of "climbing over granite 350 million years old on Great Mis Tor" and the historical "skirting the Bronze Age Grimspound." Further on is *Ten Stones*, which brings together two walks separated by the passage of 20 years. Described as taking place on "a long slope of lava dust on a flank of the volcano Hekla" in Iceland, the text reads:

"A line of five stones sent rolling down it in 1974 / a line of five stones sent rolling down it in 1994."[16] Later, one finds two texts in direct dialogue, the more recent walk erasing the earlier. *Granite Line* (1980) and *Granite Line Removed* (1995) are printed on facing pages: the earlier text in a single color, as Long was wont to produce his texts in the past; the more recent text in black and red. The earlier reads: "Scattered along a straight 9 mile line / 223 stones placed on Dartmoor // England 1980"; the later: "Along a straight 9 mile walk on Dartmoor / 223 stones thrown off and scattered away from the walking line // ENGLAND 1995."[17]

The variousness of Richard Long's career, the tremendous diversity within the self-established boundaries of his formal vocabulary, makes it very hard to write concisely and yet do him justice. I have here attempted to provide a comprehensive overview of his work, but fear I have managed only to draw the faintest perimeter.

"All the works…flow in and out of each other."[18] As Long continues to walk, to make his sculptures and his texts, this flow becomes ever more complexly articulated. But his work remains intensely simple in its conception. In *Five Six Pick Up Sticks, Seven Eight Lay Them Straight*, he wrote: "I like common means given the simple twist of art." For all its nuanced variation, his oeuvre is fundamentally about walking, about real stones and simple geometries, about keeping a record. **IT**

Notes

1 Rudi Fuchs, *Richard Long* (New York: Thames & Hudson and the Solomon R. Guggenheim Foundation, 1986), pp. 44–47.

2 Roland Barthes, "From Work to Text," in *The Rustle of Language* (London: Basil Blackwell, 1986), p. 57.

3 This period is well documented in Lucy Lippard, *Six Years: The dematerialization of the art object from 1966 to 1972* (London: Studio Vista, 1973).

4 Ibid., p. 16.

5 Ibid., p. 6.

6 Reprinted in Fuchs, op. cit., p. 236.

7 Ibid.

8 Richard Long and Martina Giezen, *Richard Long in Conversation: Bristol 19.11.1985* (Noordwijk, Holland: MW Press, 1985), p. 8.

9 Ibid., p. 1.

10 An interesting point is that Long maintains an aspect of working with "whatever is to hand" by the fact that he never has stones especially cut. He told Martina Giezen: "The stones I choose are always the stones that I just find in the quarry. Sometimes they may be cut for certain uses…maybe for people to build walls, or maybe they are just thrown away, offcuts." See Long and Giezen, op. cit., p. 9.

11 Long and Giezen, op. cit., p. 8.

12 Reprinted in Fuchs, op. cit., p. 236.

13 Long and Giezen, op. cit., p. 7.

14 Richard Long, *Walking in Circles* (London: Thames & Hudson, 1991), p. 249.

15 Long and Giezen, op. cit., p. 19.

16 The first of these lines of five stones is recorded in the photograph titled *Five Stones* (1974).

17 Though Long assures me it was accidental, it is worth remarking that in *Mountains and Waters, Halfway Stone*, the text "in the middle of the road // in the middle of the walk," appears in the book's center pages—so also "in the middle of the book."

18 Richard Long and Martina Giezen, *Richard Long in Conversation: Part Two* (Noordwijk, Holland: MW Press, 1986), p. 15.

Magdalena Jetelová

by Elaine A. King
2000

The former Czechoslovakia bordered five European nations, and its capital, Prague, served as an urban crossroads into Western Europe. The Czechs have always been both intellectually and culturally astute, participating in a rich international dialogue despite the difficulties they have had throughout this century. Magdalena Jetelová, born in the former Czechoslovakia, remained in Prague until 1985, when she moved to Germany to escape the oppressive cultural climate imposed by autocratic communist policy. Her ideas, though, continue to be shaped by the richness and pain of her native country, where she spent much of her life.

For Czech artists, the late '60s, under the reforms of Alexander Dubček, were liberating. After many years of creative deprivation, a cultural explosion seemed to take place, with exhibitions and periodicals flourishing, providing boundless information about Western art, as well as about Czechoslovak artists and their relationship to an international dialogue. However, this expansive era was cut short by the spring 1968 rebellion and subsequent invasion by Soviet troops. According to Ondrej Hejma: "The art scene split into two trends: the sanctioned official culture that filled state galleries and offices, and the unofficial underground work that rarely saw the light of display...Many painters returned to... 'typical' Czechoslovak artistic traditions: aesthetic forms of Surrealism, Expressionism, and 'nice' Pop art became abundant."[1]

Jetelová, along with an emerging generation of artists and intellectuals, could not buckle under and return to producing "official" art after engaging in a vital international discourse. She and others stood their ground, refused the repressive communist system, and made art only for themselves and not for the state.[2] Despite their adroitness and indomitable stand, these dissidents were set apart from the West in the 1970s—a crucial time when a major shift from the ideals of the modern to the postmodern challenged the existing Modernist canon. During this significant period, the cultural paradigm was transformed—all facets of art production and theoretical analysis mutated. However, the impact of Postmodernism would not directly affect Jetelová until she immigrated to Germany, despite the fact that her work invariably evinced a spirit of paradox, contradiction, and openness to divergent interpretation. Jetelová's distance from the West and its art trends, in retrospect, can perhaps be seen as an advantage that strengthened her aesthetic conviction.

Her lucid comprehension of Postmodernism stems not from textbook knowledge but from a sagacious observation of shifting global culture and its transformations away from a biased Enlightenment model. Philosophy, particularly the ideas of Heidegger, has deeply influenced her thinking. In coping with the restrictive environment in Prague, Jetelová developed a unique idiom devoid of consumer materialism and mainstream art vernacular. She and other

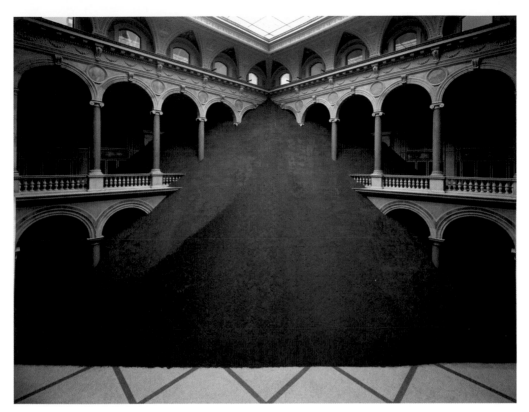

Domestication of a Pyramid, 1992.
Red sand, dimensions variable.
View of installation at the Österreichische Museum für Angewandte Kunst, Vienna.

Czech artists of similar mind produced art from ordinary everyday materials. They constructed work in unconventional exhibition venues—basements, gardens, summer houses, studios, and courtyards of tenement apartments. Forced to make art in alternative spaces, Jetelová responded to the specificity of each new location. She considered the details of each site and integrated her ideas in a systematic manner in order to transform the spatial environment. Frequently she succeeded in dissolving the exterior essence of the original space through her physical treatment of the scene and through the material presence of her construction.

In the 1970s and '80s, Jetelová began shaping the visual language of her architectural sculpture. Acknowledging the principles of Minimalism, she liberated herself from the social and political constraints of "agreeable" art. Her sculptures from 1979 through 1987 are predominately representational: mammoth chairs, looming legs, peculiar stairways leading to infinity, bizarre letters, and fantastic anatomical forms characterize this work, all consisting of brute mate-

rials, precariously balanced structures, and psychologically strained environments. When Jetelová left Prague in 1985, she had already established a reputation for her tireless zeal in creating profound sculpture as well as for her unwavering intellectual stamina. A monumental wood sculpture titled *Chair*, placed to face Prague Castle, formed part of a 1981 site-specific exhibition assembled in the courtyards of houses in the Lesser Quarter by 20 Czech artists. Today, this singular work remains etched in the memory of many who experienced it.

Jetelová's work has grown in expressive power and appearance since her emigration to the West in 1985. As she gained new freedoms and access to new information and opportunities, she gradually discarded representational elements. I first became aware of Jetelová's work at the 1987 Documenta 8, in Kassel, Germany, at which she presented *Determination's Other Side*, a massive construction composed of post and lintel wooden components. The enormous size and scale (385 by 700 by 300 centimeters) of this prehistoric-looking structure not only consumed the Museum Fridericianum's great hall, but also transported the viewer to a Lilliputian consciousness. The peculiar occupancy of this large-scale object transformed and collapsed the monumentality of the exhibition space. In light of the evolution in her work over the past decade, *Determination's Other Side* is pivotal. It confirms a definite shift in Jetelová's production. The sculpture and the interior architectural space became integrated into a site-specific work that implied dislocation and translocation.

In 1987, the Museum of Modern Art, through its Project Room series, first introduced Jetelová's work to the United States. The two works it exhibited, *Boban* and *Crossing*, are closely linked to the Documenta piece, illustrating the artist's focus on space animation and an interest in life's forces and matter. Both sculptures are constructed of rough wood and appear to stretch the boundaries of their original configuration. *Boban*, consisting of six massive raw oak trucks stripped of their bark, hints at being a type of chair. However, this hovering tectonic configuration vacillates between resembling a symbol of domestic life and an absurd biomorphic shape that has artificially grown out of proportion into a type of non-functional architecture. Jetelová views this structure as a tale about the energies and forces of life and matter, and about the mystery of being and not being.

Crossing, a fragile, archaic-looking structure, stands as if it were an attenuated bridge or road. Its oak surface discloses the artist's roughly chiseled marks. Pole-like legs precariously support an expanse of wood. The strange contrasting relation between the massive span and the delicate supports is striking but results in a conflicting statement. One wouldn't dare encroach on this pathway to the unknown.

References to landscape, contradictory forces, medieval architecture, and archaic cultures inform Jetelová's work. However, her ideas are not manifested through narrative representation but through symbolic metaphor and a synthesis with architectural components. She incorporates historical and cultural data about the site and her past into

the installations. This approach has yielded unimaginable, almost impossible spatial environments. Jetelová firmly believes that a viewer's alliance with a newly built structure is influenced by personal history and the site itself, as well as by the ideas of the artist. In 1988, her projects became more complex in their material execution, as she began to incorporate the total surroundings of the location into the newly fabricated construction.

In *Demystification of a Monument*, begun in 1989 (re-created several times through 1991), Jetelová was intent on expanding symbolic language and sculptural inventiveness to conceive an environment of ambiguous illusion. Geometry, technology, and chance unite in a carefully planned but open-ended configuration. This mysterious assemblage calls to mind a ritual place of a primitive culture or a landscape vaguely remembered from a dream. A viewer seeing this site work might choose to associate the wooden post and lintel mass with a monument because of its physicality. But unlike traditional monuments, Jetelová's structures, at this point in her career, neither belonged to the past nor commemorated a person or special event. This mystical structure is intended to be a place for private reflection and not a site of commemoration. Outside the space, one is a detached observer; once inside, however, the viewer becomes a participant, an unidentified character in the realm of the unknown.

The visitor plays a significant role in this sculpture, becoming a silent actor on an unusual stage. A grand wall mural functions as a frame or backdrop for the temple-like setting. Composed of soot and an excerpt from T.S. Eliot repeatedly handwritten across the wall's surface, the work addresses the cyclical notion of time. An intriguing presence is achieved by the black, charred surface and the endless calligraphy that mediates motion and the entropic process of time. The endless litany flowing across the burnt wall is suggestive of ritual chanting: "...time present and time past are both present in time future; time future contains time past."

The issue of time is always at the center of Jetelová's enigmatic architectural projects. An underlying philosophical attitude permeates this work, focusing on humanity's connection to nature, the ephemeral character of experience, the transient quality of human life, and the archaeology of human memory. The power of her internalized thoughts and feelings renders a visual language that stems from a complex process—this conglomeration of data results in a remarkable reality that at times appears absurd.

Jetelová's projects continually demonstrate a far-reaching treatment of space itself. In 1992, she appropriated interior spatial environments and altered their boundaries by marking and sectioning their surfaces. At this point she incorporated laser light into her work by using it as a marking tool. Prominent installations from this period include *Iceland Project* and *Domestication of a Pyramid* (constructed in four sites between 1992 and 1994: Österreichische Museum für Angewandte Kunst, Vienna; National Gallery of Contemporary Art Zachenta, Warsaw, Poland; Martin-Gropius-Bau, Berlin and Rottweie, Germany).

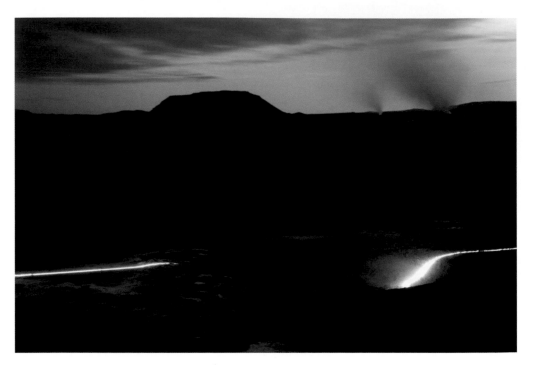

Iceland Project, 1992.
Site-specific work in Iceland.

Jetelová became fascinated by a 15,000-kilometer-long mountain range known as the Mid-Atlantic Ridge in the sum-
mer of 1992. Mostly submerged under the Atlantic Ocean, this ridgeline spans the globe and marks the geological rift
that separates the North American and Eurasian Plates in the North Atlantic, and the South American and African
Plates in the South Atlantic. In Iceland, the Mid-Atlantic Ridge rises above sea level, creating a landscape of lava
flows, geothermal fields, and crater lakes where the ongoing effects of plate tectonics are made visible. After a detailed
geological analysis of Iceland's terrain, Jetelová, together with a team of workers, developed a concept to depict
this dividing line; using laser light, she drew a luminous stripe across Iceland's desolate, craggy landscape. Fourteen
photographs illustrate the course of this translocation borderline. These photo-documents hung side by side to re-
create a panoramic image of this mammoth illusory project. Although *Iceland Project* was produced in 1992, it shares
a kindred vitality with the Post-Minimalist work of Walter de Maria and Christo.

In *Domestication of a Pyramid*, Jetelová entered into an investigation of distinctive architectural sites and incorpo-
rated within each an essence of antiquity's ultimate mysterious emblem, the pyramid. The pyramid (Western civiliza-
tion's classic symbol of power and advanced technology) provided Jetelová with a challenging framework
to amplify her exploration of installation art and spatial location. In each building where she fabricated the dramatic

sculpture, composed of only one side of an imaginary pyramid, she had to reconstruct the form and take into consideration the perspective of the viewer as he or she would traverse the new construction within the distinct details of the architectural interior. Viewers, on the other hand, not only had to grapple with their perceptions of familiar surroundings and their history, but also had to reflect on a new spatial dimension resulting from the architecture's transformation. Frequently, stairways, halls, and passageways were totally blocked or modified by mountains of sand or lava ash.

The successful completion of this widespread, multi-part project led Jetelová to push her investigations into even more complicated structural territories. Two arduously analytical installations that signify another point of departure in her work were produced between 1994 and 1996. Both installations, *Translocation* (1994), housed in the Kunstverein Hannover, and *Translocation II* (1996), produced at the Institut Mathildenhöhe in Darmstadt, represent a dialogue with architectural institutional space and the intertwining of intention, experience, site, sound, and time. In each site, a monumental holistic appropriation of a building took place, achieving a reordering of structure and space.

Within each interior, Jetelová re-created a replica of the structural space with all of its boundaries, turns, and passageways. Essentially, she produced a simulated veneer that corresponded to the actual physical interior of each institution. In a postmodern sense, she appropriated the original architecture to produce a hybrid sculpture, but one that is married to the primary structure. The original and simulated structures would meet at convergent spatial points. This integration of architecture and sculpture was so complete that a viewer could not perceptually separate the harmonious blending of the original walls and the newly constructed inserts. Visitors could only experience these works when they had traversed the boundaries and openings existing in a pure white setting. The organization and execution of *Translocation II* was a more challenging and difficult endeavor because of the Jugendstil architecture of the Institut Mathildenhöhe and its vaulted glass roofs. Often because of the structural configuration of the modified architectural setting, viewers could hear the echo of their footsteps as they entered sections of the space, a futuristic sensation.

The 50th anniversary of the erection of German bunkers along the Atlantic Coast from Spain to Norway was observed in 1994. This year also marked the 25th anniversary of the publication of *Bunker Archaeology*, by the French philosopher Paul Virilio, in which he presents a philosophy of military space. Both the remains of the Atlantic Wall in Jutland and Virilio's inquiry became the inspiration for Jetelová's *Atlantic Wall* project. During a 1995 visit to Jutland, she became impressed by the power of nature, over a span of 50 years, to reduce these enormous monuments to crumbling ruins. Because of the region's powerful tides and the mammoth structures' lack of a firm foundation, water continuously eroded their massive presence. The notion of time passing and architecture's complex connective relationship with time past, present, and future inspired Jetelová to produce a project that integrated the

past with the present. The process of laser projection and her appropriation of Virilio's text allowed for a synthesis of the ethereal and the physical—a debate between the intellectual and the existing disintegrating structures. The light script placed on a diagonal across each bunker's surface created a new reality that contradicted the Nazi intent of these fortified war monuments. Through her photographic documentation of the new conglomerate fabrication, Jetelová transformed a military strategy into a sublime actuality.

Prior to *Dislocation* (1996), humor had not been an element in Jetelová's site work; however, in this project, produced at the Museu d'Art Contemporani de Barcelona, it is a vital element, despite the seriousness of the artist's reason for altering the surface structure of Richard Meier's familiar architecture. Jetelová's project attempted to contextualize the unapproachable, fortress-like character of Meier's Postmodernist architecture within its neighborhood setting. She chose an appropriately Postmodernist approach, engaging in architectural deconstruction. Instead of building a new installation, she appropriated Meier's signature white panels and placed them in specific spots around the community, as well as in and around the museum. Unlike many politically motivated deconstructionist artists, whose work is all intent and too subtle to have an impact, Jetelová's physical displacement packed a powerful punch. The strange positioning of tile clusters bordered on the absurd.

Translocation (1999), a time-based installation, is Jetelová's newest work. Its underlying theoretical construct represents an anomaly among her monuments. Here, the psycho-physiological intensity of the work is not only general evidence of the perception of location, space, and time. The work was designed to commemorate the spirit of a specific individual: Jill W. Watson, who perished in TWA Flight 800 (July 17, 1996). Watson was an alumna of Carnegie Mellon University, an architect who had returned to the College of Fine Arts to pursue an MFA in sculpture. Watson's life came to a premature end at the onset of a trip she was making to Paris to study public space and urban lighting.

In the spring of 1999, Jetelová was awarded the first WATS:ON Festival transdisciplinary award for her extraordinary artistic achievement. She was invited to construct a site installation on the Carnegie Mellon campus that would celebrate the inventive spirit of Jill Watson, also an interdisciplinary thinker and artist who aspired to use her knowledge of art and architecture to better the world. Jetelová welcomed the challenge of this commission and produced a piece that transgresses the immediate moment or boundary of place, even as it memorializes a particular person.

Translocation is hardly noticeable except for a metal frame that outlines the borders of the distinct site. This rectangular subterranean spot is situated on the lawn not far from the Hornsbostel Building of the College of Fine Arts. It consists of two interior spaces linked analytically to Jetelová's earlier translocation projects. The existing space is sectioned to signify two rooms, measuring approximately 20 by 8 feet and painted white)—one marks day and the other night. The time of day and the viewer's position affect the optical experience of the installation. In day-

light, both rooms are visible; at night, it appears as if one space has disappeared. The illusion is achieved through the incorporation of a sophisticated lighting system designed to emphasize architectural and spatial qualities. The radiating blue glow emanating from the ground adds to the charm and conundrum. We can neither see the whole piece from one vantage point nor enter the sealed glass container; we are only allowed to move around the exterior of the site in order to inspect its interior space. A portion of the interior is always visually blocked. The interior space, confined by a transparent glass sheet, can be perceived only from a birds-eye perspective.

When one looks down into the ground, one observes an illusory architectural antechamber—these minimal rooms were inspired by Jill Watson's office. They are divided by a diagonal wall that slices across the entire space. The interiors have deliberately been set at an angle 15 degrees "from true," in carpenter's parlance. If we could step down inside and stand there for a moment, we would realize that nowhere inside this dream-like chamber is it possible to stand fully erect or feel secure. Jetelová's use of angular dissection enhances one's physical awareness of the incline and induces a sensation of falling. In her lecture about the angular construction of the site, Jetelová explained that the awkward angular construction is deliberate, because Jill Watson disappeared into space.

Why is this piece so inviting in its silent purity? Perhaps because of its situation and the air of mystery pervading the site. At first glance, the work appears to resemble a grave; on closer examination, one is surprised to discover the two rooms built into the ground. Jetelová said, "We stand in present time, but time past and time future inform this installation." For the Carnegie Mellon version of *Translocation*, Jetelová received assistance from technical director Bob Johnson of Fine Art Handling and from Arthur Lubetz Architects and Associates. This installation is the first station in a two-part series—the second will be built in France, its coordinates changed to correspond to its Paris location. The artist hopes that a conversation will ensue between the viewer, this structure, and the site.

In each specific project, Jetelová moves further away from a fantastic realist base toward a conceptual exploration of space. Much of the new work denotes a metaphoric sensibility influenced by the legacy of Jetelová's own historical past and an acute sensitivity to place, space, and time. In a recent conversation, Jetelová remarked: "I am an international citizen...Once you leave the country of your birth, you begin to see places and things very differently...My art takes me to many nations and I have meaningful friends living throughout the world. The work is not about a single issue or social problem—it is intended to be transnational and open to multiple references."

Her eclectic assemblages connote a dialogue involving art, architecture, and space, as well as form and strategy. Implicitly, Jetelová focuses on existential concerns and human perception as she explores the meaning of space. Mystery, truth, alienation, isolation, and identification appear to be subjects in her art. Moreover, the process of the artwork's making is an integral part of the installation's outcome.

Most public artists work within an interactive and collaborative bureaucratic system and must submit their vision to a team of professionals ranging from architects, city planners, real estate developers, engineers, and community officials, but Jetelová's artistic production thus far remains outside that paradigm. Magdalena Jetelová is perhaps one of the most inventive sculptors of our era—a person who is not afraid to produce her particular brand of art. **EAK**

Notes

[1] Ondrej Hejma, "Czechoslovak Theater of the Absurd" (After the Revolution: Art in Eastern Europe), *Artnews* (May 1990): 173.

[2] See my essay, "Hermitage, Quiescence & Enigma," in the booklet, "Magdalena Jetelová," published by the Carnegie Mellon Art Gallery, March 1991.

Tadaaki Kuwayama

by Robert C. Morgan
2000

It is refreshing to know that there are artists working today who are not seduced by the allure of popular culture, who are willing to step back from the banalities of everyday life and see art in its own terms through its own visual syntax and within the terms of its own space. I am not referring to what the French Nabis called "art for art's sake" nearly a century ago. Nor am I advocating an approach equivalent to the formalist movement in American painting during the peak of high Modernism in the '60s. What is indeed unique about Tadaaki Kuwayama's art is a certain boldness in coming to terms with a new paradigm that exists outside the domain of popular culture. While the American Minimalists provide a clear antecedent, there is a question as to whether this is the proper or even the most appropriate term to describe the work of Kuwayama. While one cannot deny that Minimalism has had an effect on changing the direction of art in recent years, or disregard the fact that Kuwayama's reductive position is obliquely tied to that history, it should be clear that not all art that carries a reductive posture is Minimalist.

Although Kuwayama began his career as a painter—in fact, a reductive painter—in the late '50s in New York (where he eventually exhibited at the famous Green Gallery), it is important to examine the development of his work for what it is. His relationship to the frontal surface, for example, is distinct from what defined many of the ideas inherent in Minimalism. The inappropriate term "minimal painting" has been persistently used, in both gallery and museum exhibitions, as a means of identifying a kind of painting that might better be called "reductive." From this perspective, one might consider the "non-relational" paintings of Barnett Newman as having had an influence on the early paintings of Frank Stella and Brice Marden, not to mention on the early work of Kuwayama, whereas the late "black paintings" of Ad Reinhardt seem less conducive to painterly influences than to works by early Minimal and conceptual artists, including Donald Judd, Carl Andre, Lawrence Weiner, and Joseph Kosuth.

Even so, there are those who will insist that the obsession with the frontal surface is primarily about the object or the transformation of surface into object. This evolution toward objecthood through the frontal surface of painting finds antecedents in works by the Constructivist Alexander Rodchenko and later in the monochromes of the Nouveau Réaliste Yves Klein. Although their efforts were made nearly 40 years apart, there is a clear direction toward reductive painting that has little to do with the Minimalist object. Engaging in a reductive posture, whether on the frontal surface or in object form, may proceed from very different and diverse intentions. For an artist to work reductively does not automatically imply Minimalist art any more than an artist with a good idea should imply conceptual art. I would argue that Kuwayama is an artist who evolved from a reductivist position, though his work has often, if mistakenly, been called Minimalist.

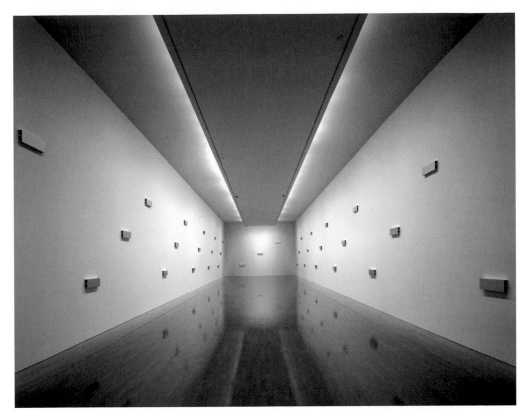

Installation at the Kitakyushu Museum, Japan, 1999.
Anodized aluminum with yellow, blue, and aluminum color, each element 8 x 24 x 2.5 in.

In 1967, Kuwayama painted a series of monochrome panels, placed vertically in frames and tangential to one another, with titles such as *Red, Mustard Yellow,* and *Pale Blue.* The important feature of these works was that the color was directly painted on canvas and therefore still contained within the fictionalized space of the painterly field. Their subject matter is as reduced as that of Newman's *Vir Heroicus Sublimus* or the *Untitled* white panels of Rauschenberg—both of which were painted in 1951 and therefore could be cited as antecedents of the vertical monochromes of Kuwayama, painted six years later.

Whereas painting retains the space of fiction, no matter how constructive or reductive, Minimalism is essentially about the object—a point established by Donald Judd. Once art leaves the fictional space of the surface without necessarily becoming sculpture (in the "relational" sense of diverse parts in search of a formal resolution), and if it retains a position of reductive neutrality in object form, usually fabricated, then we can talk about Minimalism.

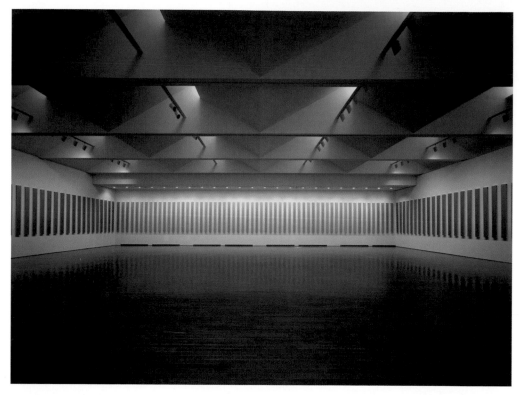

Installation at the Kawamura Memorial Museum, Japan, 1996.
Metallic pink and yellow on Bakelite, 136 pieces, 8 ft. high.

While the method that supports this position may be a type of linguistic formalism (unrelated to Greenberg's aesthetic formalism), the result is perpetually directly related to form—more specifically, the form of the object within a given context.[1] The more recent modular work of Kuwayama is distinguished by its forms (panels or linear elements), which are designed not so much to intercede within a given space as to create a new space through modular equivalence and repetition. In doing so, a reversal begins to happen whereby the emphasis is no longer given to the forms themselves but to the total space they inhabit. It is here that the viewer may begin to embark on another approach. Instead of focusing attention on the formal elements in order to create some sort of dialectical encounter with the space, the forms (as in the artist's recurrent use of color-tinted Bakelite panels) visually recede into the space. Having been altered through the placement of the panels, the recession of the forms into the space reaches a point that the artist calls "infinity"—a space without beginning or end, a "pure" space. In essence, the form(s) disappear and create space.

As a theoretical comparison, this is different from the large-scale steel sculpture of Richard Serra. Whereas Serra (whom the critic Robert Pincus-Witten once termed a "Postminimalist") is concerned with site-specificity,

his weathering steel plates are still within the context of sculpture. Serra's work is pragmatic in its confrontational value. It offers itself as an intervention in everyday time and space. Kuwayama's approach goes in another direction. Instead of insisting on his work as "sculpture," Kuwayama transforms the space through the repetition of modular elements and thereby offers a completely new syntax to the way a space is normally perceived, both physically and conceptually. This was made evident in his recent site-specific installations at the Chiba City and Kawamura Memorial Museums in Japan in 1996. Although different elements were employed in each case, using different sizes and modular shapes, fabricated in synthetic Bakelite or constructed in Mylar, glass, and aluminum, the emphasis was not on the sculpture but on the transformation of the space through the use of modular elements and the concept of disappearance in relation to the repetition and placement of the elements. In a Kuwayama installation, the space becomes the object through this process of reversal. The materials are simply the vehicles to make a passage into the reality of a new kind of space, to bring space into being—which is close to the practice of the great 15th-century Japanese landscape painter Sesshu.

Kuwayama likes to refer to this kind of space as "absolute," as if there were no beginning or no end, as if the transference into time were an entry into the moment, and the moment would be absolute, unequivocal, unremitting in its perceptual sense of wholeness, its gestalt. There is a "purity" here that again recalls the unwavering commitment often attributed to Ad Reinhardt. One of the most lucid articulations of this concept in relation to Kuwayama has been written by the Japanese critic Koji Taki: "Pure space may seem very different from the actual space in which we live, but this purity stimulates our imagination. Purity means more than mere simplification. And we are made to leap into this pure space, carrying our load of complexity, moving beyond the real world with the freedom of the imagination. We do not see a world which is breaking down, a world going to ruin, a world full of amorphous human passion, or a world of simple beauty. Rather we see a world which appears beyond human perceptions, beyond settled and familiar meanings, a world which horrifies and thrills our spirit. We experience simultaneous terror and ecstasy transcending reality."[2]

This "pure space" is the space of the imagination made real—without interference, without temporal intrusions. One could argue that Taki's description of pure space is close to Minimal art—specifically the light installations of Dan Flavin, the stacks of Donald Judd, the elevated grid structures of Sol LeWitt, the alloy planes of Carl Andre. It might even apply to the "white" paintings of Robert Ryman (although given his concern for the framing edge, Ryman could not be considered a Minimalist). But there are other factors (previously described) that distinguish Kuwayama's recent installation from the work of these artists, both formally and conceptually. The concern here is how to deal with the isolation of a pure space—a space that is somehow exempt from the flow of history, that is entirely within the realm of the imagination, a space somewhere between phenomenological Neoplatonism and Sesshu's "marvelous void."

The theologian Paul Tillich once spoke of "the space of tragedy" as a condition in which the historical sense of time is lost. In his book *Theology of Culture*, he refers to the Greek tragedies as events conceived in a space that is removed from diurnal processes: "Human existence under the predominance of space is tragic. Greek tragedy and philosophy knew about this. They knew that the Olympic gods were gods of space, one beside the other, one struggling with the other. Even Zeus was only the first of many equals, and hence subject, together with man and other gods, to the tragic law of genesis and decay. Greek tragedy, philosophy, and art were wrestling with the tragic law of our spatial existence. They were seeking for an immovable being beyond the circle of genesis and decay, greatness and self-destruction, something beyond tragedy."[3]

Somehow Tillich's concept of spatial dominance seems too overtly Western in its interpretation, too laden with the cultural weight of the past, and therefore exempt from the possibility that space exists as a reversal of form in relation to time. As a visual antidote to Tillich's theology, Kuwayama offers a reversal of form through the abstraction of the measured interval, a rhythmic punctuation that lightens the effect of the physical space. The premise of spatial dominance is suddenly transformed into a recession of form, thereby permitting a meditative pure space to evolve into the viewer's consciousness as an intentional act. We see it, for example, in the artist's recent anodized aluminum panels (what he calls "channels") in which two channels, measuring 19 centimeters are jointed and alternate according to two chosen colors. We see it again in the Kozo paper works in which three layers of paper are laminated through the artist's wax-pressing technique. Using modular elements in a repeatable format, Kuwayama places a single horizontal pencil line in each of six units, alternating three times between blue and red.

Given Moholy-Nagy's cultural synthesis of space and time into a single space/time based on his own research and experimentation in visual perception and relative motion, it would appear that Tillich's view of culture is more related to a single linear view of time that is essentially pre-relativistic. This is not to dismiss Tillich's understanding of spatial predominance as a cultural force capable of usurping history in favor of mythology. An abundance of spectacles supports Tillich's view, based on the current fascination for visual art that echoes the vapid premises of pop culture. Ironically, it is within the realm of globalized pop culture that the mythological references to the mass media are strongest, not in the reductive art of Kuwayama. Simply stated, the tragic sense of space in Western history—which is slowly becoming a history of media—should not be confused with the concept of pure space in Eastern culture which tends toward a deeper spiritual understanding of reality. It is this latter reality that concerns Kuwayama. It is a reality removed from the everyday media and all the material consequences that it entails.

One could make the claim that the kind of pure space advocated by Kuwayama is not so much a tragic space as it is an evocation, an opening or a threshold, that allows for a moment or moments of elevation beyond the banalities that pull us down into the gravity of our existential reality or even the denial of that reality. Kuwayama has

described the desired effect of his art as being "something not of this world," in other words, transcending what we already know through the mass media and through the tragic events that surround us. He is not concerned with making an expression or with signifying a social truth or with offering a new global paradigm for art. Fundamentally, Kuwayama is interested in the kind of rarefied experience that can be obtained through his form of total art. What he describes as "something not of this world" is indeed a perception of infinity, a rare glimpse of something to which human beings have not yet been acculturated. One might call it science fiction, but this is too facile. It is not science fiction.

I like the concept of the Noh actor described by Nobuyuki Hiromoto, *riken no ken*.[4] As I understand Hiromoto, who cites the work of Zeami, one of the great practitioners of Noh theater, *riken no ken* is the method by which the actor looks at himself by using his internalized outer image. This concept may seem close to the Western "gestalt," but it goes beyond the Western analysis of perception. Kuwayama's art is fundamentally concerned with the act of perception—indeed, the viewer's experience—through the reversal of form into space, whereby the material focus is transformed into an arena of pure space. This is far removed from the pragmatic objecthood of Minimalism. Yet, at the same time, Kuwayama does not deny the essential materiality of his work. Rather, he is concerned with how the act of perceiving this materiality as a modular sequence of forms gives us the exacting quietude of a spiritual experience. **RCM**

Notes

1 The distinction between aesthetic and linguistic formalism is analyzed and discussed in my essay,
 "Formalism as a Transgressive Device," *Arts* (December 1989).

2 Koji Taki, "Tadaaki Kuwayama's New Project," in *Tadaaki Kuwayama Project '96*, co-published in conjunction with
 exhibitions at the Kawamura Memorial Museum of Art (June 1–July 21, 1996) and the Chiba City Museum of Art
 (June 15–August 18, 1996), p. 54.

3 Paul Tillich, *Theology of Culture* (New York: Oxford University Press, 1964), p. 33.

4 Nobuyuki Hiromoto, "Objective Space: Looking Forward to Project '96," in *Tadaaki Kuwayama Project '96*, op. cit., p. 61.

Regina Frank

by Cathy Byrd
2001

Whether bathed in blue light in a darkened room or enclosed in a glass-fronted display, German installation and performance artist Regina Frank seeks ways to humanize our digital universe. Her meditative, often interactive performances sculpt space, sometimes creating physical objects that document the temporal relationship between virtual and real experience. "I've developed strategies of deceleration and reduction to give the participant/perceiver a taste of silence within a tumultuous world of acceleration and economic performance," says Frank.

In *Inner Networks*, at the 1999 Digital Arts and Culture conference at the Georgia Institute of Technology in Atlanta, she involved viewers in a 45-minute performance: "My goal was to be interwoven, entangled with the stage. When I invited the audience to participate, I wanted to connect them with the stage, too." For that direct interaction, Frank was seated with a computer on a round dais shrouded in white tulle, a wall-sized screen behind her. In the darkened room, she communicated with the audience through voice and keyboard. Her words, repeated by the computer and projected on the screen as a running text, contemplated the notion of "being." As Frank reframed the question, "Who am I?" seven spectator/performers began to spin a web of colored threads around her seated figure. The threads wound out into the audience, where members tightened the filaments until the artist became trapped. In the end, as she released herself, her voice cut through a deep silence, urging listeners to "restart...rethink...reinitialize."

At the Venice Biennale's Italian Pavilion in the Spazio Oreste, on October 23, 1999, the same performance elicited a different response. In Atlanta, her motions were freer, allowing Frank to mediate between technology and the audience. In Italy, viewers who understood less of her English-language dialogue responded directly to her mood and movement. They became more emotional, spinning her closer and tighter.

The computer served as a sculptural element as well as an actor or agent in the performance. Along with a digital speech program, *Inner Networks* used software that Frank had developed to produce *Monk@Sea—Encoding the Present*, a 1998 interactive digital performance. She collaborated on that CD-ROM project with Keith Roberson of Florida State University. Finding its inspiration in a 19th-century seascape painted by Caspar David Friedrich, *Monk@Sea* proposes a less personal opportunity for the viewer to direct Frank's movements.

On a wall-sized projection, she stands at the edge of the ocean. Her voice repeatedly implores the viewer to write to her on a keyboard nearby. As prompted by keyed words and symbols, she is gradually wrapped in a slender fibrous

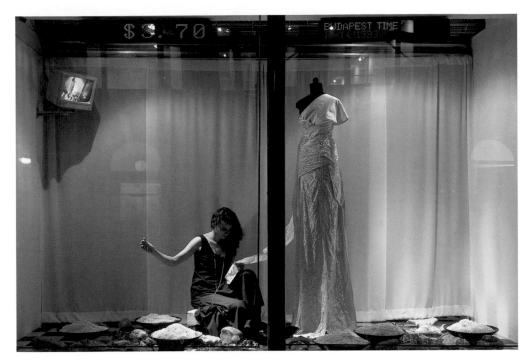

L'Adieu—Pearls Before Gods, 1993.
Performance/installation in the window of the New Museum of Contemporary Art, New York.
Frank sewed pearls onto a white silk gown, receiving 28 different wages paid to seamstresses around the world.

band of Morse code until her torso and legs are completely bound. Continued communications succeed in untangling her figure. At once audience and director of her synthetic performance, the viewer reclaims the artist's narrative as an individual creation.

Frank staged a more immediate interactive work in Atlanta in 1997, where she inhabited *The Glass Bead Game* for seven hours a day over two months. Behind a clear glass wall, she used a small computer to receive messages from visitors, as well as Internet contacts from Australia, England, France, Germany, Greece, India, Japan, and Russia. A special computer program transformed the written notes into virtual beads and sent them to her. For each bead she received, Frank stitched real beads onto a paper kimono that hung in the space. In *The Glass Bead Game*, she became both the medium and the message in a symbolic visual conversation.

Catching and releasing the pressure building in our present-day techno-culture, Frank manipulates the digital in a way that reminds us of our humanity and our temporality. To achieve this, Frank exploits dramatic time by repeating real-life tasks with an inward focus. At the same time, she reflects on our increasing tendency to forge virtual relationships, and she shows how to create a context that may authenticate and give meaning to new forms of interaction.

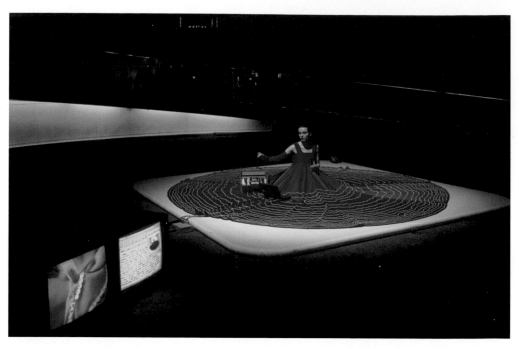

Hermes' Mistress, 1994–99.
View of performance/installation in which Frank embroidered favorite texts, found on the Internet, in Atlas silk.
Performances began in New York and ended in Tokyo.

Frank has engaged in a spectrum of conversations with her audience over the past 10 years. In a number of projects, sewing was her metaphor for digital networking; constructed dress objects stood for Frank herself. Always made of flowing silk, the dress-as-façade retained its classical dialectic function—leading the eye toward an object (woman), while marking the artist's physical and spiritual boundary.

Her practice of a once-common domestic art, combined with the manipulation of technology and the dress form, has countered many universal preconceptions about women and women's work, but Frank's work is not without its own internal contradictions. While she has embraced technology, she compares its mediated encroachment on culture to "moths eating up our clothing." As a cure for malaise in an increasingly indifferent world, she constantly interjects her physical presence.

In certain earlier works, Frank focused less on interaction than on theatricality to illustrate the permeable membrane between art and technology. She became *Hermes' Mistress* at Exit Art/The First World in 1994. For 35 days she wore and slept under a red silk dress with an enormous circular skirt. *Hermes' Mistress* was a seductive performance:

Frank's scarlet frock, red-lacquered nails, and ruby lips conspired to discount the monotony of the data she was processing. The artist sat with her laptop downloading text transmissions from the Internet and "rewrote" them, letter by letter, stitching words to her skirt in a spiral of alphabet beads. She personalized the impersonal by deliberately selecting and saving messages that were important to her. Calmly considering the ceaseless flood of knowledge that came to her through cyberspace, Frank took time to think.

Spending hours and days in public to actualize a concept is not new. In some ways, Frank's stagings have echoed Joseph Beuys's live-in performance pieces of the 1960s. Both Beuys and Frank engage tactile personal metaphors. Like his *Coyote* project, her tests of endurance have spanned weeks.

Although her repetitive visualizations may be considered a nostalgic requiem to real intimacy, their techno-twist permits Frank to demonstrate the possibility that we might integrate the self into an increasingly mediated reality. Inside her performances, her body becomes a lyrical sculpture that relies on the audience to be fully realized. Even in her more remote computer-based works, she means to dissolve viewer/performer boundaries. Outside the glass box, the wrapping and weaving motions that she elicited from the audience in *Inner Networks*, for example, literally connected them with her and her ideas.

In 1999, Frank created *The Mushroom Dress*, her most organic work to date, for Kunsttage-Dreieich, in Frankfurt, Germany. On a bed of straw covered by a large full-skirted ball gown made of jute and tulle, the artist poured a mushroom substrate. She watered the dress and clipped holes in it to release the sprouting fungi. As she tended the mushrooms over two weeks, they grew into cabbage-like blooms. "For the first time in my life, I made something that I couldn't control. I had to pray for weather, to water and take care of the dress, so the mushrooms would grow. The dress played the game and it was wonderful." At the Kunsttage opening, and for weeks after, Frank harvested the mushrooms and cooked them outdoors for passersby. Symbolically, the act of imbibing the mushrooms implied that the viewer/participant internalized Frank's aesthetic. The artist transmuted the notion of nature versus culture by nurturing a sculptural encounter. Frank insinuated nature into her concept of self (the dress), then shared that fragile revelation with her spectators.

Another environment-based performance, *Formen des Seins*, or *Forms of Being*, took place in summer 2000 at the Akademie Tutzing in Germany. Frank staged the two-phase *Formen* inside a round performance space and outdoors at the edge of Starnberger See. Indoors, she slowly shifted from a lotus position into fluid movements that grew from her visual communion with a wall-sized video projection and tonal music. The video replicated the lake environment and echoed the artist's breathing in its measured rise and fall. Her simultaneously spoken words meditated on the life of water and air.

In *Formen*, remembers Frank, "Da wo es herkommt geht es auch wieder hin." ("Everything returns from whence it came.") As the wall image followed a cloud moving from one side of the room to the other, the artist led viewers outside, where she repeated the performance with real water from the lake, then walked into the water and swam away.

Last year, at the International Expo 2000 in Hannover, Germany, Frank reinterpreted her 1993 dress project, *L'Adieu: Pearls Before Gods*. Making a feminist statement, she had lived in a windowfront of the New Museum of Contemporary Art for 28 days, sewing pearls by hand onto a white silk gown. A digital monitor above her projected the dollar amount of wages she might have earned per day for the same work in different countries around the world. As Richard Vine says, "One could not help but feel a certain queasy complicity, an illicit enjoyment (inseparable from a simultaneous moral revulsion)...Thus does the reality of economic exploitation, with its subliminal erotic charge, become a consciously lived, and deeply felt, experience. We can no longer, as First World consumers, deny that we are the beneficiaries of a masochistic process which is usually hidden—in other nations, behind factory walls—but which Frank's performance makes compellingly present."[1]

A vitrine in the Pavilion of the International Women's University was the venue for *Performance & Performance*. Frank's expo project employed CQG software by Trading House Net—a brokerage firm for day traders. Involving the stock market meant an irregular, sometimes staccato, tempo for her two performances at the event (one eight-hour and another 10-hour performance). In a graph projected on a scrim behind her, the figures of rising and falling stocks became the curves of stitched lines in red and green. If the stock was rising, the artist stitched her dress to the screen with green thread. If a price fell, she took up a red thread to attach herself to the matrix. Explains Frank, "The performance was about the connection between our life and the virtual life of the stock market, and how we become economically tangled in the process."

An upcoming project reveals Frank's ongoing attraction to contemporary issues. She is organizing "Digital Senses," an exhibition to debut at the Spoleto Festival in Charleston, South Carolina, in June 2001. Presented by the Charleston Center for Contemporary Art, the exhibition will also travel to Hamburg and Venice in autumn 2001 and spring 2002. Frank has sought out a group of international artists to examine the present technological limits and extensions of photography, painting, and drawing. She intends for their work to illustrate how computer-generated chance and calculations have come to affect the creation of art.

As both artist and curator, Frank relates language, the body, and technology in a way that binds analog to digital and past to present tense. Interestingly, some of her most recent work—*The Mushroom Dress, Formen*—bend away from techno-science, revealing a growing desire to connect her art with a less complicated environmental theater. While the world's fast-lane viewers might become impatient with the laborious intensity of her long performances

and slow-growing sculptures, some may well be soothed by the studied repetition and the determined balance of motion and stillness. Played out in the ironic context of a world constrained by infinitely "liberating" cyberwebs, there is sensitive wisdom in the tightening and releasing of tension implicit in the work of Regina Frank. **CB**

Notes

1 Richard Vine, "Mystic Threads," in *Regina Frank: The Artist is Present (Performances 1992–1999)* (Berlin: Druck Vogt GmbH, 1999), p. 8.

Olafur Eliasson

by Jane Ingram Allen

2001

Olafur Eliasson puts the viewer first in his work. He states, "I always begin work from the point of view of a spectator…This is important to make sure that the piece doesn't become more important than the people looking at it. Because the work is really nothing. It is only interesting at a specific time, in a specific place, with a specific spectator."[1] Eliasson respects viewers and lets them create their own art experience. He controls that experience somewhat by the materials, props, and gadgets he provides, but his work depends almost entirely on the physical, mental, and emotional contribution the viewer is willing to make.

Eliasson asks a lot of his viewers. He makes use of light, air, water, fire, rather simple machinery, and minimal materials to create sensory experiences. A feeling that the artist did nothing extraordinary may arise if the viewer is rushed or approaches Eliasson's work with the usual gallery marathon attitude of seeing as much as possible in the shortest amount of time. The viewer must be willing to stay awhile, hopefully alone in the space without distractions. This slow contemplative process of viewing is rewarded by a special sort of "aha" experience and a realization of your own position in time and space. Eliasson has said that he wants viewers to "see [themselves] seeing." You begin to feel your own effect on the surroundings, and the surroundings have an impact on you. It's easy to figure out how Eliasson creates his sensory experiences; his simple machinery is plainly exposed for everyone to see. The real power of his work lies in what the object does to you and the interchange between you and the object. As Eliasson puts it, "I think that the subject has an impact on the object, and vice versa, the object has an impact on the subject."

Eliasson's first one-person exhibition in an American museum was held at the Institute of Contemporary Art in Boston in 2001. The exhibition contained seven works, each inhabiting its own separate space on several levels of the museum building. Eliasson's title for the show "Your only real thing is time," is at first a bit puzzling. It follows a recent article in a popular science magazine that details physicist Julian Barbour's new theory of time, which argues that every moment past, present, and future exists simultaneously—there is only now and "time" does not exist.[2] In the catalogue interview Eliasson explains, "The sense of time that I work with is the idea of a 'now'…There is only a 'now'…our belief in time is just a construct." It seems that Eliasson is right in tune with the newest science. His ephemeral work, with its dependence on the viewer's perception in that particular moment, emphasizes the concept of "now" as the only reality.

Two new site-specific pieces were created for the ICA's eccentric building, a converted fire station. Both were eye-catching technical feats of construction. *Neon Ripple* addressed one of the unique features of the building, a spiraling

Neon Ripple, 2000.
Neon, water, scaffolding, and wood, installation view.

staircase. Eliasson called attention to this staircase by erecting a new floor right on top of it between the existing floors. On this new floor he installed a black pool, filling it with water over which hung a neon light made up of concentric circles. The light flashed onto the reflective surface in successively larger rings, simulating the effect of ripples caused by throwing a stone in a pool, repeating this pattern over and over again. There was a slight feeling of danger here. The pool was level with the rest of the floor and had no barrier. It was so still that it appeared to be highly polished black stone, and the viewer might have easily stepped into it, unaware that it was water. Coming up the stairs and seeing the underside of this construction, the massive beams and large C-clamps holding things together, was a powerful experience.

The element of danger was especially strong in the basement gallery, where Eliasson installed *No nights in summer, no days in winter* (1994). This "Ring of Fire" consists of a metal ring with gas jets emitting flames reaching out from the wall toward the viewer. It too was unprotected, and heat emanated through the expansive darkened room. The warmth was especially noticeable on a cold winter day. The sensory experience was strong, visually and tactilely. It is rare that an artwork provides actual physical warmth.

360-degree expectation, 2001.
Halogen bulb and lighthouse lens, installation view.

Another example of the object affecting the viewer was the "breathing" wall work, *convex/concave* (1995–2000), situated near the exhibition's entrance. This sculpture at first appears to be a Minimalist square of mirror-like material suspended slightly away from the wall, with a loud motor attached. After standing there puzzled for awhile, the viewer realizes that the Mylar surface of the piece subtly changes from convex to concave and back again as the machine pumps air. The picture is breathing, and the spectator soon matches his breath to the same rhythm. This piece exemplifies Eliasson's mysterious power in joining technological machines and natural phenomena. His works are created with very simple means and are neither alienating nor intimidating. Eliasson somehow reverses our usual subject-perceiving-object way of looking at art.

In *360-degree expectation*, Eliasson created a round room that enclosed the viewer within circular walls. This new piece made for the ICA galleries also involved lots of exposed construction work. A halogen lamp and lighthouse lens hung in the center of the space to project a horizontal, rotating pattern of light on the white wall, continuously circling the room. Viewing this phenomenon gave one an eerie feeling of disoriented vertigo—almost like being seasick—as the horizon line kept shifting in the spinning light. The mechanism made strange noises that echoed through the circular space. Sound is important in many of Eliasson's works, increasing the viewer's total sensory

immersion. As with all of his constructions, everything about how *360-degree expectation* worked was exposed for the viewer to see. Spectators standing in the room appeared as silhouettes on the wall, thus becoming part of the piece. Reflected shadows are an extra bonus in many of Eliasson's pieces. This shadow-effect was also especially strong in *Fivefold Eye*, whose stainless steel framework projected out from the wall inviting viewers to look into the mirror within and see reflected images of themselves. The metal framework created striking shadow patterns on the adjoining white walls.

This exhibition marks the first time that Eliasson included his photographic works along with the sculptural installations. He showed two large photo-mural works, *The Aerial River Series* and *Cartographic series*. The photographs focus on multiple views of the Icelandic landscape. Eliasson was born in Denmark and now lives in Berlin, but Iceland is his family home. He regularly returns to vacation and make photographs. He produces photos, grouped in grid-like wall installations forming one large mural. The images emphasize change in the landscape over time and present the same subject from many different points of view. They are about the act of seeing, and looking at them one is aware of the photographer's vision of the world. Eliasson thinks of these photographs as conceptual sketches for his sculptural installations, and one can see a relationship to his concepts of time and space in these works. One is especially struck by the raw wildness of the Icelandic landscape and how that might affect Eliasson's attitude toward nature. In these wall murals, Eliasson presents his personal view of the world from different angles and points in time. In contrast, his sculptural installations allow viewers to contribute their own individual viewpoint and point in time.

Eliasson presents something new and different with his sculptures. His sculptures and installations are simple but bold, spare, and technical, with a real connection to the natural world and the human condition. Although his work is not overtly political or issue driven, it does help us to see ourselves seeing, while creating some breathtakingly beautiful visual and sensory experiences.

Museums are for precious objects, reverent attitudes, and permanent artifacts. Eliasson's work is more about process, and the objects he makes are common, fleeting, and ever-changing. The real art of Eliasson's works lies in the experience created, not in the concrete things generating the perception. This art of phenomena works best in the spaces of everyday life, interacting with ordinary people. JIA

Notes

1 All quotations are taken from an interview with the artist by the exhibition curator, Jessica Morgan, published
 in the catalogue, *Olafur Eliasson—Your only real thing is time* (Boston, MA: The Institute of Contemporary Art, 2001).

2 See "Does Time Really Exist?" by Tim Folger in *DISCOVER* magazine, December 2000.

Beverly Semmes

by Jane Ingram Allen
2001

Beverly Semmes's installation *Watching Her Feat* (2000), at the Fabric Workshop and Museum in Philadelphia, filled two floors of gallery space. One floor featured gigantic coiled fluorescent-yellow stuffed fabric tubes, and the other contained simultaneous, repeating video images of the artist's own feet. Semmes created this work during an almost year-long collaboration with the Fabric Workshop, which is devoted to teaming with contemporary artists from around the world to create works in fabric. This was Semmes's second project with FWM; in 1995, she created *RISEANDFALL* for "Changing Spaces," a Fabric Workshop traveling exhibition curated by Mary Jane Jacob.

When entering the exhibition, it was surprising to find the gallery door closed. The logic quickly became clear: opening the door produced an immediate assault of color. An unearthly yellow-green glow seemed to emanate from the room. Three huge tubes made of chartreuse ripstop nylon confronted the viewer, taking up most of the space. Helen Cahng, project coordinator for Semmes's work with the Fabric Workshop, said that 300 yards of fabric were used to create the tubes, along with many bags of biodegradable foam stuffing. Cahng added that the fabric was ordered once and then doubled after Semmes realized that the work needed to be much larger. Semmes first tested the nylon shapes in various sizes in her studio and then collaborated with the workshop staff on the logistics of realizing the work on a grand scale.

The sculptural forms were so large that one had to creep between the massive piles or hug the walls. The tubes varied in length from one to 20 yards. Their color continued to overwhelm the eyes, and one felt encased in the eerie chartreuse glow. The texture and appealing plumpness of the stuffed forms invited touching and made one feel like diving in; however, the color and scale gave rise to ambivalent feelings of repulsion and attraction. The tubes looked like giant animals coiled up, their loosely stuffed ends resembling paws. They also evoked piles of guts or even feces. The piles loomed over the viewer, and the space-filling color seemed palpable.

Upon reaching the far side of the tubes, one entered an open and seemingly empty adjoining space. Semmes said that she wanted to provide some relief from all the neon yellow. She spoke of creating "a balancing act" with the two spaces. The second space neutralized the overwhelming color and crowding produced by the tubes. It soon became apparent, though, that you were not alone. A person sat in a chair in the middle of the space, dressed completely from head to foot in the same fabric as the tubes. She did not speak or acknowledge the viewer's presence, and one wondered if she was the artist. Was she a guard, a guide, or what? This room too had a strange, colored glow. The lone window was covered with transparent red fabric sewn into tubes that filtered the light and cast a pinkish glow into the room, mingling with the bright yellow-green of the adjoining room and reflecting purple onto

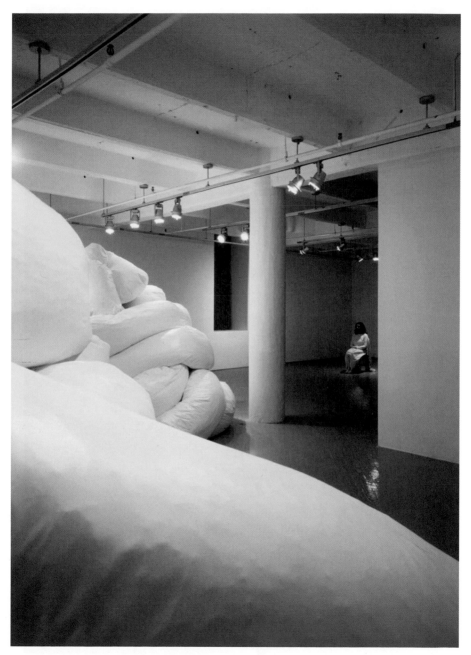

Watching Her Feat, 2000.
Installation view, created in collaboration with the Fabric Workshop and Museum, Philadelphia.

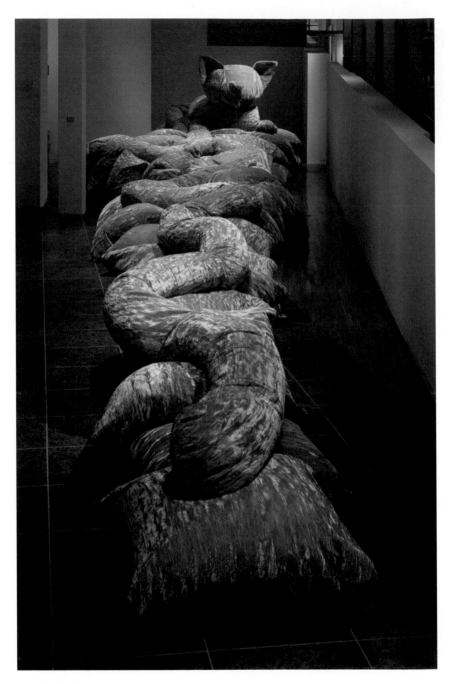

Stuffed Cat, 1997.
Crushed velvet and stuffing, 8.5 x 12 x 87.5 ft.

the white walls. It was indeed a remarkable color experience. When questioned, the attendant said that she was a volunteer and her job was to be there "watching." She seemed definitely allied with the tubes and raised puzzling questions about her role in the installation.

Semmes said that this was the first time she had used a live attendant in an installation, an idea that evolved from her use of friends and models wearing her garments for photographs and earlier videos. The experience of working with a French dance company in 1995, making the costumes and set for a production, also influenced her decision in this installation to use a live female attendant wearing the same fabric used in the sculptures. Since the Fabric Workshop exhibition, Semmes has continued to explore the use of a costumed attendant as part of her installations. Her spring 2001 exhibition at Leslie Tonkonow Artworks + Projects, New York, included parts of the FWM installation, and she is also exhibiting new work in a group show about fashion and art at M.A.K. in Cologne, Germany.

Semmes appreciated working with the Fabric Workshop and praised the organization highly. It was a great opportunity to create work for a particular site with ample time to work in the installation space. A residency such as this means that the artist can adjust the work and make changes as she lives with the space. As Semmes said, "The work evolved in the space." She initially installed the work in the Fabric Workshop galleries for the September 14 opening date and then came back in October to change it around. In September, there were several neon-yellow stuffed pillows scattered on the floor in the second room with the attendant. In October, the pillows were removed and tossed on top of the coiled mountains in the first room. Semmes felt that the residency and collaboration provided a great opportunity for her to work in the space over a period of time, pushing things around and trying out various configurations before deciding on the final form. The video projections were also changed from their first installation. Initially Semmes included sounds of walking and some music. Later in October, the sound was eliminated, and the installation focused completely on the visual impact of all those moving feet. Some of the videos were also moved to different spots in the gallery and entryway.

This work marks a departure from Semmes's signature large-scale fabric dress forms, which billow off the wall out onto the floor. She first became widely known in the 1990s for her installations involving these dresses, created with elongated sleeves or truncated, sewn-up openings. Recently the dresses became moving sculptures, continuously rising up and falling down with the aid of motorized components, as in her 1996 pieces *She Moves*, exhibited at the Whitney Museum of American Art at Philip Morris in New York, and *Big Silver*, created for an exhibition at the Smith College Museum of Art in Massachusetts.

Semmes began as a painter, and as an undergraduate at the Boston Museum School in the late '70s she did figure drawing as well as photography. In graduate school at Yale University in the mid-'80s, she began doing sculptural

works using metal mesh constructions, which were concerned with surface and color. Semmes said that the hanging dresses evolved from her previous work with fabric costumes in photo and video works: for her, "the hanging dresses brought surface and structure together for the first time." The costumes she had used earlier in photographs and performance work became sculptures.

While the FWM project has abandoned dresses in favor of massive coiled tubes, the scale of Semmes's work is still larger than life, defiantly big. She plays with the traditional expectation that women's work be small and dainty. Here, a woman has made work that is too large yet soft, limp, playful, and humorous. These fabric forms are vulnerable, and feminine, but they are used in an aggressive way. Large scale has always been important in Semmes's work. She speaks of the sculptures as "taking up too much room." There's even something infantile about those tubes and all that attention to feet. The videos recall the joy of infants playing with their feet, kicking them up in the air as marvelous specimens. With the coiled piles of stuffed tubes, one is reminded of an infant's wonder at his own production of bodily waste. The neon brightness and massive scale keep it humorous rather than repulsive. When speaking about her work, Semmes says she likes to keep herself entertained. One of the major accomplishments of her creation is its power to regenerate our childish delight and awe at the wonder of the human body.

The use of coiled tubular forms is not entirely new for Semmes. She included the small coiled stuffed tube sculpture *Men's Wear Snakes* in her 1992 exhibition at the SculptureCenter in New York. She admits that the "pile of guts in the corner" was largely overlooked because of the attention drawn by the huge dresses, but the tube form has been present in her work almost from the beginning. It also echoes the paws and tail of the giant stuffed cat she exhibited in 1997 at the Wexner Center for the Arts in Columbus, Ohio. With *Watching Her Feat*, Semmes has expanded the tubular form to equal the impact of her massive dress forms.

Semmes's extensive use of video in this installation marks another new direction for her. Although she has exhibited both still photographs and videos documenting her fabric sculptures being worn, this was her first installation to combine sculpture and the video work. Although the two were separated by their placement in galleries on two different floors, they were joined in more ways than one. The play on words in the installation's title is an immediate connection. An attendant in the fifth floor space watched the feat of producing those massive fabric tubes, and the artist was literally watching her own feet in the sixth-floor video projections.

The use of her own body in video is new for Semmes, and the videos constitute a series of self-portraits, with the artist holding the camera waist high and focusing on her moving feet. These mesmerizing, repetitive videos were projected in various sizes, from about six inches to wall size, and at varying heights on the white gallery walls. Some of the videos appeared at floor level, increasing viewers' awareness of their own feet and the process of walking through the space.

The videos record Semmes's feet moving silently in various ways and in varied settings. The largest projection showed her feet, giant and animal-like, swathed in Vaseline with bits of dirt clinging to them, treading through rustic terrain. This sequence made one think of the paw-like qualities alluded to in the coiled fabric tubes. A medium-sized projection showed Semmes's feet walking with a billowy, fluid skirt swirling around her ankles and pooling on the floor. The color of the fabric was the fluorescent yellow of the tubes. In another smaller video, Semmes's feet, swathed in various cartoon character Band-Aids, playfully paddle about in bright blue water. Humorous and strange, this video somehow evoked memories of the pools that collect on the floor when Semmes's giant dresses flow off the wall. In a video playing in the gallery foyer, Semmes's feet were bathed in an eerie greenish glow, with the toes bound in brightly colored fabric, endlessly walking.

With her room-sized installation of videos Semmes created a sculptural presence. The space became part of the work, and the projected repeating images produced allusive forms and mass. Reflected images flickered on the polished floor, and one became engulfed in a massive exploration of self—focusing on what is perhaps our most unattractive body part with all of its myriad associations. **JIA**

Jane Alexander

by Marilyn Martin
2003

"Jane Alexander may be the most difficult and least definable artist in South Africa. An 'original' in a world of infinite copies, a visionary whose inner world is so exposed to our three-dimensional gaze that we shy away from entering it."[1] These words by Sander Gilman capture the challenges that face anyone attempting to write about an artist whose work is both profoundly socially conscious and enigmatic, an artist who is so acutely aware of the pitfalls of misinterpretation and misrepresentation that she avoids recorded interviews.

The work with which Alexander won the National Fine Arts Student Competition and the Martienssen Student Prize at the University of the Witwatersrand, Johannesburg, in 1982, when she was an undergraduate, prefigures the body of sculpture that was to follow in the next two decades. The two figures are constructed of bone, plaster, and wax. They are flayed and decomposing—hooked and hanging like meat in an abattoir. They are stripped not just naked, but to the bone, and in places beyond the bone, revealing inner cavities and decay. They are no longer humans but archetypes for torture and suffering and metaphors for a society in crisis. And they will not allow us to forget. Gilman writes: "These early works are South African forms of memory in that they evoked and used the ravaged remains of kills seen at the game park she frequented as a child (and whose remains she later dragged back to art school—her teachers holding their noses and muttering about the danger of anthrax and pollution). But these early hung bodies also reflect on the body politic of her South Africa under apartheid, of the bodies half destroyed by such a world, bodies only partially remembered, half forgotten, half formed in memory. Not only the bodies of the victims but also the distorted bodies of the perpetrators—all merge in these hung corpses. They are "white" corpses—for the bleached colorlessness of bones makes it impossible to remember the color of a person's skin. Person or animal—there is little difference in her world."[2]

It is impossible to eradicate from one's mind and one's memory the experience of Alexander's one-person exhibition of sculpture and photomontage at the Market Gallery in Johannesburg in 1986. The *Butcher Boys* formed part of a substantial body of work and remain the single most powerful index of South African art at the time of the declaration of the Second State of Emergency in the country in that year. And more than that, in Ashraf Jamal's words, "The *Butcher Boys*...as an allegorical force, an invisible core, and not only as figures in themselves, pose the crux of art-making—a crux that cannot be avoided, that must set the mood, the tone, the gravity, and the question of what it means to exist and make art in South Africa—today." Written in 1996, these words still hold true.[3]

The three male figures are life-sized and consist of plaster of Paris cores, covered with builders' plaster, sealed and oil painted. The smooth, powdery surfaces persuade the viewer to take a closer look, to be attracted and/or repelled.

Butcher Boys, 1985–86.
Plaster, bone, horns, oil paint, and wood,
128.5 x 64 x 80 cm.

The human figures, on the threshold of total bestiality, mutate to animals—dog-like faces with twisted horns and spines that protrude through flesh and skin. Their glazed eyes look past the spectator, yet follow him or her; their mouths are gagged. They show neither pain nor anger, neither hope nor despair; they just sit there—simultaneously perpetrators and victims like so many of Alexander's personages. Their unrelenting presence compels us to recognize and confront the evil in ourselves and to question our responses to and complicity in the state of the world in which we live. Then and now.

Alexander chooses not to speak about her work, but her interests and the formal and theoretical underpinnings of her oeuvre are lucidly expounded in her dissertation submitted for the Master of Arts in 1988: "Aspects of Violence and Disquietude in late 20th century three-dimensional human figuration." She selected Duane Hanson, George

African Adventure, 1999–2000.
Mixed media, dimensions variable.

Segal, Edward Kienholz and Nancy Reddin Kienholz, Mark Prent, and Malcolm Poynter. For her, their work reflects "…a direct relationship of scale, proportion, and occupied space to human experience within the urban environment," and she explains how they achieve this. One can trace Alexander's own quest for the formal and expressive means by which to explore the associative and evocative potentialities of material, form, composition, and space from the earliest sculptures. She employs realist techniques not to achieve realist ends, but to seek conceptual possibilities that evoke contradictory emotional and intellectual responses. Reality is edged into symbol and metaphor, the subconscious penetrates observation, "real" tableaux and environments controvert the world of experience and manifest surreal, enigmatic presences. This combination of formalism and narrative insight, sometimes expressed through classical form, gives rise to the leitmotifs of her work: ambiguity and metamorphosis. For every concept, every idea and emotion, there is a counterpoint. Often they are seen as binary opposites, but for me they are painful, yet seamless transitions or interstices of action and meaning that act as agents in the process of making visible the invisible. And we are constantly reminded that "the past is never over. It is as real and perhaps more powerful than the present."[4]

These characteristics of Alexander's art are revealed in her sculpture as well as in her photomontages. *Erbschein: an den Bergen* is a biographical sculpture that confronts the viewer with the horrors of Nazi Germany and the displacement of her father's family (he came to South Africa from Germany in 1936).[5] The sculpture contains a painting of the house left behind, as well as the anti-Semitic mayoral document of the district, and evokes the anti-Semitic monument erected near the former family home in Berlin. The photomontages, with titles such as *Sauberkeit ist Gesundheit: ancestor and Triumph over capitalism: Lustgarten* elucidate the sculpture. They appear in the little Photo-Book that explores the artist's family history and offers a universal indictment of oppression and greed, of physical and psychological violation, and of exploitation and mutilation.[6] The ills of society and the landscapes marred by human—or inhuman—occupation are captured in nightmarish visions in which images of the sculptures frequently appear.

Race is a recurrent theme in Alexander's work. The sculpture *Racework—in the event of an earthquake* (1999) refers, among other things, to the classification of Japanese people as "non-white" by the apartheid regime. International reaction and fear of the economic impact of such an act led to a situation in which employees of Japanese businesses were given certain privileges and were called "honorary whites."[7] The two figures are the same, one dressed in a seemingly traditional Oriental manner, the other in Western clothing. The one looks Asian but is in fact wearing a mask and gray flannel trousers under the kimono. Which identity is real? Is all identity masked?

The concepts of integration and programming (segregation having been imposed by the apartheid government) gave rise to a series of major sculptures in the 1990s. In *Integration Programme*, Alexander is concerned not so much with social integration, but integration (or the lack and impossibility thereof) in the workplace and the intentions of those who invent and drive such programs. The figures, created in 1992, 1993–94, 1995, and 1996 are dressed for work, either in the characteristic overalls worn by the "house boys" who cleaned homes and apartment buildings in Durban and Johannesburg or in a suit. Black men doing manual labor were (they probably still are in many places in South Africa) called and addressed as "boys." The man in *Integration Programme: man with TV* (1995) wears a suit as if to affirm his adulthood and watches a black and white television film of a white man in a suit, who unceasingly and unsatisfactorily tries to improve his appearance by straightening his tie and smoothing his hair in a reflective surface. In *Integration Programme: man with wrapped feet* (1993–94), the man is completely incapacitated, as the title indicates. He hangs upside down against a rich blue background and has a golden halo. He has given up and passed on, thereby transcending deprivation and achieving redemption.

The same sense of utter alienation is achieved differently in *Bom Boys* (1998), the work with which the artist won the Daimler-Chrysler Award for South African Sculpture in 2002. The figures are life-sized, but the size of children, and have been cast from the same mold, irrespective of whether they are meant to be children or adolescents. The scale

makes it necessary for adults to go down on the floor to connect with them, to see them properly. Some are naked, some dressed, masked, or blindfolded. These little personages, their arms slightly outstretched, fingers open, as if in a plea or imminent movement, refer to the many displaced children in South Africa. They are abandoned or orphaned, increasingly as a result of HIV/AIDS, they suffer from malnutrition, and many are addicted to taking drugs and sniffing glue (hence the stunted growth of the adolescents). Often they are raped, or they resort to prostitution and may therefore be infected with HIV/AIDS themselves. They are helpless victims and yet their capacity to survive the damage is reflected in some of the figures. They can also be dangerous and fearsome. The work derives its title from a graffito, "Bom Boys," that Alexander saw in Long Street, Cape Town, where she lived for a long time. It is probably the name of a gang, *bom* in Afrikaans meaning "bomb." The brutalization, metamorphoses, and ambiguity that are constants in Alexander's work find poignant expression in these little figures. And the viewer cannot escape the indictment.

African Adventure has occupied Alexander since 1999. Fifteen photomontages, forming sets of three, lead and introduce the visitor, as tourist, to an adventure that focuses on Cape Town. These images, however, have nothing in common with the promises and pictures offered by the tourist agencies that promote "the fairest Cape in all the world" and the exotic, exciting continent beyond. The landscape is real, but it is bleak and burning and inhabited by Alexander's harbingers of evil and desolation. The "tour" goes through an informal settlement and two industrial areas, and the photomontages subtitled *Mountain View* (a favorite name for homes and businesses in the Cape) focus on the realities and contrasts of Long Street. *Adventure Centre 2000* consists of horizontally elongated views that are digitally projected.

The sculpture installation *African Adventure* (1999–2000) was conceived for, photographed, and filmed in the British Officers' Mess of the Castle of Good Hope in Cape Town, the oldest building in South Africa. Originally built by the Dutch East India Company after the arrival of Jan van Riebeeck in 1652, it became the British military headquarters in the early 19th century and subsequently a symbol of Afrikaner militarism and oppression. The man seen in the back of the photograph is a refugee from Kinshasa, Democratic Republic of Congo; he also features in the video work of the same title. Simon Njami writes: "The most recent piece, *African Adventure*, seems to me emblematic of the new vein Alexander has chosen to follow. The title, the positioning of the subject, and the implicit criticism of an all-embracing system bring us to a work that suddenly begins to speak. As does Jane Alexander: 'This installation has been in progress since 1999 and consists of sculpture, video, and photomontage, a confluence of related fragments linking experience in South Africa and its recent history with other parts of Africa. Elements refer to tourism, racism, proselytism, and aspects of war.' Rather than an installation, I see this work as a tableau reassembling the elements of a sparse, scattered world. Like the end of a historical period, of a section of a life." [8]

This work differs from Alexander's earlier installations in that organic materials such as earth and animal skin are combined with well-used implements and toys, wooden boxes, a brightly painted drum, fine fabrics, and ornament. These elements disrupt and alter the clinical austerity of her earlier installations. Personages—repeated, transformed, reinvented—are now placed on dark red soil. The main protagonist, *Pangaman*, drags a multitude of objects tied to strings through a singular landscape of Bushmanland earth. His attribute, the *panga* (machete), is associated in the minds of South Africans with black aggression, but his skin has an ashen gray surface that resembles the color of the *Butcher Boys*. The participants in this adventure all look away from him, in different directions, oblivious of one another and the spectator. Three figures in *Radiance of Faith* occupy boxes that once contained explosives and are marked "dangerous." *Doll with industrial-strength gloves* has tightly bandaged legs and feet, while the exquisite garment, golden horns, and miniature tiara of *Girl with gold and diamonds* contrast sharply with her handless arms. The *Custodian*, a monkey sitting on a platform, surveys this scene of threat and foreboding without looking.

Once again, the viewer is confronted and asked to engage with a work that combines restraint and melodrama, alienation and intimacy, enigma and familiarity, humanity and bestiality, the personal and the political, the particular and the universal. Alexander plumbs the depths of self, searching inward and drawing not only on the collective unconscious but also on universal consciousness in her quest for understanding and knowing. We feel strange, inadequate, and insecure in the company of her personages. Yet they are accessible, if we would or could be open and receptive, so that we may be dislodged from our complacency and so that they may provoke and seduce us to allow our inner worlds and buried dreams to be reached, excavated, recognized. By delving into darkness, Jane Alexander brings things to light and dares us to dream, fear, long, weep, be bruised, elated, and elevated, and feel the betrayal of our own souls in the adventure that is our lives. **MM**

Notes

1 Sander Gilman, "Truth Seeking, Memory and Art: Comments Following Four Weeks of Life in the New South Africa," *Africus* '95, Johannesburg Biennale, 1995, p. 37.

2 Ibid.

3 Ashraf Jamal, "Jane Alexander: *Integration Programme*," in Sue Williamson and Ashraf Jamal, *Art in South Africa: The Future Present* (Johannesburg: David Philip Publishers, 1997), p. 15.

4 Mike Nicol, "Lest We Forget the Blind Tragedy," *Cape Times*, 15 April 1996, p. 2.

5 Alexander clarified her Jewish connections to the author: "My father…was Jewish…only in the Nazi sense, i.e., he had Jewish blood…but was not a practicing Jew…in National Socialist policy, he and his family were regarded as disguised non-Aryans."

6 *Photo-Book: Photomontages by Jane Alexander* 1981–1995 (Cape Town, 1995).

7 *Jane Alexander: Daimler-Chrysler Award for South African Sculpture 2002* (Stuttgart: Hatje Cantz, 2002), p. 119.

8 Simon Njami, "A Turbulent Silence," in *Jane Alexander*, op. cit., p. 18.

Ravinder Reddy

by Collette Chattopadhyay
2003

Examining relations between memory, history, mythology, and contemporary reality, Ravinder Reddy studies the ironies of modern Indian society in which "tradition, religion, and modernity co-exist so strongly that it is often difficult to draw a line between them." A graduate of Goldsmiths College of Art in London, Reddy is part of the Hindu Renaissance, which includes Indian authors publishing in English as well as computer wizards in California's Silicon Valley. Unlike their post-independence forbearers who challenged Western hegemony by constructing a distinctively nationalistic vision, Reddy and his generation accept the historical circumstances that fostered India's modern reincarnation, constructing a place for themselves within the existing international context.

Profiled recently at the Arthur M. Sackler Gallery of Art, Deitch Projects, and the Warhol Museum, Reddy emerged on the international scene in 1999 at the Australian Asia Pacific Triennial. He is celebrated for his irreverent injection of secular pop-culture themes into the dialogues of canonical art, and he occupies a unique position in both the international art firmament and the contemporary Indian art scene. As his New Delhi gallerist Peter Nagy explains, "He is the only sculptor [in India] to create an entire oeuvre consisting of inherently self-contained forms [that construct] a formal language which spans millennia, from the ancient to the futuristic." Probing time, his sculptures echo ancient Indian, Egyptian, Benin African, and Mexican sculptures, while conversing with the contemporary works of Niki de Saint Phalle, Fernando Botero, Luis Jiménez, and Jeff Koons.

Reddy's images of women, couples, and families identify the human body as a site of social, sexual, religious, and cultural identity. Iconographically dense, his works explore the nexus of ethnic, national, and global identities. Adopting an Olmec passion for monumentality while borrowing cubic clarity and rigor from Dynastic Egypt and then infusing the whole with a vitality and sensuality that echoes ancient Indian prototypes, his sculptures manifest a modern, transcultural breadth. He references ancient Vedic and pre-Vedic mythologies, though such allusions are usually made indeterminate through reconfigurations of established archetypes. Concurrently, these sculptures explore the impact of media and consumer culture on contemporary consciousness, manifesting a keen interest in what Baudrillard has called hyper-reality and what Neil Leach has discussed as hyper-consumption.

Colossal female heads and nudes have emerged as Reddy's two most significant bodies of work. With its title, size, and gold-leaf, *Krishnaveni* (1997), from the head series, can be read as a representation of the legendary consort to the Hindu deity Krishna. But the title could equally allude to any number of contemporary women who go by that name, complicating any facile interpretation. Further, while the immense scale suggests the mythic consort's function as a female exemplar, it simultaneously alludes to a fixation with the movies. Like the facial close-ups in 1950s

Installation view at Deitch Projects, New York, 2001.

Bollywood films, Reddy's immense heads fill the viewer's field of vision—imbued with an intense sensuality that endeavors to offset any boredom or distraction. Linked to these emphases is Reddy's recurrent suspicion of traditional narratives of idealization and splendor, which he continually unravels.

Wryly playing with and against stereotypes, Reddy refashions the female countenance in the likeness of India's own physiognomies. He banishes the British Raj period's ideal of Indian women as pale-skinned Europeans, as well as ancient Indian literary and modern filmic preferences for the fair-skinned. Reddy subtly exaggerates a prominent nose, full checks, or a thick neck, accentuating selected facial features almost to the point of caricature. The heads also explore how cultural identity, economic status, and social class are mapped by hair. Carrying Benin sculptural emphases forward while highlighting traditional Indian hairstyles, Reddy lavishes extreme detail on modern "plastic" hair ornaments, often festively arranged in excess, underscoring the subcontinent's love affair with consumer products. While critiquing the multi-billion-dollar companies that profit by selling goods to the developing world, these works also satirize the consumer who equates product acquisition with personal transformation into a goddess.

Woman on Charpoy, 2001.
Painted and gilded polyester fiberglass, 64 x 41 x 40 in.

Similar ironies appear in his nudes. Imperial in size and color, these works celebrate the matriarchal figure and evoke the subcontinent's pre-Hindu beliefs in a mother goddess. Far removed from the thin, teenage ideals of American media, Reddy's nudes superimpose reality with ancient artistic and literary legacies that define female power in terms of fertility and sexual prowess. Erotic and voluptuous, the nudes evidence a familiarity with such ancient Indian prototypes as the female earth spirits (*yakshis*) of Bharhut and Sanchi, as well as the copulating couples of Khajuraho.[1] Departing from the traditional Indian *tribhanga* pose, however, Reddy's nudes stand, stride, or sit with surprising candor and naturalism. Winking to Duchamp and succeeding where the Kaurava brothers failed, Reddy metaphorically presents Draupadi stripped bare by contemporary patriarchal culture, even.[2]

Challenging the ancient Hindu caste system, which was legally replaced in modern India with secular democracy, Reddy mingles traditional Indian high and low cultures. His works mix modern secular interest in the plight of the lower classes with the ancient rhetoric of power as immense scale. Reconfiguring the female image, he creates

a goddess of a different social class. Like Manet's *Olympia* or Picasso's *Les demoiselles d'Avignon*, his sculptures are forever separated from their ancient models because they elevate formerly socially debased women to a status previously reserved for goddesses. While potentially blasphemous, this gesture celebrates modern India, creating a new image of Indian society. Simultaneously extravagant and poor, exuberant and awkward, Reddy's work explores the illusion of appearances, seducing us with extravagant size, sumptuous surfaces, and sensuous hollows and hills. **cc**

Notes

1 The *yakshis* at Bharhut date to the 2nd century BCE; those at Sanchi, which are considered premiere examples of early Indian Dynastic art, date from the 3rd century BCE to the 1st century CE, while the medieval North Indian Hindu temple bas-reliefs at Khajuraho date roughly 950 to 1050.

2 The story of a powerful woman known as Draupadi is recounted in the ancient Sanskrit epic poem, *The Mahabharata*, dated by some scholars to the 12th century BCE. In the epic struggle between two branches of a noble family that forms the core of the story, the five Pandavas brothers lose their one wife, Draupadi, in a gambling match to the rival Kaurava brothers, who then attempt to strip her naked. Miraculously, with the help of the Hindu deity Krishna, Draupadi remains clothed even as a pile of clothes stripped from her gathers on the floor.

Carsten Höller

by Anja Chávez

2003

Carsten Höller is one of the most important young sculptors and installation artists to emerge from Europe in the last 10 years. Though he has recently presented works at the São Paulo Biennial (2002) and had exhibitions at such key institutions as Baltic Centre for Contemporary Art (Gateshead, U.K.) and the Fondazione Prada (Milan, Italy), the work of this Stockholm-based artist remains largely undiscovered in the United States. This situation has been partially remedied by Höller's long overdue, one-person exhibition "Half-Fiction" at the Institute of Contemporary Art, Boston.

Born in Belgium, Höller moved to Germany to study agricultural sciences (not biology as some have claimed). He engaged in these studies simply because he knew nothing about the field.[1] He specialized in psychopathology and wrote several works on communication between insects, receiving the German degree of "Habilitation" in 1993 from the University of Kiel, Germany.[2] This educational background has led many to over-emphasize the scientific perspective in his work. As Höller is quick to admit, his education obviously bears on his work, as do his diligent research and thoroughness of execution, a thoroughness most apparent in his published art books. His work nevertheless goes beyond questions of perception, philosophy, and psychology, addressing subjective experiences that lie outside the realm of the sciences and blurring distinctions between media such as sculpture and architecture.

Since 1989 (when Höller started to exhibit), he has worked in various media, creating an oeuvre that consists of performances, films (often in collaboration with such artists as Liam Gillick, Douglas Gordon, Pierre Huyghe, Philippe Parreno, and Rirkrit Tiravanija), videos, drawings, photographs, sculptures, installations, and architectural models (independently and also in collaboration with Rosemarie Trockel).[3] Since the early 1990s he has focused on interactive works that emphasize means of transportation, the so-called "vehicles," and other interactive sculptures and installations for which he is best known today. Surprisingly, the close dialogue between his work and architecture is often overlooked. This is all the more astonishing since his work from the mid-1990s until the present addresses architecture directly. For instance, his site-specific sculpture *Flying Machine* (1996/2000), installed at the Contemporary Arts Center in Cincinnati in 2000, emphasizes the visitor's ability to sense that he or she is flying, an effect obtained from the natural light produced by the building's dome-like architecture. Other well-known installations suggest a radical transformation of a given architectural space. Höller is also clearly fascinated by the possibilities of altering viewers' perceptions. In *Upside Down Mushroom Room* (2000), as seen at the Fondazione Prada, immense spinning sculptures of upside-down mushrooms are suspended from the ceiling, providing a dazzling perception of a wholly different world. *Upside Down Mushroom Room* is close to another of his works, *Upside Down Spectacle* (1993), for which the visitor is provided with glasses that invert the objects seen through them. This mechanism is further developed in *The Forest* at the ICA, Boston. Visitors wear special glasses containing an LCD moni-

Upside Down Mushroom Room, 2000.
Mushrooms: polystyrol, polyester, wood, metal, and electrical motors; room: plasterboard,
wood, neon lights, glass, acrylic paint, and iron, overall dimensions 12.3 x 7.3 x 4.8 meters.
View of installation at the Fondazione Prada, Milan.

tor in each lens. Each "screen" shows the same film shot with two separate cameras, but the sequences are not always synchronized, at which point it is the viewer who is split into two different and divergent perceiving beings. Certainly, Höller's desire to question perception and to push the viewer's visual experiences to the limit is a leitmotif in his work, yet his dialogue with architecture runs deeper still.

Sculptures such as *Valerio I* and *II* (1998) for the Berlin Biennial are part of a major series of works-in-progress related to slides (the kind you usually find on playgrounds, but in different materials) that visually and intellectually redefine existing buildings. Taken out of its usual context, the slide can act as a critique of current architecture. Höller's use of the slide underscores the necessity of conceiving another way to travel up and down and through buildings—a way that might incorporate some of the playfulness of slides. This was obvious in 1999 at the Wilhelm Lehmbruck Museum, Duisburg, where Höller envisioned mounting many of his slide-related works onto pre-existing architectural structures in the industrial German city.[4] What matters to Höller is that realizations such as his slide-related works be not just inventions or fictions but also projects with a real impact: "A slide, because it presents a futuristic means of transportation. I don't see why houses are constantly being built without slides, every house should be well lined with all types of slides. Then it would be possible to move swiftly and elegantly from one place to the next. Also, there is a moment of paradoxical loss of steering that interests me."[5]

Höller often refers to two main sources of inspiration for this body of work. The first is a childhood memory. As a boy living in Brussels he often passed by a nursing home. He clearly recalls the park surrounding the nursing home, a beautiful red-brick house with metallic slides running down its sides—the fire escape system. The other source is more recent and relates to his fascination with contemporary West and Central African architecture, which he considers important because, unlike modern Western architecture, it expresses a psychological state and can be read in terms of belonging to the space in which it is situated.[6] His interest in architecture as a means to envision another model of the city is all the more evident through his research on the French revolutionary architect Etienne-Louis Boullée and on the Russian Constructivist G.T. Krutikov. Höller is especially interested in their never-executed visionary models. The life-sized *Eyeball/A House for Pigeons, People and Rats*, which Höller realized with Rosemarie Trockel for EXPO 2000 (Hannover, Germany), takes the form of an eye, an allusion to Boullée's *Cenotaph for Newton* (1784). The building's design also refers to Newton's proof of the earth's spherical shape. Boullée had repeatedly emphasized the philosophical and aesthetic role of architecture, which he redefined as poetry; here, the shape of the building pays homage to Newton.[7] Höller and Trockel have also collaborated on 10 animal-related projects, creating functional models for unusual structures that range from *Eyeball/A House for Pigeons, People and Rats* to the simple pigpen in *House for Pigs and People* (Documenta X, Kassel, 1997). In all of these projects, the role of architecture is not only functional, but also poetic and metaphorical. In *Addina* (1997)—*addina* is Italian for "chicken"—the sculpture is the outline of an egg that interferes with the architecture's interior space. The many egg-

shaped holes on either side of the sculpture form a clever conceit, but they also provide the chickens inside the structure (where they are invisible to viewers who can only smell and hear them) with a place to lay their eggs. This project brings to mind André Bruyère's *L'Oeuf = The Egg*, which the French architect presented in 1978 for the city of New York, where a building was to be built in the shape of an egg in order to "present some different concepts for the great city."[8]

Höller's art has its roots in a desire to realize works defined through a "fantastic moment of beauty" that can nevertheless be realized. His unusual model *Kommunehaus* (2001) for the exhibition "Home/Homeless" in Malmö, Sweden, is based on utopian plans for the *Compact Communal House of the Flying City* (1928), the thesis of Krutikov, which was only published 40 years later.[9] Krutikov envisioned a futuristic city where the earth is rid of all buildings; people dwell in the air and commute from one suspended position to another via mobile houses. It is in terms of these plans, along with the distinctions Krutikov established between vehicles and housing complexes, among others, that Höller realized a transparent house in which everything, including the screws, is made of Plexiglas. The material used and the transparency of the structure represent lightness and non-physicality. Höller's fascination with Krutikov is already explicit in his project *New City* for the Duisburg exhibition, which includes commentary on the Russian Constructivist and several illustrations.[10]

Höller distinguishes between "architecturally related sculptures" (slide-related works), "hypothetical models for houses" (*Maison Ronquières: The Laboratory of Doubt*), the "modernist-functional house," "effect machine(s)," "devices," "vehicles," and a "monument of incomprehensibility" (*House for Pigs and People*) that is "psychoactive."[11] Most of the time he refers to his work as "art," explicitly avoiding the words "sculpture" and "architecture," which might confine his works to one field or the other. Höller is instead interested in art forms—such as *Upside Down Spectacle* or *The Forest*—that embrace various media and are thus difficult to reduce to any one art historical category. His approach to sculpture is partially based on the Minimalist reconsideration in the 1960s of the relationship linking sculpture, architecture, and landscape—a reconsideration that led Rosalind Krauss to define sculpture as an "expanded field" and that has led sculpture to branch out, devising, among other things, a complicated dialogue with architecture.[12] While Höller envisions his slide-related sculptures as "architectural," he also clearly refers to architecture as sculpture through his "open" non-functional slides, such as in his *Slide House Projects (Accra No.1/1; Accra Nationaltheater No.2/1)* from 2000. Here, the slides are deprived of their function and add another rhythm and structure to existing architecture. On the other hand, *Valerio I* and *II* (1998) are far more utilitarian, underlining architectural and scientific principles and presenting the slide as a sculptural element that can control an architectural space both from the inside and the outside.[13]

Visually, Höller's site-specific sculptures transform buildings into construction sites. The precedent for this, as Höller agreed during our conversation, is the Centre Georges Pompidou in Paris, which initiated a new type

Valerio I, 1998.
Stainless steel, approximately 235.8 in. long.

of museum architecture. With the ventilation ducts in plain view on the exterior and the escalator winding its way up to the top of the building on the museum's front façade, the Pompidou has often been described as a "factory" or "urban machine for mass culture." The architects, Renzo Piano and Richard Rogers, proclaimed that, at its inception, their project was pure provocation.[14] The Centre Pompidou was to be accessible to everyone, not just an elite population, and it sought to renew the spirit of construction in Parisian architecture. The Pompidou was built with the idea that it would have to be a center to "produce culture," and the architects thus accepted the general comparison (even if it was meant negatively) of the museum with a factory. The long pipes enclosing the escalators most relate to *Valerio I* and *II* and later works in which Höller incorporates and redefines exhibition spaces and museum buildings (Kunst-Werke, Berlin; Galerie Schipper & Krome, Berlin; Kiasma, Helsinki, Finland; P.S.1, New York).

Like the Belgian poet, filmmaker, and conceptual artist Marcel Broodthaers (1924–76), Höller believes that the museum is a space for critical reflection. In Höller's case, it also allows for another form of learning through personal experience. Broodthaers's legacy consists of his subversive statements regarding the end of the museum, his attacks on the commercialism of art, and his use of language in art. According to Höller, what allows his work to be compared to Broodthaers's is their mutual criticism of Belgium or, more precisely, of what Höller calls the "Belgian moment."

Broodthaers's own criticism of Belgium is complex, incorporating references to the French poet Charles Baudelaire's vitriolic pamphlet *Pauvre Belgique*. This criticism is also apparent in the work of such visual artists as Panamarenko and, now, Höller, for whom the "Belgian moment" relates to a phenomenon clearly expressed in the architecture of Brussels, where Höller experienced a sort of "negative city planning" or what he refers to as "Brusselization"— where architectural disorder reigns. *Maison Ronquières: The Laboratory of Doubt* (2000), built on a mathematical model of a staircase and made out of acrylic glass, exemplifies his reaction. Slides connect all six floors within the building, while the seventh leads to the outside. The architectonic vocabulary—the staircase, the spiral, and the slides—defines a sculpture that Höller calls a "hypothetical house." His criticism of Belgium is subtle since the sculpture in fact refers to the Charleroi-Brussels water channel and the Inclined Plane of Ronquières (1962), where a system of lifts instead of sluices is used to raise and lower the water level. The subtitle, *The Laboratory of Doubt*, ironically redefines Höller's work as a location dedicated to an individual's thinking process. It is part of a series of works begun as *The Laboratorium of Doubt* in 1999 in Antwerp (Belgium), where Höller was invited to participate in the exhibition "Laboratorium," curated by Hans Ulrich Obrist and Barbara Vanderlinden (in conjunction with researchers and scientists specializing in artificial intelligence who acted as consultants to the artists). According to Höller, the project was meant to fail and was never completely realized. Convinced that in general "there is nothing to say" and specifically nothing to say regarding this project, he felt pushed to emphasize his doubts instead. His contribution thus consisted of a white Mercedes with speakers and trilingual signage in English, French, and Flemish, "The Laboratory of Doubt/Le laboratoire du doute/Het laboratorium van de twijfel," attached to its exterior. The car drove silently through the streets in front of the museum as a clear reference to Broodthaers, who realized a section of his fictive museum, The *Musée d'Art Moderne* (1969), in Antwerp.[15]

Through obvious humor and irony, Höller's slide-related sculptures and architectural models (including those realized in collaboration with Trockel) serve as metaphors, observing and critiquing architectural principles. Sculpture can integrate architectural elements such as a staircase (*Maison Ronquières: The Laboratory of Doubt*), and architecture can incorporate sculptural forms (*Eyeball/A House for Pigeons, People and Rats*). The houses he has realized for animals, fully functional architectural structures even if the idea of a model is emphasized, hold a special place in Höller's oeuvre.

According to the artist, his fondness for animals (especially for birds) goes back to his early years in high school, and the presence of animals in his work is connected to their relation to the human species and to a question of mutual respect. More than self-referential works, *Addina, House for Pigs and People*, and *Eyeball/A House for Pigeons, People, and Rats* metaphorically examine the relations between animals and humans. In *Addina* (1997), the relationship is reversed since the chickens can observe the visitors. In *House for Pigs and People* (1997), the artists transformed the architectural structure into an observatory, a space shared by human beings and their close relatives,

pigs. The space was divided into two rooms signifying the division between animals and human beings, "a little museum to observe pigs," as Höller noted.[16] A second smaller version of this work for children (in collaboration with Trockel) was installed in Paris and titled *Maisons/Häuser* (1999). Given the smaller scale, only children had access to it, and instead of living animals, a film of pigs was projected. This work certainly presented a challenge to the museum as an institution (Musée d'Art moderne de la Ville de Paris) and reinforced Höller's wish to suggest contemporary alternatives to the museum's conventional definition as a repository for cultural artifacts.

Höller's desire to create works that link the real and the poetic is nowhere better expressed than in his exhibition "Half-Fiction" at the ICA, Boston, which allows a wide experience of his multi-faceted art. Many major and new works are presented in the form of a circuit through which the viewer passes. Visitors are challenged by each work in a different way, but always in terms of visual perception. Interactive works, such as *The Forest* and *Light Corner*, which focus on optical illusions, have been re-adapted specifically for the show.

Sculptures such as *Corridor* and *Slide#6* are intended to radically rearrange the given architectural space, thereby manifesting Höller's continuous dialogue with architecture. *Slide#6* demonstrates that Höller's art is as playful as it is thoughtful, presenting sculpture as a way of radically altering the museum and its architecture and perhaps allowing it to become a space where playing, experiencing, and thinking, for both adults and children, can be closely (re)connected. **AC**

Notes

1 Conversation with the artist, November 28, 2002. Unless otherwise noted, all quotations are from this communication and have been translated from German into English by the author.

2 The "Habilitation" is the rough equivalent of the position attained by a tenured professor in the United States.

3 His films include *Vicinato I* (1995), with Philippe Parreno and Rirkrit Tiravanija, and *Vicinato II* (2000), a 35mm film transferred to DVD, with Liam Gillick, Douglas Gordon, Pierre Huyghe, Philippe Parreno, and Rirkrit Tiravanija.

4 This group exhibition, "kant park," also included Clegg & Guttmann, Olaf Nicolai, and Kiki Smith. See the catalogue, *kant park* (Duisberg: Wilhelm Lehmbruck Museum, 1999).

5 Carsten Höller, "A Thousand Words," *Artforum International* (March 1999): 102. Reprinted in the exhibition catalogue *Production* (Helsinki, Finland: KIASMA, 2000), p. 9.

6 Höller has photographed approximately 70 buildings that he intends to edit as a special book project. These contemporary West and Central African buildings inspired him to create the drawings that usually precede his slides.

7 This comparison between *Eyeball/A House for Pigeons, People and Rats* and Boullée's *Cenotaph for Newton* was discussed during our conversation. See also Philippe Madec, *Boullée* (Paris: F. Hazan, 1986), pp. 47, 61, 63.

8 Andre Bruyère, *L'Oeuf = The Egg* (Paris: Editions Albin Michel, 1978), pp. 19–20. As Bruyère put it: "Since this project will not be constructed, I might as well do it."

9 O.S. Han Magomedov, "Georgij Krutikov. Projet de ville volante," *Cahier du Musée National d'Art Moderne Paris*, 2 (October/December, 1979), pp. 241–47.

10 Höller, "Neue Stadt," *kant park*, op. cit., pp. 40–49.

11 Höller, in *Production*, op. cit., pp. 15, 24–25, 35, 57. See also his interview with Germano Celant in the exhibition catalogue *Register* (Milan: Fondazione Prada, 2000).

12 Rosalind Krauss, "Sculpture in the Expanded Field," in Hal Foster, ed., *The Anti-Aesthetic. Essays on Postmodern Culture* (Port Townsend, Washington: Bay Press, 1983), pp. 36–38. "Sculpture is no longer the privileged middle term between two things that it isn't. Sculpture is rather only one term on the periphery of a field in which there are other, differently structured possibilities."

13 The name "Valerio" may well reference the Italian mathematician Luca Valerio (1552–1618) whose work focused on volumes and centers of gravity. Höller refers to an experience of mass hysteria in Rome and to a general criticism of conformity and utility-oriented social behavior. See "A Thousand Words," op. cit.

14 Renzo Piano and Richard Rogers, "Entretien avec Antoine Picon," in *Renzo Piano, Du plateau Beaubourg au Centre Georges Pompidou* (Paris: Editions du Centre Georges Pompidou, 1987), pp. 15–16.

15 See Höller's video *One minute of Doubt*. His slide-related work for P.S.1., *Female Valerio* (2000), also stands in this tradition of Broodthaers. Opposite to the slide on the wall was a panel indicating the "Rules for use of slide." The user was instructed to sign a release form, told how to slide, and then ordered to yell "clear" when arriving at the bottom.

16 Höller, in *Production*, op. cit., p. 44.

Ann Hamilton

by Judith Hoos Fox
2003

In 1985, while a graduate student at the Yale School of Art and Architecture, Ann Hamilton created her first instal-lation/performance, *the space between memory*. In this early work, Hamilton introduced speech as an element in the composition: a woman, suspended in a tilted and moving porch swing, spoke quietly in Swedish, recalling her childhood memories, distanced by time and miles. Joan Simon wrote about this work: "Here language becomes a palpable material, a flow of background tone, as subtle and yet as pervasive and multi-dimensional as the water spreading from the melting ice [referring to a 300-pound block of ice that sat on the studio floor]."[1]

Hamilton was not concerned with the meaning of the Swedish words. It was the cadence of language spoken softly, language as sound, that interested her. Seventeen years later, in Knislinge, Sweden, Hamilton created a major site-specific piece for an 18th-century storehouse on the estate where the Wanås Foundation is located.[2] In *lignum*, sound emerged from the background to become a central, defining medium of the piece: sonorous, resonant, sur-rounding, sung, spoken, and hummed tones and words that are heard and felt, that envelop and reverberate through viewer and space.

In 1999 Marika Wachmeister, director of Wanås, invited Hamilton to make a single work for the five-floor store-house. Hamilton had already used an entire building in 1991 when she created *indigo blue* in Charleston, but this was the first time that Wanås dedicated the building to a single artist's work.[3]

The storehouse, built in 1823, is part of the still-active farm. Its walls are the granite and stucco typical of this region of southern Sweden, and its roof is covered with the ubiquitous orange tiles. Outside are paddocks with animals (including Jason Rhoades's fiberglass horse, *Frigidaire [cold wind]*, 1996). Hamilton visited Wanås several times dur-ing the development of her piece. After landing at the stylish airport in Copenhagen and crossing the Öresund by the sleek bridge that opened in 2000, she would travel some 120 miles along two-lane roads flanked by gently rolling fields of wheat and through small hamlets, driving northward toward Knislinge. Stone walls mark the estate bound-aries. The grounds of Wanås—an allée of chestnut trees along a gravel drive leading to a 15th-century castle sur-rounded by formal gardens, pond, stone walls, and 17,000 acres of forest and fields—are immaculately kept. As she does in preparation for each new project, the artist walked the site, the buildings, the tilled and forested land; she studied the economy and history of the place and made contact with local and regional craftspeople and sup-pliers. All these elements are woven into *lignum*.

lignum, 2002.
View of entry room. Site-specific installation in the storehouse at the Wanås Foundation, Knislinge, Sweden.

Hamilton's early training in fiber arts is always present within her installations; indeed, her body of work can be regarded as a complex woven tapestry. That she sees each work as part of a larger whole is reinforced by her use of the lower case in titling her pieces. An element occurs in one work, just as a new color is introduced into a woven pattern, and then recurs in later works, as a color reappears in a design, the thread carried over. At Wanås, the threads of early installations come together to form a singular tapestry that is, as gallery owner Sean Kelly remarked to the artist at the opening, "every piece you ever made."[4] But the achievement of this work is that it is also integrally connected to its remarkable site, so much so that the foundation extended its duration.

A rectangular room on the ground level of the storehouse, which can be entered only from the outside, is the first entrance to the piece. This room, which Hamilton "cleared" just as she does all of the spaces in which she works, is painted white. A revolving projector of the sort she had devised for *ghost—a border act* (2000), at the Bayly Art Museum, the University of Virginia, throws against the rough white walls the continuous and circling text (in both Swedish and English), one line at a time, of *Nils Holgersson*, a Swedish fairytale by Selma Lagerlöf. This segment of the story treats a moral problem with which the protagonist struggles: having been shrunken in punishment for torturing animals, Nils now has to face the situation of a despondent caged mother squirrel who pines for her babies. This defining moment in the fairytale is immediately recognizable to the Scandinavians who visit. For foreign visitors, the words function like the spoken text in the *space between memory*, implying story time through a blocky serif typeface, evoking the elusive memories of childhood. The other elements in the room are a long moving black cord and a chain hanging through a square opening in the ceiling, a strong vertical bisecting the horizon of text. These accumulate and coil within a fenced-in square area. This shaft once served as a chute for the grain that farmers on the estate brought in from the fields. In her study of the structure Hamilton discovered this opening, which had been sealed for decades. She opened it up, replicating it at each of two levels above, and created four new shafts that channel through the vertical space, some cutting through just one more level, others through two or more.

Hamilton had similarly connected floors by making openings in her collaborative work *Ann Hamilton/David Ireland* (1992), for the Walker Art Center in Minneapolis, and *whitecloth* (1999), for the Aldrich Museum of Contemporary Art in Ridgefield, Connecticut.

Slowly traveling up and down the shafts at Wanås are reconfigured spinning Leslie speakers, made for the Hammond B-3 organ. These speakers separate the bass from the treble, with the treble issuing from the revolving cones. The bass speaker points downward. The double movement of the speakers creates a haunting tremolo. They project a rich mélange: the voices of singers in a local choir who pass sustained notes among themselves, the artist reading a poem, Charles Wachmeister reading from a 1534 text on computations and later humming, his

12-year-old daughter humming and later playing at a counting/clapping game with her cousin, the ambient sounds of the farm (grain pouring into a silo, pheasants just before hatching, cows lowing and being called). Like separate handfuls of wool spun into a single strong thread, these many aural elements projecting from the spinning speakers blend together into a seamless harmony that seems both familiar and eerie, ascending and descending in volume and through space. Hamilton first introduced pre-recorded sound into an installation in 1988; previously sound had been the result of actions performed within a piece (foghorn, water, tennis ball machine). In *still life*, part of the "Home Show" in Santa Barbara, California, selections from *Carmen* and *The Magic Flute* filled the eucalyptus-leafed room.[5]

Ten years earlier, in *malediction* at Louver Gallery in New York, Hamilton incorporated the history of the gallery building, a bakery, into the fabric of the piece, and sound became part of the subject matter: Walt Whitman's "I Sing the Body Electric" and "Song of Myself" were read softly.[6]

At the Venice Biennale in 1999, the background audio component of Hamilton's *myein* was her voice reading Abraham Lincoln's Second Inaugural Address, translated, letter-by-letter, into the international phonetic code. This was the first time she used her own voice. At Wanås, she read again, this time a poem by A.R. Ammons, the contemporary American nature poet referred to in Robert Pogue Harrison's evocative book *Forests*.[7] This book greatly influenced Hamilton as she considered the relationships between the nearby forests, the tilled fields, and the structures of the estate and the nearby hamlet.

After her initial visit to Wanås, the artist knew she wanted to do something about or with the floor as part of her installation. It is an architectural element she had worked with before: the floor was a major focus in *aleph* (1992) at the MIT List Visual Arts Center in Cambridge, Massachusetts, and in *whitecloth* (1999) at the Aldrich Museum. In *aleph*, a false floor of steel sheets created a harsh environment in a book-lined space, and in *whitecloth*, an eight-foot-diameter circle was cut into the wood floor of the museum and inlaid with a spinning mechanism. Those who dared could step onto this revolving disk and experience a kind of dislocation that formed part of Hamilton's investigation of New England Puritanism, the Shakers' bodily expression of spiritualism, and the Spiritualists' beliefs.[8] Hamilton re-used this mechanism at Wanås, setting it into a parquet floor of alternating and interpenetrating patterns that she designed with locally milled cherry and maple. Once one has stepped on the disk, one stands still and experiences the room circling around, just as on the floor below, the viewer had to spin to follow the revolving text. This floor also pays homage to the remarkable parquet floor of the private library of the castle at Wanås.[9]

After ascending the rough stairway at the end of the storehouse, one enters the second level, looking down its 93-foot length across the polished, reflective floor. The room seems to glow with warmth due to the faintly reddish-tinted filters on the windows—filters that deepen in saturation ascending from floor to floor. Hamilton had previously

lignum, 2002.
View of the package room on the basement level.

altered glass to achieve the intended quality of light in *tropos* at the Dia Center for the Arts in 1993 and *view* at the Hirshhorn Museum and Sculpture Garden in 1991. The segment of spinning floor and the majestically rising and falling Leslie speakers—the one first encountered at ground level is joined by another and the harmonic tones increase accordingly—are the other events in this long chamber.

Hamilton has said that each floor addresses another level of the body.[10] As one ascends through the building, one has the paradoxical sensation of traveling deeper into the space of the storehouse, as well as deeper into one's own consciousness. A sea of wooden tables, approximately waist high, fills the third floor. This had been the accounting room, where the records of farmers' production were made. Still evident on the wood columns are tally markings. Tables, with their multiple associations (communal and ritual sites for eating, working, and making), are consistent elements in Hamilton's installations, beginning with *lids of unknown positions* (1984) created in her studio at Yale. To use tables in such numbers, like stand-ins for the many farmers and accountants who worked in this space, is new for the artist. Made from beech felled on the Wanås grounds, the tops of these simple long worktables of slightly varied heights and lengths are carved to accentuate the grain and to suggest the trace and rhythm of the work. In contrast, carved into the tops of some tables are sharply incised lines and grids, copies of line patterns from medieval accounting tables.

The solid supporting beams of the fourth floor are meticulously wrapped with cotton sewing thread. Similarly, Hamilton used flax, a hair-like material, in the *capacity of absorption* (1988), where she twisted the fibers into a giant

rope that enveloped a 14-foot-high megaphone. And she activated another large loft space with yarn wrapped around columns in 1993, in Toronto, at the Power Plant. The artist walked miles to wrap the two columns in that space with yarn, which was then knitted throughout the duration of the exhibition. At Wanås the cotton is meticulously wound, threads never overlapping, to separate the room into 10 corridors bounded by floor-to-mouth-level fiber walls. The horizon has risen from the one created by the waist-height tables below. These dividers oscillate between opacity and transparency, depending on the viewer's position. Here, on the fourth level, one is almost overwhelmed. The flax threads resemble the woof of a giant loom, the strings of some monumental instrument. The thoughts that this gently darkened and muted space elicits become the warp of the loom, the fingers against the strings.

Arrival at the top level, under the rafters of the steep roof, brings one into the darkest and densest space of the installation. The only source of light is the one window at the far gable end of the space. The saturated red light, a beacon of sorts, draws one to the end of the room. Turning, with the window now at one's back, one discerns through the dim air the piles of clothing and quilts folded over the joists overhead. And, hanging down from the roof ridge, even more difficult to make out above the heaped clothes and linens, are fabrics twisted to become almost anthropomorphic in form. These effigies bring back the suppressed bad dreams of childhood, the dark memories omitted from the softly uttered Swedish words in the *space between memory*. Only two Leslie speakers reach this constricted top level. The sound is so much a part of us by now that it seems as though we are not hearing it, but creating it. It is inside our heads.

When Hamilton first encountered the exit space on the ground level of the storehouse, she knew instantly that she wanted shelves erected along its 45-foot wall. Only later did she learn that she was replicating the original furnishings and function of this space. Stacked on these floor-to-ceiling shelves are bundles wrapped in brown paper and tied with string. If we feel that we have opened ourselves up to dig deep within, this is the place where we can pull ourselves together, recompose our façade. But perhaps our interiors are somehow re-ordered: like Nils in the fairytale, we have experienced some kind of determining moment.

The success of the sound component in *lignum* signals Hamilton's arrival at a pivotal place in her work: she has brought together the visual, tactile, olfactory, and aural, composing with equal attention to each sense. At Wanås, Hamilton strode into an area new to her. Before, sound had been environmental or had taken the form of a single voice.[11] Here, with the resources and support of the Wanås Foundation and the Wachmeister family, she had the confidence to move into unfamiliar territory.

Lignum means "wood" in Latin, both in the form of trees and timber for building. Its second meaning is a wooden writing tablet, and the plural form, *ligni*, means firewood. The economy and history of the Wanås estate are embedded

in timber—its ornamental trees, forests, forestry industry, and neighboring sawmills. Wood has appeared in all its states in Hamilton's 20 years of work, from the wooden toothpicks that coated a wool suit in *suitably positioned* (1984) to the wood floor in *LEW Floor*, her new Seattle Public Library commission. There, Hamilton's 7,200 square feet of raised wooden type explores the LEW Collection—the department of world languages, English as a second language, and literacy—and the concept of typesetting.

Wood is at the core of Hamilton's work: a loom is made of wood; paper, books, and text are organically connected to wood. The Wanås installation brings together two fundamental elements—wood, which provides the framework for a loom, for architecture, for shelter; and weaving, metaphorically, the activity that animates the framework, that creates the tapestry and another essential need, clothing. The elements in *lignum* form a grid, horizontals bisected by verticals. The matrix for creating Hamilton's work, however, extends far beyond this essential duality: it embraces how we read experience, recall memory, and understand culture and history. **JHF**

Notes

[1] Joan Simon, *Ann Hamilton* (New York: Abrams, 2002), p. 44. This carefully researched book was essential in the research for this article.

[2] Gregory Volk, "The Wanås Foundation: Patronage and Partnership," *Sculpture* (January/February, 2001): 31–35. This article provides a full description of the foundation, its history and activities.

[3] Marika Wachmeister and Elisabeth Alsheimer, *Wanås 2000* (Knislinge: The Wanås Foundation, 2000). Janine Antoni, Miroslaw Balka, Monika Larson Dennis, Paul Ramirez Jonas, Susan Weil, and Robert Wilson have all created works for various parts of the storehouse.

[4] Conversations with Ann Hamilton and Elisabeth Alsheimer, curator at the Wanås Foundation, November 8 and 9, 2002.

[5] Simon, op. cit., p. 63.

[6] Ibid., pp. 121–125.

[7] Robert Pogue Harrison, *Forests: The Shadow of Civilization* (Chicago: The University of Chicago Press, 1992).

[8] Simon, op. cit., pp. 214, 218.

[9] Hamilton treated the ceiling inversely in *volumen* (1995), at the Art Institute of Chicago, where circular tracks attached to the ceiling allowed for curtains to swirl in a dislocating way.

[10] Conversation with Hamilton and Alsheimer, op. cit.

[11] Simon, op. cit., p. 82.

Sook Jin Jo

by Robert C. Morgan
2003

My interest in the Tao Te Ching—the great text said to have been spoken by the legendary Chinese sage Lao-tzu in the 6th century BCE—began many years ago while I was living in Santa Barbara, California. I recall those bliss-ful days, sitting and reading on the cliffs overlooking the Pacific Ocean. When I got tired of reading, I would walk for miles along the beach, collecting shells, stones, and pieces of driftwood swept by the force of the waves into the sand. In such an environment my mind moved easily toward thoughts of Eastern spirituality. After spending time each day at the seashore, I would return to my small apartment, make green tea, and contemplate a verse from the *Tao Te Ching*: "We join spokes together in a wheel/ but it is the center hole/that makes the wagon move."[1]

Many years later, after settling in New York City, I returned to this passage one day during a conversation with the Korean sculptor Sook Jin Jo. I had long admired her constructions made of found wood and was eager to learn about the aesthetic ideas behind the work. In viewing Jo's assemblages, I find it difficult not to consider the words of Lao-tzu. In a work titled *Space Between* (1998–99), she has added a subtitle that quotes directly from the concluding stanza of the passage cited above: "We work with being, but non-being is what we use."

To see the actual sculpture to which this passage refers is to understand the meaning. Jo has constructed a kind of pyre, an open structure in which branches have been cut and assembled into square units rising from the ground to a height of 10 feet. The opening inside the branches is a spatial enclosure, implying a kind of sacred space, a static hollow entity or a celestial well where spirits of heaven and earth reside. Through the horizontal placement of the branches one can see the light, thus revealing the interior from all sides. One can read the meaning of the enclosure as containing the spirit of the senses. As with many of Jo's constructions, there is an active engagement with the work as a shelter that nurtures body and soul.

One could say that the Tao in *Space Between* is built on the absence of worldly things. Without them, this empty container functions as a kind of poetry. *The Windows of Heaven are Open* (1995), composed of a horizontal line of old and empty window frames abutted against one another, with two broken folding chairs placed on the floor to the right, holds a pregnant emptiness—what in Zen Buddhism is called by the Sanskrit term *sunyata*. Here, the self is allowed to vanish, to escape the drudgery of formal analysis, the redundant theories of identity politics, and the agonizing rhetoric of otherness and subjectivity.

A similar concept is embodied in the related work *We are standing in His presence* (1998). There is a trace of cerulean paint, faded and scraped, on two upright door panels. In front of each panel is a table frame, the right one

Zen Garden, 1998.
Solar turbines and window frames, 1.6 x 30 x 20 ft.

larger than the left, that keeps the viewers at a distance. The sheer beauty and exaltation of found simplicity, as in Shaker furniture, is visual and practical. *We are standing in His presence* offers a statement of simple beauty that connects with the structural and physical elements. The form abides within itself. It transforms presence into absence and thus engages the viewer in a transcendent phenomenon.

The concept of absence in Taoism functions less as a theory than as an affinity. More than a guide, it offers an inspired way of thinking and feeling, a way of discovering the language of art. This ancient though modest transcript holds a fascinating breadth of knowledge. Many of the intuitions employed in Jo's constructions are indirectly noted in the *Tao Te Ching*. For example, there is the notion of oppositions held in suspension, the interplay and overlay between one force and another, the subtle reversals of power, the course of nature as a way of understanding the present in relation to the past and future—these are ideas related phenomenologically to the way one may approach an experience.

Space Between: we work with Being, but non-being is what we use, 1998–99.
Mixed media on wood, 120 x 70 x 68 in.

Jo works with wooden forms in the context of an installation or an environment. While the parts make up the whole, the whole is always greater than the sum of its parts. I am attracted to the deliberate lack of precision in her work, the way things come together in a crude, unfinished way. This concept of the unfinished in her magnificent wooden constructions is intentional. As she has explained in a written statement, her work intends to express "the essence of materials" as belonging to "the order of the cosmos: the ultimate revelation of why things exist."[2]

This is another way of saying that being and non-being are inseparable. But the focus on non-being is what allows being to emerge. This comes close to the spirit of Zen, a philosophy with a strong historical and philosophical affinity to the thought of Lao-tzu. In the West, the author Alan Watts has been particularly important in clarifying the relationship of Zen to the creative arts: "Although profoundly 'inconsequential,' the Zen experience has consequences in the sense that it may be applied in any direction, to the conceivable human activity, and that wherever it is so applied it lends an unmistakable quality to the work."[3]

The spirit of Zen is applicable not only to the way we think about Jo's sculpture, but also to the process by which her sculpture is made. The process evolves through the application of found objects—things from the everyday world, eroded objects that have washed up on the beach or have been deposited in a junkyard, subjected to rain, wind, heat, and snow. As our post-industrial world becomes infested with worn-out machinery and discarded gadgets piling up in our global dumping grounds, Jo has discovered in these "waste products" numerous possibilities for sculpture.

Cathedral: Korean Ex-Votos (2002) was constructed from 500 wooden objects suspended in a highly congested arrangement from the ceiling of a corridor-like gallery space. The impact of this impressive installation implied a kind of excessive fusion between Jo's indigenous Korean culture and what she acculturated from her Brazilian experience a year earlier in Itaparica (Bahia). During the two-month residency in Brazil, Jo worked on an exterior mural, collaborating with young students from the João Ubaldo Ribeiro school in a small village close to the seashore. As with previous works constructed in wood and found materials, the mural incorporated colorful objects collected by the artist each morning along the shoreline. The students were asked to creatively place the objects into wet cement, thus covering the wall with a composition of related shapes based on the indeterminate forms and colors of the diverse objects. The work was collectively titled *Vamos a Escola (Let's go to School)*. Reflecting on the two cultures, Korean and Brazilian, Jo discovered that they share a fascination with the sea, with a fluid state of mind in which objects are transformed over time and transcend the limits of their materiality in their elevated lightness.

On a visit to Brooklyn three years earlier, she discovered several discarded solar turbines, made of steel, all rusted and bent. She had them delivered to her studio in Chelsea, where she placed them in an indeterminate visual field directly on the floor. Jo became interested in the space between the rusted turbines, how they commanded the

space and, in a certain way, defined it. She decided to place an old window frame around one of the turbines, thus setting off a singular space in relation to the whole. This *Zen Garden* (1998) refers to the famous gardens in Kyoto, such as the Ryoanji, and to the isolated mountain temples north of Gwangju in South Korea. What is startling about this installation is how accurate these elements appear—like the weathered stones at Ryoanji—asymmetrically placed and irregular according to any logical standard of taste.

The question is—whose taste? From the point of view of the Zen practitioner, taste is irrelevant. The unevenness in the placement allows the spirit of the form to reveal itself, to exist in planar terms, without elaboration or accessories. From a Zen perspective, unevenness represents an aesthetic that is never new, but a reinvigoration of old materials, an energized space. The success of *Zen Garden* is based precisely on the premise that indeterminacy is the basis of thought, at least, in terms of Zen thought, which according to the sutras is without deliberation or forethought. The form simply reveals itself in time and space without an afterthought, yet is potent with inspiration and illumination—a true witness to the status of the chance encounter over predetermined ideas.

In keeping with her sculptural aesthetic, Jo was commissioned to build *Meditation Space* (2000), a work using tree trunks, branches, and old floorboards from a former Zen Center in upstate New York. It was conceived in such a way that the structure becomes virtually transparent by optically disappearing into its forested surroundings. *Meditation Space* appears nearly as a mirage, a specter, a dissemblance of material reality within the scope of nature's force and intrinsic power—a parallel statement to the force of the Tao itself—a compelling work of art that reclaims peace and reconciliation in a chaotic and desperate world.

In a work such as *Meditation Space*, which coincides with its environmental habitat so completely—as, on a grander scale, Frank Lloyd Wright's Falling Water does in Bear Run, Pennsylvania—the consciousness of non-being comes alive and is transformed into consciousness. Here, the wheel of harmony and the unity of oppositions begin to turn. In the forest, amid the growth of plant and animal life, and their concomitant decay, the inner-spirit of Jo's work may be felt. This kind of overlay between physicality and dematerialization is precisely what the art of Sook Jin Jo aims to achieve—an essence of objecthood that exists concurrently between two worlds, the material and its unknown spiritual counterpart. **RCM**

Notes

1 Lao-tzu, *Tao Te Ching*, translated by Stephen Mitchell, (New York: Harper Collins, 1988), Verse 11.

2 Sook Jin Jo, untitled statement, 2002.

3 Alan W. Watts, *The Way of Zen* (New York: Pantheon Books, 1957), p. 146.

Alice Aycock

by Brooke Kamin Rapaport
2003

Alice Aycock, the public artist and sculptor, is at work in her Lower Manhattan studio. In the background, National Public Radio blares, broadcasting the anxieties of the day. She does not turn it off. Not for a visitor. Not for the art dealers she speaks to on the telephone. Not for her studio assistants. Since September 11, 2001, when she climbed to the roof of her SoHo loft building and witnessed the terrorist attacks on New York City first hand, Aycock has hung on to news reports as if life depended on them. To be uninformed is to be buried. Aycock's work has always relied on voracious combinations of erudite and accessible sources. Today, the unfolding events of our time seep into her sculpture as naturally as the mythological and scientific studies that she relied on in the past. Across the range of her recent work—drawings, sculptural objects, public projects, and installations—Aycock seeks to place the complexities of our uncertain moment within a larger sense of history.

The urgency of her recent work is nowhere more apparent than in a proposal she was invited to make in 2002. Aycock and 20 other artists were asked to submit proposals to a competition for an indoor public memorial, sponsored by the American Express Company to honor members of its corporate family lost on September 11. The requirements were broadly defined. American Express sought a "fitting tribute to 11 employees…who were hard at work at One World Trade Center…when the terrorist attacks occurred." Aycock proposed a large aluminum sculpture of swirling forms with an interior set of off-kilter stairs realized in mirror and glass. At 19 feet high, dwarfing human scale, the proposed piece and its stair drew the eye upward, heavenward. Victims' names were inscribed at each level. A green form at the center, summoning the neck and scroll of a violin, suggested an elegy played at each step of a journey. The memorial might have been among the finest of Aycock's many important contributions to public art over the course of the last three decades. Yet for all the sculpture's emotional resonance, the American Express panel selected a proposal by someone else.

The disappointment may have been particularly acute for Aycock. While she works constantly and is teeming with ideas, she has not received as many notable commissions in recent years as might be expected. After her renown in the 1970s and '80s as a public art innovator, one might ask what Aycock has been doing. The art world hasn't heard very much about her since her acclaimed retrospective at the Storm King Art Center in 1990. So why the silence about her work?

Perhaps the silence says less about the vicissitudes of one artist's career than it does about the role of public art itself at the present time. The field is riven by many unsettling questions about the nature of public art and its purpose. In theory, what kind of work falls within the realm of "public art" in the first place? And in practice, have the

Functional and Fantasy Stair and *Cyclone Fragment*, 1996.
Structural steel with painted steel sheathing, cone:
24 x 22 ft.; stairs: 28 ft. long.
Work installed at the San Francisco Main Library, San Francisco.

particular kinds of work being produced now become Disneyfied to the point of irrelevance? Indeed, don't many ambitious examples of contemporary architecture have greater bearing on the character of our public spaces than does so-called public art? Underlying such questions is a broader sense that, for a number of years, we have lived in an era of artists burdened by bitterly fought public art controversies—notably the one surrounding Richard Serra's *Tilted Arc*—which may have soured many people, perhaps permanently, on the whole idea of public art. It remains to be seen whether the nascent memorials and monuments inspired by the events of September 11 will eventually win a new place for public art in the national consciousness, as the unexpected success of Maya Lin's Vietnam Veteran's Memorial did two decades ago.

These issues about the past and future of public art deeply concern Aycock, who said recently, "The more the world becomes just a franchise, the more imperative it is to go against the grain; to be idiosyncratic and independent." This is what she continues to do. In recently realized projects and others still in draft form, she challenges viewers' expectations, and her own. "My job is not to give you what you think you want or are comfortable with," she said referring to public art competitions. "My job is to do something that is exciting and interesting and not about the everyday."

In the same breath, however, Aycock re-affirms her commitment to enriching people's lives through her work: "I talk to people and explain things," she says. "It's a way of breaking out of the elitist art world. I don't deal with ideas that are so theoretical that only a graduate student will understand them."

Aycock has also been a champion of bringing younger artists into the public art fold. Tom Eccles, the director of the Public Art Fund in New York, recalled recently: "We worked hard together when she was a board member of the Public Art Fund. Alice helped us to establish the In the Public Realm program—an opportunity for emerging artists to undertake the challenge of creating a temporary work in a public space." Further demonstrating her commitment to future generations of artists, Aycock has spent two decades mentoring students. A former chair of the graduate program in sculpture at Yale, she was on the faculty at the School of Visual Arts during the 1970s, and she teaches there again today.

In the last few decades, the very definition of public art has expanded and shrunk, becoming clearer and more con-fused. In *Public Art Review*, Patricia C. Phillips wrote in 1999: "Public art excludes no media, materials, or process…It can be momentary or lasting. It can at once excavate the past and envision the future…It can hap-pen at almost any time, with anyone, and virtually anywhere."[1] That all-embracing definition can catch practically any kind of work of art in its wide net.

In a 1979 speech, the artist Robert Morris also sought to define public art. His precision is helpful in understanding the work of Aycock and many other public sculptors. "[T]he term public art has come to designate works not found in galleries or museums (which are public spaces), but frequently in association with public buildings, and funded with public monies."[2] Morris further described works that are "invariably manifested outside and... generally of a large scale."[3] Morris's ideas locate public art in a space beyond the prescribed art world. As Tom Finkelpearl wrote in the preface to his book *Dialogues in Public Art*, this kind of work was "meant for anyone interested in art outside the walls of the museum."[4] In addition to this basic concept—large-scale outdoor works in public "non-art" places—there is another form of public art: a community-based activity, as an artist comes to a particular location and conceives of a project inspired by local people, history, and current events.

Morris's ideas were a formative influence on Aycock; she was his student in the early 1970s at Hunter College (where she received an MA). She has since worked on a wide variety of public projects, whether objects for particular buildings (realized with public or private funding), freestanding sculptures, or site works. Just as important to her was the ethos of the times in which she developed: in the 1960s as a student at Douglass College in New Brunswick, New Jersey, she came of age in an art world burgeoning with the Pop, Minimalist, and Conceptualist movements, an environment of seemingly limitless creativity. Those were heady times for a young artist, full of the possibilities that the liberal political climate of the period afforded women artists—the freedom to explore the new and untested.

Aycock's early works began to envision the new possibilities. *Segment of a Cloud Piece* (1971), a photographic essay in grid patterning, catalogued the transience of a natural form. Her mission was a call to provoke people into investigating their surroundings: why a cloud's shape changes; how an individual experiences the flux of the natural environment; or what it means to cross a geographical boundary, as in her first conceptual work, *Tropico de Cancer: Boundary Line 23 1/2 Degrees North, Tamaulipas, Mexico* (1974).

In 1975, Aycock created a piece that combined a Minimalist vocabulary with an interest in public participation in an architectural setting. On a farm in Far Hills, New Jersey, she built the 50-foot-long *Simple Network of Underground Wells and Tunnels* (now destroyed). To experience the work, part bunker and part cave, visitors descended a ladder and followed below-ground passageways. There, they began to lose the sense of connection to everyday life as they moved through the interior pathways. Light came only from occasional rectangular openings to the surface. In an era of grand gestures by Earthwork artists such as Michael Heizer and Robert Smithson, who strove to make artworks out of the vastness of the American West, Aycock's East Coast project framed a modest statement that embraced a more human scale.

A Simple Network of Underground Wells and Tunnels, 1975 (destroyed).
Concrete block, wood, and earth, 28 x 50 x 9 ft.

In 1977, Aycock's *Project Entitled The Beginnings of a Complex...for Documenta* was presented at Documenta 6. Her wood and concrete "buildings" formed a Potemkin village of empty façades standing in a field, their towers evoking Kassel's historical architecture. Like a fortress or a castle from the Franconian rule of the city in medieval times, the work included a simple ladder for visitors to climb up into one of the towers. But there was nothing to see once one ascended, perhaps an allusion to the bombing of Kassel in World War II. The 32-foot-high main tower existed as a roughcast structure, its condition wavering between collapse and completion. The piece was subsequently destroyed.

By the 1980s, Aycock's work moved away from rough-hewn, hand-built environments with their celebration of the way the body moves through and experiences built structures. Instead, she began to investigate industrialization and technology and their effects on individuals. She created sleek machines that spun and whirred, produced heat and wind. These threatening devices had no purpose but their own existence. In creating them, Aycock not only used scientific and scholarly sources, but also drew on the lore of demons and animals and on certain historical figures.

The Savage Sparkler (1981) is a 10-foot-high and 20-foot-long machine. Devoid of a rational function, it is a purposeless thing. Its aluminum fans, copper tubing, fluorescent lights, whirring motors, and rack of hot coils,

if they evoke anything at all, suggest a futuristic drying apparatus—but one that pivots toward the sun, striving to grasp its light. Unlike Aycock's earlier work in which the viewer—or the artist herself—could readily take part, *The Savage Sparkler* repels. Only the foolhardy would dare step up to this object as it noisily moves and emits heat.

A sharply contrasting work, *Three-fold Manifestation II* (1987), was the centerpiece of Aycock's 1990 retrospective, "Complex Visions," at the Storm King Art Center. Its three elliptical bowl forms of white-painted steel stood out against the surrounding landscape of lush, green fields. Like an outsized marble chute, the engaging object features sleek passageways that lead the eye visually up and down its ramp. Aycock meshes the imagery of a childhood toy with the organic backdrop of the outdoor setting.

Aycock's work from the 1990s to the present is a compendium of commissioned work that demonstrates feats of engineering. Her favored materials—steel, aluminum, advanced plastics—must be of industrial strength to withstand weather conditions and the wear and tear of exposure to the public, including rogue teenagers. She has realized large projects at the Sacramento Convention Center (1996), the U.S. Airways terminal at Philadelphia's International Airport (2001), and *Dallas Dahlia*, a 25-foot-high motorized aluminum flower for the new police headquarters in Dallas (2002). She has made drawings and proposals featuring an outré jellyfish spitting into a gigantic porcelain teacup; a fountain in which the flow of water is mimicked by other circulating materials; and a stage set titled *Waltzing Matilda*, where dances from various cultures and historical periods interact.

Aycock's current objects are often drawn first on a computer with the help of an assistant. Although Aycock says that the computer renderings are "idealized," they provide a working two-dimensional image that helps her to achieve three-dimensional malleability. Once a project has been approved, she credits the technical expertise of her collaborators, often engineers, with making the work a reality. "They make it possible," she affirms. When the public finally sees a work, her goal is to tweak the individual's everyday perception. "You have to look, to consider, to pause," Aycock says.

In 1992, Aycock used a "machine age" form in *Roof Sculpture for the 107th Precinct Station House* in Queens, New York, a building designed by Perkins Eastman Architects. Perched atop the police station's roof like an electronic transmitter, her quirky, Constructivist-style fiberglass dome with painted steel elements rises 23 feet above the building. Aycock says, "The sculpture is meant to represent communication—always an important part of the role of police in any community." Indeed, the object's placement, easily seen from the ground and the adjacent buildings, suggests a dialogue with the borough's hectic street life. The work has several parts: a disk with a stepped form inside faces out, a steel cone points downward, and visual points of entry including a door, an abstracted stairwell, and a ramp dominate the complicated form. *Roof Sculpture* was commissioned by New York City's Percent for Art Program.

What do people in the neighborhood think of this Rube Goldberg-like addition to the rooftop of their local "big house"? Do they think that it's art? Or does its appearance—peering down at them with its mechanical elements—suggest a police surveillance device? Aycock relishes these questions as she strives to make people think about the objects in their daily lives. "It is what you see, and it has a vocabulary a lot like the world," she said recently. "That's what it is and that's what it means. It's an architectural vocabulary, but it's not used in the normal way."

That architectural vocabulary was the key to Aycock's major commission for the new San Francisco Main Library, which opened in 1996. Her contribution was funded by a local California ordinance allocating up to two percent of a new building's construction costs for art enrichment. The library features three works authorized by the San Francisco Art Commission and accomplished with the library's architects, James Ingo Freed of Pei Cobb Freed & Partners and Cathy Simon of Simon Martin-Vegue Winkelstein Moris. The artists Nayland Blake, Ann Hamilton, and Ann Chamberlain were also selected for library works.

Aycock's *Functional and Fantasy Stair* and *Cyclone Fragment* in the library's atrium are two elements of a 24-foot-high engineering feat of aluminum, structural steel, and painted steel sheathing. *Functional and Fantasy Stair* is a spiraling object designed to fit between the fifth and sixth floors of the library's reading room. It is a paean to literacy and the ability of knowledge to transport the individual (literally and figuratively). Aycock had incorporated stairs in earlier works, mostly as a formal stepping-stone to direct the viewer's eye from one element to another. In the San Francisco piece, however, stairs are transformative. It is as if the individual, entering the atrium in a benighted state, is finally overtaken with discovery. Here, the staircase climbs to encircle a broken-up cone of aluminum. The ascending stairs then dissolve into space, scattering with the sheer possibility of truth.

The geometry of the staircase is transformed into an accordion shape in *East River Roundabout*, a 100-foot-long piece that inaugurated a waterfront park pavilion at the east end of 60th Street in Manhattan in 1995. A lengthy roster of public and private organizations joined to sponsor and fund the project. It was commissioned by the East River Waterfront Conservancy, the Parks Council, the Municipal Art Society, and various civic groups; funding was provided by the New York Hospital and the Hospital for Special Surgery; the pavilion was designed by Quennell Rothschild Associates/HOK. Aycock found inspiration for this work in disparate sources, from Fred Astaire's dance movements to the particle diagrams of quantum physics.[5] The elongated accordion fans out to become a roof amid roller-coaster-like curves that shoot up into the city skyline. These organic curlicues stretch over a supporting steel roof. Visitors can walk under the geometric "bridge" and exhilarate beneath the swerving ride of abstract art.

Similarly, Aycock's 60-foot-diameter project at John F. Kennedy International Airport rises above viewers' heads. *Star Sifter: The Rotunda Project for Terminal One* (1998) incorporates the motorized elements from her 1980s machine pieces while trawling the universe for sculptural forms. Constellations, galaxies, and ideas of space travel are all sucked into her cosmic configuration, which pulses in and out, transforming a once mundane waiting room into a seat in the heavens. Tired, bored travelers waiting for their flights now see an optimistic vision of air travel's potential future.

And now, after decades as a public artist, after 9/11 was dropped on her doorstep, after the trials and tribulations of competitions and corporate proposals, where is Aycock drawn? To a garden. "One thing that's come into the work," she said recently, "I crave doing a garden." It is a nurturing symbol for her, based in childhood memory, and steeping over the years as a sign of what is good. "My grandmother had a garden. It was a world. You could move on the paths and tell stories. It became a universe." In Aycock's own secret garden, childhood imagination has become adult inspiration.

After a career that has plumbed and endured the machinations of the public realm, Aycock's dream project connects the misty recollections of youth to the syntax of adult life. She conjures a favorite text, *Invisible Cities* by Italo Calvino. He writes about cities and the garden where the aged Tartar emperor Kublai Khan relaxes with the young Venetian explorer Marco Polo. Inspired by these scenes, Aycock would like to complete a dance garden and an erotic love garden. As in her sculpture where inspiration pirouettes within the imagination long before appearing in three dimensions, Aycock wants to pattern the garden's form on the steps of the elegant French society dance, the minuet. "You wind your way through the paths," she says, emphasizing the romantic possibilities of partnership in verdant, perfumed passageways. "In some abandoned part of the city, I would love to take a deserted place and do this." Aycock, who has built some lasting monuments to contemporary culture, may just realize her dream. **BKR**

Notes

1 Patricia C. Phillips, "Dynamic Exchange: Public Art at This Time," *Public Art Review* (Fall/Winter 1999): 4.

2 Robert Morris, "Earthworks: Land Reclamation as Sculpture," in Harriet F. Senie and Sally Webster, eds., *Critical Issues in Public Art, Content, Context and Controversy* (Washington, DC: Smithsonian Institution Press, 1998), p. 250.

3 Ibid., p. 251.

4 Tom Finkelpearl, preface to *Dialogues in Public Art* (Cambridge: MIT Press, 2000), p. viii.

5 Monroe Denton, *Alice Aycock at Grand Arts*, exhibition brochure, (New York: Grand Arts, 1995).

Charles Ginnever

by Bruce Nixon
2004

Charles Ginnever was on vacation in Maine in 1993 when he went to work on a design that had already been in his mind for a while. He started, as he often did, by tinkering with shapes cut from foam core; when he was done, he had produced an object that could stand freely in 11 positions. By the time a full-scale version of the piece was constructed at mid-decade, further adjustments enabled it to stand in 15 positions, and as a design it fully declared the sculptural concerns that had occupied him for more than 30 years. He called it *Rashomon*, borrowing the title from Akira Kurosawa's film version of a novella by the early Japanese Modernist Ryunosuke Akutagawa: after a number of witnesses to a particularly heinous crime are questioned at length, police investigators are startled to find that each story differs from the others in some distinctive way. For both Akutagawa and Kurosawa, this unreliability of witness, based, of course, in the sheer subjectivity of vision, offered an exemplary demonstration of the Modernist program. The reference is just as precise for Ginnever, though it is not bound to anything as specific as literary Modernism. He had discovered that the sculptural *Rashomon*, an open geometric form without right angles or parallel lines, not only stood in a remarkable number of positions, but it was the rarest of witnesses who could recognize it as the same work from one position to the next.

Ginnever was not surprised. To him, the situation reflected the sorry state of the Western spatial imagination. The argument of *Rashomon* is that many centuries of architecture, urban planning, and perspectival systems in art—all based on the right angle and consequently insistent on both the readability and predictability of spatial configurations in the human environment—have dulled our ability to anticipate, even to perceive the complexity of form in space. The tendency to control space with form has tangibly altered our sense of what space is, and so we move through a rich, challenging, often exhilarating world of forms without seeing all that is really there, insensitive to the implications of our loss. The origins of this condition are various, and by now perhaps impossible to differentiate, but they must lie to some extent in social and philosophical systems that support the drive for human domination over the natural world—that the world is a place that can and should be controlled.

Like most of the large-scale steel works that Ginnever has been building since the late 1960s, *Rashomon* is unremittingly experiential. If at first glance it suggests itself to be another of the big, weathered steel objects now familiar in public and outdoor settings, there is something enigmatic about it too, a strangeness that beckons to us. It requests our participation. We approach it, and as we walk around the piece, it reveals formal shifts that were not initially apparent. It is not what it appeared to be, and soon we realize that no single view or perspective will reveal it in its entirety.

A lot of large-scale sculpture is meant to pique our interest by arousing a specifically visual curiosity, and we have grown accustomed to the visual sleight of hand at the heart of these designs. Ginnever is more ambitious. His goal,

Rashomon, 1998.
Steel, 13 x 13 x 13 ft., three units.

well before *Rashomon*, has been to reveal, in a literal, empirical way, that perceptual experience is inseparable from the continuum of space and time in which the experience occurs. The work may prohibit a single comprehensive perspective, but, in fact, the locus of experience lies in the viewer, who can only reveal the work over time, from a continuous, seamless multiplicity of perspectives. Thus the work (ideally) catalyzes the surprise and delight of visual possibility and stimulates a creaky spatial imagination.

A row of 15 maquettes on a narrow tabletop is pretty jazzy, like a line of jagged, swooping, contorted dancers, but Ginnever envisions an ideal setting in which 15 full-scale pieces are spread across a landscape, each in a different position. (In the largest installation to date, three 13-foot *Rashomons* were placed on the Stanford University campus in 2000, where they remained for two years, providing a lesson in the problems of site. They stood among the groves near the university art museum, where they were difficult to see in a long perspective and even more difficult to see as a network of related forms.) Yet, if *Rashomon* can be said to constitute a critique of deeply embedded

cultural values and the world view in which they originated, it has no desire to draw attention to shortcomings in the individual observer. It wishes primarily to provoke the perceptual imagination, and it is not a harsh instructor.

When Ginnever arrived in New York in 1959, he had already been working for more than a year at a large scale, using railroad ties to construct open, exuberant forms—one thinks of David Smith's notion of drawing in space expanded to the proportions of a giant. These works stood firmly on the ground, refusing to separate themselves from the viewer's space and offering little sense of front or back or side, with no spine or obvious center to establish an orientation for the viewer. Writing about the young sculptors in the city for *Arts* magazine in early 1965, Max Kozloff associated Ginnever with George Sugarman, David Weinrib, Mark di Suvero, Tom Doyle, and Ronald Bladen. These sculptors shared, he noted, "a sculptural syntax that stresses extendibility and the proliferation of forms through space." For Kozloff, the work of these artists showed the breadth of sculptural response to contemporary conditions; it was typically anti-illusionistic, preferring instead to act against visual and, indeed, sculptural expectations.

Today, most of these artists are well known individually, but their appearance as a group, at that particular moment, remains under-appreciated, partly because their variety resists the summary qualities of a movement and partly because, as a group, they do not adhere to the art historical trajectory of painting during the same era. The work tends to be profuse, incorporative, hot rather than cool, and indifferent to prevailing doctrines. Ginnever worked in many of the current modes, from performances and happenings to painted assemblage. The numerous tabletop-scale constructions that he made during those years often suggest inside-out versions of John Chamberlain's work with crushed automotive sheet metal, striving for an expansiveness of form where Chamberlain seeks compression and a terse discontinuity of surface. But even Ginnever's assemblage works ask to be circumnavigated, and, regardless of size, their wily formal shifts can spark considerable surprise.

As a Californian, Ginnever brought certain concerns of his own to this wide-open sculptural environment. He had grown up on the San Francisco Peninsula, where the crystalline and vast creeping fog banks can produce unusual visual disjunctions that distort cursory readings of space and distance. For him, the mysteries of perception had always been an issue. This, of course, was hardly a novel theme in art: investigations regarding both the subjectivity and the unreliability of sight constitute a significant aspect of the modern tradition. Ginnever had gazed across great distances in much the same way that Cézanne had, with similar questions, and he would become one of the first artists to probe the nature of spatial experience using predominantly abstract sculptural forms; it is a theme that continued in the subsequent decade in the hands of Richard Serra and others.

Ginnever's breakthrough work during this period was *Dante's Rig* (1964), a large, loosely vessel-shaped construction consisting of a hammock-like frame, lots of guy wires, and two rows of quivering trapezoidal aluminum "wings."

A work of ethereal lightness, it was shown in New York at the Park Place Gallery, sharing the space with work by Peter Forakis, and was widely seen by other sculptors in the city, at least some of whom recognized its originality and daring. Within its atmosphere of fragile, tentative reference, *Dante's Rig* can be characterized by several related elements: it develops an implied, insubstantial, finally uncertain volume, one in which edge is never clearly defined, or is defined schematically by the use of wires. As a result, the work seems to dissolve at a distance, especially outdoors; as we approach, however, it seems to tingle in skittish, light-footed interaction with the space immediately around it. By the same token, its rendering of form is so different from various points around its periphery that it defies reflexive readings, requiring instead that the viewer be attentive to the experience of engagement. In the end, the leap from the transparency of *Dante's Rig* to the puzzle-like geometry of *Rashomon*, a kind of Rubik's Cube of the spatial imagination, is not very far at all.

Steel permits durability and scale, but, for Ginnever, it had the additional attraction of strength. The combination of material and scale allowed him to erase the kinds of sculptural gestures that typified his work before the mid-1960s—his work is not about personality. But most important of all, anything he imagined could be built in a stable form, and, as a result, a good deal of his work, well into the 1980s, is based on complex, often irregular rectangles and trapezoids arranged in extended, gravity-defying stacks or modular networks. These forms generally have their own internal planes, and so they tilt dramatically or seem to be spinning crazily across space. Many, including *3+1* (1967), the untitled constructions made between 1968 and 1971, large, planar forms such as *Fayette (For Charles and Medgar Evers)* (1971), the jazzy *Dovecotes* (1972), and *Détente* (1974), seek some pretty dramatic formal shifts. In a "frontal" position, they appear to be immense or impossibly heavy, only to disappear from another vantage point or suddenly to reveal some unexpected hole in space.

These, too, are works of intense visual delight. But for all their high spirits and formal extroversion, they are decidedly peripatetic. Like di Suvero, Ginnever is quite skilled at playing against visual habit—where the eye expects gravity to exert itself, the work springs into space, and as the spectator moves around it, a reading of material weight is challenged as the forms seem to disappear, as though suddenly weightless. This is not mere novelty. Ginnever enjoys working with big forms, but it is serious play. Everything exists to demonstrate the ways in which we interpret form, in its presence and in real time—what we miss as well as what we see.

Still, these forms do little to hide their means. It is very easy to see how they have been put together. With the feeling that this put him, like di Suvero or Tony Smith, too firmly in a strict Constructivist tradition, Ginnever overcame the condition during the mid-1970s in a remarkable sequence of works based on triangular forms (in actuality, they are parallelograms bent along diagonal lines) that lean or tilt precariously into each other. Some especially strong individual pieces from the series include *Daedalus* (1975), *Nautilus* (1976), *Protagoras* (1976), *Crete* (1978),

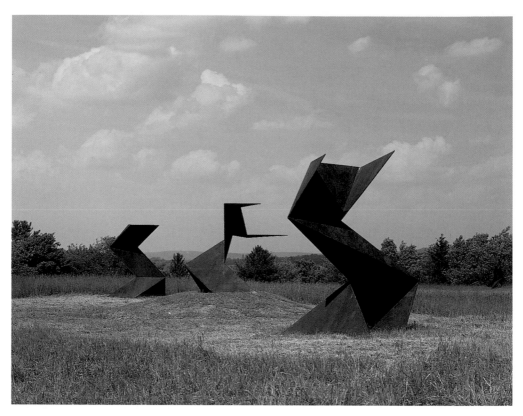

(right to left)
Luna Moth Walk I, 1983, steel; *Luna Moth Walk II*, 1985, steel; *Luna Moth Walk III*, 1982, steel.

and *Koronos II* (1978). These sculptures are integrated with the earth on which they stand, contesting the architectural space around them, but, in their crazy tilt, they seem to be holding themselves in place against all odds, with a precarious delicacy of balance at odds with the weight of the steel. As in some of Serra's large steel installations, material weight adds a bodily sense of peril to the formal shifts. And while the outer edges of the forms may suggest a comprehensive, generic shape—a pyramid, for instance—they in fact look quite different from every perspective.

Writing about an indoor installation of *Daedalus* for *Art in America* in mid-1976, Carter Ratcliff observed that commonplace assumptions regarding geometric sculpture did not apply to Ginnever: meaning resided entirely in, and was limited to, direct experience. He recognized, as well, that these designs lie outside the logic of Western spatial design and that Ginnever was attempting to shift responsibility for the experience of the work away from the kinds of cultural determinations embedded in Western spatial systems. The work would always be different, for each viewer, each time it was seen. Ginnever represented an alternative to Western spatial concepts, in other words, by rejecting the reassurances of a predictable right-angled space.

Walking Man, 1994–95.
Fiberglass over steel, 56 x 57.5 x 19.75 ft.
Work installed in Munich, Germany.

Walking to the Sky (detail), 2004.
Stainless steel and fiberglass, 100 ft. high.
Work presented by TishmanSpeyer Properties and organized by Public Art Fund,
installed at Rockefeller Center, New York.

stands adjacent to the Messeturm in Frankfurt, Germany. The man hammers while we work, play, and live out our lives. The image holds universal appeal and evokes layers of meaning: the artist as worker, the countless laborers who work with their hands, the model citizen. For Borofsky, it is part of himself: "The worker in myself…if I can get myself moving and start doing something physical, I usually feel good." This mysterious hammering man stands as a constant reminder, banging out a silent tempo, measuring time with each strike of the hammer. Through him, both the public at work and Borofsky at work stand dignified.

Similarly, Borofsky has adapted his persona and its manifold incarnations (running men, dancers, molecule men, stick men, and men with briefcases) to the outdoors. In this world, art is no longer protected by a small supportive audience of well-wishers, collectors, and dealers: it has now entered the world of CEOs and board rooms, selection committees and juries, politicians, art councils, cultural and municipal agencies, public art administrators, engineers, fabricators, designers, and architects, all of whom are engaged in and part of the dialogue by which the work is proposed, conceptualized, and accomplished. This is a far cry from the studio, with its solitude and self-editing. Faced with this world, Borofsky has condensed his ideas, moving from the pluralistic zeal of his multi-part installations into more specific and determined single statements. "Minimal with content" is how he likes to describe it.

Few sculptors can manage the scale shift from human to superhuman, to take a work that is meant to stand on the floor of a gallery or sit neatly on a pedestal and enlarge that same idea to meet the challenges of architectural space. Calder did, Picasso did not. Giacometti's figures reached toward this scale, but in the end he, too, limited his ambition. Tony Smith and Ronald Bladen achieved monumental scale, but they adhered to architectural paradigms and Modernist abstract principles. Unlike others of his generation, Robert Smithson or Michael Heizer, for example, Borofsky in this phase of his career did not leave the gallery system in order to work on a large scale in nature. He simply stepped out of the gallery into the urban environment and embraced the setting to make it his own in sculpture that he has called "easily digestible." Borofsky makes these statues of the common man (and woman) as another kind of self-portrait, gigantic in proportion and scale, taking his message into the traffic and congestion of the city and more directly to the people. The international appeal of these monumental and dynamic constructions continues, as works are proposed and built in Canada, Germany, Switzerland, Japan, Korea, and the U.S. Native language, cultural differences, and political allegiances present neither barriers nor impediments to the understanding of what Borofsky is expressing through these enormous works. Those who choose a Borofsky piece for their site do so with a knowledge that the nature of the work will be mostly understood and accepted by their varied audiences: sightseers, city dwellers, travelers, the curious, art lovers, even dubious politicians and cynical critics.

The context of these works strongly suggests and influences their ultimate meaning, so that the individual locale and historic character of a place will be entwined within the meaning of the work for those who confront it.

Politics aside, the spiritual message is clear and the idiom is not abstract: it is definitely and defiantly representational. *Freedom* in Offenburg, Germany, is a case in point. Borofsky states that "the sculpture is meant to commemorate the role Offenburg played in the democratic development of Germany. Offenburg was the starting point of the democratic revolution, which took place in Baden. On September 12, 1847, the Demands of the People of Baden were made public in Salmen Hall at the assembly of the Confirmed Friends of the Constitution. Two further publicized meetings were held in 1848 and 1849, both ending in an appeal for revolution. After the defeat of the revolution, many sympathizers had to flee or were ruined economically. Nevertheless, the 1847 demands still hold a significance today. Many of them were used in later German constitutions, and are an important part of the present constitution of the German republic."

The spiritual nature of Borofsky's work is tied to social and political views, to a deep regard for the individual and a respect for character—this no doubt instilled in him by his musician father and architecture-trained artist mother who opened the world to him, made it a place to explore and to be actively engaged as an artist. Among his most recent installations is *Walking to the Sky*, commissioned by Rockefeller Center, facilitated through the Public Art Fund. It is a work placed in the heart of the world, so to speak, Rockefeller Center's 11-acre site in the middle of Manhattan. With this piece, Borofsky has re-engaged an earlier idea, *Male Walking to the Sky*, presented at Documenta IX in 1990, a work that comes from an even earlier drawing (1977). In the Kassel work, a solitary man walks skyward. The new version of the tableau is more complex, and there are more figures of particular types and characters, different in age, race, and gender—"all kinds of human beings," Borofsky says. The three figures on the ground appear to act as both observers and observed, as if in a Greek drama: they watch the figures walking toward the sky, perhaps knowing their fate. For many, the image will undoubtedly evoke memories of 9/11, souls rising, people moving on; yet the beings portrayed are marching in an orderly fashion, striving toward goals or destinies, seemingly moving to the future. Borofsky again speaks to his audience through these figures, reminding us that our shared commonality, our humanity, is the knowledge that we are here to achieve. At the same time, his ensemble also serves as a respite—a place to go and reflect, separate from the teeming crowds and the din that surrounds and fills the site.

In 2003, in Toronto's new international airport, Borofsky completed and installed another group of figures, only this time they hang some 30 to 50 feet above the floor. Like an acrobatic formation, they are sheathed in brightly colored, translucent skins and appear both weightless and buoyant. *I Dreamed I Could Fly* comes from both a drawing and a painting, but it is also akin to numerous installations in which Borofsky or a surrogate appears to fly. With this installation, the act of flying is given over to five figures, suspended below a 40-foot-wide skylight in the ceiling of the terminal. The figures are schematized, simple outlines or streamlined forms. The distinction between figures is more in shape than details, avoiding the issue of nudity altogether. In fact, these symbolic figures have no identi-

fying characteristic or feature that would make their narrative more explicit. They are images of the mind, and, because they are imagined rather than real, they represent the idea of the human, the character or the presenter of a political or social ideal. In Germany, a word for it is "freedom," in Baltimore, it is "humanity." But the figures are always some aspect of Borofsky himself, bigger than life, standing, acting, and finally guiding us through his personal thoughts and visualized actions. Art, as Borofsky proclaimed in a 1989 lithographic print, is for the spirit; it is no less true today than it was 15 years ago.

This past spring for the city of Baltimore, Borofsky prepared another vertical piece, a somewhat Jungian archetype of a male/female figure commissioned by the Municipal Art Society and placed in front of Pennsylvania Station. The brushed aluminum sculpture stands 51 feet tall. A pulsating LED sits where the two figures intersect; the light emitted over a 60-second cycle ranges from cobalt blue to fuchsia, denoting spiritual energy. "The whole idea of this piece is two energies becoming one," Borofsky says, "two energies coming together to create a greater force." Or, as one passerby shouted with delight as he walked by the piece on the day of its unveiling, "It's humanity!"

In late 2004, in the town of Verden, southeast of Bremen in Lower Saxony, a bank, Kreissparkasse, is placing another aluminum walking figure in front of its headquarters. Conceived as a single continuous, drawn line, it includes the outline of a figure astride, drawing both into space and around space. The sculpture is industrial in appearance, a grand Léger-like walking machine. The sculpture's contours are articulated in the shoulders and hips to underscore its motion and mechanized appearance. This piece echoes the determined pace of an earlier six-story *Walking Man*, completed in 1995 and on view on the fashionable Leopoldstrasse in Munich.

With this growing and highly observable oeuvre, Borofsky continues on a path that articulates his public spirit. Working in the world, outside the confines of the contemporary gallery scene, he is broadening the sense of what his art can be and what mission it can achieve. **MK**

Tony Oursler

by Elaine A. King
2005

Part of a generation raised on television and a witness to the ongoing explosion of new electronic media, Tony Oursler realizes that technology is capable of controlling and even dehumanizing us as a race. For him, "technology is the real 'heart' of our age, continuously surrounding, influencing, and changing us." At the onset of his career, he perceived how technology compels people yet simultaneously intimidates them. He has remained interested in how technology makes individuals feel uneasy despite its commonplaceness and its penetrating impact on global society. Oursler embraced technology as an artist's tool not because it was hip or trendy, but because he saw it as a means of probing the inner self—a liminal zone where abstruse truths abound but are faintly perceived. His steadfast experiments over the past 25 years make apparent that all along his work has anticipated swift advances in the production and transmission of signals, emanations, images, and codes.

Raised as a Catholic, Oursler continues to be fascinated by contrasts between good and evil, right and wrong. He capitalizes on such dual forces to empower technological sculptures that break down barriers between art and life, between the work and the viewer. He recognizes that the bizarre and the uncanny, together with the old dialectics of good and evil, science and magic, still endure today, magnetically enchanting the human psyche. These antithetical forces behind human life are at the root of his artistic productions, along with his interest in humanism and society's relationship to technology and science. Magic and superstition hold a special place in his psyche: wizardry especially has always been a part of his life (his grandfather, an amateur magician, knew Houdini).

Despite the overt presence of technology, Oursler's constructions cut across multiple media—sculpture, painting, photography, video, drawing, video/digital projection, space, and CD-ROM. He refers to his brand of art as a type of "meta-media" capable of extending the definitions of any medium beyond its conventional use. The works of Nam June Paik and Marcel Duchamp have been inspirational in shaping his ideas. Oursler, along with such artists as Vito Acconci, Jonathan Borofsky, and Bill Viola, combines materials and employs text and sound to convey diverse concepts about the various states of the human mind. Electricity is a cryptic force that affords him freedom to push beyond expectations. For nearly 25 years, through multi-disciplinary channels that involve the layering of data and the use of new technology, he has expressed visual fables about a world encountering serious alterations. Combining a strong sense of theatrical presentation with technology, Oursler constructs fantastical oddities that insinuate contradictory states of humor and fear. His work serves as a type of theater of the absurd, akin to Antonin Artaud's definition of the theater: "The domain of the theatre is not only psychological but also plastic and physical."[1]

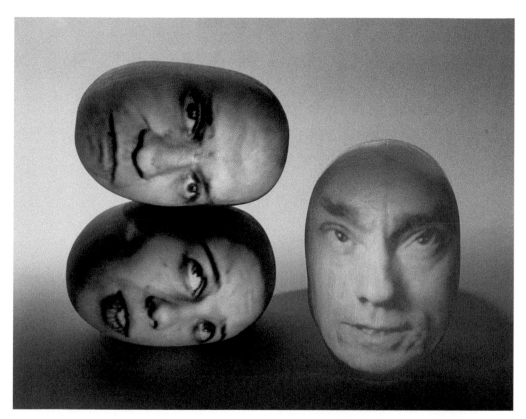

Mansheshe, 1997.
Video projection, glass, acrylic paint, and ceramic, 28 x 11 in.

Oursler's ethereal actors, composed of light and ordinary objects, are capable of rupturing the viewer's experience of everyday reality. For instance, on a fall evening in 2000, *Influence Machine* surprised visitors to New York's Madison Square Park. Without warning, the buildings and trees became animated by video projections of banging fists and rolling texts. The park was populated with talking heads that coalesced and dissolved into clouds of floating smoke filling the area. *Influence Machine* explored the history of technology and its ability to give voice to the spirit world.

Since the '80s Oursler has explored violence, mass media, sex, drugs, mental illness, good/evil, love, chaos, popular culture, religion, Catholicism, technology, pollution, and social dysfunction. Although irony informs his peculiar constructions, Oursler's art—unlike many post-Postmodernist works—holds no place for cynicism. He does not pretend to have answers about society's problems or wrongs. Simply put, he is not an ideologue but an artist-investigator who chooses to take the pulse of our time through his video/digital pageants. Through his animated,

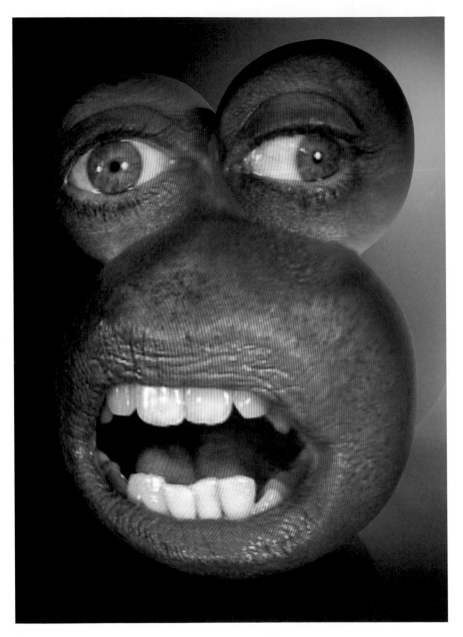

Purp, 2003.
Video and aqua-resin, 40 x 33 x 24 in.

phantasmagoric, humanoid figures, he raises open-ended questions about human relationships and what produces angst in the post-industrial age.

This intersection of video, sculpture, cinema, performance, physical reality, and virtual technology is repeatedly perceived by some as being strange and eccentric. It's hard to understand why. Isn't the unknown seductive as well as disconcerting? Aren't we living through a tough period of transformation and instability? Why shouldn't the art of this age push and blur boundaries?

Oursler's output is diverse and complex despite the fact that it is frequently linked to sculptural-installation media projection. Traditional media such as drawing and photography remain important to him. As a contemporary creator, he is a conglomerate type: artist, researcher, social philosopher, inventor, film director, writer, cameraman, photographer, actor, draftsman, and producer. As a child, Oursler liked to paint, and he was interested in becoming a painter when he began his formal education in 1975 at Cal Arts. There, he studied with such artists as Judy Pfaff, Douglas Huebler, Jonathan Borofsky, and John Baldessari, who stressed content over form. At the age of about 20, Oursler was introduced to video, and, by 1976, he had produced his first serious media work, *Joe, Joe's Transsexual Brother and Joe's Woman*. In such early shorts as *I'm Pretty Nice, Get Out of the Tree, Crazy Head* (1977–79), *The Loner* (1979), and *Spinout* (1983), an amalgamation of media is evident—drawing, sculpture, painting, space, and video.

Already an underlying contradictory sensibility was evident. In his fanciful figural works, the videotape collapses two worlds—his early painted environments and fantastic space. The tension linking the two-dimensional painted environments, the constructed spaces, and the videotape prompts the visitor to examine carefully Oursler's miniature stage sets. Oursler once said, "I realized that the medium of video lent itself to easy image alteration. I would put a little bit of paint or tape on something and the camera would read it in the same way as the wall behind it…Masking tape became dry wall…that really interested me, that I could collapse space; space was completely malleable…that was the thing that I really loved about video right from the beginning."[2]

Throughout his career, serious-mindedness and humor have consistently co-existed within animated forms that reside in corners, doorways, and free-floating organic shapes. However, it is the very element of playfulness that reverses our expectations of reality. The infiltrating sensibility of fantasy is catalytic in seducing viewers to step closer, to engage visually and mentally in a dialogue with the anthropomorphic objects.

In the '80s, Oursler began experimenting and expanding his mixed-media constructions. In *L7–L5* (1984), the video functions as a vital part of a dislocation/installation existing in real space. His imagery is now set free to engage tinfoil, pieces of broken glass, and tinted water—the imaginary narratives are no longer confined to the boxed TV

monitor. The space is dark, with the exception of the light from the television that is all around and nowhere to be seen.

Constance DeJong and Oursler began making collaborative pieces in the mid-'80s—they wrote, videotaped, and performed numerous works together, and their collaboration continues today. While Oursler is not particularly fond of performing (he prefers to be behind the "curtain," like the Wizard of Oz), DeJong gladly assumes the role of actor. In 1988 they produced *Relatives*, a one-hour performance in which DeJong interacts with an hour-long videotape— the work functions as a type of face-off between screen and human.

Along with Stephen Vitiello, the artists put together varied installation-collaborations that became benchmarks in their new and challenging engagement of multiple points of view, visions, talents, and ways of using materials. DeJong and Oursler especially share an interest in bafflement and the grotesque, along with the use of unexpected humor. This cooperative process yielded unfettered artistic potential for all parties and provided each with a unique intellectual exercise.

Fantastic Prayers (1999) is perhaps the trio's most ambitious and complex collaborative project. This multi-staged production resulted in a dream-like, distorted landscape environment manifesting an in-between state of flux. Originally performed inside Dan Graham's architectural sculpture on the rooftop of the Dia Center for the Arts, the work tested not only the artists' endurance but also that of the viewing audience, whose members braved the biting cold to watch the enactment. The original performance was recorded and adapted for Dia's Web site, and it has since evolved into an interactive CD-ROM distributed by Dia.

Since Oursler's early collaborations with DeJong in 1984, he has worked with a wide range of musicians, filmmakers, and performers, including David Bowie, Tony Conrad, Karen Finley, Joe Gibbons, Jim Shaw, and Mike Kelley. Kelley and Oursler created the Poetics Project in 1997, initially for the opening of the new Richard Meier-designed Museu d'Art Contemporani in Barcelona. In this conglomerate media installation, Kelley and Oursler present an exploration of music and art, an all-embracing portrayal of cultural history from the '70s and early '80s when they were emerging artists in California. Later, Catherine David invited them to re-create a larger version of the work for Documenta X.

Language has become a quintessential component in Oursler's fantastic, multi-dimensional art, despite the fact that the communication remains somewhat enigmatic. In *Getaway II* (1994), a pillow head shouts at the viewer, "What are you looking at?" Here, an inanimate anthropoid seemingly trapped underneath a mattress draws one's attention to the assertively articulate yet puzzling creature.

In the politically charged, theatrical installation *Mansheshe* (1997), Oursler projects videotaped images onto glass and ceramic surfaces. The hybrid talking faces, which occupy ovals suspended from poles, stare directly at the camera and viewer. Each one utters found aphorisms about sexuality, religion, interpersonal relationships, and identity. The offbeat, biting commentary is marked by an absurd humor that resonates through every bizarre projection.

In the '90s, Oursler became interested in the power of pure light, as well as in a somewhat Minimalist manner. Walking through a gallery, one could unexpectedly happen upon a piece such as *Red, Talking Light Switch* (1996). Suddenly the viewer is subjected to an outpouring of questions: "What are you doing? Where are you going? What happened? What went wrong?" It isn't quite clear where these sounds are coming from until the viewer observes a red light behind a wall grid. The "Talking Light" series illustrates a Minimalist sensibility, but with an idiosyncratic voice. Frequently one sees only a single exposed light bulb. The naked bulb "speaks" by flashing on and off at varying intervals and in different ranges of brilliance as a text unfolds through a synchronized soundtrack.

Oursler's recent media sculptures bring together elements from his various series of "Heads," "Eyes," and "Teeth," and his output remains at the forefront of contemporary art. His position on the exploratory edge was again evident at Metro Pictures in May 2003, when he introduced a new brand of mutants. Stepping inside, viewers could imagine that the toons from *Roger Rabbit* had taken up residence in the gallery. Eight animated, phosphorescent, biomorphic creatures, varying in size and shape and displaying human characteristics like eyes, teeth, and mouths, occupied three rooms. Oursler used his own or friends' body parts for the projected human anatomy. At first glance, these bizarre alien beings might appear entertaining. However, one realizes all too soon that behind the blinking eyes, fluttering lashes, big beaming smiles, gleaming teeth, and puckering red lips, this pageant of projected images aglow with endearing virtual faces is not a funny affair.

All through his career, Oursler has been a storyteller, and his sagas intensify in his current complicated presentations. His poignantly fictitious inventions highlight states of loneliness, isolation, and miscommunication—despite the frequently comical look of the toon-like fabrications. Such awesome sculptural androids as *Big Eyes, Baby, Coo, Woo, Cyc, Sug*, and, *Purp* humbly expound disjointed tales of alienation, apprehension, and loss.

These soft-spoken mutated head-bodies utter barely audible, yet captivating and sad monologues through an adjacent speaker. One hears whispers such as "Good, good-bye, yes, did you do a bad thing?" or "Kissey, kissey" or "Who, wait, hot, hot!" or "You treat me like garbage—I told you I love you, but I don't. Thanks for nothing!" By and large their exposés of vulnerability, panic, hysteria, and insecurity express a perceptiveness that lies just beneath the surface of a post-postmodern American society. Oursler's technological configurations are not only plugged into philosophical issues of identity, abjectness, and spectacularity, but his uncanny virtual beings tap into

a disorienting array of social, psychological, and existential issues. They link the differences between delusion and illusion, technology and miraculous apparition. Unlike the digital animations of James Duesing, which hint at similar subjects, Oursler's works pervade real space and time and are not confined to a screen. His freakish sculptures maintain sufficient human characteristics to elicit both compassion and enchantment.

Conforming to the convex surfaces of white, bulbous fiberglass, Oursler's human-like forms render a thought-provoking phantasmagoric environment. It is amazing how much attention he has paid to the details, seamlessly integrating the taped and projected human performances with each form. Each programmed image brings virtual life to his metamorphosed creatures, and each sculpture seems to possess a strong human corporeal alertness—appearing to be alive but remaining trapped within its spooky biomorphic structure. This is especially apparent in *Big Eyes*, with her porcelain-white skin, lush lashes, red lips, and delicate eye shadow; *Baby* displaying perfect teeth and glistening eyes; and *Purp*, with his fleshy purple glowing jowls, swelled eyelids, and expressive lips and tongue. Throughout this new body of work, the image of the face and the material object on which it is projected meld and prompt an interplay between substance and illusion. Metaphorically each piece suggests memory and a need to communicate what is buried within the recesses of the mind. And, beyond the waggish appearance of these techno-inventions, the mortal nature of humanity is accented—in every hair, wrinkle, delicate vein, and muscle. Each character is exaggerated, as are their strained gestures of speaking.

Whatever the emotional and disquieting qualities that run rampant in his mutant sculptures, Oursler perseveres in tackling rigorous concepts and generating powerful work. An examination of his encyclopedic oeuvre confirms that his varied art has undergone significant metamorphosis and that his work continues to develop, expand, and change. Elements from previous series are recycled and incorporated into the freshly evolving constructions, as an uninterrupted visual/technical vocabulary expands into commanding new environments and shapes. Because of his methodical approach to everything he tackles, Oursler has acquired astute media sophistication and a piercing clarity of vision. Technology, humanism, social consciousness, and artistic invention synthesize to form the matrix of his aesthetic practice. Oursler pushes the signification of sculpture and art as he continues to surprise us. **EAK**

Notes

1 Antonin Artaud, *The Theater and Its Double* (New York: Grove Press, 1958), p. 71.
2 Mike Kelley, "An Endless Script: A Conversation with Tony Oursler," in *Tony Oursler, Introjection: Mid-Career Survey 1976–1999*, exhibition catalogue, (Williamstown, Massachusetts: Williams College Museum of Art, 1999).

David Ireland

by Terri Cohn
2005

Throughout his career, David Ireland has merged his life with his art in remarkable ways. As a sculptor whose vision was nurtured during the 1970s by the process- and concept-based practices of conceptual artists in the San Francisco Bay area, his consistent interest has been to restore a voice to objects, materials, and environments that have been neglected or overlooked. One of Ireland's primary ambitions has been to create work that is so well integrated into existing spaces as to be fundamentally imperceptible, an approach that was kindled early on by his involvement in Tom Marioni's *The Restoration of a Portion of the Back Wall, Ceiling and Floor of the Main Gallery of the Museum of Conceptual Art* (1976). Ireland's role was to carry out Marioni's notion of restoring the space to its original state, returning the trace of its incarnation as a printing company and preserving the residue of activities by artists who had worked in the MOCA space.

Ireland's conceptual and phenomenological approach to materials and environments has also been motivated by his philosophy of art-making, which embraces a Buddhist-based non-duality between art and life and the belief that all things are of equal value. This worldview has motivated him to transform everyday materials and objects in ways that evoke an emotional or psychological response to their surface qualities or forms, whether the intent is to revive the interior surfaces of a building, to give a worn chair or broom renewed presence as sculpture, or to make all-over drawings from a 94-pound sack of cement every day until the material is depleted. Ireland has achieved this, in part, by creating visual contradictions that delight, fascinate, and confound our visual and conceptual expectations. These contradictions are best known through his approach to two long-term projects: restoring the walls and floors of his house at 500 Capp Street and his ongoing process of creating "Dumbballs," hand-sized spheres that he creates by tossing a lump of wet concrete back and forth between his hands for many hours until it dries into a ball-shaped form.

Both projects reveal the relationship between Ireland's non-hierarchical perspective on and approach to materials and his play with ideas of authorship. By stripping away the layers of surface treatment applied to the original walls and floors of 500 Capp Street, and then augmenting the luster of that cracked and stained primary state, Ireland has unveiled and venerated the original idea of the interior, as well as the palimpsest of its history. With the "Dumbballs," he inverts this idea by removing any ego involved in the concept or creation, which again reveals his Zen attitude toward the equality of materials and forms by suggesting that they are mute objects that anyone could make. The extended procedures necessary to create both the "Dumbballs" and the Capp Street house, along with the uneven patina and embedded finger marks in their surfaces, also reveal Ireland's interest in the passage of time.

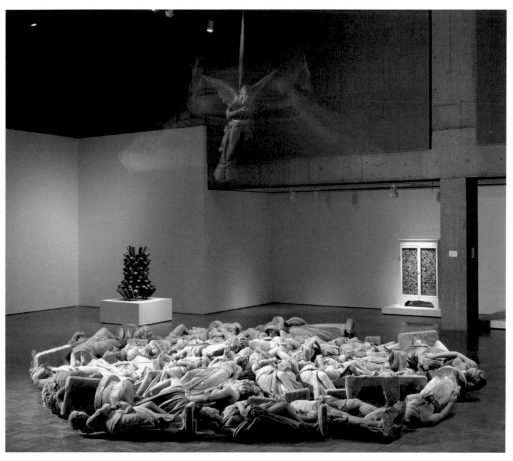

Angel-Go-Round, 1996.
Fiberglass and cast concrete figures, motor, and nylon belting, 22 x 25 ft. diameter.

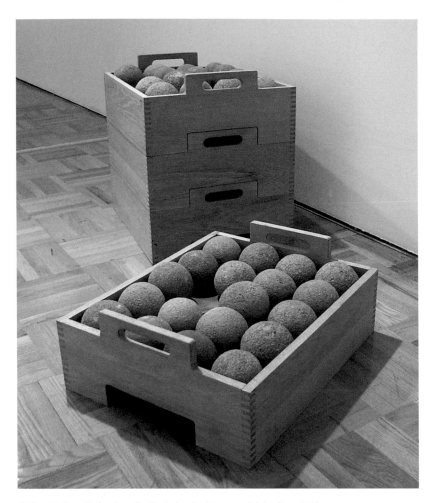

79 Dumbballs with Carriers, Dedicated to the Memory of John Cage, 1992.
Concrete and wood, 32 x 21 x 17 in.

These fundamental philosophical and material concerns also define his primary paths of exploration as an artist. His recent retrospective, "The Way Things Are" at the Oakland Museum, re-affirmed his deep interest in process—which he considers as meaningful as the resulting artwork—and provided an opportunity to observe the ways in which he consistently sets up and resolves seemingly paradoxical relationships in his work. These complex qualities are evident throughout his oeuvre, ranging from the strange beauty of his early work with dirt, talcum, crayon, and cement on paper to his ongoing play with scale, function, and intent (especially of chairs), to his interest in unmasking and displaying the underpinnings of exhibition spaces and the corporeal remains of their excavation. The conceptual and material paradoxes he sets up are well articulated in works that combine his conceptual/material deliberations with tributes to artists for whom he feels an affinity. He pays consistent homage to Duchamp,

manifested in works such as *Duchamp's Tree* in which Ireland branded pieces of wood with the identification "D.I." and then impaled them on a bottle rack. Such work also demonstrates Ireland's ongoing consideration of questions of authorship, in this case a parody of Duchamp's ideas concerning choice in art-making.

Ireland's meditations on process, sound, and chance are evident in his interpretations of John Cage's aesthetic. In *79 Dumbballs with Carriers, Dedicated to the Memory of John Cage,* 79 "Dumbballs" (Cage died at the age of 79) are rolled across the floor to create the installation visually and aurally. With *A Variation on 79, Side to Side Passes of a Dumbball, Dedicated to the Memory of John Cage* (1912–1992), Ireland combined his own experimental interests in printmaking with Cage's by rocking a "Dumbball" over an etching plate 79 times to make incidental marks, which were then printed on paper etched to look like blank sheets of music. For the four other scores in the piece, Ireland threw bits of string and rubber bands onto the etching plates and then had the random arrangements printed as musical compositions. This methodology not only refers to Cage's practice of throwing the I Ching to guide his artistic decisions, it also hints at the humor employed by both artists. In Ireland's case, humor serves to further upstage our assumptions about artistic process and product.

This complex amalgamation of sensibilities and practices reaches a high point in *Marcel B.,* for which Ireland commingled the more unpolished and playful aspects of his sculpture with Cage's ideas about noise as music. Here, Ireland also gives a nod to Marcel Broodthaers, whose sculpture *Pupitre a Musique* was a model for Ireland's unrefined slatted box, which serves as a three-dimensional musical score into which empty kipper cans, dabbed with blue paint, are dropped. The action of the empty tins landing on the "score" creates sound, and their jumbled appearance on the staves of the box and on the floor has an absurd and awkward presence that surprises the viewer with oddly linked musical references and function. Karen Tsujimoto writes of *Marcel B.,* "In its terse immediacy, it advocates the Zen point of view of distinguishing between listening and simply hearing, between seeing and merely looking." This statement also re-affirms Ireland's belief, which he codifies through his integral art/life process, that "you can't make art by making art." **TC**

Robert Morrison

by William L. Fox
2005

The first time I realized that Robert Morrison had something new to say was when, perversely, he said nothing at all. It was in 1981. The sculptor, who had gone straight from doing graduate work at the University of California, Davis to teaching at the University of Nevada, Reno in 1968, had recently been involved in a local experimental poetry workshop and was participating in a performance series at the historical Piper's Opera House in nearby Virginia City. The 19th-century building had become the improbable stage for a series of avant-garde events, one of which featured four tape recorders sitting 15 or so feet apart from each other on the floor to form a square. Morrison threaded blank recording tape in a loop through the machines, turned on both the microphones and speakers, and hit the start buttons. Then he walked away.

The tape dragged across the floor, picking up dust and debris from the old wooden floorboards, which made appalling sounds on reaching the heads of the machine—sounds recorded and added to and played back by each machine in a building crescendo of unbearable ambient magnification. If Morrison hadn't switched off the machines, either they or the ears of the audience would have burst. The piece, which gave the space a voice without any specific authorship by the artist, exhibited many of the tensions that would inhabit Morrison's work for the next two decades.

Morrison has installed his work outside of Nevada only rarely. Appearances in San Francisco, San Antonio and Arlington, Texas, and New York can be counted on the fingers of one hand. Although offered the opportunity for a retrospective in California, Morrison resisted any such entreaties until he was approached by the Nevada Museum of Art, which in 2003 opened a new building with galleries large enough to accommodate his installations. Now we have a chance, at last, to see his major sculptures exhibited together and in conversation with one another.

Before Morrison began working with electromechanical installations, he was painting schematics for them, works represented in the retrospective by two *Powerhouse* paintings and a related sculpture from 1968. In one of the former, dense rectangles of black paint on opposite sides of the canvas communicate with one another via a series of parallel hard-edged horizontal lines resembling an electronic circuit board. Later that same year, frustrated that paintings could not achieve genuine flatness, he sandblasted similar images on the front and rear panels of a glass cube. As your eye flickers from one image to refocus on the other, it seems as if your vision is momentarily lost in nothingness, precisely the state of mind Morrison wishes your vision to manifest—the negative space of a sculpture.

During the time between those three works and the sound piece, Morrison had been doing more than simply looking at visual works by his contemporaries. He listened to musicians such as John Cage and Steve Reich, pondered concrete texts by Emmett Williams and Ian Hamilton Finlay, read the aleatory works of Jackson MacLow, and

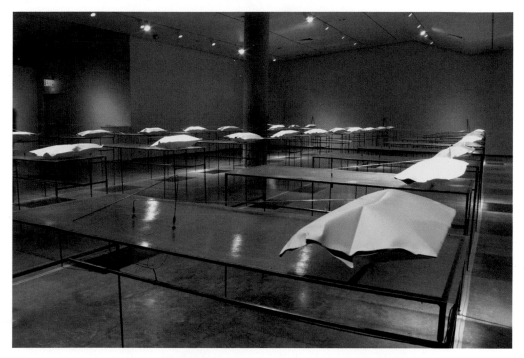

Tongues: The Half-Life of Morphine, 1987.
Steel, fiberglass, and electronics, 36 steel cots, dimensions variable.

experimented with both video and performance art. It is perhaps no fault of the museum's that this period is not represented in the show—many of the works have either been lost or damaged extensively while in storage. But the story resumes with a piece that successfully combines Morrison's earlier formalist visual vocabulary with his newly acquired expertise in sound and electronics.

Mumbles (1983) consists of 10 thin steel panels that hang vertically on the wall. The dark and mottled metal sheets have had polygons, often triangular, excised out of them with a plasma cutter, and the lower left- or right-hand corner of each panel has been bent upward. Tucked above each right-hand corner is a covered unit for a doorbell buzzer, which holds a bent wire arm. As current is fed into the hidden copper coils, instead of a clapper hitting a metal bowl, the wires transfer the electricity to the metal plates, which act as highly imperfect speakers. Hence the mumbles. Each wire is bent differently, creating a unique voice for each piece.

The panels are handsome enough to hang on the wall as examples of serial Modernism, evoking that mildly euphoric and pleasurable reverie we derive by virtue of an austerity that hints of infinite variation through geometry. The pleasures of such Minimalism seem never to have gone out of style since the 1960s. But the anxiety produced

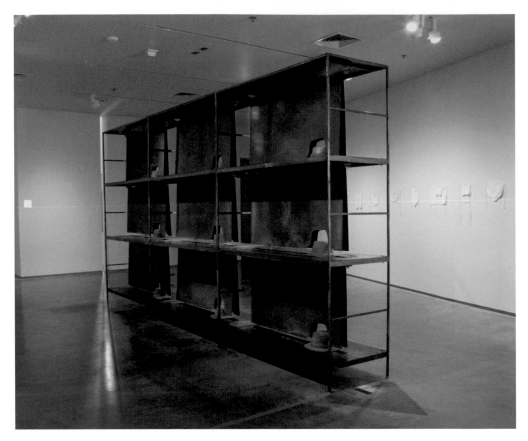

M. Hasard, Dressed to the Nines, 1992.
Steel, water elements, and electronics, 96 x 24 x 180 in.

by an anonymous agent voicing into a space, its abrasive echoes defining the shape of the room, mitigates against mistaking these works for decorative late Modernism. They would drive you nuts.

There's a corollary tension here between form and content, between the intensely formal aspects of the material and the equally intense implication of an unknown narrative. The doorbells are powered by current derived from a series of radio receivers tuned to various radio stations—or the spaces in between the stations, which on an analog tuner capture the perfect white noise of nothingness comparable to that empty space in the glass cube from 15 years earlier. As Jeff Kelley points out in his catalogue essay, Morrison is forcing signals through a material that resists them, thereby removing discernible content and leaving us only with timbre.

Morrison ratcheted up the tug of war between form and content even more in *Tongues: The Half-Life of Morphine*, the largest installation in the show. Thirty-three cots, 11 each in three long rows, stretch out to the left and right.

Smaller and higher than a bed, each cot holds a white pillow at its head and hosts one or two bent wires bolted into its translucent plastic surface, which is supported on a welded skeletal bed frame. The pillows, which look soft enough to fall asleep on, indicate Morrison's high level of craftsmanship. Many people will mistake them for cloth or paper headrests, but they're steel, delicately crumpled at the edges and painted a high matte white.

The hard surfaces of the cots bear drawings in thin black marker, inspired by the drawings that surgeons make before cutting into a person during an operation—say, a bone graft made on your leg after it's been demolished in a wind-surfing accident in Hawaii. You might remember this kind of mark while you're recuperating at home with a heavy-duty opiate circulating through your system—which is when Morrison received his vision of the installation, the only time he has been gifted with such a full-blown inspiration.

The wires are attached to solenoids under the beds and are bent according to directions embedded in the drawings. The ends of the stiff steel wires, most of which rest on the pillows, jitter nervously on yet another surface meant to distort the signals, which in this case originate from a synthesizer that sits out of sight in a back room. The individual sculptures hiss, rasp, buzz, fall silent, and then come alive again at random intervals. As in *Mumbles*, the drawings and wires work out geometrical variations on the theme of the beds. Once again a formalist vocabulary has been translated from two into three dimensions, the objects transferring energy from one side to the other, in terms of performance from the back of the house to the audience. The entire installation reads as if *Mumbles* had pushed off the wall and picked up both a deeper voice and more attitude.

It's not necessary to know the pharmaceutical history of the sculpture any more than you need to know how the principles of electromagnetics make the wires jump up and down. But understanding that Morrison's mechanics are underwritten by autobiographical narrative—a story encoded and filtered through a hard-surface Minimalism until unrecognizable—is to admit that his work transforms life into art while describing the process, a trope that is itself a critique of the Modernist inability to represent completely the human condition.

Two years later, Morrison presented his audience with what he admits is the darkest work in the retrospective. The title of *O'Coeur* derives from the chant of Jean-Paul Marat's followers as they sat underneath the heart of the French revolutionary, which was suspended in an urn from the ceiling of their meeting place. The piece is dark by association and by installation, set in a dim alcove.

Twelve narrow steel tubs filled halfway with water sit in a row, each inside a wire screen booth. The cubicles are eight feet high but only 30 inches wide; even though they are semi-transparent, the dimensions are claustrophobic. The tubs, their backs angled forward, their feet covered with sheet metal, appear impossibly small to hold a con-

temporary American adult, but they were made according to the actual dimensions of Marat's legendary bath in which he sat each day writing. The water rapidly cultivates a mineral scum, an unlovely analogue for the scrofulous skin disease suffered by the polemicist.

The murder of Marat in what would become his funerary conveyance is a well-known image in art history and the wider culture. Morrison has newly invested it, however, with a noir morbidity. Above each of the tubs hangs a lit electric light bulb of indeterminate wattage, each suspended from old-fashioned and grubby house wiring. Standing in front of a primitive light fixture that hangs directly over a tub—the heart of the Frenchman a dim beacon at best—creates a frisson between the supposedly redemptive powers of the bath and the ambiance of an electric chair.

Individually the effect of the cubicles is one of pathos; together as a group, their mood is again eerily institutional. To peer into the sculpture from either end, the bulbs appearing to recede within an infinite series of enclosures, is to be reminded that there is no escape from history or its repetitions. As if it weren't enough to be plunged into gloom by this mute installation, the nervous chittering of the beds in the room next door gives you the distinct impression that you're in an 18th-century insane asylum. The juxtaposition is not accidental. The remaining large installation, and what Morrison has declared to be his final sound piece, is the "M. Hasard" collection, housed in a separate gallery. Built in 1992 and titled after one of Marcel Duchamp's obscure pseudonyms, it consists of three steel chairs hanging on a wall, a large steel sculpture in the middle of the room, and 11 "Sanitary Aprons" hanging on the opposite wall.

The chairs read as a lexigraphic prologue to the piece. *Child's Chair* holds a closed steel cube on its seat, while the seat of *Bicycle* is pierced by a vertical wheel, and sitting on *Night Chair* is a rusted homburg. Together they recapitulate the ages of a man, from childhood through adolescence to maturity, as well as of 20th-century art—from Picasso (Cubism) to Duchamp (the found object) to Joseph Beuys (his trademark headgear). Perhaps they also acknowledge Morrison's maturation as an artist from the over-determined geometry of the Powerhouse paintings to the performative gestures of "M. Hasard."

The central and largest element is the armature of four steel shelves, *M. Hasard, Dressed to the Nines*, a welded unit divided into nine squares, each filled with a piece of sheet metal folded in half and hung over a rod. The silhouette of a homburg is cut out from the bottom edge of each of these doubled-over plates, and set in the empty space is one of the rusted hats. Hidden beneath the bottom shelf are the steel wires that give the piece its voice, a raspy chatter that picks up random martial cadences every minute or so.

The dark shelving with its hanging elements is reminiscent of an armoire, and the hats, like the pillows, are so soft and perfectly, slightly irregular that they, too, appear to be made of anything other than metal. Beuys had a metal plate

in his head, the aftermath of an injury from World War II, and he always wore a soft felt hat for comfort. The hats in *M. Hasard* sit on their own metal plates, a formal nod to the readymades of Duchamp and the influence of the older artist on Beuys. If *Tongues* could be said to embody Morrison's fascination with pathology, and *O'Coeur* the dark side of redemption, then "M. Hasard" is his intellectual paradigm, a personal art history codified, filtered, and serialized.

The final element of the work consists of 11 white muslin aprons, which look as we might imagine the menstrual apparatus of an earlier century, bibs to be tied about the waist that vaguely reference female buttocks and genitalia. But they are invented. Designed by Morrison and sewn by an assistant, then laundered, bleached, and ironed as if to create distressed antiques, they are fictional readymades untouched by the hand of the artist in their construction. They almost disappear on the museum wall, yet they make a surprisingly strong counter-gesture to the hard macho surface of the steel.

Morrison's installations are among the strongest works of contemporary sculpture to be made in Nevada, and this may be their last reincarnation. Morrison had to repair, replace, and reconstruct many of their elements, since the originals were destroyed in a flood. Art is, to be sure, a mortal matter. Not only do objects disintegrate over time, but even the documentation fades irretrievably. That is, of course, part of an installation's rationale, to demonstrate the transitory nature of perception and the power of entropy over all things material. Morrison's retrospective, with its deliberate deconstruction of content into form and signal into sound, presents us with a reliquary for these fundamental concerns of sculpture during the last century. **WLF**

Judith Shea

by Martin Friedman
2005

Judith Shea, a notable presence on the New York sculpture scene since the 1970s, seemed to have unaccountably withdrawn from it some 10 years ago. Her last major work to attract critical notice was an enigmatic equestrian sculpture carved in black-stained wood. In September 1994, it was sited on 59th Street, just southeast of Central Park, strategically placed behind another man-on-a-horse, Saint-Gaudens's 1903 gilded bronze Civil War monument that bears the lofty appellation *General Sherman Led by Lady Victory*. It took little for passersby to grasp that Shea's sculpture was more than a thematic variation on its grand predecessor. Titled *The Other Monument*, its rider was no conquering general but an emancipated slave.

Following that acclaimed public presentation, Shea resumed making gallery-scale works, increasingly interested in exploring other approaches to figuration. She had the opportunity to do so when she was awarded a fellowship by the American Academy in Rome. Beginning her residency in fall 1994, she immersed herself in the study of the Eternal City's artistic past, in particular its High Renaissance sculptures, filling her notebooks with innumerable drawings. "At night, in the library at the Academy, I'd read about those artists, particularly Bernini and Michelangelo. Being in my 40s then, and with considerable experience as an artist, I wanted to know what it took to do what they did. How were they able to continue for so long? Longevity was certainly a factor. Both of them lived productive long lives. There weren't disruptions of the sort that would essentially get them off track. Since the Church was the patron, the 'given' was that their sculptures had to be holy images—popes or saints or other religious figures, living or dead. But what interested me more than that was what they were saying about themselves and their lives as artists through their sculptures."

Shea says, "With Bernini, there was tremendous passion but also tremendous fun in his works. Sometimes, even the passion is tongue-in-cheek." "Really?" I asked her, "Where's the fun, for instance, in the carved marble of a feverishly ecstatic Saint Teresa of Avila, her body about to be pierced by a smiling angel's gold-tipped arrow?" "Well, yes," was her amused response, "not everything was fun and games, and, after all, that was dire martyrdom he was depicting. But I looked at all his sculptures, not just the saints but also his mythological figures." As an example of that master's all-stops-out approach to non-saintly subject matter, she cited the erotically charged abduction depicted in *Pluto and Persephone* in Rome's Borghese Gallery. "What you have with Bernini is this constant explosion. In the religious commissions, he goes to the limit of martyrdom and to the limit of passion; in pieces like the Persephone, he goes to the limit of aggression, to the limit of sex. With Michelangelo, it was a very different set of emotions. It's not fun. His sculpture is also passionate, but it has a much darker nature. He didn't represent acts of martyrdom the way Bernini did. I think on some level, he felt too much personal pain, and that's expressed in his

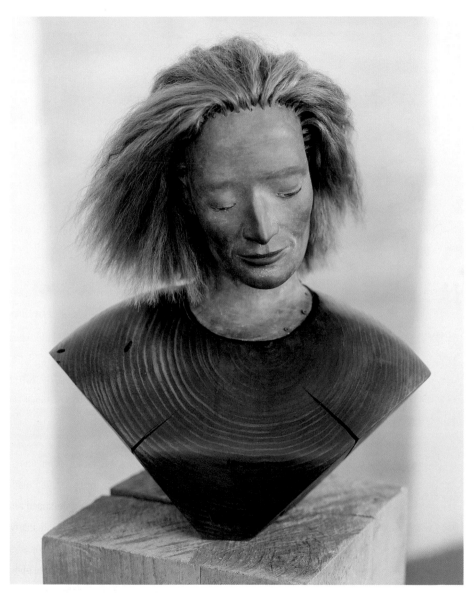

Cara, 2000–02.
Wood, bronze, and hair, 19.5 x 16 x 10 in.

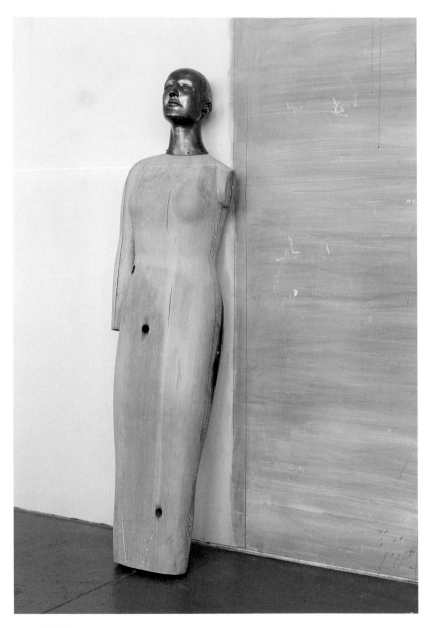

Icon, 2003–04.
Wood and bronze, 62 x 16 x 13 in.

work. There is certainly high drama about it—I'm thinking about *The Dying Slave*—but I wouldn't call it theatrical. What I ended up feeling was that both artists were communicating, whether consciously or unconsciously, their experience of life more than anything else."

Not long after her Italian sojourn, and still thinking about new directions for her work, she headed south to live and work for a while in Oaxaca. Mexico, she says, had quite an impact on her: "You're driving in the desert, in the middle of nowhere, and suddenly there's a church full of saint figures, all of them newly dressed in handmade clothes—and some with real hair. There's a little of that in Italy, but, there, the clothes and hair are mostly carved." Mexican folk art, with its exaggerated human forms and strong craft sensibility, had interested her well before her stay in Oaxaca. While pursuing a fine arts degree at Parsons she was in charge of display at the United Nations folk-art shop where, she says, "I got to know those objects in depth."

For all their overt expressiveness, the polychrome saint figures she encountered in Mexico were no great surprise, since she had more or less grown up with more sedate versions of them. "My early childhood was in middle-class suburban Philadelphia," she points out. "The first sculptures I ever saw were not in museums but figures in churches. I was fascinated by those statues and tried to figure out what they were saying and doing. All of that is in my work." Her parochial-school education, she concedes, affected her view of things. While she regards herself as a freethinking, liberal-minded artist for whom traditional religious values are secondary to overarching social ones, she is nonetheless ineluctably drawn to the mysteries and import of the Catholic Church's iconography.

Her ambivalence is expressed in the tension-fraught images that composed her recent "Statues" exhibition at the John Berggruen Gallery. (She chose "statues" because for so long the term was one of denigration among art world cognoscenti.) After a year in the San Francisco Bay area, where she took on a few sculpture commissions, she came back to New York in the summer of 1997. She found herself a new, light-filled studio in an industrial section of Long Island City, with a spectacular view of the Queensborough Bridge. There, she began making life-size sculptures of heads and bodies, some in wood, others in clay. The heads, specific in their detail, had been foreshadowed a few years earlier in a series of small works, some only a few inches high, formed of clay and hardened in kitchen and toaster ovens. The idea, she explains, was to teach herself to make accurate, descriptive portraits: "I carved some in beeswax that I bought in the markets in Oaxaca. I took those little heads with me in a shopping bag wherever I went, carrying them around from airport to airport."

Prior to her return to New York, most of her single-figure sculptures were headless. Her best-known earlier works were, in her words, "clothes without figures in them." Armless "hollow dresses" symbolized women, and voluminous overcoats were male surrogates. Gradually, she says, "I began filling the clothes with people." For whatever

reason—whether sustained exposure to Baroque figuration, in which facial expression was as important as bodily gesture, or to the martyred Christs and lachrymose saints of Mexico—she decided to pursue a less distanced and more immediate reality. This turned out to be an idiosyncratic form of portraiture, its descriptive detail in inverse proportion to the abstraction that had characterized her figure sculptures: with one important caveat—these portraits were of no one in particular. They were of invented beings, heads in search of bodies.

During successive visits to Shea's studio, I could see how this new specificity was becoming an increasingly important factor in how she dealt with the human form. The place abounded with highly descriptive male and female heads, some alone on work tables, others attached to necks and shoulders, and still others joined to carved wooden bodies. In the midst of this jumble was an imposing, larger-than-life-size standing male figure wearing a long overcoat. Figure, overcoat, and flat, low base were modeled in red wax. Introduced to me as St. Francis, he was the first of Shea's depictions of well-known saints in the guise of ordinary people.

The face of this sculpture, since named *Urban Francis*, tilts heavenward. It is as though Shea's humble saint were hearing things denied to the rest of us. When I asked how she had come up with so prosaic a figure to represent so spiritual a being, she replied, "My perception of Francis of Assisi as an earthy, simple man was greatly affected by what I read in Nikos Kazantzakis's book about him. The book was a starting point for my interest in this character. While I was reading it on the subway one day, I looked up, and there was a man in ragged clothes sitting across from me. Suddenly I had the feeling that he could be Kazantzakis's saint. He seemed to be in an altered state; his reality was not the same as anyone else's around him. What Kazantzakis does in his books is to take mythologized figures like St. Francis and bring them into real time. You wonder, if this man lived on your block whether you would even go near him."

In addition to *Urban Francis*, Shea showed two other sculptures with religious themes in the exhibition. Each of their subjects, she maintains, is as prominent in the public imagination as a major Hollywood celebrity. "Mary Magdalen and Joan of Arc are just as much household names today as Julia Roberts and Elizabeth Taylor. Mary Magdalen is even more famous now, basically because of the popularity of *The Da Vinci Code*, whose story focuses on her as the companion of Christ. But I started work on my *Magdalen Fragment* before I read the book. And, of course, every girl knows who Joan of Arc was. You didn't have to grow up Catholic to be interested in her."

Shea's Magdalen is a partial figure, extending from mid-thigh to head and formed of silvered bronze. Hollow, like Shea's generic female figures of the 1970s, she wears a thin, form-revealing, low-neckline shift. She is at once a full-bodied, sensuous creature and a profoundly abject one. Highly defined as her body is, her face is even more so, suggesting one of Bernini's vision-struck saints. She looks as transported as *Urban Francis*. Though traditional

depictions of the Magdalen focus on her long red hair, in Shea's portrayal only scraggly wisps remain. It is as if, in her anguish, Shea's Magdalen had violently pulled most of it out.

Far more serene in demeanor is Shea's *Joan, for Twain*, named for Mark Twain's book about Joan of Arc's life as peasant girl, warrior, and defendant in her trial for heresy, as recounted by a fictitious sympathetic chronicler. Unlike Shea's portrait of the Magdalen, her Joan is a woman in mystical rapture. Her mouth is slightly open, her eyes gaze into the far distance. In 2002, when I first saw this truncated bust in Shea's studio, the cuirass bore a gleaming, silver-leaf fleur-de-lys, so bright that light reflected from it across the room. She subsequently toned down the silver-leaf surface, burnishing it with a torch so that it became almost subliminal.

Although Shea's current sculptures began with religious themes, they are not the only ones to project degrees of spirituality. Just as inward-looking are the women depicted in two other sculptures, *Cara* and *Nobody's Angel*. What is evident in these works is that the line between the spiritual and the secular blurs easily in Shea's imagery. *Cara*, a composition in the form of a traditional portrait bust, is, like others in the Shea sisterhood, an amalgam

of wood, bronze, and human hair. Her downward-looking eyes are barely open. Her features include a high forehead, well-defined cheekbones, an aquiline nose, and a small mouth. Her thick blond hair is short and roughly cut. We have no idea who *Cara* is. The sculpture's title, "dear" in Italian, doesn't tell us much.

One of the first sculptures Shea made after working her way through the saints was *Nobody's Angel*, which, for all its stylistic similarities to the Magdalen and Joan, portrays a woman decidedly of this world. In many ways it is an unresolved work, combining slabs and chunks of wood cannibalized from sculptures she had earlier abandoned. "Some of its parts go back to 1990, when I lived in the Berkshires," Shea recalls. "I dragged huge logs down from the mountain and cut them up." *Nobody's Angel*'s torso is constructed of white pine and reddish fir. Her skirt, uneven at the bottom, is formed of wide sections of wood. Her legs are thick, roughly defined, and her feet are like pads.

There are extremes in this curiously doll-like creature. Her smooth face and left hand, both in gleaming bronze, contrast sharply with the rough-hewn quality of the sculpture's lower half. Overall, *Nobody's Angel* is an unsettling work. The subject's face is youthful and fresh and, at the same time, frenzied and frazzled—as improbable a composite of expression as of materials. "She looks both determined and anguished," Shea says of her imperfectly fitted-together woman. "Her right arm ends in a clenched fist. It's as though she were saying, 'I'm not letting myself come apart.'" There is a slightly crazed quality about this sculpture, which in my view makes it all the more engaging. "She is far from perfection and forever incomplete, so who would want to claim her?" Shea wryly observes. "She's *nobody's* angel."

It's hard to ignore the evidence that Shea's portrayals of women, saintly or otherwise, are in many ways self-portraits. I suspect that this is also how she perceives them. Maybe that's why she takes so much time with the details: which head works best with which body; whether a figure's hair should be real, rope, or a synthetic material. It's hard to know which was the first of her female figures, an emotionally volatile lot, because she worked on them simultaneously, trying combinations of heads and bodies until the character she wanted finally emerged. Commenting on their realistic detail, she says, "Making these pieces used so much that I know as a woman—playing with the hair, painting the faces. Even though the clothes are carved of wood, I knew how to make them from my training in design."

Quite apart stylistically and emotionally from its wild-maned predecessors is the fifth female sculpture in this group. Cryptically titled *Icon*, it is the embodiment of calm. Its gleaming, polished bronze bald head is dotted with holes into which Shea, at one stage, had intended to stuff tufts of hair. Its body was carved from a single great timber that had an earlier life as a railroad trestle. It still bears holes made by the huge spikes that joined it to the trestle's other beams. (It might be a stretch, but those perforations, especially in the context of this exhibition, might be read

as symbols of saintly martyrdom.) The smoothly formed body of this single-armed personage looks as if it had been wrapped, mummy-like, in a stiff garment. There is, in fact, something vaguely Egyptian about *Icon*, whose face, impassive except for a slight smile, adds to the aura of antiquity—not a great surprise, since over the years Shea's sculptures have alluded to Egyptian and classical deities.

Acknowledging the stylistic break between *Icon*, whose head and body are generalized, and her more literal works, Shea says, "Next to the female figures that preceded it, maybe she does go off in a different direction. Her face is clearly not that of a saint. It's benevolent but not spiritual. I like the fact that they have hair and she doesn't." And, as if to emphasize *Icon*'s secular down-to-earth nature, she adds, "I also like the fact that her head is fastened to her body with visible screws." (More evidence of martyrdom?)

Another apparently secular presence is *Clarion*, the dreadlocked head of a black man. At one point, this character was destined for a loftier calling. During her early ponderings of saintly iconography for our times, Shea had seriously considered casting this head in the role of John the Baptist. Though she did not assign him that fateful duty, this massive head nonetheless has biblical potential. Its subject, I suggested to an amused Shea, could easily qualify as Goliath, given his larger-than-life size, but she had other plans for him. She was demoting him from saint to prophet, or even to preacher—"Maybe a herald of social change," she says. *Clarion*'s scraggly real hair and patch of beard below his lower lip—a "soul patch," in today's parlance—are Shea's subversive take on the aristocratic portrait busts she had seen in such profusion in French and Italian palaces. She liked the idea of using that convention to depict a black man. In a sense, *Clarion* is an updated version of the head of the man on horseback in *The Other Monument*.

What is the connection, I asked Shea, between these new works and her earlier generic figures, which bordered on pure abstraction? "They are a continuation of them," she maintained, seeing no disjunction between past and present. "When I think about my first works, which were made of cloth and looked like clothes installed flat on the wall, I realize that even then I was looking for characters, for personae, really, to occupy them. I used clothes as stand-ins for people. They were like types, maybe even stereotypes. I refined those clothing forms down to the overcoat and the dress, which, as the work grew three-dimensional, became the leading man and the leading lady." As her work became more volumetric, it also gained in emotional depth. When I asked if she ever felt that something might be lost were she to continue her pursuit of detailed description, her unhesitant response was: "Not at all. For me, what I'm doing now is a continuation of what I've always tried to do—to make sculptures, whether they are extremely formal or obsessively descriptive, that will express human states." **MF**

Tom Otterness

by Vince Carducci

2005

One Sunday in late November near dusk, a family walks down Broadway toward Lincoln Center on Manhattan's Upper West Side. As they approach 65th Street, the mother, a casually but stylishly dressed woman, says, "There's a sculpture over here I don't quite understand, but I think it's hysterically funny." She leads the group to an L-shaped assembly of bronzes in a broad plaza that divides the uptown, downtown, and cross-town lanes of rushing traffic and also contains entrances to the 1 and 9 subway lines. They gather around the sculpture's various elements: a six-foot-long squat rectangular pedestal on which sit a mouse, two dogs, and a bird; a shorter two-tiered pedestal set perpendicular to the first, supporting an owl on a perch on the upper level and a cat sitting on its haunches on the lower; and a hound standing on its hind legs on the ground, facing the cat. Dressed in a business suit, the hound holds one paw behind its back and a sheaf of papers in the other. The entire vignette is rendered in comic-book fashion.

The family discusses the work, trying to decide what it's about. The mother, a psychotherapist, recognizes a jury trial in progress. The grown-up daughter, a medical librarian, looks intently for a moment. "It's the cat that swallowed the canary!" she pronounces, pointing at the accused on the witness stand, feathers sticking out of its mouth.

The piece in question is *Trial Scene* (1997) by Tom Otterness. It's one of 25 examples of the sculptor's work, created between 1984 and 2004, installed from Columbus Circle in Midtown to 168th Street in Washington Heights as part of "Tom Otterness on Broadway," a public art project undertaken by the City of New York Parks and Recreation Department, the Broadway Mall Association, and Marlborough Gallery, the artist's dealer. Originally scheduled to be on view during the fall of 2004, the temporary exhibition was extended twice to run until the middle of March 2005 and later traveled to downtown Indianapolis.

Catherine Plumb and her daughter, Abigail Plumb-Larrick, essentially "got" *Trial Scene* even if they weren't aware of the fact that the sculpture was inspired by the O.J. Simpson trial, which adds a layer of social commentary to their interpretation. The illumination brought on by chance encounters between artworks and ordinary people is generally held up as an ideal of public art. And Otterness is perhaps the quintessential public artist for the postmodern age, a time when individuals are said to be savvy to the come-ons of the culture industry and yet at the same time skeptical of the purported authenticity of "pure" art.

Born in Wichita, Kansas, Otterness has been a player on the New York scene for nearly three decades. In 1977, he helped found Collaborative Projects, Inc. (Colab) as part of a group of then-emerging artists that included Jenny Holzer and Kiki Smith. Colab's legendary 1980 "Times Square Show" was mounted in a former bus depot and massage

Life Underground, 2002.
Bronze, multi-part work commissioned by MTA, New York City.

Trial Scene, 1997.
Bronze, 74 x 69 x 84 in. View of work installed on 65th Street, New York.

parlor building found by Otterness and sculptor John Ahearn at Seventh Avenue and 41st Street. (A cooperative endeavor, the exhibition announced the entrepreneurial aspirations that inflated the art market bubble that was to come, launching the careers of Jean-Michel Basquiat, Keith Haring, and a host of other 1980s art stars.) He now works out of an extensive studio complex in Brooklyn, two blocks from the East River.

One of America's most prolific public artists, Otterness has created outdoor sculptures for locations from coast to coast and throughout Europe; he's also represented in numerous private and public collections. His work blends high and low, cute and cutting. The combination of accessibility and thoughtfulness, the melding of fine-art production and pop-culture style, shows the influence of the Whitney Museum Independent Study Program, which he entered in 1973. Like many artists who have come through the program, Otterness walks the line between theory

and practice, aesthetic autonomy and political engagement—although some might contend that his inclinations have more in common with the worldly ambitions of fellow ISP alumnus Julian Schnabel than with the critical aloofness of alumna Andrea Fraser.

Otterness's aesthetic is best seen as a riff on capitalist realism. On the one hand, it relates to the recognition by Gerhard Richter, Sigmar Polke, and Konrad Lueg (who took up the term for an exhibition of paintings in 1963) of the realities of the art market in which supposedly autonomous objects of disinterested contemplation circulate as highly desirable commodities to be bought and sold. But it's also about what has come to be more popularly understood by the term "capitalist realism," the representations of advertising and the media, following Michael Schudson's influential 1984 study, *Advertising, the Uneasy Persuasion*. Otterness's work is a contemporary form of social (as opposed to socialist) realism, an art of post-Cold War disenchantment, an expression of anxiety in the face of global capital unbound.

This is especially evident in works in which images of capitalist and proletarian are dialectically intertwined. In *Educating the Rich on Globe* (1997), a circle of worker-figures forms the pedestal supporting the earth, like Atlas in Greek mythology. A top-hatted plutocrat in evening clothes lies on his back on top of the world, coins falling from his pockets. Astride his belly sits a woman reading a book. The sculpture visually presents Karl Marx's base/superstructure analysis, with labor power constituting the foundation on which the capitalist world rests; in turn, culture depends on capital (what Clement Greenberg in "Avant-Garde and Kitsch" calls "the umbilical cord of gold") to provide respite from the need for toil in order to be free to pursue "higher" endeavors like literature and fine art. In *Marriage of Real Estate and Money* (1996), a daisy-topped house dressed in a skirt stands next to a penny, which holds a bowler in the crook of its arm. It's a portrait of a happy couple, aristocracy and bourgeoisie in blissful dominion over land rents and wage labor, the mechanisms for wresting control of the means of production from the proletariat and the foundations of alienation under capitalism.

Capitalist realism is also present in Otterness's more sublimated work that engages myths and other imagery in the public domain. Especially in recent years, Otterness has explored traditional folk and modern mass-representational forms as if to argue for a public sphere that is increasingly under siege with the contested terrain of intellectual property in the wake of the Digital Millennium Copyright Act of 1998 and the vertical integration of the media and communications industries. The DMCA is referred to by its critics as "the Mickey Mouse law" because its primary corporate sponsor, The Walt Disney Company, wanted to extend the monopoly over its cartoon character whose copyright protection was about to expire. Paradoxically, Disney has secured tremendous revenues by converting folktales and myths into marketable commodities with brand extensions that boggle the imagination, fencing off vast regions of the collective memory for its own profit. With works like *Frog Prince* (2001), *Kindly Gepetto* (2001), and *The Lion and the*

Mouse (2003), Otterness seems to take aim—like a hacker posting a company's proprietary software code on-line for others to see—at the enterprise referred to surreptitiously by its own employees as "Mauschwitz." (Indeed, a writer for *Interview* magazine once characterized Otterness's work as being like "Disney on crack.")

With the fall of communism, the overthrow of capital seems like a dream destined to remain unfulfilled. This disillusion has expressed itself in Postmodernist art from the beginning in the recognition of cultural production as an avenue of resistance in lieu of the transcendence no longer deemed possible to attain. Following Renato Poggioli in *The Theory of the Avant-Garde*, one option is "undergroundism" (as distinct from "ivory towerism"), given literal and metaphorical expression by Otterness in the sculpture cycle *Life Underground* (2002), installed in the New York City subway station at 14th Street and Eighth Avenue.

Life Underground consists of over 100 cast-bronze sculptures placed throughout the platforms and stairways of the A, C, E, and L lines. The various groupings read like panels of a comic book, the archetypical expressive medium of mass-culture alienation. And like Fyodor Dostoyevsky's novella *Notes from Underground*, Otterness's cycle addresses the petty offenses against authority perpetrated by the disaffected. There's a fare jumper crawling under a metal gate and a homeless woman being rousted by the police. (These figures are well-dressed, in sardonic reversal of conventional social roles.) Otterness subtly invites deviant behavior with a floor sculpture of two large feet cut off flat at the ankles, the perfect platform for boom-boxes banned on the New York subway. Another grouping shows two figures holding a crosscut saw, going after an I-beam that holds up a stairway. The underground culture of urban legends takes the form of one of the alligators rumored to populate the New York City sewer system emerging from under a manhole cover to snag a small man with a moneybag head.

This quality of resistance, however, can also be read as a deconstructive moment, the site of a play of meanings that can be read both positively and negatively. What from one perspective is understood as resistance (i.e., the refusal to submit to authority) may from another be seen as catharsis, the dramatic release that gives vent to pent-up frustrations, the channeling of discontent into socially acceptable mechanisms such as works of art. And artworks, contentious though they may be, are still things to be possessed, part of a system of rarefied commodities whose very existence is made possible by the forces under critique. Thus, as with Dostoyevsky's main character in *Notes from Underground*, the reliability of Otterness's narrative becomes an issue to be resolved. And along with this questioning comes a consideration of public art in these postmodern times.

In *Public Sculpture and the Civic Ideal in New York City, 1890–1920*, Michele H. Bogart identifies the 19th-century fin-de-siècle as the moment when public art first flourished on a broad level in America. John Massey Rhind, Daniel Chester French, Frederick MacMonnies, and the National Sculptors Society put artistic representation at the service

of republican ideals at a time of dramatic social change. Neoclassical allegories in monuments and architectural ornamentation worked alongside Progressivist politics and the City Beautiful movement to help assuage predominantly Anglo-American middle- and upper-class anxieties over the seemingly imminent demise of the American Way in the face of rising immigration and the chaos of urbanization. While new immigrant groups also sought to mark their place in American society through monuments to ethnic pride, the overall process was managed from the top down, with gatekeepers such as the Municipal Art Society in New York facilitating acceptable projects.

Ironically, self-referential Modernist sculpture first emerged in the same period in Europe, as Rosalind Krauss notes, starting with Auguste Rodin. Referring to nothing beyond itself, the nomadic work of Modernist sculpture sometimes sits sphinx-like, to the bafflement of the average passerby. In densely populated areas, the "placeholder" character of much public sculpture reflects zoning ordinances that seek to free street-level space from the shadows cast by skyscrapers towering above, the creation of a vacuum that human nature abhors. As with the commissioned sculpture of the Progressive Era, the process is still managed by gatekeepers, typically the owners or developers of the real estate projects where the work will ultimately reside. And those who control the use and flow of space do so to suit their own interests and values. The potential for conflict in this model is famously exemplified by Richard Serra's *Tilted Arc* (1981), which although it may have responded brilliantly to its site on an aesthetic level, arguably failed to consider its function on a social one.

Just like public art and Modernist sculpture at the end of the 19th century, Postmodernist art emerged at another moment of dramatic social change: the transition from industrial to informational society that began in the late 1960s and early '70s. In this new environment, the civic ideal, if it can be said to exist at all, has taken the form of crowd-pleasing entertainment, the happy consciousness of spectacle society. The contemporary cultural milieu requires that public art be nothing if not socially aware, responsive to multiple constituencies.

The accessibility of Otterness's comic-book illustrational style acknowledges what Dave Beech and John Roberts term the "specter of the aesthetic" (i.e., the philistine, who is uninformed not necessarily so much by personal choice as by social circumstance) that permeates the ether surrounding the public sphere; but Otterness's work doesn't condescend like so much Postmodernist appropriation of popular culture seems to do. The work's complex, often subversive content also lends itself to more reflective appreciation. In this way, Otterness integrates the realms of popular culture and fine art, which in reality have always been united by their alienated condition under capitalist rule. Their mutual alienation is made all the more apparent by the work's insertion into the public domain. For although art is autonomous, something created in, of, and for itself, its independence is bound by social determination. Freedom from any purpose other than its own existence (the privileged position atop capital's soft belly) comes at a price: art can speak the truth but can't do anything about it. And with public art, this short-circuiting of redemption is put on display for all to see, philistine and aesthete alike.

Otterness demonstrates kinship with viewers of all stripes by using popular forms of address to express distance from commonly recognized modes of authority (including Modernist art conventions), acknowledging that in "the real world" artist and audience inhabit the same unstable environment. However, the nature of his sculpture—the sheer expense of its construction, the maze of official channels that must be negotiated to bring it to fruition as a public work—requires self-effacement before the powers that be. This seeming contradiction makes it possible for one critic to dub the artist a "Coca-Cola communard," while at the same time wealthy collectors lay down big bucks for limited-edition bronzes like *Marriage of Real Estate and Money*. And while kids enjoyed playing on *Large Covered Wagon* (2004), a lumbering representation of the pioneer spirit pulled by a male ox, driven by a pipe-smoking woman, with tussling siblings hanging out of the back, installed on 147th Street, adults fretted about it as a sign of impending gentrification in their Harlem neighborhood. Comfort and anxiety, submission and resistance are the equivocal conditions of both popular culture and fine art in the postmodern world, two sides of the same coin that add up to a dialectic. As Walter Benjamin writes, "There is no act of civilization that is not at the same time an act of barbarism." Otterness may indeed be an unreliable narrator, but in so being he speaks to our times. **VC**

Willie Cole

by Rebecca Dimling Cochran

2006

Willie Cole creates elegant artworks that challenge prevailing ideas of identity and perception. His combination of visually seductive materials and witty humor serves to temper his serious and sometimes difficult subject matter. In his deft hands, discarded domestic items are transformed into mythical figures and objects that carry poignant commentaries within their iconographic arrangements.

Cole reached a crucial point in his career in 2006, garnering serious national attention and critical appraisal in a series of important exhibitions. New sculptures and prints by the artist were on view in January 2006 at Alexander and Bonin Gallery in New York. "Afterburn," an exhibition of selected works from 1997 to 2004 organized by Susan Moldenhauer, began a six-venue tour across the United States in 2005. A second traveling exhibition curated by Patterson Sims opened at the Montclair Art Museum in New Jersey in March 2006.

The surveys, in particular, expose the linear threads that run through Cole's work. The household iron, for example, is an object he has returned to again and again. Since his first sculpture of a crushed iron in 1988, Cole has explored the utilitarian object from different angles, always coming up with new and interesting ways to exploit its implied references.

Some of his earliest experiments involved using the steam iron as a tool to make works. His "paintings" on canvas and wood are created by scorching the surface with a steam iron. Cole arranges the burns in repeating geometric patterns to form pleasing images. Yet their critical overtones are indicated in titles such as *Lost Soles* or *Branded Irons*, which evoke references to the permanent scarring caused by slavery, as well as corporate branding.

Some of Cole's other iron works contain more literal references, such as his large woodblock print *Stowage* (1997). In the center of the large page is the outline of an ironing board. Adorned with lines of dots, the image takes on the look of black and white diagrams displaying the inhumane way that captured Africans were transported within the hold of a ship. Around this, Cole cut the wood block and inserted 12 actual irons of different makes and models. When printed, the irons' different steam hole configurations form distinctive designs, as if representing the shields of various tribes taken into captivity.

Cole has also made numerous sculptures that emulate or derive from irons. He has dissected heaps of discarded models, re-assembling their various bits and pieces into Erector Set-like figures such as *Perm-Press (hybrid)* (1999). In *Chewa 600* (1997), *600%*, and *Mother and Child* (2002), he fabricated massive versions of the household item, some enlarged as much as 600 times their original size. *Steaming Hot* (1999) takes a distinctively different tone,

Mother and Child, 2002.
Steel and plastic, 34.5 x 24.5 x 15 in.

Speedster tji wara, 2002.
Bicycle parts, 46.5 x 22.25 x 15 in.

fitting a standing iron with feathers to appropriate the look of steam escaping from its base. Another series explores the uncanny resemblance between various irons and tribal masks.

To appreciate how one object can hold such interest after more than 15 years, it is helpful to understand Cole's conceptual process. He rarely makes sketches; instead, he generates word lists that pertain to a particular item. For example, his word list for a steam iron begins with "iron." The next words may visually describe what he sees, reducing the black handle and silver body to "black" and "silver." The shape may suggest the words "shield" and "mask." Then he'll consider what is not there, such as "heat," "fire," and "steam." Each time he handles the object and perceives something different, he'll add a reference to the list, which usually hangs on his studio wall. "With a long list," Cole explains, "I can make work that speaks about that object forever because I'm speaking about it from so many points of view."[1]

Words have always been an important inspiration for Cole: "My great grandfather had a library full of illustrated children's books, and I spent hours reading them and copying the illustrations." The experience came in handy in the 1970s when he worked as a freelance illustrator and writer. He quit in 1983 to become a full-time artist but, as he explains, "The words and images always come together."

The connection is particularly apparent in Cole's titles. He admits that his witty and often wry choices can be "evocative, and they turn the key for the person seeing the work." Often these hints are necessary. In 2004, Cole created a series of near life-size chickens with feathers made from overlapping matchsticks. The title, *Malcolm's Chickens*, is the clue to understanding the incendiary works, which were inspired by a comment made by Malcolm X following the assassination of President John F. Kennedy in which he intoned that the event smacked of "chickens coming home to roost." "Sometimes the language is so encoded that a person still might not get it, but they'll wonder about it," Cole admits. "Like *To Get to the Other Side*. It seems logical to me that it's the answer to a question, so now that you know that, you can begin to put the puzzle together."

Created in 2001, *To Get to the Other Side* is a giant chessboard. On alternating squares of rusted and clean steel rest 32 cast concrete lawn jockeys. The figures in the front row on each opposing side (the pawns) are painted in glossy red and black and hold the traditional horse-hitching ring in their hands. By contrast, the pieces in the back row (rooks, knights, bishops, king, and queen) are dirtier and heavily adorned with African religious symbolism. The knights are imbedded with nails, like *Nkisi* figures from the Republic of Congo that Kongo peoples created to uphold ancestral law and promote divine justice. The rooks and bishops, some with grass skirts, wear sacred offerings cinched in pouches or dangling from their necks. The king and queen are adorned with wound copper jewelry and colorful necktie clothing.

Like much of Cole's work, *To Get to the Other Side* is layered with meaning. It is one of a series of large-scale "games" that he says were inspired by his father's family, whom he describes as "scoundrels and gamblers." Many of these works reference Elegba, the Yoruba deity sometimes known as the trickster, who is often associated with black and red. Cole's game pieces all begin with those colors but, just as history intervened with those brought from Africa, Cole's figures also become differentiated. From mutual beginnings, the pieces become separated into the clean shiny pawns (the house slave) and those dressed to honor their African heritage (the field slaves).

Beyond the historical references, many works allude to Cole's personal experiences. He grew up between the sleepy suburb of Summerville, New Jersey, and the city of Newark, which in the '60s and '70s was a hotbed of cultural activity. Although it takes only 30 minutes to drive from one to the other, Cole often felt that the two places were worlds apart. This piece, he acknowledges, comes out of shuttling between "my own experience in a Christian family and my learned experience being in a contemporary African American community filled with multi-lingual speech and African religions."

Cole lived in New Jersey with his mother and grandmother, both domestic workers with a strong Christian faith. "For me," he explains, "'Why did the chicken cross the road? To get to the other side' is more than a joke. I think about what 'the other side' means. In this world, the other side is the spiritual world. And what does a chicken have to do with the other side? For some people it is just a clever title, they don't understand the deeper meaning."

To truly understand the complex intricacies of Cole's pieces, a road map is often necessary. Fortunately, his works are so visually strong that is not necessary to plumb their depths to enjoy them. A good example is a series of sculptures created from assembled bicycle parts in 2002. Cole's manipulations turn seats into faces, wheels and spokes into manes, handlebars into horns. The visual connection to animals of the African plains is evident. In fact, the sculptures directly reference the antelope headdresses called *tji waras*, which were used in agricultural rites by the Bambara of Mali. To acknowledge the correlation, Cole gave each work a title that combines the type of bike used and its inspiration, such as *Pompton Schwinn tji wara*, *Pacific tji wara*, and *Speedster tji wara*.

A similar playfulness appears in two pieces made during Cole's residency at the John Michael Kohler Arts Center in 2000. Given unlimited access to the porcelain manufacturer's factory, he assembled discarded faucets and plumbing fixtures into a pair of figures, *Abundance* and *Desire*. The first suggests a female figure wearing a skirt, her legs splayed in an inviting pose. Her male counterpart is similarly configured but endowed with a spigot that leaves no question as to his gender. Juxtaposed one against the other, the amusing sexual innuendoes are unmistakable. Both figures bear an uncanny resemblance to Ganesh, the elephant-headed son of the Hindu god Shiva. Cole acknowledges that the Kohler warehouse, where freshly baked toilets are stacked four or five high on pallets,

reminded him of a marble-columned Hindu temple. "I carried [that feeling] back to the studio with me. The final sculptures evolved out of a subconscious process wherein I merely played with the fragments for five to 15 minutes at a time until something emerged."

The art, religion, and imagery of Asia have long fascinated Cole. The Newark Museum houses one of the largest collections of Tibetan art in the country. He studied Eastern religion and philosophy as an undergraduate at the School of Visual Arts in New York City and was a practicing Buddhist and yoga student for several years. "Worlds of Transformation: Tibetan Art of Wisdom and Compassion," a traveling exhibition that Cole saw in 2000, was particularly inspirational. His admiration for the paintings, particularly those of Mahakala, the protector of Tibetan faith, can be seen in one of his newest series of works. In these assemblages, women's high-heeled shoes fit one inside the other to create patterns of color and shape that resemble the glowering eyes and fang-like teeth of this fierce god.

Like irons, shoes appear in Cole's work at various points in his career. In 1993, he experimented with men's shoes in *Winged Tipped Ibeje 1* and 2, but found himself drawn to the complex references and construction of women's high-heels. Stacking them one on top of another, he constructed a series of female figures with provocative titles such as *Screaming Venus* and *Black Leather Venus with Gold Lips and Bows*. Most impressive, however, is *Made in the Philippines*, a series of throne-like chairs made from the same materials.

By using recycled objects as raw materials, Cole immediately imbues his work with a human presence. This subtle undertone is very important. His work is driven by a desire to connect the present with the past, and he constantly derives inspiration from the world around him. When Cole established his first studio in Newark, the city was undergoing a construction boom. He remembers that he "walked around with the phrase 'high tech primitive art' in my head," with the idea of making sculpture out of contemporary building materials. Most of his work during this period was made of galvanized steel strips, like the woven *High-Tech Security Jacket for Executives Only* (1988).

Not long afterward, his mantra changed to "archaeological ethnographic Dada." During this period, he recalls, "I was finding things and creating a culture. Like the archaeologists who find a pile of bones and put them together and people believe that it was a dinosaur." One of the first things he found was an abandoned factory down the street from his studio filled with thousands of blue and white hairdryers. He brought them back to his studio and began to disassemble them. He made numerous works from the hairdryers, but "the work that I probably feel best about," he recalls, "were the masks. I wanted to see how much variety I could find in an image using just that one object. So I made seven or eight masks out of hairdryers, and each had its own personality."

Patterning and repetition play an important role in Cole's work. Sculptures such as *Wind Mask East* (1992) result from stacking, turning, and flipping the hairdryers this way and that as Cole pursues his self-admitted penchant toward symmetry. His arrangements exploit the diverse visual characteristics inherent in the dryers' construction to evoke a human-like visage.

Cole sees his work in the vein of perceptual engineering as described by Wilson Bryan Key in *Subliminal Seduction*. His hope is to "make people see in a way that they've never done before." His process requires that each piece be carefully and beautifully constructed. He has an extraordinary versatility with materials: he bends, weaves, solders, joins, paints, and adorns his work with amazing adroitness. But this visual prowess comes second to his ability to harness the conceptual meanings of his objects. He understands the underlying currents within such mundane things as irons, hairdryers, and matches and exploits them in his poignant titles. Once viewers get past the "aha!" moment of recognizing the unusual materials behind the images, they must confront strong and provocative ideas.

Many of the issues that Cole tackles easily fit within current conversations on history and identity. But this reading of his work may be too narrow. "I think that African American artists have spoken extensively, not exclusively, but extensively about spirituality in art and I'm still addressing that issue," he asserts. "I still think of myself as releasing the spirits from the objects, and I believe that they guide me. I believe that they exist, that it's not just conversation."

He also sees a similarity between his work and some of the contemporary work coming out of Asia. He acknowledges that the visual construction and underlying references are different, but he feels a certain kinship with the dark humor. "There are Asian artists who have sinister and cartoony imagery. I see the work that I'm doing in that vein."

Cole engages in a complex conversation. His interests are broad and far-reaching, but each serves as part of his ongoing exploration into his role in society and the world around him. "There is the original flow and then there are the tributaries," he explains, "but they're all going in the same direction." **RDC**

Notes

1 All quotations are from the author's interview with the artist, May 17, 2005, and subsequent e-mail correspondence.

Photo Credits